JAPAN

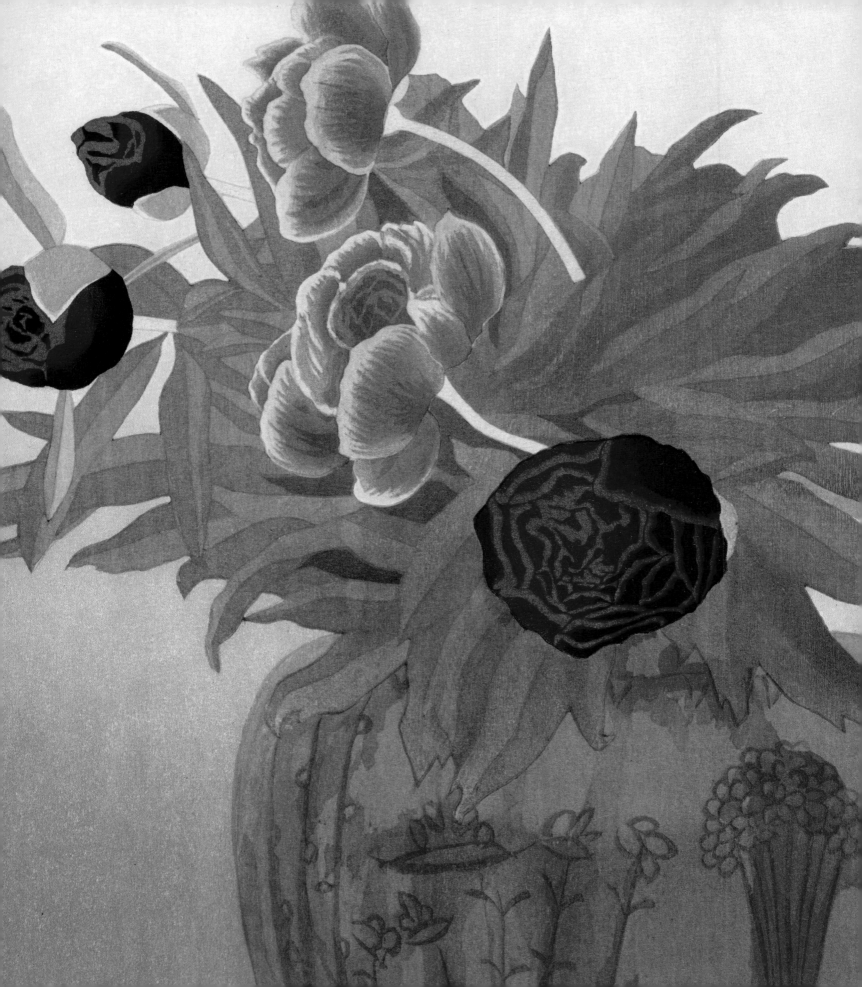

日本の芸術

JAPAN

COURTS
AND
CULTURE

EDITED BY
RACHEL PEAT

ROYAL COLLECTION TRUST

Published 2020 by Royal Collection Trust
York House
St James's Palace
London SW1A 1BQ

This catalogue has been published with generous support from the
Pilkington Anglo-Japanese Cultural Foundation.

ISBN 978 1 909741 68 3

102285

British Library Cataloguing-in-Publication Data:
A catalogue record for this book is available from the British Library.

Edited by Gerard M.-F. Hill
Designed by Paul Sloman
Project Manager: Hannah Bowen
Production Manager: Sarah Tucker
Colour reproduction: die Keure
Typeset in Hiragino and Erato
Printed on 150 gsm Magno matt
Printed and bound in Belgium by die Keure

Printed on biodegradable materials using 100% green energy and
environmentally sustainable processes by our eco-friendly printer.

Published on the occasion of the exhibition *Japan: Courts and Culture*
at The Queen's Gallery, Buckingham Palace, London, in 2020–21.

Front cover: Iida & Co., Kyoto, Japan,
Embroidered folding screen (detail),
c.1880–1900 (cat. 137)

Back cover: Uchida Kuichi, *View from Bridge
Tagonourabashi to Fudzisan* (detail), 1865–75
(see cat. 67)

Frontispiece: Urushibara Yoshijirō,
Peonies in a vase (detail), c.1925 (cat. 128)

Facing Foreword: Utagawa Kunihisa II,
Folding fan (ōgi): Mount Fuji (verso)
(detail), c.1870–90 (cat. 150)

CONTENTS

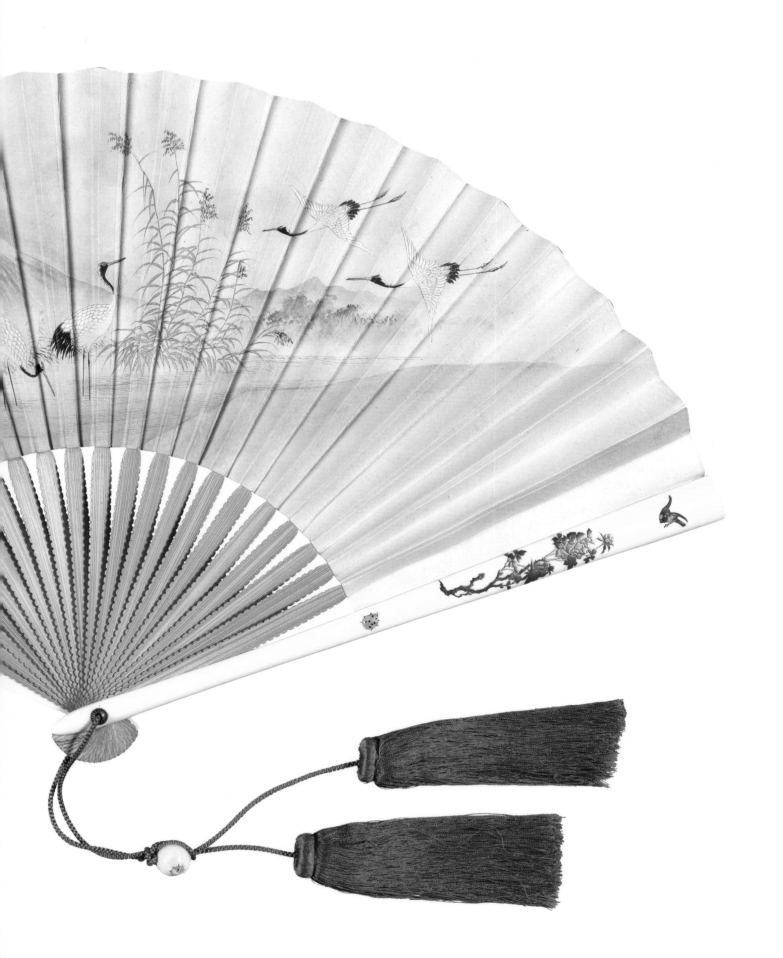

The year 2020 marks the 400th anniversary of the death of William Adams – the first Englishman to reach Japan. Since that time, citizens of both nations have travelled long distances to experience one another's culture, people and art. The first member of the British royal family to do so was Queen Victoria's son, Prince Alfred, Duke of Edinburgh – the first royal foreigner of any nationality to be invited to the modern Imperial Court. His meeting with the Emperor Meiji in 1869 was an historic encounter between 'East' and 'West'. On his return home, the young prince suggested that the exquisite pieces of Japanese craftsmanship he had acquired – including porcelain, lacquer, arms and armour – be displayed at the South Kensington Museum. This rich collection later adorned the walls of his home, Clarence House, which is now the official London residence of both my wife and myself. It is the same spirit of admiration for Japanese art, and desire to share it with as wide an audience as possible, that informs the present exhibition.

Royal visits between the British and Japanese courts took place frequently in the late nineteenth and twentieth centuries. Personal and diplomatic gifts accompanied these exchanges, and the Royal Collection was consequently greatly enriched by fine embroidered screens, metalwork, fans and insignia. Diary entries, letters and photographs in the Royal Archives meanwhile offer a unique insight into the worlds of ritual and honour which united the two royal families. For the first time, highlights from this outstanding collection are brought together to show how members of the British Royal Family have imagined, encountered and celebrated Japan.

Today, the relationship between Britain and Japan remains rich and animated. In 1975, my mother, The Queen, became the first reigning monarch of the United Kingdom to visit Japan. Having first visited Japan in 1970, I most recently travelled to the country in 2019, when I had the pleasure to attend the enthronement celebrations for the Emperor Naruhito, having attended the enthronement of his father, Emperor Akihito, nearly twenty-nine years before. The new era's name, 'Reiwa', means 'beautiful harmony' – an apt description of the spirit of ongoing relations, as well as of the elegant works of art which grace this exhibition.

このたび、The Queen's Gallery, Buckingham Palaceにおいて、英国王室と日本皇室のたゆみない交流の軌跡を明らかにする展覧会、Japan: Courts and Cultureが開催されますことを大変うれしく思います。

200年あまりに及ぶ長い鎖国状態にあった日本が世界に門戸を開き、新しい国家が形作られていく中で、日本が最初に迎えた国賓は、英国のエディンバラ公アルフレッド王子でありました。1869年の世界周遊の途中で来日され、明治天皇と謁見されて交流を深められ、帰国しておられます。その12年後にはアルバート・ヴィクター王子とジョージ王子が来日、昭憲皇太后に「獣二匹」を献上されたことが知られています。この「獣」とは、両殿下が日本の前に立ち寄られたオーストラリアのお土産であるカンガルーのこと。日本に初めてやってきたカンガルーが英国の皇孫殿下からの贈り物であったとは、心が浮き立つようなお話です。

私自身、オックスフォード大学留学中にエリザベス女王陛下にバッキンガム宮殿にお招き頂き、お茶を頂きながら親しくお話をして頂きましたことは、6年間の留学生活の中でのハイライトともいうべき珠玉の思い出となっていますが、エディンバラ公と明治天皇が端緒を開かれた英国王室と日本皇室の交流の歴史の中に自分があることを、本当にありがたく、幸せに思います。

本展覧会には、日英の王室と皇室が築かれてきた絆を示す作品の数々が展示されます。両国の陛下、殿下方の友好の思いが込められた作品をご覧頂き、日英交流の歴史の一端に触れて頂けましたら幸いです。

I am delighted that The Queen's Gallery, Buckingham Palace will be hosting the *Japan: Courts and Culture* exhibition. This exhibition traces the history of the long and solid relationship and exchanges between the British Royal Family and the Japanese Imperial Family.

As a renewed Japan opened its doors to the world again following its centuries-old period of national seclusion, the first official royal visit it welcomed was that of Prince Alfred, Duke of Edinburgh. He visited Japan and met the Emperor Meiji in the course of his world tour in 1869, helping to forge strong bilateral relations between both countries. Twelve years later Princes Albert Victor and George came to Japan and presented Empress Shōken with two 'beasts'. These 'beasts' were in fact kangaroos from Australia which the princes had visited prior to arriving in Japan. That the very first kangaroos were brought to Japan by the two British royal princes is a wonderful story that still makes us smile.

For me personally, the time I spent with Her Majesty The Queen over tea at Buckingham Palace when I was studying at Merton College, Oxford was the highlight of my six-year stay in the United Kingdom. I am delighted to find myself playing a part in the history of the relationship between the British Royal and the Japanese Imperial Families initiated by Prince Alfred and the Emperor Meiji.

This exhibition presents items that speak of the strong ties between the Royal and Imperial Families of Britain and Japan. It is a joy for me that many visitors will be able to enjoy these special objects that have been assembled through friendship and gain new insight into the history of the relationship between our two countries.

This chronology includes the main events discussed in the text, with particular emphasis on Japanese–British royal and imperial relations

1467–1568	Period of the Warring Provinces (*Sengoku Jidai*)
1543	Portuguese reach Japan and introduce firearms
1549	Jesuit missionaries arrive in Japan
1582	Toyotomi Hideyoshi assumes power
1584	Spanish establish a trading post in Japan
	Japanese Christians tour Europe
1588	Two Japanese boys arrive in England, brought from the Spanish ship *Santa Ana*
1592, 1597	Toyotomi Hideyoshi invades Korea
1598	Toyotomi Hideyoshi dies
1600	Tokugawa Ieyasu begins to take power from Hideyoshi's young son, Hideyori
	William Adams arrives in Japan
	The Honourable East India Company (EIC) founded
1602	The Dutch East India Company (VOC) founded
1603	Tokugawa Ieyasu assumes the title of shōgun
	James VI of Scotland accedes to the throne as James I of England
1606	Tokugawa Ieyasu retires in favour of his son, Tokugawa Hidetada
1609	The VOC establishes a trading post at Hirado
1613	Captain John Saris arrives in Japan; EIC trading post established at Hirado
1614	Christian missionaries expelled from Japan
	Captain John Saris returns to Plymouth aboard the *Clove*
1615	Tokugawa Hidetada defeats Hideyori's supporters at Osaka Castle
	Beginning of Edo Period
1616	Trade by European ships restricted to Nagasaki and Hirado
1623	English factory at Hirado closes
1624	Spanish expelled from Japan
1626	Emperor Go-Mizunoo visits the Tokugawa at Nijō Castle
1633–9	Series of edicts limiting contact with the outside world, a policy later known as *sakoku*
1635	Japanese forbidden to leave Japan

1639	Portuguese expelled from Japan
1641	Dutch traders confined to the island of Deshima
1658	The first Japanese porcelain reaches Europe
1673	EIC sends ships to Nagasaki to reopen trade relations, but is refused
1701–3	Akō Incident: 47 *rōnin* avenge the death of their master
1709	Secret of hard-paste porcelain discovered in Europe
1720	Restrictions on importation of foreign books relaxed in Japan
1727	Engelbert Kaempfer's *History of Japan* published
1799	Dissolution of the VOC
1853	Commodore Perry arrives in Japan, demanding establishment of commercial and diplomatic relations with the United States of America
1854	Anglo-Japanese Friendship Treaty
1857	Manchester *Art Treasures of the United Kingdom* exhibition
1858	United States, United Kingdom, Russia, France and the Netherlands sign trade treaties with Japan
1860	Rutherford Alcock, British Consul-General, arrives in Japan
1861	British Legation attacked by anti-foreign Japanese
1862	Namamugi Incident: Satsuma samurai attack a group of Britons in Japan
	Japanese embassy (the 'Takenouchi Mission') visits Britain
	London International Exhibition
1863	British bombard Kagoshima when demands for compensation following the Namamugi Incident are not met
1865	Group of 15 students from Satsuma province travel illegally to Britain to study
1867	Tokugawa Yoshinobu resigns as shōgun and returns power to the emperor
	Paris *Exposition Universelle*
1868	Osaka and Hyōgo (now Kōbe) opened to foreign trade
	Meiji Restoration: return to imperial rule under the Emperor Meiji
	Civil war between Meiji and Tokugawa forces
	Edo renamed Tokyo
1869	Ezo formally incorporated into the Meiji state and renamed Hokkaidō
	Prince Alfred, Duke of Edinburgh visits Japan

1871	*Daimyō* domains abolished and replaced by 72 prefectures	Japan Society of London holds exhibition of Japanese arms and armour	
	A.B. Mitford's *Tales of Old Japan* published	1906	Prince Arthur of Connaught invests the Emperor Meiji with the Order of the Garter
	Prince Higashi-Fushimi Yoshiaki (later titled Prince Komatsu Akihito) visits Britain	1907	Prince Fushimi Sadanaru visits Britain
1872	Exhibition of items from Prince Alfred's visit to Japan at South Kensington Museum	1910	Japan annexes Korea
	Japanese embassy (the 'Iwakura Mission') visits Britain		Prince Fushimi Sadanaru attends the funeral of King Edward VII
1876	Meiji government bans wearing of swords		Japan-British Exhibition at White City, London
1879	Japanese annex Ryūkyū Islands as Okinawa Prefecture	1911	Anglo-Japanese Alliance renewed for a second time
	Prince Arisugawa Takehito sent to Britain for naval training		Prince Higashi-Fushimi Yorihito attends the Coronation of King George V
1881	Prince Albert Victor and Prince George of Wales visit Japan	1912	Prince Arthur of Connaught attends the Emperor Meiji's funeral
1882	Prince Arisugawa Taruhito visits Britain	1914–18	First World War
1884	Prince Higashi-Fushimi Yorihito visits Britain	1918	Prince Arthur of Connaught invests the Emperor Taishō as a Field Marshal of the British Army
1885	'Japanese Village' opens in Knightsbridge		Prince Higashi-Fushimi Yorihito invests King George V as a Field Marshal of the Japanese Army
	First performance of comic operetta, *The Mikado*	1921	Crown Prince Hirohito visits England
1886	Prince Komatsu Akihito visits Britain and invests Albert Edward, Prince of Wales with the Order of the Chrysanthemum	1922	Edward, Prince of Wales visits Japan
		1922–3	Anglo-Japanese alliance discontinued
1887	Prince Komatsu Akihito attends Queen Victoria's Golden Jubilee celebrations	1925	Prince Chichibu visits Britain
		1929	Prince Henry, Duke of Gloucester invests the Emperor Shōwa with the Order of the Garter
1889	Prince and Princess Arisugawa visit Britain	1930	Prince and Princess Takamatsu of Japan visit Britain to convey the emperor's gratitude for the Order of the Garter
1890	The Duke and Duchess of Connaught visit Japan		
1891	Japan Society of London founded		
1894	Treaty of Commerce and Navigation revises the unequal Anglo-Japanese treaty of 1858	1937	Prince and Princess Chichibu attend the Coronation of King George VI
1894–5	Japanese victory in the Sino-Japanese War	1939–45	Second World War
1897	Prince Arisugawa Takehito attends Queen Victoria's Diamond Jubilee celebrations	1953	Crown Prince Akihito attends Her Majesty The Queen's Coronation
1899	Treaty of Commerce and Navigation comes into effect	1971	The Emperor Shōwa makes a State Visit to the United Kingdom
1900	Japan, Britain and other powers suppress the Boxer Rebellion in China	1975	Queen Elizabeth II makes a State Visit to Japan
1902	Anglo-Japanese Alliance signed	1998	The Emperor Heisei makes a State Visit to the United Kingdom
	Prince Komatsu Akihito attends King Edward VII's Coronation	2019	Abdication of The Emperor Heisei and accession of The Emperor Naruhito
1904–5	Japanese victory in the Russo-Japanese War		
1904	Louisiana Purchase Exhibition		
1905	Prince and Princess Arisugawa visit Britain		
	Anglo-Japanese treaty renewed and expanded		

NOTES FOR THE READER

In accordance with convention, Japanese names are presented with the family name first. Place names appropriate to the period are used, followed by the modern-day equivalent at first mention. Japanese terms appear in italics, with the exception of 'kimono', 'netsuke', 'shōgun' and 'samurai', which are deemed to have been absorbed into the English language.

'Silver' is used to describe silver alloys, some of which may be less than 92.5% purity. 'Gilt bronze' is used to describe objects with mounts distinct from silver, silver gilt and copper, although strictly speaking this metal alloy is brass. The term 'ormolu', used historically for the same material, is occasionally also used in quotation. Dimensions are height × width × depth, unless otherwise stated.

The lists of references provided in the 'Literature' and 'Inventories' sections of each entry are not exhaustive, but include the most notable records and secondary material.

Periods of Japanese history are referred to as follows:

Asuka	552–710
Nara	710–94
Heian	794–1185
Kamakura	1185–1333
Nanbokuchō	1333–92
Muromachi	1392–1573
Momoyama	1573–1615
Edo	1615–1868
Meiji	1868–1912
Taishō	1912–26
Shōwa	1926–89
Heisei	1989–2019
Reiwa	2019–

In accordance with convention, past Japanese emperors are generally referred to by their retrospective era names, as follows:

PERSONAL NAME	POSTHUMOUS NAME AND REIGN
Osahito	Emperor Kōmei (r. 1846–67)
Mutsuhito	Emperor Meiji (r. 1867–1912)
Yoshihito	Emperor Taishō (r. 1912–26)
Hirohito	Emperor Shōwa (r. 1926–89)
Akihito	*Abdicated.* Emperor Heisei (r. 1989–2019), also called Emperor Emeritus
Naruhito	Emperor Kinjō ('reigning emperor'), who will be referred to posthumously as Emperor Reiwa (r. 2019–)

Abbreviations used in the main text:

EIC	Honourable East India Company
V&A	Victoria and Albert Museum (formerly the South Kensington Museum)
VOC	Dutch East India Company (*Vereenigde Oost-Indische Compagnie*)

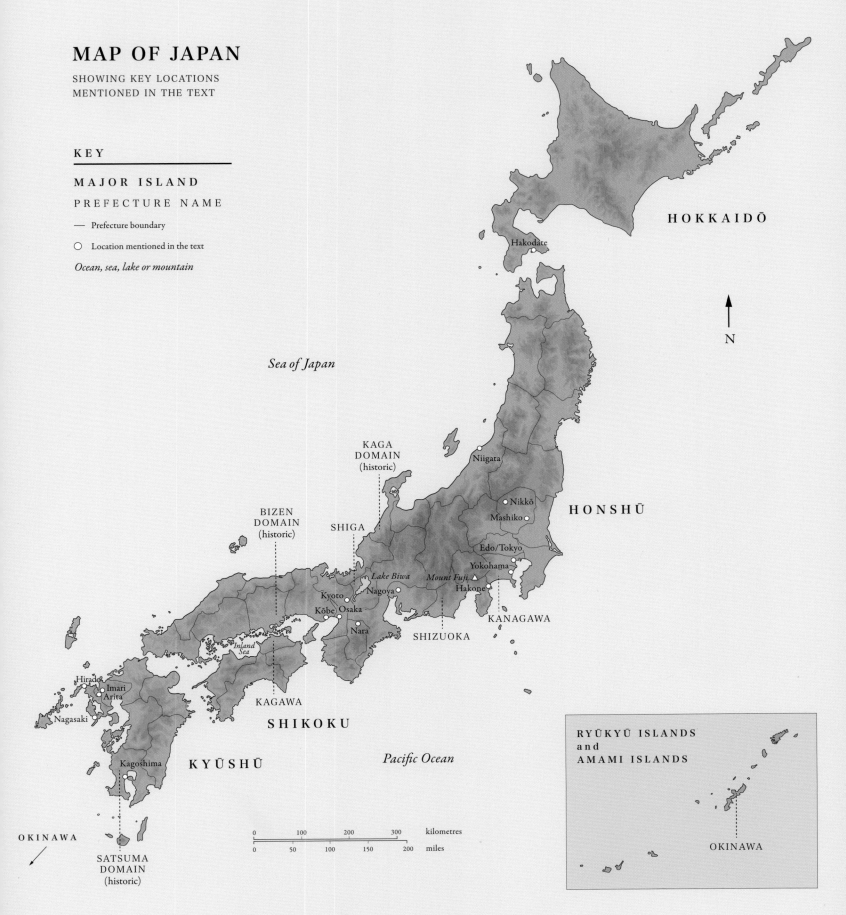

MAP OF JAPAN

SHOWING KEY LOCATIONS
MENTIONED IN THE TEXT

KEY

MAJOR ISLAND

PREFECTURE NAME

— Prefecture boundary

○ Location mentioned in the text

Ocean, sea, lake or mountain

HOKKAIDŌ

Hakodate

Sea of Japan

KAGA
DOMAIN
(historic)

Niigata

Nikkō

Mashiko

HONSHŪ

BIZEN
DOMAIN
(historic)

SHIGA

Edo/Tokyo

Yokohama

Lake Biwa *Mount Fuji*

Kyoto Nagoya Hakone

Kōbe Osaka KANAGAWA

Nara

SHIZUOKA

*Inland
Sea*

Hirado

Imari
Arita KAGAWA

Nagasaki SHIKOKU

Kagoshima KYŪSHŪ *Pacific Ocean*

OKINAWA

SATSUMA
DOMAIN
(historic)

| 0 | 100 | 200 | 300 | kilometres |

| 0 | 50 | 100 | 150 | 200 | miles |

RYŪKYŪ ISLANDS
and
AMAMI ISLANDS

OKINAWA

N

日本の芸術

INTRODUCTION

RACHEL PEAT

O N 25 October 1881, Prince George of Wales (1865–1936, later King George V) visited the resplendent temple mausolea of the Japanese shōguns (military rulers) in Tokyo. There, he and his companions marvelled at the 'real beauty produced by their vermillion painted beams, and the mass of gold and lacquer, black and scarlet, and of bronze and wood carving of birds and flowers'.[1] One of these magnificent buildings belonged to Tokugawa Hidetada (1579–1632), the first shōgun to be contacted by the British, in 1613. By a twist of fate, George would be presented with an extraordinary one-tenth scale model of this very mausoleum shortly after his accession in 1910 (Fig. 0.1). An intricate replica was painstakingly prepared by more than 150 craftsmen for the Japan-British Exhibition, visited by over eight million people that year – a monumental joint venture covering 150 acres and celebrating a new era of political and cultural alliance. As a single object, the model is a microcosm of over three hundred years of British royal interaction with Japan, from first encounter to princely diplomacy and modern partnership. Crucially, it also represents the finest Japanese craftsmanship.

JAPAN IN THE ROYAL COLLECTION

The Royal Collection contains a large and important array of Japanese material of this calibre, including porcelain, lacquer, metalwork, arms and armour, insignia, prints, screen paintings, textiles, enamels and other wares. Many are remarkable for their age and rarity; others are the work of renowned Imperial Household Artists (*Teishitsu Gigei'in*) and suppliers such as Andō Jūbei, Akatsuka Jitoku[2] and Namikawa Sōsuke (cats 108–110 and 117–118). The oldest is an armour sent to James I in 1613 – the earliest such piece to arrive in Britain and the

first non-European work of art to enter the Royal Collection that survives today (cat. 1). The newest object exhibited here is a vessel by the artist–potter Hamada Shōji (1894–1978), who in 1955 was honoured by the Imperial Government as a 'Holder of Important Intangible Cultural Properties' or Living National Treasure (*Ningen Kokuhō*) (cat. 33). Never before has so wide a range of Japanese art from the Royal Collection been assembled and exhibited.

The works in this catalogue are objects of beauty, made from the costliest materials and reflecting the finest artistic skill. They are also evidence of the unique relationship between the British royal family and Japan over a period of more than 350 years. During that time, Japanese treasures were acquired through purchase, through travel and through diplomatic engagement. Many were gifts exchanged in person by members of the British and Japanese imperial families. The objects therefore tell a uniquely royal story. They do not however offer a holistic view of European interaction with Japan, nor do they represent the full breadth and complexity of Japanese art. It may be surprising that this catalogue includes only one netsuke, and that there are no kimono or specimens of calligraphy. These absences reflect the constraints of the export trade, as well as the collecting taste of individual members of the royal family and the kinds of objects selected as suitably impressive diplomatic gifts. Nevertheless, the display and enjoyment of objects in the Royal Collection by successive generations of the British royal family provides a rich window of insight into how Japanese culture has been received and assimilated in the West.

WHICH JAPAN?

The works assembled here date almost exclusively from the Edo (1615–1868), Meiji (1868–1912) and Taishō (1912–26) periods. These centuries were marked by considerable political and artistic change in Japan. During the Edo period, the country was governed by shōguns from the Tokugawa clan, centred on the new city of Edo (modern-day Tokyo) from which the era takes its name. The remarkable political stability achieved by the Tokugawa allowed arts and culture to flourish, sponsored

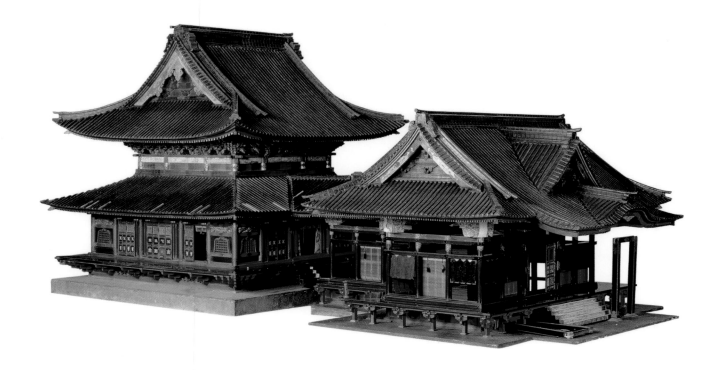

by a newly leisured samurai elite and pioneered by merchant classes emerging in the commercial hubs of Edo and Osaka. It was at this time that porcelain was first produced in Japan, and there were also numerous innovations in lacquer, fashionable dress and woodblock printing. Nevertheless, a policy of controlled interaction with the outside world (now known as *sakoku*) meant that British royal contact at this time was limited to the acquisition of goods via Dutch and Chinese traders.

Japanese 'seclusion' came to an end in the 1850s, and shortly afterwards internal and external pressures prompted a return to direct imperial governance in 1868. The hitherto reclusive emperor took the name 'Meiji' ('Enlightened Rule') and ushered in an era of dramatic modernisation modelled largely on western precedent. Japanese artists explored new international markets for their wares, while metalworkers in particular were forced to adapt following the loss of their traditional patrons, the samurai. European artists and tourists began to travel to Japan in increasing numbers, and members of the British royal and Japanese imperial families made the first diplomatic visits

0.1 Takamura Kōun (1852–1934), Kouda Minoru (active 1910) and the Tokyo School of Fine Arts, *Model of the Taitokuin Mausoleum*, 1909–10. Cypress wood, lacquer, copper alloy, paint and gold, 360.0 × 540.0 × 180.0 cm, RCIN 92903

between the two nations. Imperial gifts of swords, embroidered screens and lacquerware entered the Royal Collection for the first time.

By the start of the twentieth century, Japan was increasingly recognised as a modern power by the nations of the West. Britain accordingly entered a defensive alliance with the Meiji government which later extended into the Taishō period. The new partnership was bolstered by high-profile ceremonial engagement between the two ruling families, who exchanged insignia, attended coronations and presented exquisite gifts. Rapid industrialisation and radical artistic currents in Taishō Japan were counterbalanced by an increasing concern with ritual and tradition. Works in the Royal Collection from this period reflect the fusion of these elements.

Overall, the period from 1600 to 1937 was marked by increasing awareness, understanding and appreciation of Japanese culture by members of the British royal family. This is not to deny moments of profound miscommunication and tension. Neither is it to ignore the often-piecemeal British experience of Japan – an archipelago comprising four main islands (Honshū, Hokkaidō, Kyūshū and Shikoku) and numerous smaller ones, some 15,000 miles from Britain by sea. Even after Japan's 'reopening' to the West, the British presence there was for much of the nineteenth century confined to diplomatic enclaves and treaty ports such as Nagasaki, Edo and Yokohama. Nevertheless, Japan's artistic diversity in this period is amply demonstrated by the distinctive characteristics of wares from regions like Kagoshima (cat. 32) and Saga (cat. 30). This catalogue seeks to celebrate that variety.

RESEARCH AND DISPLAY

Japanese art in the Royal Collection has a long history of display. As well as forming an integral part of the finest royal interiors, works have long been loaned to public exhibitions. As early as 1857, Queen Victoria (1819–1901) sent a Japanese armour from Windsor Castle to the *Art Treasures of the United Kingdom* exhibition in Manchester.[3] Eight years later, she made a substantial contribution to the nascent Japanese collections at the South Kensington Museum (now the Victoria and Albert Museum, or V&A).[4] In the early twentieth century, King George V and Queen Mary (1867–1953) were likewise generous lenders to a variety of popular and specialist displays, including the landmark 1910 Japan-British Exhibition at White City. Two armours were subsequently placed on long-term loan to Maidstone Museum in 1929 (cats 72–73).

Select portions of the Japanese collection have also featured in articles and exhibition catalogues by a global network of academics and researchers. This publication builds on the excellent foundation afforded by the Royal Collection's three-volume catalogue raisonné, *Chinese and Japanese Works of Art in the Collection of Her Majesty The Queen*, which was published in 2016.[5] The royal story presented here is nevertheless one never told before in a dedicated exhibition or art historical publication. It comes at an apposite moment, coinciding with the Japan-UK Season of Culture 2019–20 and the 400-year anniversary of the death of William Adams (1564–1620), the first known Englishman to reach Japan.

This book consists of four narrative chapters (1, 2, 5 and 8), which outline British royal interaction with Japan using prints and photographs, as well as unpublished material from the Royal Archives, and six chapters (3, 4, 6, 7, 9 and 10) that introduce specific areas of Japanese arts and culture, and the rich materials, techniques and traditions which underpin them. Interspersed are illustrations and descriptions of objects arranged by type. Over half have never been exhibited before. We hope that readers will experience the same delight as Prince George of Wales during his visit to Tokyo in 1881. He discovered, like so many who have encountered Japanese art before and since, that 'the main characteristic of all Japanese work is its conscientious perfection of detail in every particular, in that which is hidden as well as in that which is exposed to the eye'.[6]

日本の芸術

1

FIRST ENCOUNTERS

1600–1639

RACHEL PEAT

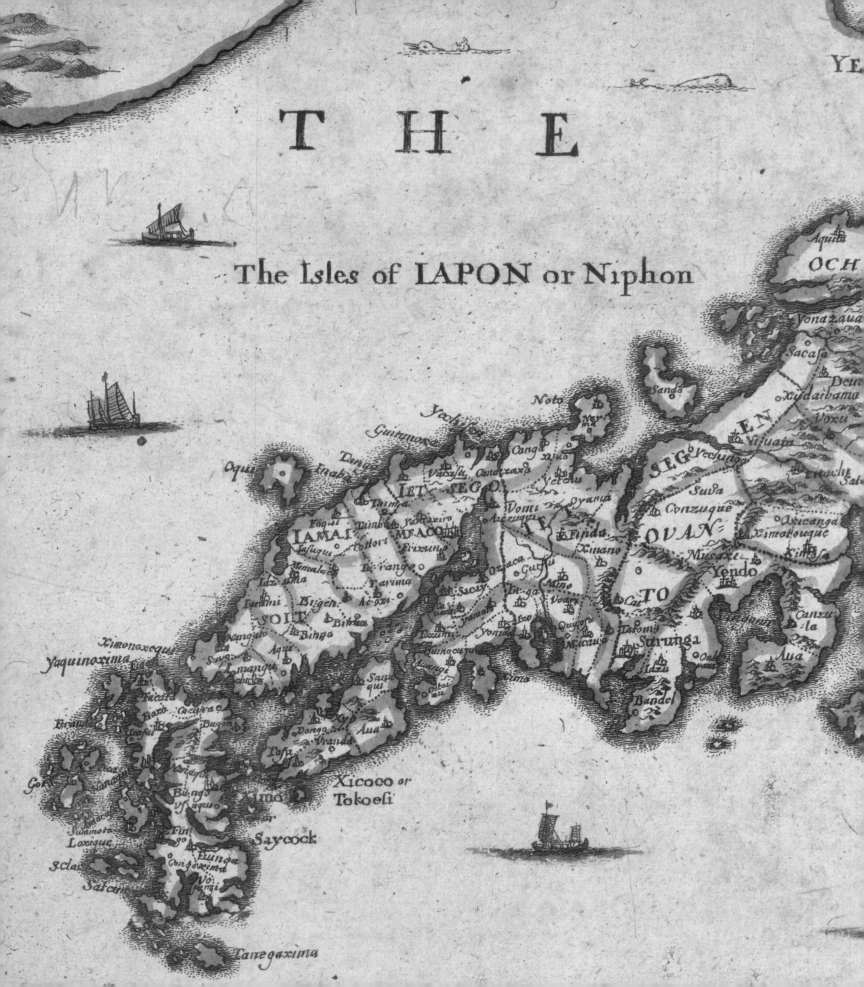

THE

The Isles of IAPON or Niphon

YE

OCH

Aquita

Yonazaua

Sacasa

Deua

Xudaibama

Voxu

Nijuata

Noto

Guitunore

Yechi

Canga

Sando

Merm

EN

SEGO

Vechinage

Tanga

Vacasta

Canatzaxa

Suua

Suda

Conzuque

Tainba

Yechu

Asicanga

IET

SEGO

Oyanua

Ximotouque

Vomi

Auzuque

OVAN

IAMAI

MEACO

Xuano

Tottori

Frixune

Finda

Musaxi

Yendo

Izuani

Ozaca

Guru

TO

Te

Canzu-

Bizen

Sacay

Inga

Voari

Cat

-la

SOIT

Sagi

Yamai

Quijone

Tacomi

Surunga

Bingo

Izumi

Yonzu

Micaua

Ximonaxequi

Idzu

Yaquinoxima

Sanu-

Auia

qui

Bandel

Onde

Donga

Auia

Vranda

Tofu

Xicoco or

Tokoesi

Bungo

Ima

Saycock

Loxique

Fin

go

S.Clar

Bunga

Satin

Wo

fumi

Tanegaxima

Though separated by ten thousand leagues of clouds and waves, our territories are as it were close to each other.

**Letter from Tokugawa Ieyasu
to James I of England,
4 September 1613** [1]

ON 4 September 1613, Tokugawa Ieyasu (1543–1616, Fig. 1.1), shōgun of Japan, wrote these words to James I of England (1566–1625, Fig. 1.2). His letter reached the king in autumn 1614, together with costly gifts of two armours and ten gilded and painted folding screens (*byōbu*). Most significantly, Ieyasu's communication included a list of trading privileges granted to British subjects in response to a request dispatched by James in January 1612. This was the first formal diplomatic contact between Japan and Britain.

Military leaders like Ieyasu had governed Japan since the late twelfth century, wielding de facto power on behalf of the emperor in Kyoto. The Tokugawa clan rose to prominence following a tumultuous era of conflict known as the Period of the Warring Provinces (1467–1568), cementing power over their rivals at the Battle of Sekigahara in 1600. Ieyasu was appointed shōgun in 1603, the same year that James succeeded Elizabeth I (1533–1603) and united the thrones of England and Scotland. By 1606, Ieyasu had nominally retired in favour of his son, Tokugawa Hidetada, and together they quashed the last resistance to the new regime at Osaka Castle in 1615.

The victory heralded a new era of stability, the Edo period (1615–1868), which took its name from the newly created city in eastern Japan (now Tokyo) which formed the centre of the Tokugawa military government. It was this world that James I encountered in the early seventeenth century.

PIECEMEAL INTERACTION

British rulers and their subjects already had a longstanding, if imprecise, awareness of Japan. Romanticised accounts by the Venetian explorer Marco Polo (1254–1324), gleaned from his sojourns in China, had told of 'Chipangu', a land where 'the quantity of gold they have is endless'. [2] In 1498 Henry VII accordingly authorised John Cabot to undertake a voyage westward across the Atlantic to find this country where 'the spices of the world have their origin as well as the jewels'. [3] It was nevertheless the Portuguese who were the first Europeans to reach Japan, in 1543 (Fig. 1.3). They soon established a formal trading post at the port of Nagasaki, and in time Japanese wares began to appear in European collections. Among them were chests, cabinets and diplomatic gifts of arms and armour. The earliest surviving Japanese object to have arrived in Britain is possibly a lacquer and mother-of-pearl chest at Chirk Castle, Wrexham, thought to have been acquired by Sir Thomas Myddelton in 1600 (Fig. 1.4). Tantalisingly, the posthumous inventory of Henry VIII's possessions, dated 1547, describes

| Detail of cat. 2

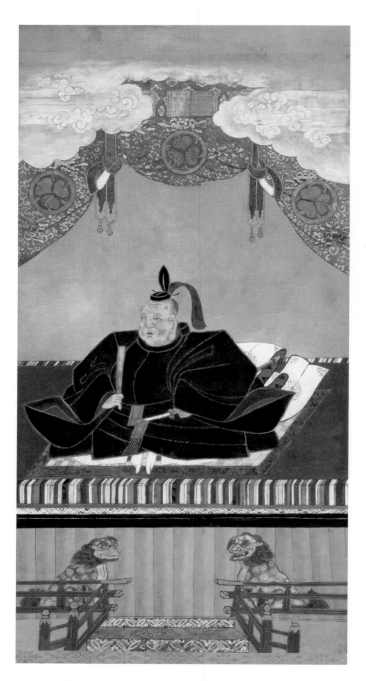

1.1 Attributed to Kanō Tan'yū Morinobu (1602–74), *Tokugawa Ieyasu as a Shintō deity, Tōshō-Daigongen* (hanging scroll, detail), 1640–74, 89.7 × 38.8 cm, Tokugawa Art Museum, Nagoya

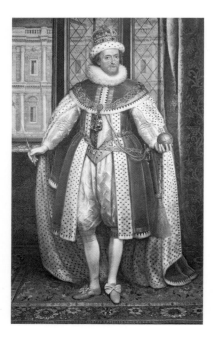

1.2 Paul van Somer (*c.*1576–1621), *James VI and I, c.*1620. Oil on canvas, 227.0 × 149.5 cm, RCIN 404446

'one Chest of mother of perle garnished with golde', which might be Japanese, if it is not Indian.[4]

The Portuguese swiftly established a Jesuit mission in Japan under Francis Xavier (1506–52), who arrived in 1549. Xavier's efforts were so successful that in August 1584 four young converts from the island of Kyūshū travelled to Europe and were received by the Pope. Though the group did not visit England, State Papers for this period suggest a keen interest in their activities at the Elizabethan Court, where reports of the 'four Japanese Indians' were carefully compiled.[5]

The first Japanese travellers to set foot on English soil arrived shortly afterwards, in 1588. Contemporaries noted 'two yong lads borne in Iapon, which could both wright and reade their owne language'.[6] They were ships' boys from the Spanish Manila galleon, *Santa Ana*, which had been captured by the explorer and privateer Thomas Cavendish (1560–92). Cavendish sought to curb the maritime success of the Spanish, who had established their own trading post in Japan in 1584. In recognition of his success, Elizabeth I dined aboard his ship at Greenwich on 5 November 1588, and it is possible

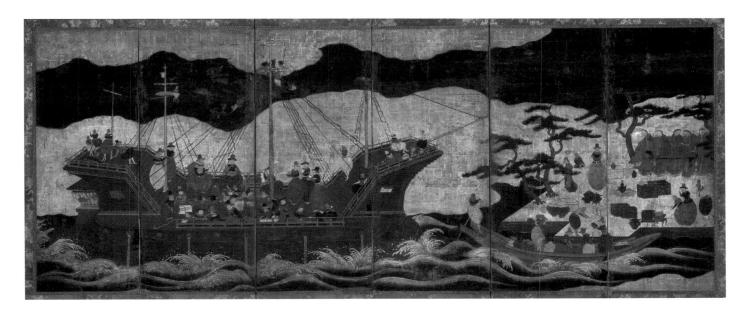

1.3 Japan, *Arrival of a Portuguese ship at Nagasaki*, c.1600–1630. Ink, colours and gold leaf on paper, 157.0 × 365.0 × 1.5 cm, V&A 803-1892

that she encountered the Japanese boys on that occasion.[7] Certainly their presence attracted comment. 'Is it not strange,' wrote the geographer Richard Hakluyt (?1552–1616), to find them 'agreeing with our climate, speaking our language and informing us of the state of their eastern habitations?'[8]

AN ENGLISH TRADING POST IN JAPAN

William Adams of Gillingham, Kent, was the first recorded Englishman to reach Japan. He was shipwrecked there in 1600 while serving as pilot of the Dutch trading vessel *Liefde*. Evidently a man of extraordinary talent, Adams soon rose to become Tokugawa Ieyasu's chief adviser on European affairs. Adams learnt Japanese, married a Japanese woman and served as official interpreter for Europeans, helping the Dutch East India Company (*Vereenigde Oost-Indische Compagnie*, VOC) to establish a base at Hirado in 1609. His letters home were the first English eyewitness accounts of the country. In 1611 he

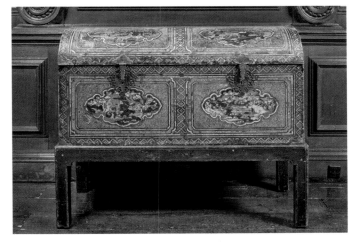

1.4 Japan, *Chest*, c.1600. Wood, mother-of-pearl, sharkskin, lacquer, gilt copper, gold and silver, 63.5 × 131.5 × 59.2 cm, Chirk Castle, Wrexham, National Trust, NT 1170737.1

wrote, 'The iland of *Japon* is a great land … The people of this Iland of *Japon* are good of nature, curteous above measure, and valiant in warre'.[9]

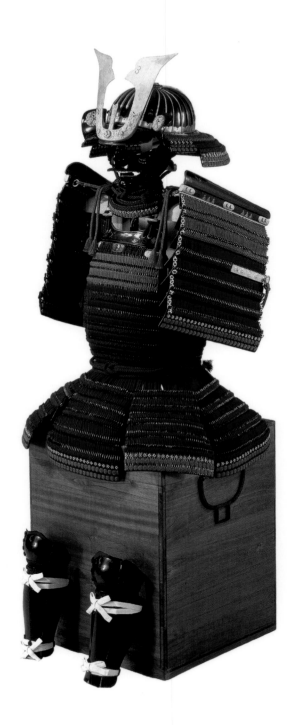

1.5 Iwai Yozaemon, *Armour (dōmaru)*, *c.*1610. Leather, iron, copper, silk, black and gold lacquer, 114.3 cm (height from tassets to top of crest), Royal Armouries, TR.843 B

Based on Adams' reports, the English East India Company (EIC), founded by royal charter in 1600, commissioned Captain John Saris (*c.*1580–1643) of the ship *Clove* to establish their own trading post or 'factory' in Japan in 1611, if insufficient goods could be procured in South-East Asia.[10] Furnished with a letter from James I, Saris arrived at Hirado in 1613. With the help of Adams, he delivered to Tokugawa Ieyasu a translation of the king's letter requesting that British subjects 'may with securitie and safetie settle their trade within your dominions'.[11] He also brought gifts from James I of a gilt basin, cloth and a silver-gilt telescope, the first of its kind to be seen in Japan.[12]

Saris then travelled to meet Ieyasu's son, Hidetada, at Edo, where he was struck by the 'glorious appearance' of the gilded and lacquered buildings.[13] There, he received 'two varnished armours for a present for our king' and a 'tatch [*sic*] or long sword' and 'waggadash' [*wakizashi*] for himself.[14] The armours were the work of Ieyasu's personal armourer, Iwai Yozaemon of Nara – one with red and blue lacing (cat. 1), the other with red and purple (Fig. 1.5). A saddle and stirrups were probably also presented at this time (cats 75–76). 'Ten Beobs [*byōbu*, screens] or large Pictures to hang a chamber with' were added when the party stopped at Kyoto on their return to Hirado.[15] Most important of all, Saris procured a letter bearing Ieyasu's red seal which granted the Company permission to establish a settlement and 'carry on trade of all kinds without hindrance' (Fig. 1.6).[16] A factory was almost immediately established at Hirado by six crew of the *Clove* under the governance of Richard Cocks (1565–1624).

Saris returned to Plymouth with the shōgun's gifts, and 11 Japanese sailors, in September 1614. He quickly wrote to London with a detailed, if unrealistic, list of commodities he thought 'vendible in Japaun', including broadcloth, lead, silk, 'drinkinge glasses of all sortes', pepper, honey and wax.[17] The Company praised him for having 'Capitulated vpon good tearmes with the Emperour [*sic*]' but censured his private trading and burnt the 'lascivious books and pictures' he had acquired.[18] Several of the screens intended for the king were probably damaged during the return voyage, for they were swapped before presentation for finer specimens already

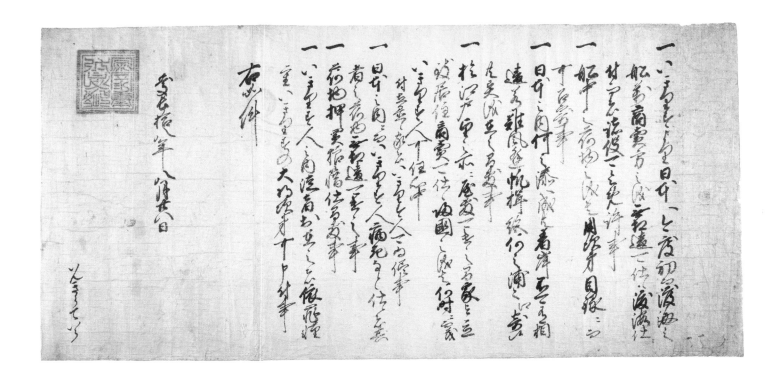

in the Company's possession.[19] A pair appeared in the 1649 Commonwealth Inventory of Charles I's possessions as 'Two China skreenes guilt', but it is impossible to tell whether these are the original gifts or the substitutes.[20] The armours were almost certainly the first of their kind to arrive in England, and at least one was displayed in the Armoury at St James's Palace by the 1640s.[21]

Meanwhile, regular reports from Japan began to arrive from Cocks, whose patron Sir Thomas Wilson forwarded them to James I as 'good recreation for your Majesty'.[22] The letters described 'so many strange things' that the king declared them 'the loudest lyes' he had ever heard.[23] James hoped to meet Cocks on his return from Japan, but it was not to be. Blighted by financial mismanagement and a poor sense of what was saleable in Japan, the English factory at Hirado failed to make a profit and was abandoned in 1623. A disgraced Cocks died on his voyage home to England. The following decade, a change in Japanese policy would make any return impossible.

1.6 Tokugawa Ieyasu (1543–1616), *Document granting trade privileges to the East India Company in Japan*, 1613. Ink on paper, Bodleian Libraries, University of Oxford, MS Jap. b.2

IWAI YOZAEMON (ACTIVE 1585–1610)
ARMOUR (DŌMARU), 1580–1610

Iron, gilt-copper alloy, *shakudō*, lacquer, silk,
horsehair, deerskin

161.0 × 72.0 × 70.5 cm (overall, approx., when mounted)

Helmet signed in red lacquer on black: *Nambu Iwai
Yozaemon saku* ('Made by Iwai Yozaemon of Nara')

RCIN 71611.a–k

PROVENANCE: Sent to James I by Shōgun Tokugawa
Hidetada, 1613

This splendid and understated armour was sent to James I of England
by Tokugawa Hidetada, third son of Tokugawa Ieyasu, who ruled as
the second shōgun of the Tokugawa dynasty from 1605 to 1623. Some
sources have suggested that the armour may once have been owned
by Takeda Katsuyori (1546–82), a *daimyō* who had fought, and lost,
against Tokugawa Ieyasu at the Battle of Tenmokuzan in 1582.[24]

The armour is of the body-wrapped (*dōmaru*) type, which hinges
around the body and fastens on the right. The 'pumpkin-shaped'
helmet (*akodanari kabuto*) is signed by Iwai Yozaemon, one of the
main armourers to the ruling Tokugawa family. Armours by Iwai
Yozaemon in other European royal collections indicate that this was
a popular diplomatic gift from the Tokugawa family, easily available
from a regular and reliable source.[25] The helmet has a very wide,
almost flat neck guard (*shikoro*), small turn-backs (*fukikaeshi*) and
visor (*mabisashi*) decorated in gold lacquer with stylised clouds. The
akodanari helmet has prominent vertical rivet lines and is lacquered
black. A raised area at the back of the helmet bowl may have been
designed to accommodate the *chonmage*, the samurai hairstyle which
consisted of a shaved pate with the hair oiled and tied at the back of the
head in a queue. This distinctive form of helmet was extremely popular
during the Muromachi period (1392–1573) and the traditional style
would have appealed to the Tokugawa family who were conservative in
their tastes. The face-mask (*sōmen*) has a fearsome appearance, although
the whiskers have possibly been trimmed over the years.

Much of the armour is laced in red and blue silk in a chequerboard
pattern. The lamellae (*kozane*) are individual pieces of iron lacquered
and laced together – a technique known as *hon-kozane* ('true' *kozane*),
which creates a more flexible armour. Continuing the conservative
style, the shoulder guards (*sode*) are very large for an armour of this
period. The solid iron upper areas of the cuirass (*dō*) are decorated with
gold lacquer dragons whose red lacquer tongues chase stylised clouds,
possibly symbolising the Buddhist pearl of enlightenment, on a

black lacquer ground. The rims (*fukurin*) and other metal fittings are of
engraved and pierced *shakudō* and gilt-copper alloy. Interestingly, the
small fittings to secure the cuirass have a discreet motif of a paulownia
(*kiri*) leaf, an imperial symbol later adopted by the Tokugawa family.
The sleeves (*kote*) are decorated in a similar fashion and have fine,
though faded, silk with auspicious motifs and areas of iron mail. The
greaves (*suneate*) are decorated with further stylised clouds in gold
lacquer on black.

This is one of the 'two varnished armours' given to Captain John
Saris of the EIC at Edo on 19 September 1613.[26] Saris returned to
Plymouth with the gifts in September 1614, but no account of their
delivery to James I survives.[27] The pair were almost certainly the first
Japanese armours to arrive in Britain. By the mid-seventeenth century,
they appear to have been separated, for only one was recorded at the
Tower of London in 1660.[28] The present armour was stored in a lacquer
box in the Armoury at St James's Palace, where it was inventoried in
1649–51 by the Commonwealth government for the posthumous sale
of Charles I's possessions. At that time, it was described as an 'Indian
Armor' and purchased by Major Bas on 23 October 1651 for £10.[29]

Following the Interregnum, the armour was returned to the Royal
Collection, but confusion about both pieces' provenance abounded.
The armour at the Tower was for example described in 1662 as a
present to Charles II 'from the Emperor Mougul', in India.[30] As late
as 1916, the present armour was confused with another in the Royal
Armouries which had in fact been given to Philip II of Spain in 1585.[31]
At that time, it was in reality mounted on the wall of the Grand
Vestibule at Windsor Castle, with other Japanese items from the
Royal Collection (see p. 195).[32] GI & RP

LITERATURE: Dufty 1965 (exh. cat.), no. 42; O. Millar
1970–72, no. 49, p. 154; Bottomley 2004, pp. 11–14;
Bottomley 2013, p. 23

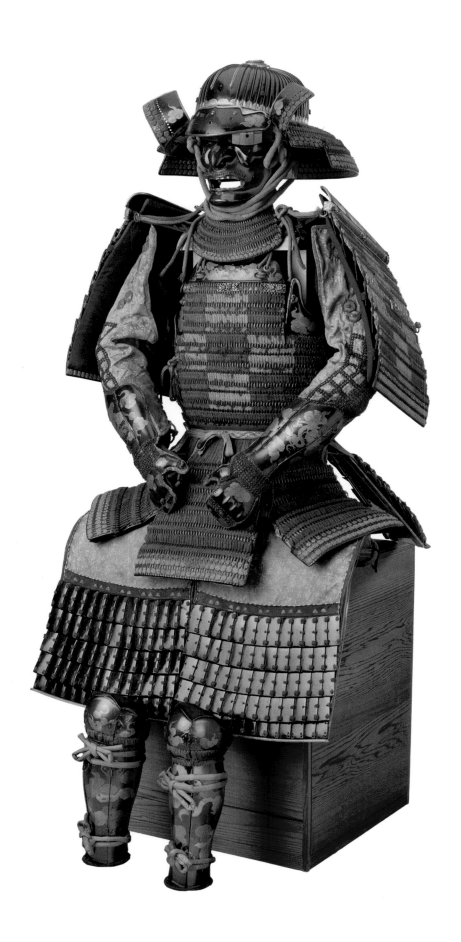

日本の芸術

2

TRADE

CONTACT
THROUGH PURCHASE
1639–1854

RACHEL PEAT

> *I showed unto him [Tokugawa Ieyasu] the name of*
> *our country, and that our land … desired friendship*
> *with all kings and potentates in way of merchandise,*
> *having in our land divers commodities which these*
> *lands had not; and also to buy such merchandise in*
> *this land which our country had not.*

Letter from William Adams to his wife
in England, from Japan (undated)[1]

For more than 200 years from the early seventeenth century, Japanese-British interaction was limited by a Tokugawa policy of controlled contact now known as *sakoku* ('closed country'). Beginning in the 1620s, the *bakufu* (military government) expelled Catholic missionaries and European traders in an attempt to strengthen domestic authority and regulate potentially disruptive foreign influence. Overseas travel by the Japanese was prohibited on pain of death. From 1639, only the Protestant Dutch – who had proved less prone to proselytising than the Catholic Portuguese and Spanish – were permitted access to Japan, alongside the Chinese and Koreans. After 1641 they were confined to the tiny island of Deshima in the bay of Nagasaki (Fig. 2.1).

No formal diplomatic interaction between Britain and Japan took place in this period. From the reign of Charles I (1600–49) to William IV (1765–1837), royal engagement with Japan was indirect, mediated almost exclusively through trade. Art and other goods were acquired via VOC traders and the owners of Chinese junks, who operated within a complex network of inter-Asian coastal trade. Japanese wares that reached Europe were either brought to South-East Asian ports and then purchased by Portuguese and British merchants, or

else sold and re-purchased at a profit by the Dutch en route to the West. Many of the lacquer chests, porcelain jars and textiles which arrived on European shores in this way were designed specifically for the export market, indicating the global connectedness of their supposedly 'isolated' Japanese manufacturers. These extraordinary goods were treasured in Britain not merely for their rarity but also for the exotic materials from which they were made. Most desirable were objects made from porcelain and lacquer, the secrets of which were not yet known in the West. For two centuries, the British royal family and their subjects would both marvel at and misunderstand these pieces, creatively displaying and adapting them in ways which reveal as much about the European imagination of Japan as about Japan itself.

LACQUER

During the first half of the seventeenth century, the most sought-after Japanese goods were chests and cabinets decorated with *urushi* (lacquer). This material, discussed in full on pp. 76–7, is a waterproof varnish made from the sap of the *Toxicodendron vernicifluum* tree (formerly known as *Rhus verniciflua*). Applied in numerous layers, sometimes of different colours, and then exquisitely embellished, Japanese lacquer was considered finer in quality than Chinese or other Asian examples. The earliest *urushi* wares to arrive in Europe were typically densely decorated with mother-of-pearl inlay, a style

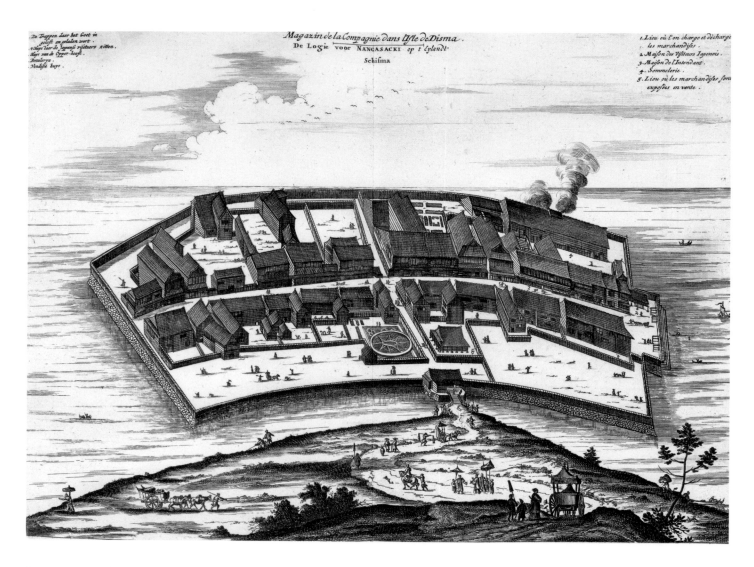

2.1 Pieter van der Aa (1659–1733), *The Dutch Factory at Deshima*, pl. 15 in *La Galerie agreable du Monde… Japon et Païs d'Eso*, 1729. Ink on paper, 39.5 × 29.6 × 5.8 cm (book, closed), RCIN 1021721

known in Japan as *nanban* (or 'southern barbarian') for its appeal to western buyers (see cat. 34). A cabinet of this kind, 'of Mother of pearle standing upon a frame of blacke woodd' was described among Charles I's possessions in 1649, when it was valued at £8.[2]

Tracing Japanese lacquer in this period is complicated by the contemporary tendency to describe all Asian wares, without distinction, as 'Indian'. Samuel Purchas, writing in 1613, confessed, 'The name of India is now applied to all farre-distant countries'.[3] Thus an 'Indian Chest' and 'Indian truncke' belonging to Charles I may well also have been Japanese. Both were sold in 1649 at Denmark House (now Somerset House) by the Commonwealth government for £10 and £13 respectively.[4]

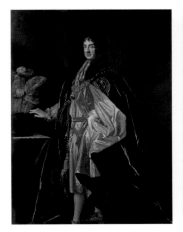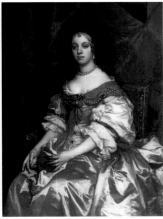

2.2 (left) Sir Peter Lely (1618–80), *Charles II* (detail), *c*.1672.
Oil on canvas, 239.4 × 147.5 cm, RCIN 405672

2.3 (right) Sir Peter Lely (1618–80), *Catherine of Braganza*,
c.1663–1665. Oil on canvas, 125.4 × 102.7 cm, RCIN 401214

Nanban-style wares were gradually replaced by furniture combining a black ground with sprinkled gold decoration of landscapes and figures. The Portuguese Jesuit, João Rodrigues Tçuzzu (*c*.1562–1634), marvelled at the Japanese ability to make a varnished object 'look as if it were made of smooth glittering gold'. He described how, 'using pure gold powder, they paint [*sic*] various objects in which they set flowers made of gold and silver leaf and mother-of-pearl. There is nothing more splendid.'[5] In Europe, cabinets of this kind were often raised to eye level by elaborate carved and gilded stands to form impressive centrepieces for important rooms. In 1661, Samuel Pepys saw 'two very fine chests, covered with gold and Indian varnish' in the closet of James, Duke of York (1633–1701, later James II) – a gift from the VOC.[6] The fashion for this furniture was reinforced in 1662 when Catherine of Braganza (1638–1705), the Portuguese bride of Charles II (1630–85), brought to Hampton Court 'such Indian Cabinets and large trunks of Laccar, as had never before ben seene here' (Figs 2.2 and 2.3).[7]

Charles II's marriage nevertheless had unforeseen consequences for Japanese-British relations. In 1673, the EIC sent the aptly named *Return* to Japan to request resumption of direct trade, but the crew was rebuffed by the shōgun. The sole reason, they were told, was that 'our King was married with the daughter of Portugal their enemy' (Fig. 2.4).[8] Portuguese Jesuits had long been despised and feared by the Japanese for the destabilising effect of converts' allegiance to Rome. Had Charles II not married a Catholic, it is quite possible that the English would have been permitted to re-establish their factory at Hirado at this time.

British customers instead had to rely on the Dutch for desirable Japanese lacquer – or find their own ways of imitating it. In 1688, John Stalker and George Parker published a book of recipes for homemade varnishes called *A Treatise of Japaning* [*sic*] *and Varnishing*. They promised results, 'so near the true Japan [lacquer] … that no one but an Artist should be able to distinguish 'em'.[9] Purchases of 'Japanned' pieces, as they were known, are recorded at this time in the accounts of the Great Wardrobe, the department responsible for royal furnishing. In 1678, William Farnborough supplied 'a large glass, table and stands of Japan' for Catherine of Braganza's State Bedchamber at Windsor.[10] The Dressing Room of Mary of Modena (1658–1718) at Whitehall was likewise later furnished with 'table stands and glass of black Japan', costing £20.[11] Such items signified luxury and prestige, and in November 1680 Charles II accordingly commissioned a cabinet 'all of Japan worke' for the Emperor of Morocco.[12] Nevertheless, these imitations could never achieve the exalted status of Japanese *urushi*. 'The glory of one Country, Japan alone', wrote Stalker and Parker, 'has exceeded in beauty and magnificence all the pride of the Vatican'.[13]

PORCELAIN

Unlike lacquer, Japanese porcelain did not arrive in Europe until the mid-seventeenth century. Before that time, this costly and highly prized material (see pp. 38–9) was procured from China, where vast quantities of blue-and-white decorated pieces were produced for the western market at Jingdezhen. It was only with the onset of civil war, which brought an end to the Ming dynasty in 1644, that Chinese production was

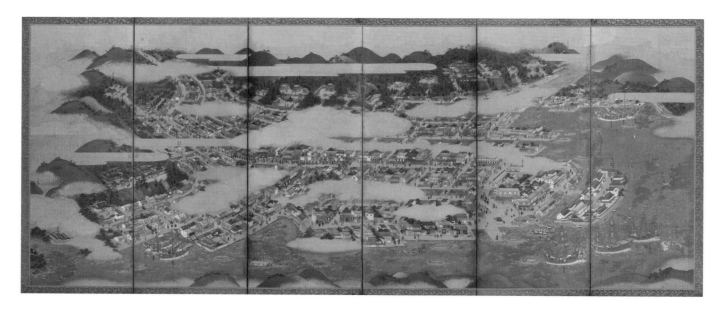

2.4 (above) Japan, *Kanbun Nagasaki-zu byōbu (folding screen depicting seventeenth-century Nagasaki)*, 1673, showing the ship *Return* in Nagasaki harbour. Colour on paper, mounted on a folding screen, 128.5 × 315.0 cm, Nagasaki Museum of History and Culture, Japan, E-Nagasaki 29-1

2.5 (right) Arita, Hizen province, *Jar and cover*, 1700–1720. Porcelain, underglaze blue, overglaze enamel, gold, 73.0 × 35.0 × 35.0 cm, RCIN 9375

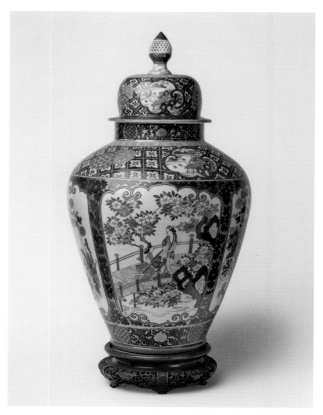

disrupted and Dutch traders were forced to look elsewhere. A box containing Japanese samples was sent to Holland in 1657, prompting an official VOC order for 64,866 pieces in 1659. Imports of Japanese porcelain to Europe soon increased dramatically, although it is impossible to procure accurate figures because there was also extensive but undocumented private trade.[14]

The new cargoes included jars, plates, bowls, salts, mustard pots, female figures, beer jugs, flower vases, incense burners and *saké* dishes. Some Japanese wares replaced familiar Chinese forms (cat. 8). Others replicated the already well-known blue-and-white decoration, including the vast sets of plates acquired by Augustus II 'the Strong', Elector of Saxony and King of Poland (1670–1733), for his crowded

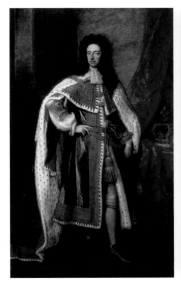

2.6 (left) Sir Godfrey Kneller (1646–1723), *William III*, 1690. Oil on canvas, 243.8 × 147.7, RCIN 405675

2.7 (right) Sir Godfrey Kneller (1646–1723), *Mary II*, 1690. Oil on canvas, 223.2 × 148.8 cm, RCIN 405674

Porzellanzimmer (porcelain room) in Dresden (cat. 28). Still other pieces incorporated European designs and motifs, such as a tankard modelled after a western metal form (cat. 15). Zacharias Wagenaar, Principal at the Dutch factory in Deshima, even described the combination of deep blue glaze and gold on one ewer in the Royal Collection as his 'own invention' (RCIN 1173).[15]

Members of the British royal family and their subjects were struck most of all by the distinctively Japanese styles they encountered. The addition of brilliant polychrome enamels to glazed wares was a revelation. Among them were brightly coloured wares with rich overglaze ornamentation picked out in deep cobalt blue and gold, known as 'Imari' after the harbour on Kyūshū from which they were shipped (cat. 20, Fig. 2.5). 'Kakiemon' pieces (associated with the Kakiemon family kiln at Arita, but actually made in various places) were by contrast distinctive for their restrained, asymmetrical

designs rendered in harmonious colours on a milky-white body now known as *nigoshide* (cats 6–10).

Wares of one or both of these kinds may have been amongst the '14 tubs of China Ware' given to Charles II by visiting envoys from Siam (now Thailand) in 1684.[16] Both types differed vastly from the plain celadon glazes and blue-and-white designs hitherto seen on Chinese porcelains, and they achieved consistently higher prices. Their polychrome decoration particularly appealed to the baroque taste for flamboyant and colourful display. Japanese porcelain thus quickly became an essential component of the fashionable interior, found on shelves and mantelpieces in grand homes like Drayton House in Northamptonshire and Tart Hall, next to Buckingham House (later Buckingham Palace). Writing of porcelain in 1711, Charles Lockyer declared, 'the best of this … comes from *Jappan*'.[17]

The greatest British royal collector of Japanese porcelain was Mary II (1662–94), who ruled jointly with William III (1650–1702) from 1689 (Figs 2.6 and 2.7). Mary married William (then Prince of Orange) at the age of 15, and for 11 years they lived in Holland, where she acquired a taste for East Asian porcelain and lacquer. At her palaces, Honselaarsdijk and Het Loo, Mary employed the Huguenot architect-designer Daniel Marot (1661–1752) to arrange vast quantities of porcelain in the latest French style: mounted on walls and cabinets in towering pyramid structures using specially designed brackets (Fig. 2.8). When parliament barred her Catholic father James II from the throne, Mary returned to England to rule in 1689, bringing with her this new fashion for massed display.

Mary's extensive porcelain collection was installed at Hampton Court Palace and Kensington Palace, which were extensively remodelled by Sir Christopher Wren (1632–1723) shortly after her accession. Three inventories indicate that 154 Japanese and Chinese pieces were displayed in the Gallery at Kensington, alongside Persian carpets and lacquer furniture. The porcelains were arranged symmetrically by form and colour on cabinets and over doors, often in rows up to three tiers high.[18] Together, they achieved a dazzling effect. At Hampton Court, the travel writer Celia Fiennes (1662–1741) likewise found the Gallery 'decked with China and Fine

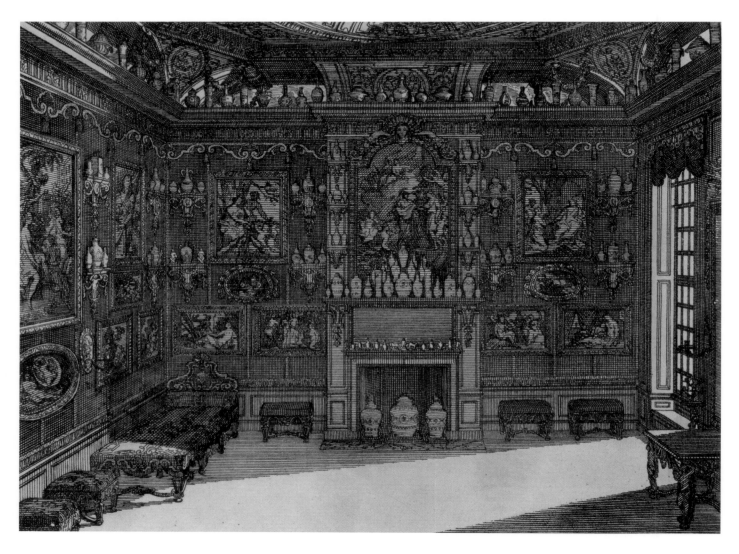

2.8 Daniel Marot the Elder (1661–1752), *Interior of a
Porcelain Cabinet with Paintings and Vases* (detail),
*c.*1703–12. Etching, 21.5 × 34.2 cm (sheet), The
Metropolitan Museum of Art, New York, 30.4(9)

Pictures'.[19] So closely are certain Japanese wares associated
with Mary's collection there that jars of one type – hexagonal
Kakiemon-style vases decorated with plants and ladies – have
come to be known as 'Hampton Court vases' (cat. 6, Fig. 2.9).
There are 19 Japanese porcelains from Hampton Court in the

Royal Collection (see cats 6, 8–9 and 13–14), but the pieces
from Kensington Palace were given by William to the Earl of
Albemarle following Mary's death and taken to Holland, where
they have since been lost.[20]

Mary was not the only person in Britain to acquire Japanese
porcelain seriously, but her collection was unique in size and
quality. Writing some years after her death from smallpox in
1694, Daniel Defoe remarked that 'the queen brought in the
custom or humour, as I may call it, of furnishing houses with

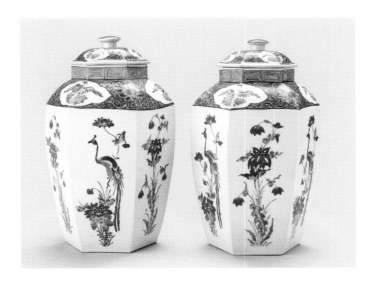

2.9 Arita, Hizen province, *Two hexagonal jars and covers*
['Hampton Court vases'], 1670–90. Porcelain, overglaze enamel,
gold, 31.5 × 26.9 × 26.9 cm, RCIN 1094.1–2.a–b, cat. 6

china-ware which increased to a strange degree afterwards,
piling their china upon the tops of cabinets, scrutores [writing
desks] and every chimney-piece, to the tops of the ceilings'.[21]

ADAPTATION AND IMITATION

The supremacy of Japanese porcelain imports over Chinese
was short-lived. By 1685 the kilns at Jingdezhen had reopened,
producing wares more quickly and cheaply than their Japanese
counterparts. Japanese porcelain remained in demand, but
exports to Europe peaked in the early eighteenth century and
by 1745 were in steady decline.[22] This trend was exacerbated by
the European discovery of the secret of hard-paste porcelain,
achieved by Johann Friedrich Böttger (1682–1719) in 1709.
Imitations of expensive East Asian wares could finally be made at
home. The first pieces were produced at Meissen for Augustus II
of Saxony in 1710, and the factory's early enamelled designs
were derived directly from Kakiemon pieces (see cat. 12).[23] In
England, the Chelsea Porcelain Manufactory (est. 1745) likewise
began to copy Japanese patterns (cat. 11).

Throughout the eighteenth century, Japanese porcelain and
lacquer remained favourite choices for palace furnishing. Yet
members of the British royal family had no qualms about
radically adapting these precious Japanese imports. In 1704–5,
Queen Anne (1665–1714) commissioned Gerrit Jensen to
refurbish a pair of lacquer cabinets for her apartments at
St James's Palace. Before delivery, Jensen replaced the drawers
with three crimson-lined shelves and detached the original
urushi decoration on the top and inner doors for re-use
elsewhere (cat. 36).[24] This dramatic treatment was surprisingly
typical of the period. Queen Caroline (1683–1737), consort of
George II (1683–1760), later kept 'a most valuable Collection of
old Japan' at Kensington, the 'great Part of which was presented
to [her] by the *India* Company'.[25] In 1742, George Bickham
noted that Mary II's 'large Collection of China' remained on
display at Hampton Court.[26]

During the reigns of George II and George III (1738–1820),
the Wardrobe accounts record numerous 'India Japan' wares
purchased for the State and private apartments at St James's
Palace. Some were probably authentic pieces imported from
Japan; others were certainly imitations supplied by chair-
and cabinet-makers like Benjamin Goodison, William Vile
and John Russell.[27] Several of these early eighteenth-century
cabinets were still on display by the time W.H. Pyne published
his lavishly illustrated *History of the Royal Residences* in
1819. This three-volume survey includes 100 hand-coloured
engravings showing, in remarkable detail, the extent to which
Japanese lacquer furniture was displayed throughout the
principal royal apartments. Cabinets are visible in views of
rooms such as The Queen's State Bedchamber at Windsor
Castle, The King's Writing Closet at Hampton Court Palace
and The King's Gallery at Kensington Palace (Figs 2.10, 4.1
and cat. 40).

CHINOISERIE AND ORIENTALISM

By the mid-eighteenth century, new information about Japan
had become available through eyewitness accounts such as
Engelbert Kaempfer's two-volume *History of Japan*, published

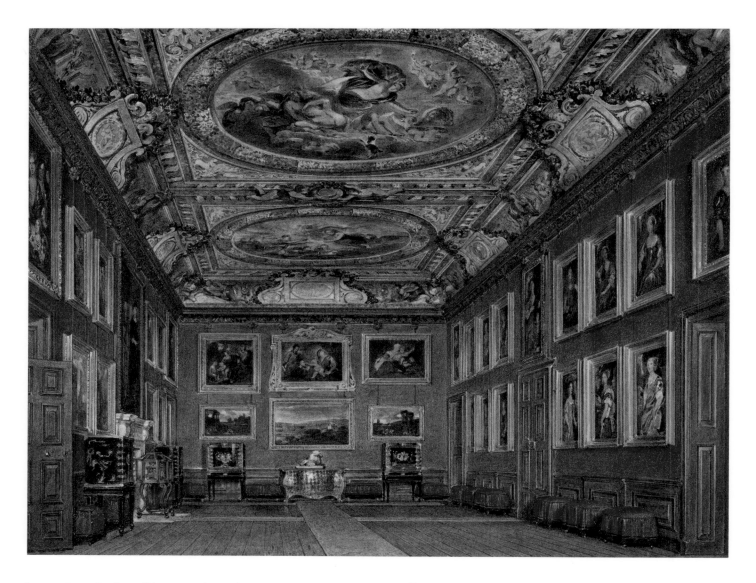

2.10 James Stephanoff (1789–1874), *Windsor Castle: The Queen's State Bedchamber* (detail), *c.*1818. Pencil and watercolour with touches of bodycolour, 20.2 × 25.4 cm, RCIN 922103

posthumously in 1727 (cat. 5). Royal enjoyment of Japanese art nevertheless remained highly fanciful. Inspired by imported wares, British craftsmen had begun to conjure up their own romantic versions of the East to meet the demand for 'oriental'

wall coverings, ceramics, clocks, light fittings and other furnishings, known collectively as chinoiserie, from the French *chinois* ('Chinese'). Queen Charlotte (1744–1818), consort of George III, embraced this vaguely-defined but sumptuous 'oriental' style, and at Frogmore House in Windsor she liberally combined authentic *urushi* with objects of diverse Asian origin and European imitations. In the Green Closet, panels of 'original japan' intermingled with Indian cane chairs (cat. 41),

while the 'Red' Japan Room contained specimens of intricately carved Chinese lacquer beneath walls 'painted in imitation of rich Japan' by her daughter, Princess Elizabeth (1770–1840).[28] After Queen Charlotte's death, bowls, bottles and boxes of 'beautiful Japan lacquer' from her collection, some 'exquisitely inlaid with mother of pearl', were sold in May 1819. The auction's title – 'Oriental Curiosities and Porcelain' – hints at the way Japanese art was subsumed under the rubric of a generic, exoticised East.[29]

The ostentatious and romantic display of Japanese art reached its apogee under George IV. As Prince of Wales (1762–1811), regent (1811–20) and finally king (1820–30), George was known for his extravagant spending and his wide-ranging love of the arts. At his London residence, Carlton House, and his seaside resort, Brighton Pavilion, he created lavish decorative schemes which evoked the spectacle of the 'Orient' using imported and imitation wares. When Lady Ilchester visited the Pavilion in 1816, she marvelled at its eclectic contents: 'There are mandarins and pagodas in abundance, plenty of sofas, Japan and China.'[30] Augustus Charles Pugin's view of the Banqueting Room Gallery at Brighton c.1823 shows four fine Japanese lacquer cabinets supporting garnitures of Kakiemon-style and Chinese porcelain (Fig. 2.11). Smaller pieces of lacquer – including a rotating table cabinet and a plate decorated with the Stuart coat of arms (cat. 44) – were purchased in Paris by George's agent, François Benois, in May 1820.[31] Such acquisitions capitalised on the glut of luxury goods from French aristocratic collections which entered the market following the French Revolution of 1789. Royal collecting of this kind followed the precedent set by Marie Antoinette, who arranged some 68 small Japanese lacquer boxes of outstanding quality in her private rooms at the Palace of Versailles.[32]

What most distinguished George's Japanese collection were the extravagant gilt-bronze mounts added to both porcelain and lacquer. These were intended to harmonise with contemporary gilded interiors and in some cases completely transformed an object's function from simple jar to incense burner, candelabrum or even clock (see, for example, cat. 18).

2.11 Thomas Bradley (active 1823) after Augustus Charles Pugin (1762–1832), in E.W. Brayley, *Illustrations of Her Majesty's Palace at Brighton* (detail), 1838. Etching with hand colouring, 19.7 × 30.5 cm, RCIN 708000.ao

Together they evoked the luxurious apartments of *ancien régime* France. Between 1800 and 1830, George assembled the largest and most important collection of mounted porcelain in Britain. Some pieces had already been adapted by European craftsmen like Pierre-Philippe Thomire, but others were mounted on George's orders by the Vulliamy family or Samuel Parker (active 1820–51). These elaborate mounts were themselves costly works of art, an indication of the value placed on imported pieces. The finished products would nevertheless have been almost unrecognisable to their Japanese creators.

George IV's vast collection also included Japanese weapons and costume. Barred from active military service by his father, he compensated by assembling at Carlton House an Armoury filled with some 3,300 specimens of arms and armour from across the globe, as well as 'an immense collection of rich dresses, of all countries'.[33] Among them were Japanese shields, swords and spears.[34] Benjamin Jutsham's meticulous five-volume inventory of the Armoury even describes an armour 'belong[ing] to a Chinese Tartar Chief', which was in fact Japanese. Purchased from Dr Buchan in April 1818, it was 'made

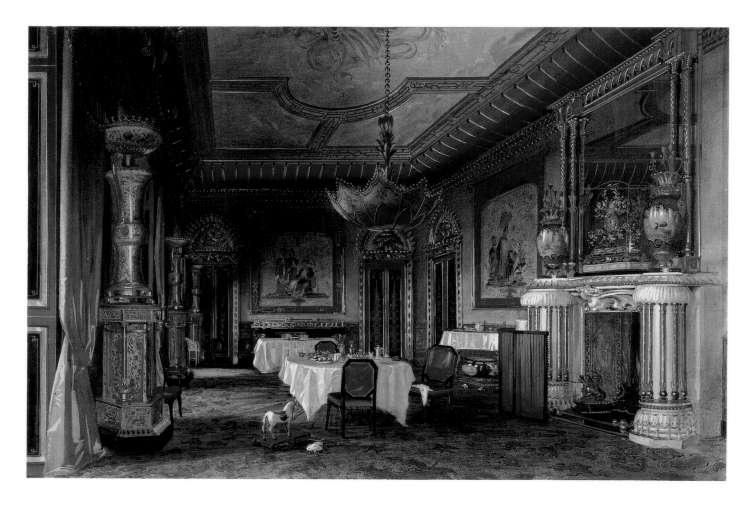

2.12 James Roberts (*c*.1800–67), *Buckingham Palace: The Pavilion Breakfast Room*, 1850. Watercolour, 25.6 × 38.0 cm, RCIN 919918. On the mantelpiece are a pair of Imari-style jars decorated with phoenixes (RCIN 203.1–2) transferred from the Royal Pavilion, Brighton

of Black Lacquer – joined together with Blue Cotton Tape' and supplied with 'a half Mask with Gilt Teeth'.[35]

Several of the Japanese weapons in George's collection were contributed by Sir Stamford Raffles (1781–1826), Lieutenant-Governor of British Java (1811–16), including a dagger (*tantō*) and sword.[36] These items were probably acquired in 1813–14, when Raffles had sent three ships from Java to Nagasaki in an attempt to reopen trade with Japan. Though bearing gifts for the shōgun of pistols, telescopes and even an elephant, the expedition proved unsuccessful. A repeat attempt was prohibited by his superiors in India in June 1814.[37] Nevertheless, Raffles received a present of more than 30 kimono from the shōgun, and one of these is probably the 'Large Robe' of lilac silk 'Stamped with Gold in Flowers' which he gave to George IV on his return in May 1817.[38]

During the early years of Queen Victoria's reign, many of George IV's Japanese holdings were transferred to Buckingham Palace and Windsor Castle. Brighton had little practical appeal for the young queen and her growing family and by 1846

she had sold the Pavilion and stripped it of its furnishings, dispatching porcelain and lacquer to furnish the new East Front at Buckingham Palace, designed by Edward Blore (1787–1879) (Fig. 2.12). Prince Albert (1819–61) meanwhile oversaw the arrangement of arms, armour and dress from Carlton House in the North Corridor at Windsor Castle.[39]

CONCLUSION

By the mid-nineteenth century, Japanese decorative arts were an established feature of palace furnishing, synonymous with luxury and cosmopolitan taste. Their presence nevertheless speaks more of British royal purchasing power than of diplomatic engagement or personal relationship. Japanese works of art were acquired indirectly, through trade, and generally limited to export wares designed with the western market in mind. Porcelain and lacquer predominated, treasured for the exotic materials which Europeans so quickly sought to imitate. Discerning collectors like Mary II and George IV nevertheless created some of the largest and finest assemblages of Japanese decorative arts of their time. Many of the pieces which survive are of exceptional significance for the history of early Japanese manufacture and export, while changing royal display – from the 'Porcelain Rooms' of the late seventeenth century to the gilt-bronze mounted pieces assembled in the early nineteenth – is a neat microcosm of the evolving taste for East Asian wares in the West.

What is most striking is the freedom with which British monarchs and their families adapted, augmented and combined Japanese objects with other Asian wares and European chinoiserie. Their collecting was fashionably aesthetic, not fustily academic. This attitude was possible in part precisely because of the lack of direct contact with Japan, and the British inability, or unwillingness, to procure accurate information about the country and its arts. Japan consequently remained mysterious but malleable, subsumed in a broader fantasy of the romantic and quaint 'East' which might be imagined at will. All this changed in the 1850s, when contact in person became possible once again.

WENCESLAUS HOLLAR (1607–77)

A NEW MAPP OF Y EMPIRE OF CHINA ...
TOGETHER W.ᵀᴴ THE ADJACENT ISLES
OF IAPON OR NIPHON ..., 1670

Hand-coloured etching

30.8 × 39.5 cm (sheet)

Inscribed: *To yᵉ Rt Worshipˡˡ / Thoˢ Robinson of yᵉ Inner Temple / London Lᵈ Sq cheif [sic] Prothonetary of his / Maᵗʸˢ Court of Comon Pleas / This mapp is humbly DD by RB / A New Mapp of y Empire of / CHINA / With its severall Provinces or kingdomes / Together w.ᵗʰ the adjacent Isles of Iapon or Niphon / Formosa Hainan etc. / 1670 / W. Hollar fecit 1669*

RCIN 802529

PROVENANCE: Probably acquired by Queen Victoria

Hollar's 'new mapp' was first produced in 1669 for Richard Blome's volume, *A Geographical Description of the Four Parts of the World....* That book, which was intended for those who might want 'to Spend some part of their Time in other Countreys' and those who 'desire to be Informed of them here at Home', included a description of Japan and China, for which this map was the illustration.⁴⁰ This hand-coloured impression has been altered slightly (possibly by a different artist) from the version first published in Blome's volume, with a change of dedication and a slightly later date of 1670.

The islands of Japan are depicted at top right and are outlined in pink watercolour. The general shapes of the main islands are recognisable – though their placement is not accurate – and some place names are given, such as Meaco (Kyoto) and Yendo (Tokyo), 'a fair, large and well built city'.⁴¹ Hollar did not visit Japan and was working in London when he produced the map towards the end of his prolific career as an etcher. It probably derives from a map in the volume *China monumentis illustrate* (1667) by Athanasius Kircher (1602–80). Hollar had copied a number of plates from Kircher to illustrate John Ogilby's *China*, published in 1669. The Kircher map may well be derived in turn from a map of 1635 by Willem Blaeu (1571–1638), mapmaker to the VOC, who also had not visited Japan.⁴² RW

LITERATURE: Blome 1670; Pennington 1982, no. 693A (iii); Turner 2011, Part VII, no. 2122 (III).

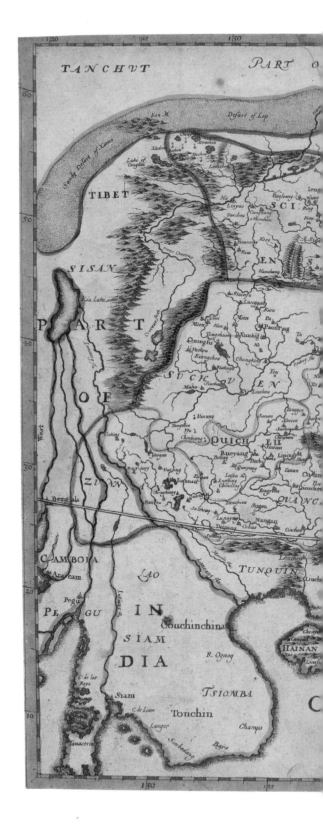

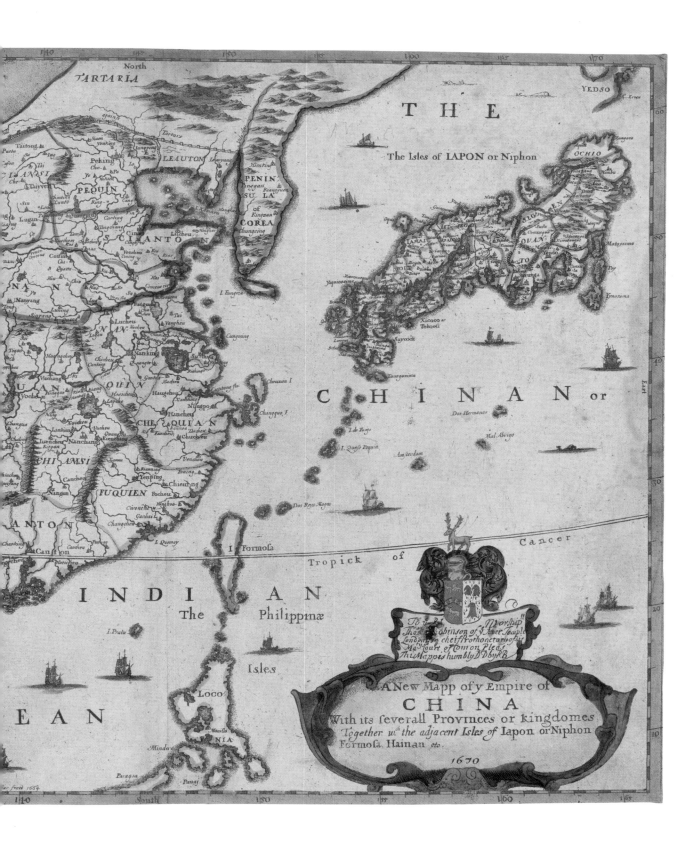

North
TARTARIA

THE

The Isles of IAPON or Niphon

CHINAN or

Tropick of Cancer

INDIAN

The Philippinæ

Isles

A New Mapp of y Empire of
CHINA
With its severall Provinces or kingdomes
Together wᵗʰ the adjacent Isles of Iapon or Niphon
Formosa, Hainan etc.
1670

3

NICOLAS DE LARMESSIN I (1632–94)

XOGUN, EMPEREUR DU IAPON, c.1673

Etching and engraving

24.2 × 16.7 cm (sheet); 23.6 × 16.6 cm (platemark)

Inscribed: *XOGVN, EMPEREUR DV IAPON,* / *Region fort*
Spatieuse Et – Estendue Consistante entres / *grand nombre*
dIsles diviséés – dautant de bras de Mer… / *A Paris chez*
PBertrand Rüe S¹ Jacques à la pomme dOr proche S¹ Severin.
Avec Privilege du Roy.

RCIN 618824

PROVENANCE: Possibly acquired by George III

Xogun, Empereur du Iapon is probably a representation of
Tokugawa Ietsuna (1641–80). In 1651, at the age of ten,
Ietsuna became the fourth Tokugawa shōgun, inheriting
a well-established military government (*bakufu*). The text
below the image makes reference to the arrival in Japan of the
Portuguese 130 years earlier. As their encounter took place in
1543, this would date the print to around 1673, by which time
access to Japan was forbidden to much of the outside world.

Portraits of rulers were not as widespread in Japan as in
Europe at this time. The shōgun himself was seen by very few
people and, in his presence, visitors would have to look at
the floor; it seems unlikely therefore that many Japanese, let
alone any foreigners, would have seen a realistic depiction
of Ietsuna.[43] It is not surprising then that this print appears
to be an imagined portrait: the shōgun wears a turban more
identifiable with dress from the Middle East, adorned with
luxurious pearl jewellery topped with feathers, his shoulders
wrapped in a cloak.[44] The dress and ornaments are probably
borrowed from costume books and prints of rulers of other
'exotic' and distant lands.

The format of this half-length portrait, set within an oval
frame, is typical of portrait prints of the reign of Louis XIV
(r. 1643–1715)[45] and is one of a series of at least 240 portraits
issued by the Parisian publisher Pierre Bertrand.[46] The
accompanying text is intended to provide an informative
description of Japan, yet the title of the print conflates the
two separate roles of the shōgun, based in Edo (Tokyo), and
the emperor of Japan, based in Kyoto, highlighting a lack of
understanding of this inaccessible place. RW

LITERATURE: Weigert *et al.* 1973, VI, no. 374

PIETER VAN DER AA (1659–1733)

**LA GALERIE AGREABLE DU MONDE ...
JAPON ET PAÏS D'ESO**, 1729

Leiden: Pieter van der Aa

39.5 × 29.6 × 5.8 cm (book, closed)

RCIN 1021721.C

PROVENANCE: Acquired by Queen Victoria,
13 June 1874

Pieter van der Aa was a Dutch publisher specialising in atlases, maps and luxuriously illustrated volumes aimed at the general public. This work, part of his monumental 66-volume *Galerie Agréable du Monde*, is a collection of plates showing panoramic views of cities, maps, scenes of everyday life and depictions of religious customs, illustrating Japan as it was known to Europeans in the early eighteenth century.

By the time this work was published, Dutch traders had been, for around a century, the only Europeans permitted to trade with Japan, following the expulsion of Spanish and Portuguese missionaries and traders. Merchants at the factory at Deshima were constantly supervised by Japanese officials and not permitted to leave the island, except during the annual procession of the factor (chief agent) to pay homage to the shōgun.[47] Reports of these processions, received from accounts such as Kaempfer's *History of Japan* (cat. 5), caused bemusement in Europe, and illustrations published by Van der Aa likely helped people to visualise these events, albeit in an exaggerated, exoticised form. **AB**

ENGELBERT KAEMPFER (1651–1716)
THE HISTORY OF JAPAN, 1727

London: printed for the translator, 2 vols

Leather-bound in red goatskin with gold tooling

46.7 × 29.2 × 5.1 cm (I, closed); 46.6 × 28.7 × 4.5 cm
(II, closed)

RCINS 1074485–6

PROVENANCE: Possibly acquired by Queen Caroline;
in George III's Windsor Library by 1780

Some knowledge of Japan had been disseminated to Europe in the sixteenth century through the accounts of Roman Catholic missionaries such as Francis Xavier. However, following the restriction of trade from the 1620s, first-hand information about the country was largely available to Europeans only via VOC merchants stationed at the 'Japan factory' at Deshima. Dutch accounts at this time evoked romantic images of an isolated country with mysterious customs, views that coloured western notions of Japan during the 'closed country' (*sakoku*) period.

The term *sakoku* in fact owes its existence to Engelbert Kaempfer's *History of Japan*. It was coined by the Nagasaki translator Shizuki Tadao in his 1801 Japanese-language edition of the work.[48] Before this time, the policy was known as *kaikin* or 'maritime restrictions'.[49] Kaempfer served as surgeon at Deshima in 1690–92 and was able to gather extensive notes on the history, culture and natural history of the country, primarily during his two excursions accompanying the annual Dutch procession to the capital, Edo.

Returning to Europe in 1695, Kaempfer began to make arrangements to publish his findings. He produced a survey of Japanese botany, *Amoenitatum exoticarum*, in 1712, but died before he was able to publish his history of the country itself. Fortunately, his manuscript notes survived and were purchased by the botanist and collector Sir Hans Sloane (1660–1753) who passed them to his librarian, Gaspar Scheuchzer (1702–29), to translate into English. The resulting two-volume publication, of which this is a copy, was dedicated to George II. It was the most comprehensive European account of Japan for over a century and the first such work in English.

Kaempfer's *History* also contained plates taken from authentic Japanese woodblock prints, including this, the first contemporary depiction of Edo to appear in European literature. The book's influence was wide-ranging and it remained an important account of Japan and Japanese life until well into the nineteenth century. AB

INVENTORIES: QC Library Catalogue, fol. 70; WL Catalogue, fol. 59

LITERATURE: ESTC T123495

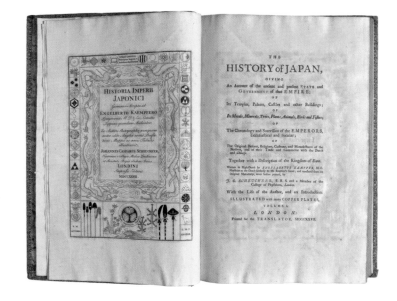

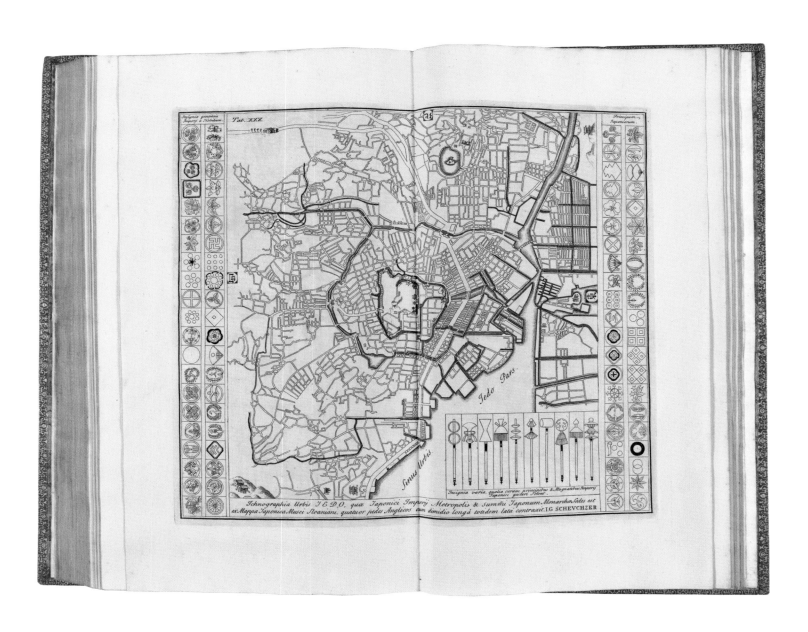

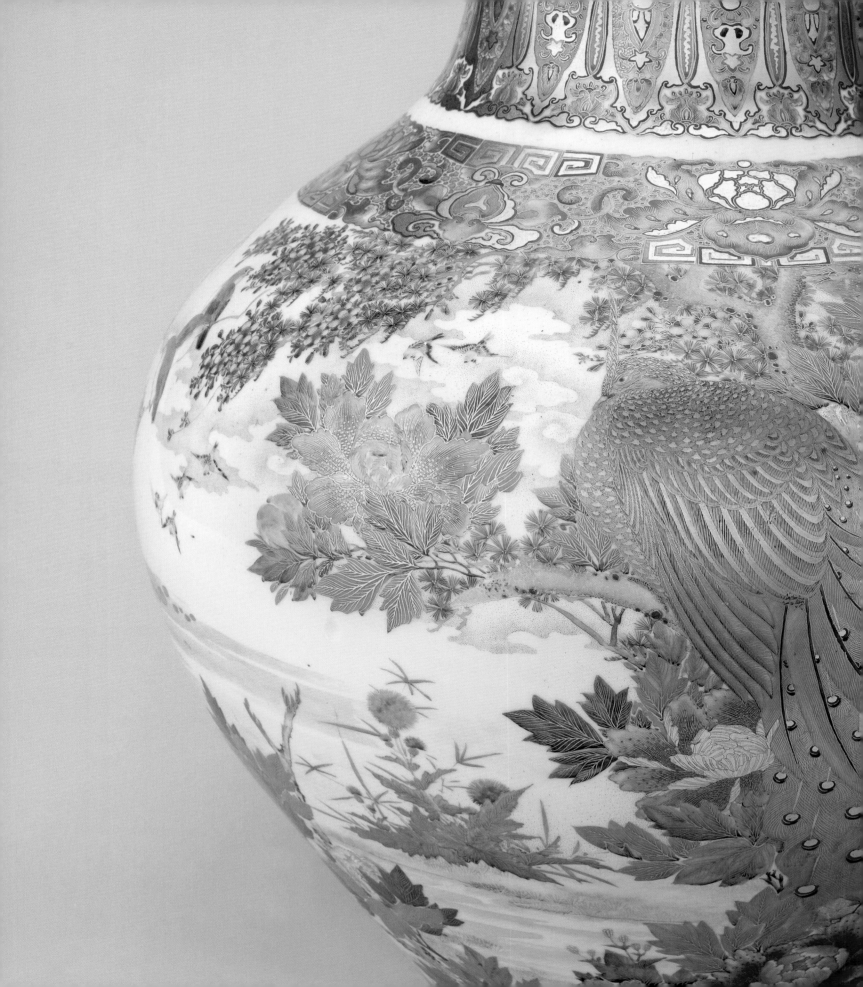

日本の芸術

3

PORCELAIN

MELANIE WILSON
AND
RACHEL PEAT

ERAMICS have been produced in Japan since the beginning of the Jōmon period (*c*.10,500 BC). At that time, coiled earthenware vessels were made with the distinctive 'cord-marked' (*jōmon*) decoration from which the era takes its name.[1] By the sixteenth century AD, stoneware utensils played a central role in highly ritualised tea gatherings (*chanoyu*), exhibiting a restrained, rustic aesthetic known as *wabi sabi*. Porcelain was prized for its hardness, whiteness and translucency, but was not made in Japan until the start of the seventeenth century. The secret of its manufacture had been known in mainland Asia since the time of the Tang dynasty (618–906), and Japanese craftspeople had long attempted to imitate Chinese recipes and methods.[2] The technique was finally learned from captured potters brought to Kyūshū after Toyotomi Hideyoshi's invasions of Korea in 1592 and 1597–8.

Japan's geology proved well-suited to porcelain manufacture. Decayed granite stone from the Izumiyama quarries near Arita, in Hizen province, was strong and relatively easy to work. The stone was crushed using water-powered hammers and then refined to produce the clay, before being either press-moulded or thrown on a kick-wheel.[3] Designs inspired by Chinese motifs might then be painted onto the unfired body using blue cobalt oxide from China, as seen on a set of plates bearing the *fuku* (good fortune) symbol (cat. 28). A clear glaze made from wood ash and clay was subsequently added by dipping or pouring.

The vessels were fired in long, interconnected kilns (*noborigama*) built into the hillside, at temperatures of up to 1400 degrees Celsius. Traces of iron typically left a faint blue tint on the white porcelain.[4] From the 1640s, brightly coloured enamels were then added over the glaze, often in separate workshops. These pigments were fused to the surface during successive firings in smaller muffle kilns, a technique perfected in Kyoto by potters like Nonomura Ninsei (active *c*.1649–70).[5] A rare eighteenth-century vase in the Royal Collection demonstrates the early application of red enamel to Kyoto stoneware (cat. 27).

Two main styles of overglaze enamelled ware were exported to Europe in the late seventeenth century. The Kakiemon style takes its name from Sakaida Kakiemon (1596–1666), who perfected the use of red persimmon-coloured (*kaki*) enamel and whose designs were imitated by a whole range of kilns operating in Arita.[6] These wares are distinctive for their fine, milky-white ground (*nigoshide*) and harmonious palette, often decorated with flower and bird motifs taken from Chinese painting.[7] Spare, asymmetrical designs accentuate the dazzling colours and bright white glaze (cats 6–10). Mary II amassed an important collection of such pieces at Hampton Court Palace and Kensington Palace, including a 'matched pair' of vases with designs that mirror each other (cat. 6).

Imari wares, named for the port on Kyūshū from which they were shipped, were by contrast boldly enamelled in rich combinations of yellow, red, green, aubergine and blue, with outlining in deep cobalt blue. The addition of gold to these pieces necessitated a separate firing at a lower temperature (cats 17, 19–20).[8] George IV collected many wares in this style for his seaside residence, the Royal Pavilion, Brighton, where European gilt-bronze mounts harmonised the porcelain with the building's glittering interiors (cats 16, 18 and 22).

Japanese porcelain first arrived in Europe in the late 1650s, when the fall of the Ming dynasty (1368–1644) disrupted kilns operating at Jingdezhen in China. The VOC was forced to turn to Japan to meet western demand, placing their first order for Holland in 1659.[9] Official exports by the VOC peaked between 1690 and 1725, augmented by goods acquired via Chinese junks operating in the South China Sea. A sizeable and largely undocumented private trade also took place, which may explain the presence in Europe of high-quality wares designed for the domestic market. Among them is a pair of rare blue-and-white altar vases (cat. 14).[10] Nevertheless, the reopening of the cheaper and faster Jingdezhen kilns meant that by 1745 Japanese porcelain exports had virtually ceased.[11]

Opportunity for the revival of the export trade came after 1868, when the new Meiji government sought to promote Japanese arts and crafts abroad. Manufacturers exhibited widely at international fairs, pioneering new styles which would appeal to buyers in the West. The term 'Satsuma' was first used at the 1867 Paris *Exposition Universelle* to describe goods from this domain with an attractive crackle glaze and romantic polychrome overglaze enamel and gold scenes (cat. 32).[12] Meanwhile a new style of ware emerged around the kilns in Kutani (Kaga Province), characterised by painterly scenes of birds and flowers and the generous use of gold and red (cat. 31). The finest examples were bought by European collectors or given as diplomatic gifts by Meiji officials. In the early twentieth century, members of the Japanese Folk Craft movement (*Mingei*) reacted against this export focus, promoting instead a return to indigenous motifs and small-scale production methods. A vessel in this tradition made by Hamada Shōji was presented to Her Majesty The Queen during her State Visit to Japan in 1975 (cat. 33).

6

ARITA, HIZEN PROVINCE
**PAIR OF HEXAGONAL JARS
AND COVERS**, 1670–90

Porcelain, overglaze enamel, overglaze gold
31.5 × 26.9 × 26.9 cm
RCIN 1094.1–2.a–b

PROVENANCE: Probably acquired by Mary II

Vessels in this form and style have become known as 'Hampton Court vases' due to their close association with the palace where Mary II amassed a large and important collection of Japanese porcelain. Each is decorated with women and birds in Kakiemon-style overglaze enamels of blue, green, yellow and red. The two vases are unusual in being a 'matched' pair – with designs that are symmetrical when placed side-by-side. Displaying porcelain in pairs in this way was a European conceit; ornamental, identical pairs were rare in Japan. The jars would have been made specifically for export, and it is possible that they were specially commissioned through the Arita factories.[13] Each hexagonal body was not made on a potter's wheel but hand-fashioned in slabs and then assembled, an intricate and time-consuming process. Producing such luxury items was so labour-intensive that after the eighteenth century they were no longer made. MW & SG

LITERATURE: Dillon 1910, p. 27, cat. 73 (I, II); Lane 1949–50, p. 31; Ayers 2016, I, nos 323–4, pp. 164–6

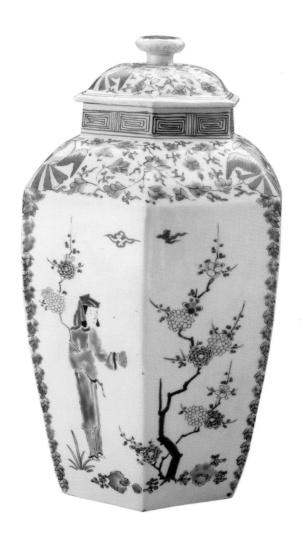
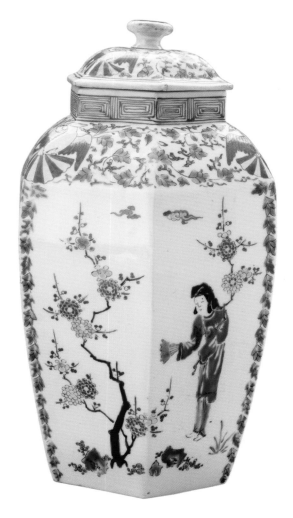

7

ARITA, HIZEN PROVINCE

DISH, 1670–90

Porcelain, overglaze enamel

21.2 × 21.2 × 2.9 cm

RCIN 58821.1

PROVENANCE: First recorded at
Windsor Castle in 1927

The dazzling white ground of this dish is a fine example of the milky-white *nigoshide* body achieved by the Kakiemon and surrounding kilns in Arita. This brilliance was a marked improvement on the grey, semi-opaque tinge of the earliest porcelain made on Kyūshū.[14] An asymmetrical design of a peafowl and a plum blossom tree in bright enamels emphasises the whiteness. On the rim, barely visible, is a design called the 'Three Friends of Winter' (*shō-chiku-bai*), delicately moulded in six cartouches. The three plants – pine, bamboo and plum blossom – are symbols of longevity and fortitude, for pine and bamboo remain green all year round, while the plum blossom is the first to flower in the New Year. The combination has been an auspicious motif in Chinese art since the Song period (960–1279) and was subsequently adopted in early Japanese visual culture.[15]

The base of the dish bears the traces of firing spurs – small feet of clay used to support the dish during firing and broken off afterwards. The dish is one of a set of five that were displayed with other Chinese and Japanese porcelain in the North Corridor at Windsor Castle in 1927, alongside Meissen pieces in the Kakiemon style (see cat. 12). RP

INVENTORIES: WC Oriental China 1927, C. 27
LITERATURE: Ayers 2016, II, no. 1511, p. 648

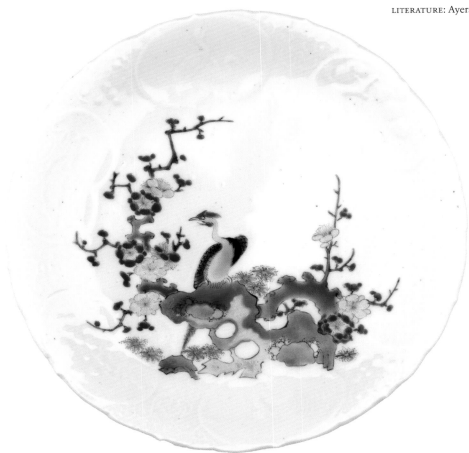

ARITA, HIZEN PROVINCE
PAIR OF BEAKER VASES, 1670–90

Porcelain, overglaze enamel

47.4 × 22.3 × 22.3 cm (RCIN 1178.1);
47.0 × 21.0 × 21.0 cm (RCIN 1178.2)

RCIN 1178.1–2

PROVENANCE: Probably acquired by Mary II

The form and decoration of these vases imitates the Chinese style popular in Europe in the late seventeenth century. The beaker shape is known in Chinese as *gu* and in Japanese as *ko*. This form was first used in China for bronzes made during the Shang dynasty (*c*.1600–1046 BC) and later copied by potters there. This pair was recorded at Hampton Court Palace in 1910 and, given their date of manufacture, most likely formed part of the collection of Mary II there.[16] MW

LITERATURE: Dillon 1910, p. 24, cat. 64 (I, II);
Ayers 2016, I, nos 317–18, pp. 162–3

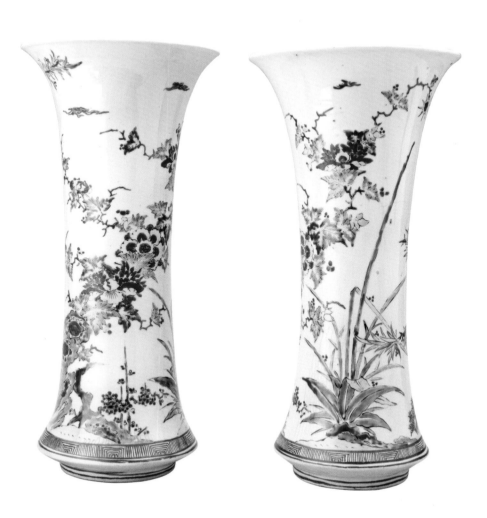

ARITA, HIZEN PROVINCE

PAIR OF POURING VESSELS OR KENDI,
1670–90

Porcelain, overglaze enamel

20.3 × 16.9 × 14.4 cm (RCIN 1047.1);
20.8 × 16.9 × 14.6 cm (RCIN 1047.2)

RCIN 1047.1–2

PROVENANCE: Probably acquired by Mary II

The word *kendi* – derived from the Sanskrit *kundika* – is used to describe a variety of South-East Asian pouring vessels often used for ceremonial oblations and in daily rituals such as handwashing.[17] This Kakiemon-style pair is of globular shape with angled spout. Such vessels usually had an elongated neck, and those exported from China were often in the form of an animal such as an elephant. Wares of this kind were known in Europe by the end of the sixteenth century, including some in the collection of Philip II of Spain (1527–98).[18] This pair may be of the same form as the 'two spout bottles' described in the Kensington Palace Inventory of 1697.[19] **MW & RP**

LITERATURE: Dillon 1910, p. 26, cat. 70 (I, II); T.H. Lunsingh Scheurleer 1962, p. 35; Ayers 2016, I, nos 321–2, p. 164

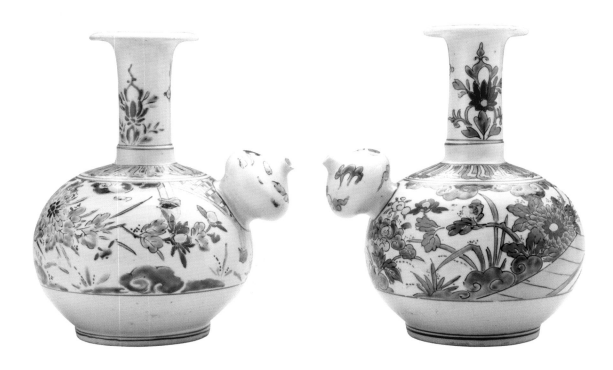

10

ARITA, HIZEN PROVINCE (PORCELAIN); FRANCE AND VULLIAMY AND SON, LONDON (MOUNTS)

PAIR OF MOUNTED SQUARE JARS AND COVERS ON STANDS, 1670–90 (PORCELAIN); 1750–75 AND 1800–25 (MOUNTS)

Porcelain, overglaze enamel, gilt bronze

51.6 × 18.0 × 18.0 cm (RCIN 2337.1);
51.5 × 18.0 × 18.0 cm (RCIN 2337.2)

RCIN 2337.1–2.a–b

PROVENANCE: Acquired by 1806, by George IV when Prince of Wales

These jars are painted in vivid Kakiemon-style enamels of red, yellow, blue, green and iron brown, with scenes of birds and cranes amongst blossoms and bamboo. They were first recorded in the Royal Collection on 22 December 1806, when the Vulliamy firm was paid £15 for removing their French mounts for cleaning and re-gilding.[20] Six years later, in 1812, Vulliamy supplied 'a Pair of metal Pedestals in the Chinese Style' to 'raise' them up, at a cost of £47 5s. 0d.[21] This is how the vases were mounted in 1819, when they were depicted in Charles Wild's watercolour of the Rose Satin Drawing Room at Carlton House, the Prince Regent's fashionable London residence (Fig. 3.1). Vulliamy may have modelled his mount designs on a pair of jars produced at the Chelsea Porcelain Manufactory, which had gilt-bronze bases of openwork design (cat. 11).[22] MW

INVENTORIES: Jutsham Dels & Recs 1, 9; Brighton Pavilion Clocks and China 1828, p. 37; Brighton Pavilion 1829A, p. 20; 1829B, p. 7

LITERATURE: D.F. Lunsingh Scheurleer 1980, p. 128, fig. 526 and p. 447; Croissant *et al.* 1993 (exh. cat.), pp. 359–60, cat. 9/24, and p. 156, fig. 116; De Bellaigue 1997, p. 31, fig. 50; Ayers 2016, II, nos 1497–8, pp. 640–41

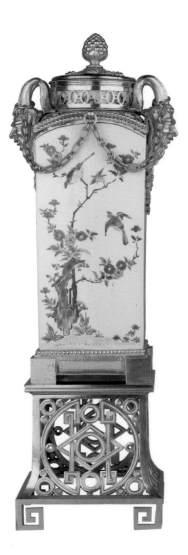
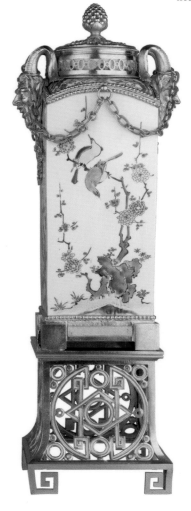

3.1 Charles Wild (1781–1835), *The Rose Satin Drawing Room, Carlton House* (detail), *c.*1817. Watercolour, bodycolour and gum arabic, 20.6 × 27.0 cm, RCIN 922180

11

CHELSEA PORCELAIN MANUFACTORY
(PORCELAIN); ?VULLIAMY AND SON,
LONDON (MOUNTS)

PAIR OF VASES WITH COVERS, c.1750–75
(PORCELAIN); 1800–20 (MOUNTS)

Porcelain, gilt bronze

50.5 × 17.5 × 17.5 cm

RCIN 2336.1–2.a–b

PROVENANCE: Probably acquired by George IV

These vases are unusually large survivors from the Chelsea Porcelain
Manufactory, which in the 1750s looked to Kakiemon-style palettes and
designs for inspiration. The hexagonal shape had been produced in
Japan for around a century prior to this English pair, but the alternating
façades of plum blossom, pine and bamboo trees with panels of red
and green foliate decoration were unusual in Japanese porcelain.
Nevertheless, the vases have variously been ascribed both English
and Japanese origins during their time in the Royal Collection.[23]

George IV employed several suppliers to add extraordinary gilt-
bronze mounts to the porcelain he acquired. The designs on these
are English approximations of Asian design but also matched the
wider decorative schemes at Brighton Pavilion where they first
stood. A pair of Japanese Kakiemon-style vases, similarly mounted
with Greek key pattern feet (cat. 10), was displayed alongside
these in the Banqueting Room Gallery at Brighton, surrounded
by commodes made from Japanese lacquer panels by Benjamin
Vulliamy (RCIN 2452.1–2).[24] The origin of such porcelain, where the
Asian and European productions appeared relatively similar, was
considered secondary to the colour palettes and interior design of
the state rooms. SG

INVENTORIES: Brighton Pavilion 1829B, p. 6

LITERATURE: Ayers *et al.* 1990 (exh. cat.), no. 153, pp. 172–3;
Ayers 2016, II, p. 641

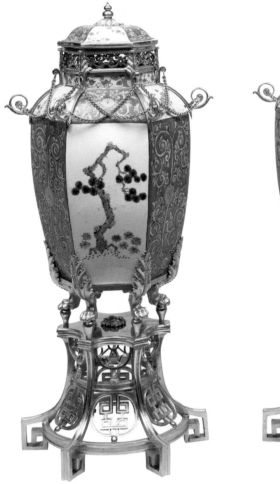
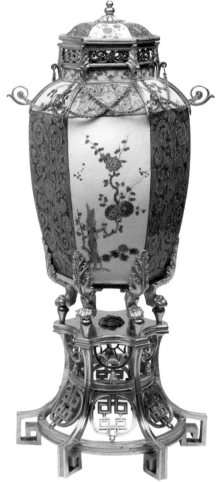

12

MEISSEN PORCELAIN FACTORY
BOWL WITH COVER AND STAND,
1725–30

Porcelain, enamel

13.0 × 16.8 × 16.8 cm (bowl and cover);
3.0 × 22.5 × 22.5 cm (stand)

Bowl and stand painted in underglaze blue with crossed
sword mark; bowl with incised *N*

RCIN 59118.1.a–c

PROVENANCE: First recorded at Windsor Castle in 1927

Unusually, the early provenance of this bowl, cover and stand in the Royal Collection is not known. As they have been separated from what was originally a much larger service, they were most likely acquired by a collector interested in their form and decoration rather than their practical use for dining. They were perhaps owned by Queen Mary, although her record-keeping rarely missed marking or labelling her acquisitions, or Queen Alexandra (1844–1925), who had a small collection of Meissen porcelain. The Meissen factory, established by the keen collector of East Asian porcelain, Augustus II 'the Strong', in 1710, turned to making imitations of Imari and Kakiemon-style wares from around 1715, using the head of state's porcelain collection for inspiration. These pieces were displayed in the North Corridor at Windsor Castle during the early twentieth century, alongside Chinese and Japanese porcelain. SG

INVENTORIES: WC Oriental China 1927, C. 27

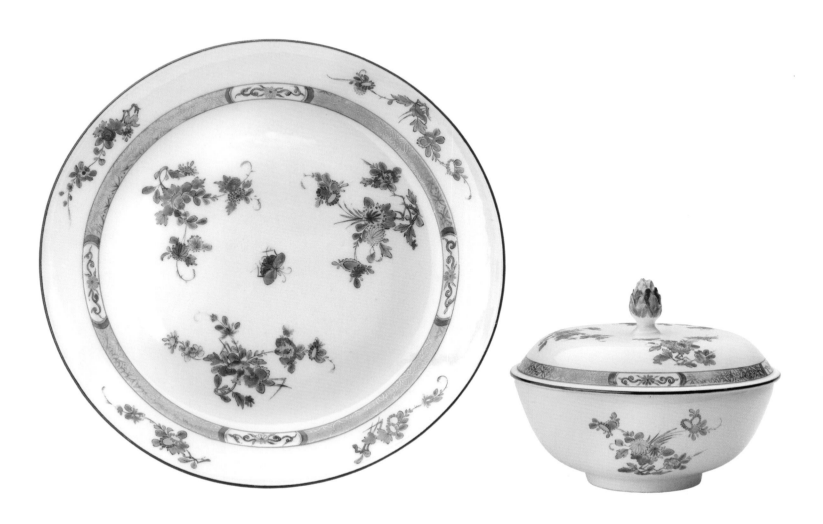

13

ARITA, HIZEN PROVINCE

PAIR OF INCENSE BURNERS IN THE FORM OF OXEN, 1640–70

Porcelain, celadon glaze

15.3 × 23.2 × 9.7 cm (RCIN 1170.1);
15.6 × 24.5 × 9.0 cm (RCIN 1170.2)

RCIN 1170.1–2.a–b

PROVENANCE: Probably acquired by Mary II

These unusual celadon-glazed oxen are incense burners. Their removable saddles conceal an opening for inserting incense, and holes in the saddles, nostrils and ears emit the fragrance, although it is unlikely they were ever used for this purpose in Europe.

Distinctive green-grey glazes known as celadon originated in China following the Han period (206 BC–AD 220).[25] The technique was much imitated in Japan, particularly on wares made at Seto during the Kamakura period (1185–1333). Potters at the Arita kilns later combined celadon glaze with underglaze blue and other colours. When Chinese porcelain production temporarily stalled following the collapse of the Ming dynasty in 1644, the VOC's awareness of this trade may have encouraged them to turn to Japanese suppliers.[26]

Although not listed in any early inventories of the porcelain collection of Mary II, the pair's long-term presence at Hampton Court Palace suggests that these oxen may have formed part of her collection. In 1857, Queen Victoria lent 'Two Indian China bulls' to the *Art Treasures of the United Kingdom* exhibition in Manchester, which were probably these.[27] MW & SG

LITERATURE: Dillon 1910, p. 7, cat. 9 (I, II); Ayers 2016, I, nos 310–11, p. 15

14

ARITA, HIZEN PROVINCE

PAIR OF BEAKER-SHAPED VASES,
1650–75

Porcelain, underglaze blue

41.7 × 20.9 × 20.9 cm (RCIN 1206.1);
42.2 × 20.9 × 20.9 cm (RCIN 1206.2)

RCIN 1206.1–2

PROVENANCE: Probably acquired by Mary II

Vases of this kind may have been made for use on local altars in
the ceramic-producing region of Arita. They are of a rare form, and
probably not intended for export. This pair was nevertheless brought
to Europe and may have formed part of Mary II's extensive collection
at Hampton Court Palace.[28] In the late seventeenth century, Japanese
porcelain manufacturers looked to China for inspiration, and these
pieces imitate the shape and deep blue palette of Ming wares. Horses,
phoenixes and waves are painted in the Chinese style surrounded
by heads of *ruyi* (Chinese sceptre-like objects prized as a symbol of
authority). The upper sections feature the 'Three Friends of Winter'
(*shō-chiku-bai*) – pine, bamboo and plum blossom – whose ability to
flourish in adverse conditions was considered an appropriate virtue
for the Confucian scholar–gentleman. MW & RP

LITERATURE: Dillon 1910, p. 16, cat. 33 (I, II); Ayers 2016, I,
nos 314–15, p. 161

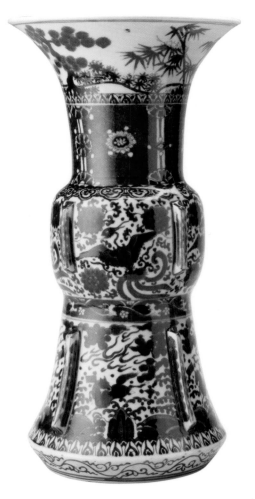
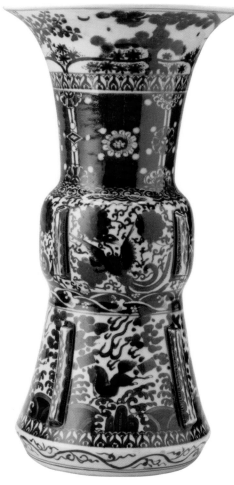

15

ARITA, HIZEN PROVINCE (PORCELAIN);
FRANCE (MOUNTS)
TANKARD, 1670–90 (PORCELAIN);
1700–30 (MOUNTS)

Porcelain, gilt bronze

16.0 × 15.0 × 10.0 cm

RCIN 58879.1

PROVENANCE: Probably acquired by Mary II

This tankard is of an unusual shape which could have been inspired by European silver versions. The porcelain is of a style known as *blanc de Chine* after the white porcelains made at Dehua in the southern Chinese province of Fujian. Here, the decoration is of applied chrysanthemums. The tankard and its pair do not have their original handles, which perhaps broke in transit or were less attractive to European taste; the present gilt-bronze handles were added in France some time later. The tankards' early provenance in the Royal Collection is not known, but they were placed alongside examples of Chinese *blanc de Chine* in the North Corridor (now the China Corridor) at Windsor Castle as part of a display of white Asian porcelain devised by Queen Mary in the early twentieth century. SG

INVENTORIES: WC Oriental China 1927, p. 19

LITERATURE: Ayers 2016, II, no. 1458, p. 628

16

ARITA, HIZEN PROVINCE (PORCELAIN);
FRANCE (MOUNTS)

MOUNTED BOWL WITH COVER, 1690–1800
(PORCELAIN); 1780–1800 (MOUNTS)

Porcelain with underglaze blue, overglaze enamel and
gold, gilt bronze

63.5 × 31.5 × 31.0 cm

RCIN 28790.2.a–c

PROVENANCE: Probably acquired by George IV

The scenes on this bowl and cover incorporate elements of the
Edo-period woodblock genre, *ukiyo-e* ('pictures of the floating
world'). This predominantly urban art form depicted pleasurable
activity as the best response to life's transience, as townspeople
(*chōnin*) 'floated' with the moment by embracing music, food, drink
and sexual fulfilment. Fashionable young ladies from the licensed
pleasure quarters embodied this philosophy. Here, beautiful
women are painted wearing flowing kimono and holding floral
blooms. Dogs play at their feet, and they pull handcarts with vases
overflowing with peonies, plum blossom and chrysanthemums.
Such scenes provided idealised images of a world of carefree
indulgence inaccessible to all but the wealthiest classes.

The motifs of elegance and luxury translate well onto porcelain
because of the brilliance of the underglaze blue, red enamel and
gold. French gilt bronze mounts, added in the late eighteenth
century, almost double the height of the object. In 1829, this bowl
was probably displayed with its pair in the Music Room Gallery
at the Royal Pavilion, Brighton – a residence which itself was
associated with pleasurable excess thanks to the extravagance
of the Prince Regent (later George IV) there. RP

INVENTORIES: Brighton Pavilion 1829A, p. 27; 1829B, p. 29
LITERATURE: Ayers 2016, II, no. 1652, pp. 673–4

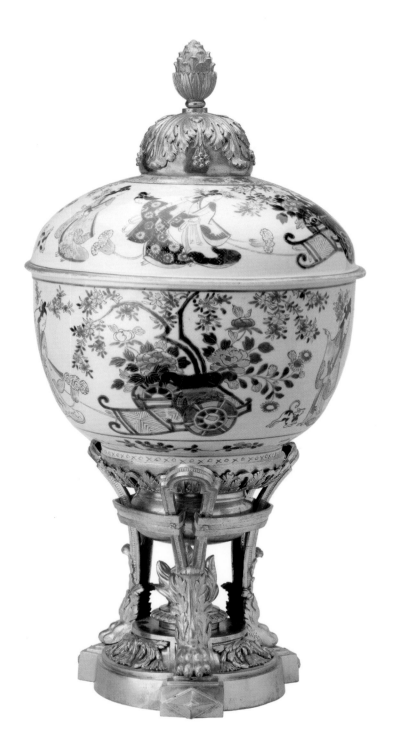

17

ARITA, HIZEN PROVINCE
TWO FEMALE FIGURES, 1690–1730

Porcelain, underglaze blue, overglaze enamel
and gold

58.0 × 18.0 × 23.0 cm (RCIN 2402.1);
55.5 × 19.0 × 17.5 cm (RCIN 2402.2)

RCIN 2402.1–2

PROVENANCE: Probably acquired
by George IV

Figures of *bijin* (beautiful women) were a popular theme
in woodblock prints of the *ukiyo-e* genre, which depicted
fashionable ladies of the urban pleasure quarters. The forms
were translated onto porcelain for the European market,
where the combination of eye-catching kimono and demure
posture created an idealised view of the exotic, amenable
Japanese woman. These figures' bright outer robes
(*uchikake*) are decorated with hares, wisteria and plum,
evoking the garments worn by wealthy courtesans of the
Edo period (1615–1868). Models for making free-standing
figures like these have been recovered at the enamellers'
quarter, Aka-e-machi, in Arita.[29] Such items were shipped
to Europe in vast quantities during the years of Japan's
porcelain export trade, often packed within lacquer cabinets
to save space.[30]

George IV evidently took an interest in depictions of
people from Japan and China, and in their clothes and
accessories. At the Royal Pavilion, Brighton, he displayed an
extraordinary series of lifelike Chinese clay figures dressed
in the garments of the Qing dynasty, whose heads nodded
with the aid of a pivoting rod,[31] while these Japanese figures
were housed in English marble-and-ormolu covered settings
in the Saloon. The Saloon furnishings were later re-used in
the Yellow Drawing Room at Buckingham Palace, where
male Chinese figures were also displayed in the niches of
the marble-and-ormolu chimneypiece (RCIN 9400.a–c).[32]

MW & RP

INVENTORIES: Brighton Pavilion 1829A, p. 12; 1829B, p. 115
LITERATURE: Ayers 2016, II, nos 1682–3, pp. 686–7

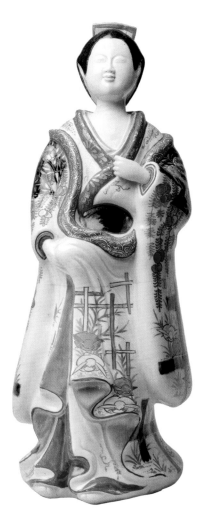
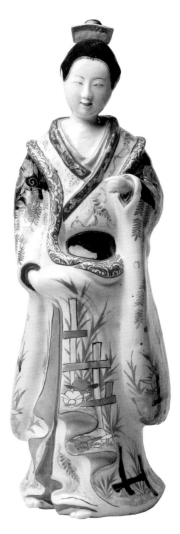

18

ARITA, HIZEN PROVINCE (PORCELAIN);
FRANCE (MOUNTS)

JAR AND COVER, 1690–1720 (PORCELAIN);
1780–1820 (MOUNTS)

Porcelain with underglaze blue, overglaze enamel
and gold, gilt bronze

42.5 × 21.0 × 23.0 cm

RCIN 39239.a–b

PROVENANCE: Purchased by George IV, 6 December 1820

Three delicate plum blossom trees appear in applied relief on the
body of this tall jar. In Japan, these five-petalled white flowers are
admired for their ability to withstand the cold, and associated
visually and poetically with snow. A poem by Ōtomo no Tabito
(665–731) declares:

> The flowers of the plum tree scatter in my garden –
> a shower of snow from the heavens![33]

The transition from winter to early spring is evoked by panels of
narcissus, bamboo and plum blossom painted in red and gold
overglaze enamels.

The jar has been mounted in Europe for use as an urn or, more
likely, a *pot-pourri*. Fragrance from petals within would diffuse
throughout the room through the pierced gilt-bronze band on the
lid. Above the foot is a spigot modelled in imitation of bamboo,
with a floral tap to release excess liquid from the wet *pot-pourri*
inside. This new function reflects – perhaps unwittingly – the
high status given to plum blossom's scent in the Heian period
(794–1185). In the seasonal poems of the first imperial *waka*
anthology, *Kokin Wakashū* (*c*.905), the blooms are praised for
their powerful aroma.[34]

George IV's agent, François Benois, bought this jar in Paris on
6 December 1820 at a cost of 190 francs. It was evidently already
mounted in gilt-bronze by this date, for it is described in the bill
as a 'fountain' ('*1 fontaine du Japon Les fleurs en Relief*').[35] It was
soon after destined for the Royal Pavilion, Brighton, where it was
displayed in the Large Lobby South by 1829. RP

INVENTORIES: Brighton Pavilion 1829A, p. 27; 1829B, p. 70;
WC '1866', pp. 412–13, no. 742

LITERATURE: Ayers *et al.* 1990 (exh. cat.), no. 250, p. 232; Ayers 2016, II,
no. 1653, p. 674

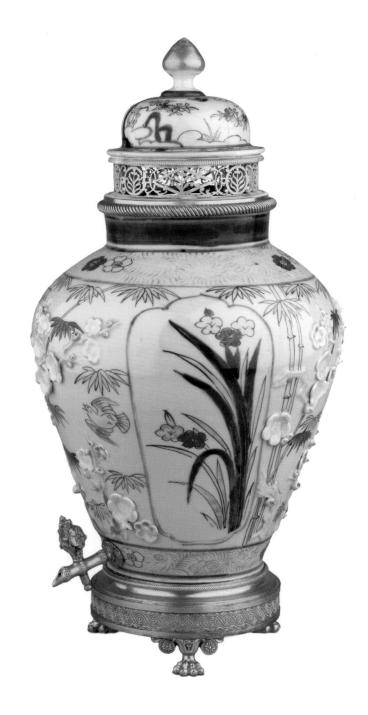

ARITA, HIZEN PROVINCE (PORCELAIN);
?FRANCE (MOUNTS)

**BOWL AND COVER MOUNTED AS A
POT-POURRI**, 1690–1730 (PORCELAIN);
1750–75 (MOUNTS)

Porcelain with underglaze blue, overglaze enamel
and gold, gilt bronze

50.0 × 38.5 × 28.0 cm

RCIN 45262.a–b

PROVENANCE: Possibly acquired by George IV

Radiating, oversized chrysanthemums are one of the most prevalent motifs on Edo-period export porcelain in the Imari style.[36] Chrysanthemum plants had been brought to Japan from China during the Tang dynasty (619–907) and were admired for their resemblance to the sun – to the extent that they were sometimes called *nikka* ('sun splendour').[37] Here, the large blue-grey and red petals are filled with stylised floral motifs, adding density to the rich enamel decoration. The undulating black lines which run from top to bottom are characteristic of Imari ware, which from the eighteenth century incorporated black enamel to achieve remarkably bold designs. Gold pigments would have been added only after the hottest initial firings, since they could not withstand the high temperatures sustained by the overglaze enamel. This vibrant style was copied widely in Europe during the eighteenth century, notably at the Worcester Porcelain Manufactory.[38]

The bowl has been fitted with a perforated gilt-bronze band for use as a *pot-pourri*. Such items were popular in Britain from the late seventeenth century, when decorative pots were used to fill a room with fragrant perfume according to fashionable recipes. The gilt-bronze pomegranate on the lid is suggestive of the bowl's sweet-smelling contents. No known bill or inventory records the item's entry into the Royal Collection, but it is not uncharacteristic of the gilt-bronze mounted porcelain purchased by George IV in the early nineteenth century, and may have formed part of his collection at Brighton. RP

LITERATURE: Ayers 2016, II, no. 1684, pp. 688–9

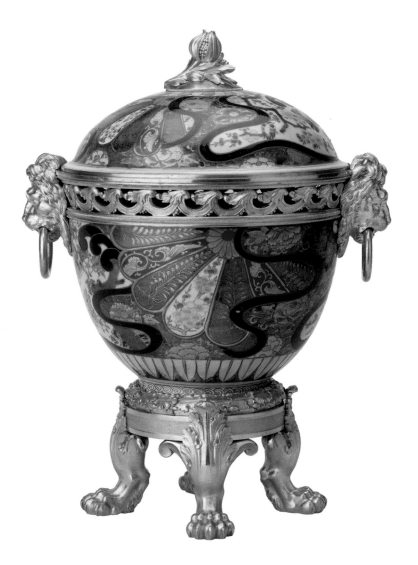

ARITA, HIZEN PROVINCE
**GARNITURE OF A JAR AND COVER
AND A PAIR OF VASES**, 1690–1730

Porcelain, underglaze blue, overglaze enamel and gold

90.0 × 33.0 × 33.0 cm (jar and cover);
58.0 × 27.0 × 27.0 cm (vases)

RCINS 194.2.a–b (jar and cover), 602.1–2 (vases)

PROVENANCE: Probably purchased by George IV when
Prince of Wales from John Hall, 30 January 1804[39]

In the late seventeenth century, European collectors increasingly
displayed Chinese and Japanese porcelain in complementary
groups known as garnitures. *Garnitures de cheminée* typically
comprised three large covered jars and two beaker-shaped
vases. Matching pieces were amassed on arrival in Europe and
then displayed on chimney mantels and cabinets, placed beside
hearths or mounted on brackets and shelves on walls and over
doorways. These dense displays were a stark contrast to the sparse
arrangement of individual pieces by collectors of the previous
centuries. Together, they created dramatic areas of colour,
enhanced by the dark walls of wood-panelled rooms. Mary II
was said to have brought the fashion for displaying these sets to
England from the Netherlands, and some of her collection is still
displayed in this manner at Hampton Court Palace.[40]

These pieces are painted in the bold red, blue and gold tones of
the Imari style. Imari wares were typically larger than Kakiemon-
style pieces, and in this instance the jar with its cover is almost a
metre high. As a result, Imari garnitures often had to be displayed
on the hearth of an empty fireplace rather than on the mantelpiece
above.[41] MW & RP

INVENTORIES: Brighton Pavilion 1829B, p. 41; BP 1911, V, p. 289
LITERATURE: Ayers 2016, II, nos 1676–9, pp. 682–3

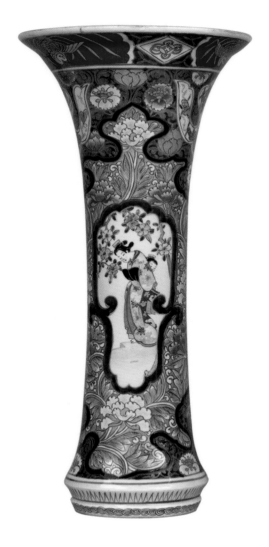

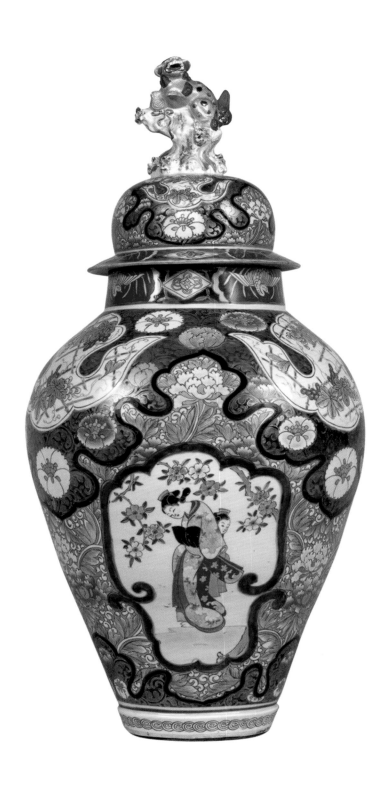
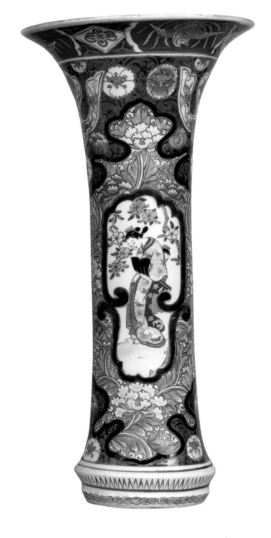

ARITA, HIZEN PROVINCE

**GARNITURE OF THREE JARS AND
COVERS WITH A PAIR OF VASES,**
1690–1730

Porcelain, underglaze blue, overglaze enamel
and gold

56.5–63.5 × 26.0 × 26.0 cm (jars and covers);
36.5 × 19.0 × 19.0 cm (vases)

RCINS 949.1–2.a–b (jars and covers), 26783.1–2
(vases), 29673.a–b (jar and cover)

PROVENANCE: Probably acquired by George IV
when Prince of Wales in 1804

The three octagonal jars in this garniture are topped by
elaborate ornaments in the shape of flower vases. Animal
and figurative knobs were common on Japanese export
porcelain by the 1680s and became even more ostentatious
during the early years of the eighteenth century. The height
of the covers also grew more exaggerated at this time, in
contrast to earlier low, flat lids which mimicked Chinese
forms.[42] This may have been to emphasise their shape and
height when displayed en masse in European houses.[43]

Sprays of peony, wisteria, chrysanthemum and plum
blossom appear in fan-shaped panels around the sides of the
jars and matching beakers. Fans (*ōgi*) had been used in Japan
since ancient times, and by the Edo period both paintings
and lacquerware were produced in forms imitating their
shape. These accessories – some so extravagant that they
were proscribed by sumptuary law in 1701[44] – became easily
recognisable symbols of Japanese culture in the West, and
proved popular motifs on export porcelain. MW & RP

INVENTORIES: Brighton Pavilion 1829b, p. 45;
Holyrood 1978, p. 9

LITERATURE: Ayers 2016, II, nos 1694–8, pp. 694–5

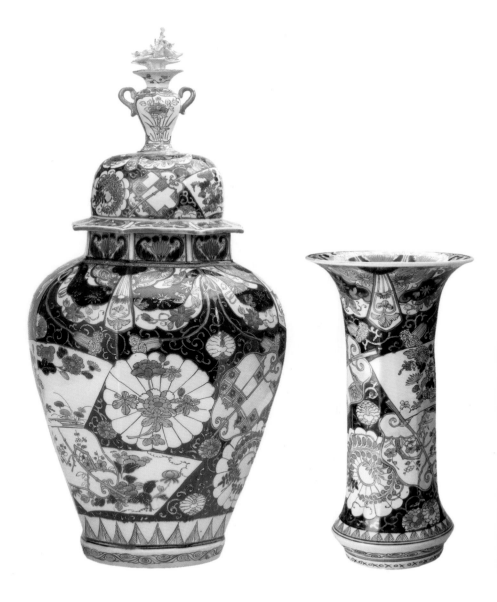

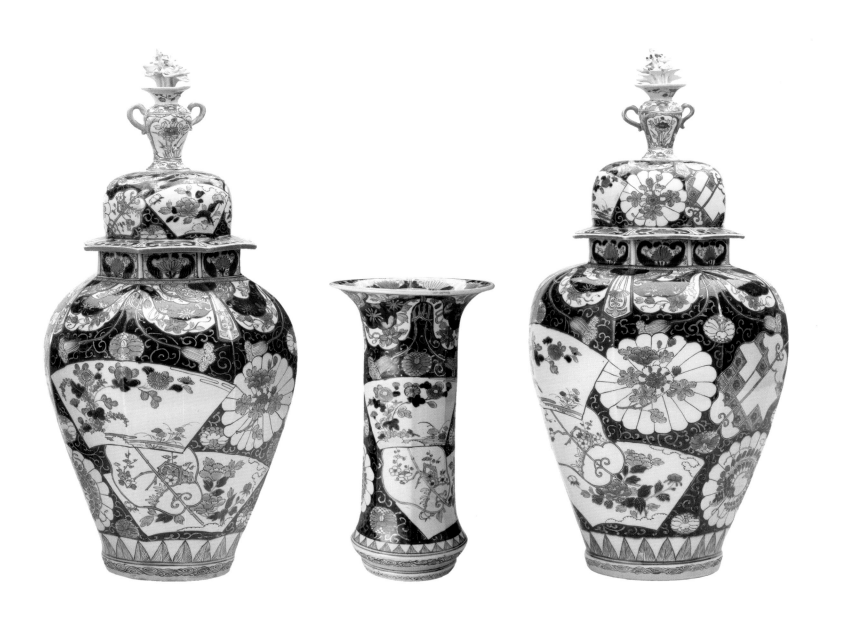

22

ARITA, HIZEN PROVINCE (PORCELAIN),
FRANCE (MOUNTS)

PAIR OF MOUNTED VASES, 1650-1700 (PORCELAIN); 1700-50 (MOUNTS)

Porcelain, brown and blue glaze, gilt bronze

25.8 × 12.0 × 10.0 cm (RCIN 3574.1);
25.6 × 12.0 × 10.0 cm (RCIN 3574.2)

RCIN 3574.1–2

PROVENANCE: Probably acquired by George IV

These vases represent an ingenious visual pun or *rebus*. In Mandarin, the word for 'squirrel' is a homonym for 'pine', and the word 'grape' is a homonym for 'peach'. Pines and peaches are symbols of longevity in China and Korea, and so the combination of bushy-tailed squirrels and grapevines is a cleverly expressed wish for long life.[45] Grapes additionally indicate the desire for abundant offspring, for the phrase *wan dai* can be translated as both '10,000 hanging [grapes]' and '10,000 generations'.[46] These borrowings indicate the strong influence of Chinese symbols and motifs on early Japanese export porcelain.

Each vase is moulded and glazed to resemble a tree stump, and their backs have been pierced with a hole for suspension. They were mounted in France and almost certainly later acquired by George IV. They furnished the Yellow Bow Room at the Royal Pavilion, Brighton in 1829 and were sent to Buckingham Palace in March 1847.[47] RP

INVENTORIES: Brighton Pavilion 1829A, p. 31; 1829B, p. 86; Brighton Pavilion Clocks and China 1828, p. 112

LITERATURE: Ayers 2016, II, nos 1475–6, p. 633

23

ARITA, HIZEN PROVINCE (PORCELAIN);
FRANCE (MOUNTS)

**PAIR OF PASTILLE BURNERS IN THE FORM
OF TORTOISES**, 1680–1700 (PORCELAIN);
1700–50 (MOUNTS)

Porcelain, brown and blue glaze, gilt bronze

25.0 × 21.7 × 15.0 cm

RCIN 4961.1–2.a–b

PROVENANCE: Probably acquired by George IV

The tortoise (*kame*) is a symbol of longevity in China and Japan. One mythical tortoise known as *minogame* is said to have lived for 10,000 years – so long, in fact, that a trail of algae began to grow on its back. In Europe, this trailing weed was often misinterpreted as fire, giving rise to the name 'flaming tortoise' for these creatures.[48] Strands of algae are absent here and the tortoises' upturned necks and open mouths instead suggest a playful interaction with the young on their backs.

Models of this kind were imported by the VOC as early as 1665, when the ship *Nieuwenhoven* brought to Holland some 295 'statuettes on tortoises' and 346 tortoises.[49] This pair are nevertheless rare examples of this form. Enlivened by dots and lines incised on their bodies, the creatures serve as pastille burners. The tortoises were originally designed to emit incense through their open mouths, but the addition of the hollow stump has blocked up the cavities. Instead, fragrance now diffuses via the gilt-lined holes which were added to the stumps in France.

This pair was recorded at the Royal Pavilion, Brighton, in 1829,[50] and later displayed by Queen Mary in her Tea Room at Buckingham Palace in 1917.[51] RP & MW

INVENTORIES: Brighton Pavilion 1829A, p. 14; 1829B, p. 109;
BP 1911, IV, p. 114

LITERATURE: Ayers 2016, II, nos 1521–2, p. 651

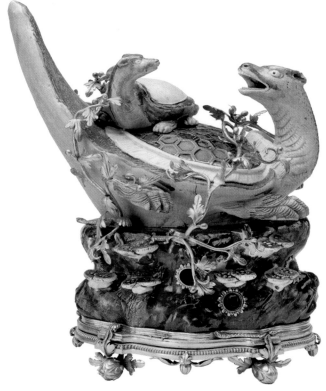

ARITA, HIZEN PROVINCE

PAIR OF PASTILLE BURNERS IN THE FORM OF HARES, 1680–1720

Porcelain, underglaze blue, overglaze enamel and gold

22.0 × 21.5 × 13.5 cm (RCIN 100967.1);
21.9 × 21.0 × 13.5 cm (RCIN 100967.2)

RCIN 100967.1–2

PROVENANCE: Purchased by George IV when
Prince Regent, 5 April 1818

Usagi (rabbits or hares) are often associated with the Year of the Rabbit, the fourth year in the *jūnishi* zodiac calendar.[52] They appear frequently in netsuke and porcelain, as well as in screen paintings, prints and textiles. Mythology surrounding the hare was adopted from China, where the animal was associated with the moon and thought to assist in preparing the elixir of immortality.[53] The theme of longevity is reinforced here by the *reishi* (fungi) growing on the rocks; these fungi are said to proliferate on Mount Hōrai, the mystical land of the Immortals.[54]

The colourful geometric and floral designs give these hares a playful, humorous feel. These patterns were charmingly described as 'harlequin patches' when the pair was inventoried at the Royal Pavilion, Brighton in 1829.[55] The decorative pieces serve as pastille burners, and the incense when burnt diffuses through holes in the brown glazed rockwork.[56]

The hares evidently appealed to successive generations of royals. Originally acquired by George IV for Brighton on 5 April 1818, the pieces were later sent to Buckingham Palace, where by 1911 Queen Mary displayed them prominently on top of a Chinese cabinet in the 'Lacque Room' [*sic*] in her private apartments (see Fig. 8.8 on p. 194).[57] Queen Elizabeth The Queen Mother (1900–2002) subsequently used them to furnish her rooms at Clarence House. There, they formed part of a menagerie of Chinese and Japanese porcelain animals which surely appealed to her discriminating taste and sense of humour.[58] MW & RP

INVENTORIES: Brighton Pavilion 1829A, p. 20; BP 1911, IV, p. 114; QEQM CH 2000, p. 165

LITERATURE: Ayers 2016, II, nos 1523–4, p. 652

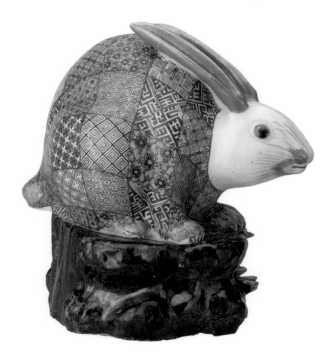
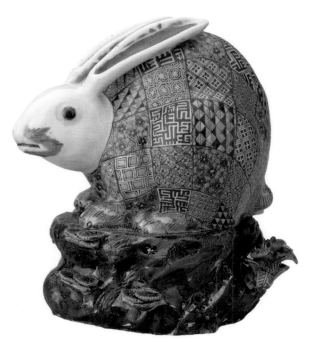

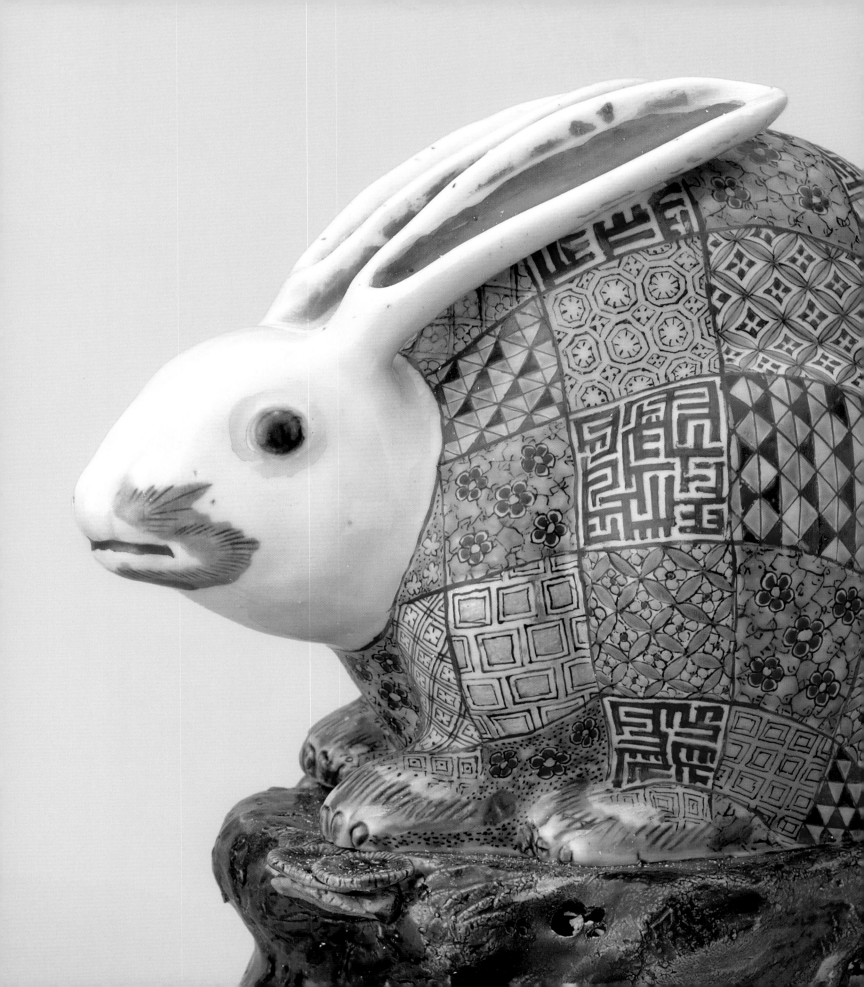

25

ARITA, HIZEN PROVINCE (PORCELAIN); FRANCE (MOUNTS)

PAIR OF MOUNTED VASES, 1690–1720 (PORCELAIN); 1725–50 (MOUNTS)

Porcelain with underglaze blue, overglaze enamel and gold, gilt bronze

34.9 × 28.0 × 20.5 cm

RCIN 12.1–2

PROVENANCE: Probably acquired by George IV

Chinese tradition tells of carp (*koi*) attempting to swim upstream at the Dragon Gate rapids, impeded by demons who increased the height of the waterfall. After considerable struggle, the carp which succeeded were turned into golden dragons. The fish consequently became an emblem of perseverance and success (Fig. 3.2). The scene on these vases evokes the legend, and may be related to a samurai's coming-of-age ceremony (*genpuku*) or Boys' Day (5 May) when carp streamers called *koinobori* are flown on poles.[59] In Japan, *koi* are particularly associated with the steadfastness and determination of the samurai.

The vases are fashioned from square porcelain flasks which have been cut down at the shoulder. Flasks of this kind were derived from Dutch forms, mimicking the metal and glass sets used to hold spirits on ships. Large numbers were made for export from Japan from the end of the seventeenth century.[60] The *Silberkammer* in the Hofburg, Vienna, contains identical vases with similar mounts, as well as matching, taller flasks which have not been cut down.[61]

The elaborate French mounts are of exceptional quality and represent the full vivacity and inventiveness of French eighteenth-century rococo design. In this instance, the mount-maker has reflected the porcelain's subject: undulating lines at the base mimic the turbulent water of the river.

These vases are probably the pair described in the Library at the Royal Pavilion, Brighton, in 1829.[62] Interestingly, they were displayed alongside black lacquer pieces in this room, perhaps because of their complementary rare black enamel ground. MW & RP

INVENTORIES: Brighton Pavilion 1829A, p. 32; 1829B, pp. 36, 60

LITERATURE: Ayers *et al.* 1990 (exh. cat.), no. 249, p. 231; Croissant *et al.* 1993 (exh. cat.), no. 9/30, pp. 362–3; J. Roberts 2002–3 (exh. cat.); no. 312, p. 351; Arizzoli-Clémentel and Salmon 2008 (exh. cat.), nos 19–20, p. 52; Ayers 2016, II, nos 1531–2, pp. 655–6

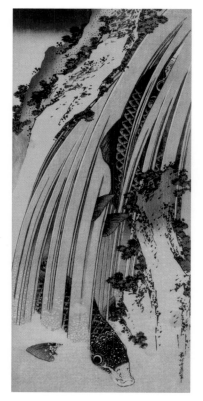

3.2 Katsushika Hokusai (1760–1849), *Two carp leaping up a waterfall*, c.1833. Colour woodblock print, 52.2 × 23.2 cm, British Museum, BM 1927,0413,0.14

26

ARITA, HIZEN PROVINCE (PORCELAIN);
FRANCE (MOUNTS)

PAIR OF JARS WITH MOUNTS, 1740–60
(PORCELAIN AND MOUNTS)

Porcelain with underglaze blue, overglaze enamel, gilt bronze

19.4 × 22.5 × 13.5 cm (RCIN 388.1);
19.4 × 23.5 × 13.0 cm (RCIN 388.2)

RCIN 388.1–2

PROVENANCE: Probably acquired by George IV

3.3 Sèvres porcelain manufactory, *Vase à bâtons rompus*, 1764. Soft-paste porcelain, bleu nouveau ground, gold, gilt bronze, 53.0 × 29.8 × 19.7 cm, RCIN 2290

These rare Arita jars are almost enveloped by their elaborate French gilt-bronze mounts, but the small hexagonal vessels beneath are of unusual form and decoration. Each is decorated with minuscule moulded figures of men and children along with bamboo and sprays of plum blossom. The designs are glazed and coloured in blackish-blue and red, and the unglazed surfaces coloured with washes of pinkish-red. Both jars are also impressed with small stars in a 'honeycomb' pattern, which was noted when they were inventoried in the Music Room Gallery at the Royal Pavilion, Brighton, in 1828.[63]

The mid-eighteenth century mounts have no practical function and must be considered works of art in their own right. They may have been modelled on a design used at the renowned Sèvres porcelain manufactory (est. 1740) near Paris. That design, known as the *vase à bâtons rompus*, featured angular handles and laurel garlands similar to the present example (Fig. 3.3). The French vase was manufactured from 1764 and possibly designed by Étienne-Maurice Falconet (1716–91).[64] George IV acquired both the Sèvres piece and this Franco-Japanese confection, in keeping with his varied and cosmopolitan taste. **RP**

INVENTORIES: Brighton Pavilion Clocks and China 1828, p. 55; Brighton Pavilion 1829A, p. 29

LITERATURE: Ayers 2016, II, nos 1519–20, pp. 649–50

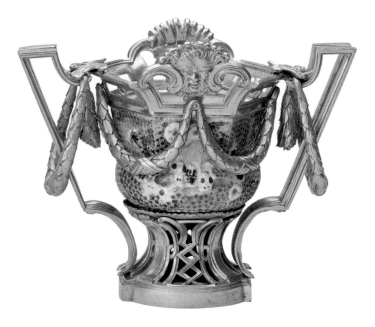

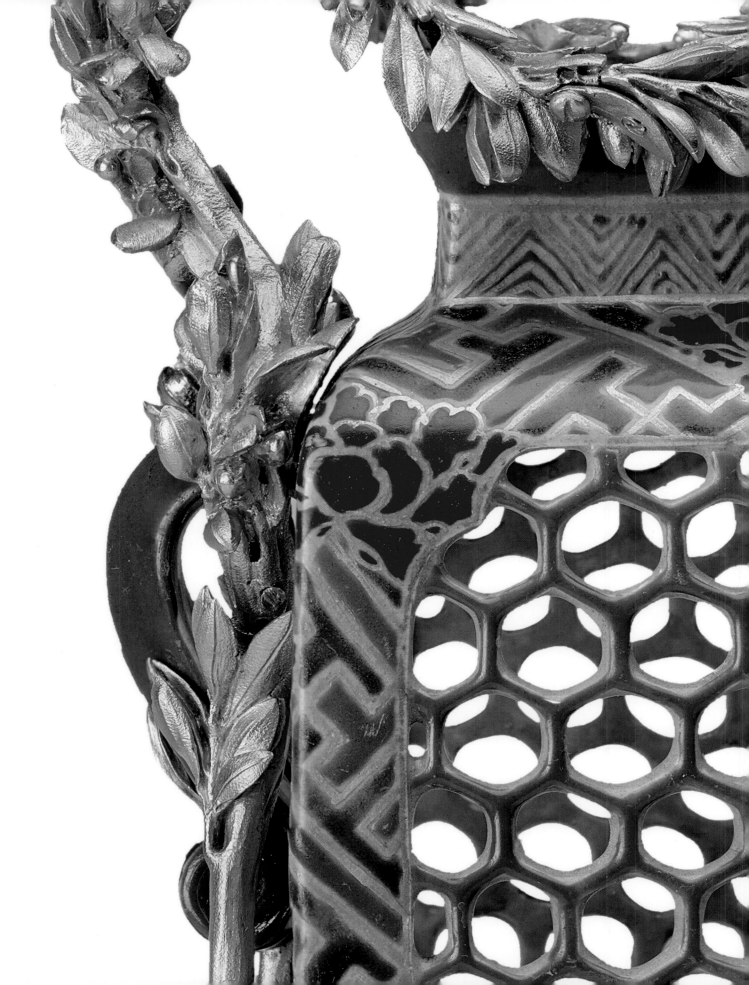

KYOTO (STONEWARE); FRANCE (MOUNTS)
MOUNTED VESSEL, 1700–75
(STONEWARE); 1750–75 (MOUNTS)

Buff stoneware, glaze, overglaze enamel with gold,
gilt bronze

29.9 × 14.4 × 10.2 cm

RCIN 100937

PROVENANCE: Probably acquired by George IV

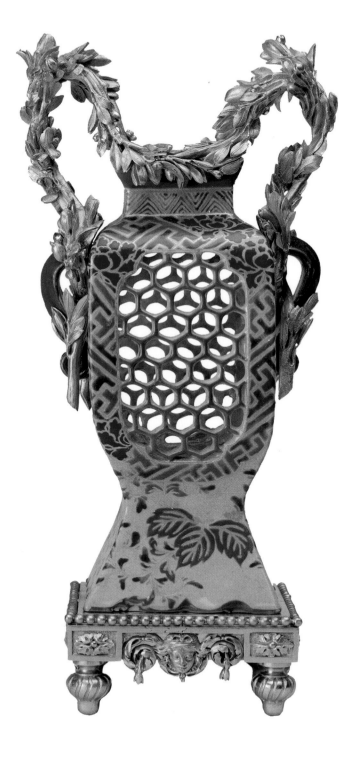

This is an exceptional piece for which there is no known equivalent. It was made in Kyoto, where stoneware with a restrained enamel palette was produced during the seventeenth and early eighteenth centuries. Kyoto was the Japanese capital at that time, and so these pieces are known as *Kyōyaki* ('capital wares'). Enamellers there developed techniques independently of the porcelain kilns of Arita and Ōkawachi (Nabeshima), creating elegant, subdued colours which appealed to the refined taste of their courtly patrons. Blue, green and purple enamels were common, but red was used sparingly and mostly only from the nineteenth century.[65] The vivid red blooms seen here are therefore a striking example of the very early use of red overglaze enamel on *Kyōyaki*.

The piece is also unusual for its shape. Delicate, stylised latticework was one of the hallmarks of *Kyōyaki* from the Kyoto kilns,[66] but the small size and vase-like form of this piece have no known parallels. Early Kyoto wares were seldom exported from Japan and few are found in European collections today. Rare examples include two tiered boxes at Burghley House and several hanging vases at Dresden, which may possibly have belonged to Augustus II.[67] A section from a Kyoto tiered box with similar hexagonal fretwork is in the Freer Sackler Collection.[68] The present piece is possibly modelled on metalwork braziers used to hold burning coals.

When the vessel was inventoried at the Royal Pavilion, Brighton, in 1829, the intricate meshwork sides were described as 'honeycomb panells'.[69] Each section is so delicate that the French mounts are draped around the neck and shoulders so as not to pierce the vase itself. The piece was first recorded in the Royal Collection in 1815, when George IV had it sent to Brighton on 4 September.[70] RP

INVENTORIES: Brighton Pavilion 1829A, p. 15; 1829B, p. 72

LITERATURE: Ayers 2016, II, no. 1719, pp. 706–7

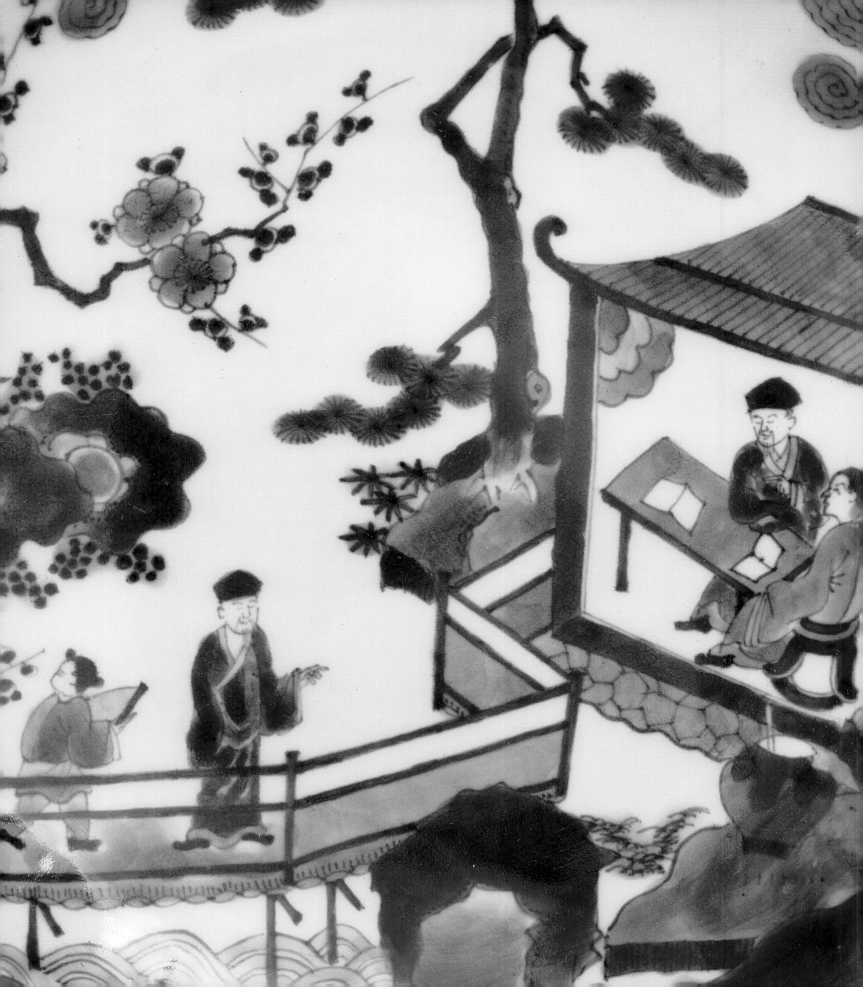

28

ARITA, HIZEN PROVINCE
DISH, 1670-90

Porcelain, underglaze blue

22.0 × 22.0 × 3.0 cm

Base marked in black with the inventory mark
of Augustus II: 'N. 469' over a wavy line

RCIN 58992.1

PROVENANCE: Probably acquired by
Queen Victoria before 1860

This dish was once part of the celebrated collection of Augustus II 'the Strong', Elector of Saxony and King of Poland. From 1715, he amassed a vast array of East Asian porcelain including Imari and Kakiemon-style wares, which he displayed in towering pyramids in his purpose-built *Japanisches Palais* ('Japanese Palace') at Dresden.[71] These pieces were augmented by porcelain produced at his own factory, established in nearby Meissen in 1710.

The dish, with three others, is likely to have entered the Royal Collection through family connections in Germany. They probably arrived before 1860, for in that year Queen Victoria presented an identical piece to the South Kensington Museum (V&A no. 7331-1860). The decoration is typical of the Chinese motifs borrowed by Japanese painters: two scholars are seen reading in a pavilion under a pine tree, approached by another scholar and his servant who cross a bridge. On the base is a square mark denoting *fuku* (good fortune). MW & SG

INVENTORIES: Staatliche Kunstsammlungen Dresden 1779, nos 464 and 469

LITERATURE: Ayers 2016, II, no. 1463, pp. 630–31

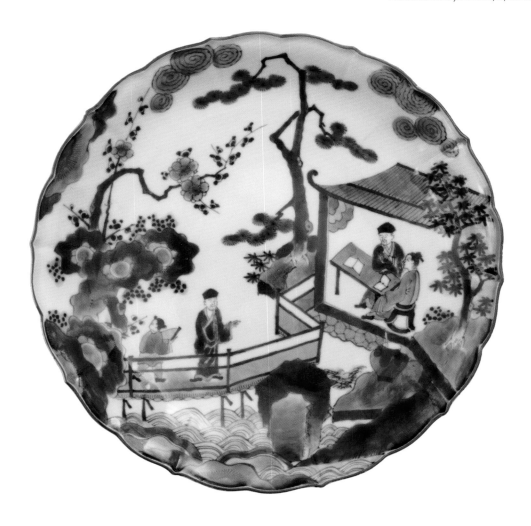

29

ARITA, HIZEN PROVINCE

TWO SAKÉ BOTTLES, 1840–60

Porcelain with underglaze blue, white slip

21.7 × 14.0 × 14.0 cm

RCIN 27526.1–2

PROVENANCE: Probably sent to Queen Victoria
by Shōgun Tokugawa Iemochi, 1860

These white porcelain jars still contain traces of their original contents: *saké*. This alcoholic drink is made from fermented rice and has been known in Japan since the third century AD. The first jar is painted in underglaze blue with the 'Three Friends of Winter' (*shō-chiku-bai*): pine, bamboo and plum blossom. White slip (liquid clay) has been used to highlight the blossom. The second jar is painted with a bird perched on a rock beside a clump of chrysanthemums, convolvulus and grasses.

Queen Victoria gave four vessels of this kind to the South Kensington Museum in 1865.[72] Two labels attached to those bottles read *Safuran-shu* ('Saffron *saké*') and *Iyo Imaharu Edo uribiki Honchō I-chome* ('produced at the Imaharu Brewery, Iyo Province [modern Ehime Prefecture], Edo, Honchō I-chome'). They are almost certainly part of the same set. The bottles may have formed part of the gift received by Queen Victoria from Shōgun Tokugawa Iemochi (1846–66) in 1860, although *saké* jars are not mentioned in either of the two extant lists of presents.[73] **RP**

LITERATURE: Ayers 2016, II, nos 1487–8, p. 635

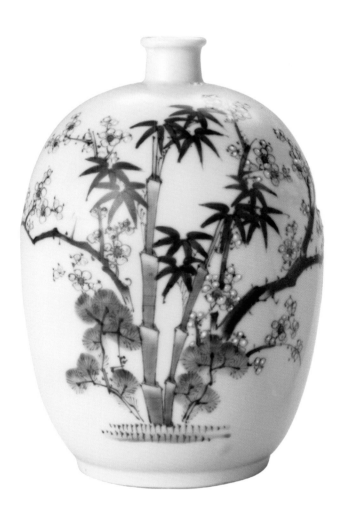

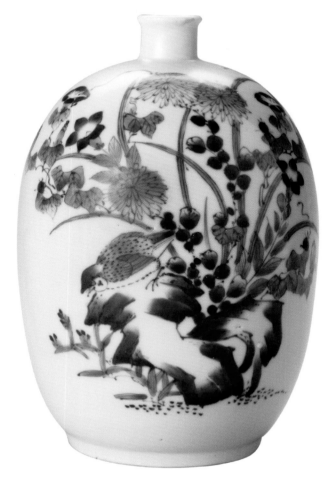

30
ARITA, NABESHIMA FACTORY
DISH, 1800–60

Porcelain painted in underglaze blue

5.8 × 20.5 × 20.5 cm

RCIN 2389.1

PROVENANCE: Probably sent to Queen Victoria by Shōgun Tokugawa Iemochi, 1860

In the late seventeenth century, the Nabeshima *daimyō* (feudal lords) of Saga established their own porcelain kilns in Ōkawachi, 8 km (5 miles) from the porcelain-producing town of Arita. These highly exclusive wares were intended as gifts to win favour with the shōgun and other nobility. Designs and techniques were kept a closely guarded secret. At their peak, the Nabeshima kilns produced some of the most elegant and harmonious porcelain of the period, which was unavailable on the general market.

Because they were not designed for export, the porcelains reflect Japanese rather than European taste. Here, many of the characteristic features of Nabeshima ware are evident: soft shades of cobalt blue, natural motifs (in this case, a willow tree) and a tall foot. High feet complemented the raised lacquer bowls with which the dishes were used when dining. This bowl's foot is decorated with the typical Nabeshima 'comb teeth' (*kushide*) pattern.

In light of Nabeshima wares' quality and rarity, the arrival of this dish in Britain in 1860 is exceptional. It almost certainly formed part of the gift from Shōgun Tokugawa Iemochi to Queen Victoria following the agreement of an Anglo-Japanese Treaty of Amity and Commerce in 1858. In 1865, Queen Victoria presented nine identical dishes from the set to the South Kensington (later V&A) Museum, where they were identified as 'Modern Japanese'.[74] RP

LITERATURE: Ayers 2016, II, no. 1477, p. 634

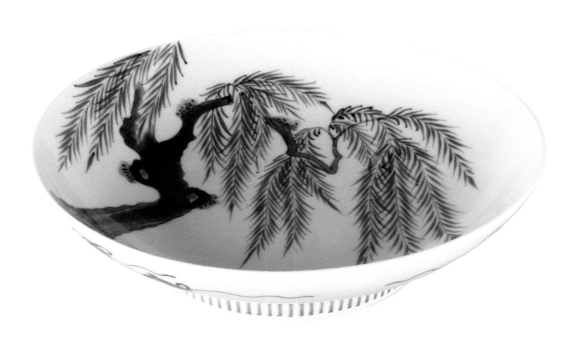

31

KUTANI, KAGA PROVINCE
(NOW ISHIKAWA PREFECTURE)
PAIR OF JARS, *c.*1870–90

Porcelain, enamels, gold

45.3 × 44.3 × 44.3 cm (RCIN 829.1);
46.0 × 42.9 × 42.9 cm (RCIN 829.2)

Each inscribed on the base: 大日本加賀国九谷 綿埜製造
(*Dai Nippon Kaga-no-kuni Kutani Watano seizō*;
'Made by Watano, Kutani, Kaga province, Great Japan')

RCIN 829.1–2

PROVENANCE: Probably acquired by Queen Victoria;
first recorded at Osborne House in 1891

This pair of jars represents a new style of porcelain produced near
Kutani (Kaga Province, now Ishikawa Prefecture) after the Meiji
Restoration of 1868. Production in this region at first suffered from
the loss of feudal patrons, but an innovative new industry quickly
emerged which became popular with overseas buyers. Kutani wares
of this period are distinguished by enamel scenes of birds and
flowers, painted over the glaze after firing, and the generous use of
gold and red. Here a resplendent gold peacock and peahen appear
in a river landscape accompanied by peonies, hydrangea, iris,
reeds, cranes, lotus, thistles, ferns and a willow tree.

The base of each vase bears the mark of the Watano family, who
successfully exported wares to Europe from Kōbe and Yokohama.
In 1889, Watano Kichiji (1859–1946) exhibited flower vases, tea cups
and earthenware bowls at the 1889 Paris *Exposition Universelle*; this
pair is probably also his work.[75] These examples may have been
purchased in Japan, for they bear a local label identifying them as
'Number 48 / One Pair / 45 yen'.

Both jars are visible in a photograph taken in January 1891
at Osborne House, where they were used as props in a Japanese
tableau vivant performed by Prince Arthur, Duke of Connaught
and his family (cat. 70). The duke and his wife had visited Japan the
previous spring, and it is possible that they purchased the jars at
this time. During a trip to the Third National Industrial Exhibition
in Tokyo, Mary Fraser noted that the duke bought 'two splendid
vases to take away to the Queen', which may be these.[76] However,
the *tableau* at Osborne included lacquerware, metalwork and
screens previously acquired by Queen Victoria, and it is possible
the jars had likewise already entered the Royal Collection by other
means. The photograph indicates they were used as plant pots at
that date. RP

INVENTORIES: Osborne 1904, p. 35; BP 1911, V, p. 294

LITERATURE: Ayers 2016, II, nos 1717–18, pp. 704–5

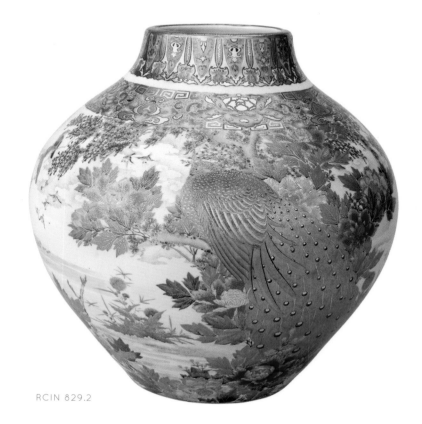

RCIN 829.2

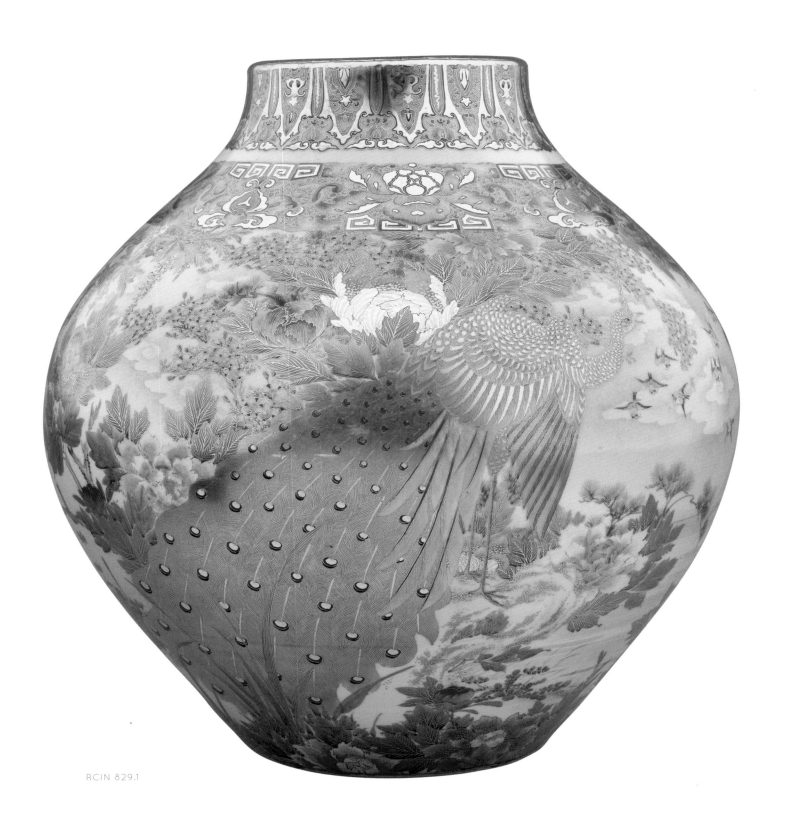

RCIN 829.1

32

KEIDA MASATARŌ (1852–1924);
UEHARA KUMAJI (ACTIVE 1900–22)

PAIR OF VASES, 1900–22

Pottery, enamels, gold

46.3 × 20.5 × 20.5 cm

Inscribed on each base in gold: 大日本 (*Dai Nippon*;
'Great Japan'); 薩摩 (*Satsuma*); 慶田謹製 (*Keida kinsei*;
'Made with care and attention by Keida'). Red seal of
Keida Masatarō and underglaze stamp of Uehara Kumaji.

RCIN 152.1–2

PROVENANCE: Presented to King Edward VIII when Prince of
Wales by the Kagoshima Prefectural Office, 9 May 1922

These elegant vases represent spring and autumn respectively. The first
(RCIN 152.1) is decorated with cherry blossom, signifying spring, and
the other (RCIN 152.2) with chrysanthemums, indicating autumn. Both
scenes appear in swirling clouds which dissolve into the cream glaze of
the vase, suggesting the ephemerality of each season. The vases have
high shoulders near the neck, a shape known as *katatsuki*, which gives
prominence to the main decoration on the body. The design is the work
of Keida Masatarō who by the early twentieth century was considered
one of the foremost potters in Kagoshima; in 1904, he won a Gold
Medal at the Louisiana Purchase Exhibition.[77]

Porcelain in this style was displayed to resounding success by the
Satsuma domain at the Paris *Exposition Universelle* of 1867. European
and American consumers were dazzled by the combination of a white
body with crackle glaze and delicate gold and polychrome enamel
decoration. Further interest at the 1873 Vienna World Exhibition and
the 1876 Philadelphia Centennial Exposition generated considerable
demand for export pieces, which were soon produced across southern
Kyūshū and elsewhere in Japan. Many displayed minute figures and
imaginary landscapes evoking an 'exotic' Japan which would appeal
to western taste.[78] Here, by contrast, established Japanese motifs are
rendered confidently and sparingly. Uehara Kumaji's delicate, moulded
decoration round the neck is of particularly fine quality.

The chrysanthemum and paulownia flowers in the borders are
associated with the Imperial Household, indicating the official
character of the vases.[79] They were a gift to Edward, Prince of Wales
from the Kagoshima Prefectural Office during his visit to that prefecture
on 9 May 1922.[80] Few Satsuma-style wares are found in the Royal
Collection today, although they evidently appealed to royal taste:
Queen Mary bid unsuccessfully for a large lot of Satsuma ware at the
C.T. Hawkins sale in 1927.[81] RP

LITERATURE: Ayers 2016, II, nos 1720–21, pp. 708–9

33
HAMADA SHŌJI (1894–1978)
SQUARE VESSEL, 1960–75

Stoneware, *kaki* glaze

22.2 × 17.0 × 16.2 cm

RCIN 68402

PROVENANCE: Presented to Queen Elizabeth II by
Prime Minister Miki Takeo and his wife during
her State Visit to Japan, May 1975

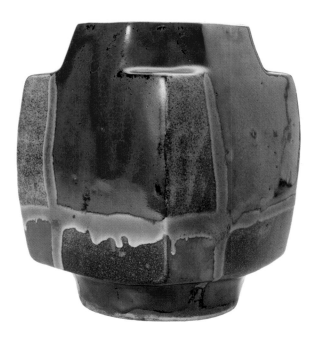

Hamada Shōji was a leading artist–potter of the twentieth century
and a pioneer of the Japanese Folk Craft movement, *Mingei*. The
school emerged in reaction to the rapid industrialisation and
westernisation of the Taishō period (1912–26), as artists sought to
return to rural values and a distinctively national aesthetic. The name
is an abbreviation of *minshūteki kōgei* ('crafts of the ordinary people').
Central to this tradition is an emphasis on handmade rather than
mass-produced objects, created by craftsmen working close to nature.

This thickly potted square vessel is typical of Hamada's work,
which is marked by a solidity of form and generous glaze. Here, his
rich *kaki* (literally 'persimmon') glaze is interspersed with mottled
and gritty sand-coloured patches, outlined in lively brushstrokes of
bluish-green. The overall effect is earthy and spontaneous. Hamada had
experimented with thousands of original glazes made from powdered
stone and ash during his early career at the Tokyo Technical College
(1913–16) and the Kyoto Municipal Research Institute (1916–19).[82]
In 1920, he moved to England to collaborate with the British studio
potter Bernard Leach (1887–1979) in St Ives, Cornwall. Their lifelong
partnership did much to cement the connection between *Mingei* and
the English Arts and Crafts movement, which shared similar aesthetic
and social values.

After his return to Japan in 1924, Hamada established a workshop in
the small pottery-making village of Mashiko, 100 km (60 miles) north
of Tokyo. The move reflected the *Mingei* commitment to rural industry
and a conviction that artists should operate within small communities.
On this pot, Hamada has applied thick pigments according to old
Mashiko practice: using a homemade brush fashioned from the long,
coarse hair at the back of a dog's neck.[83] In 1955 he was honoured by
the Imperial Government as a 'Holder of Important Intangible Cultural
Properties' (*Ningen Kokuhō* or Living National Treasure).

The vessel was presented to Her Majesty The Queen by Prime Minister
Miki Takeo during her State Visit to Japan in May 1975. On the same
occasion, The Queen gave the emperor and empress a stoneware plate
and soft ground etching by Leach.[84] RP

LITERATURE: Ayers 2016, II, no. 1722, p. 710

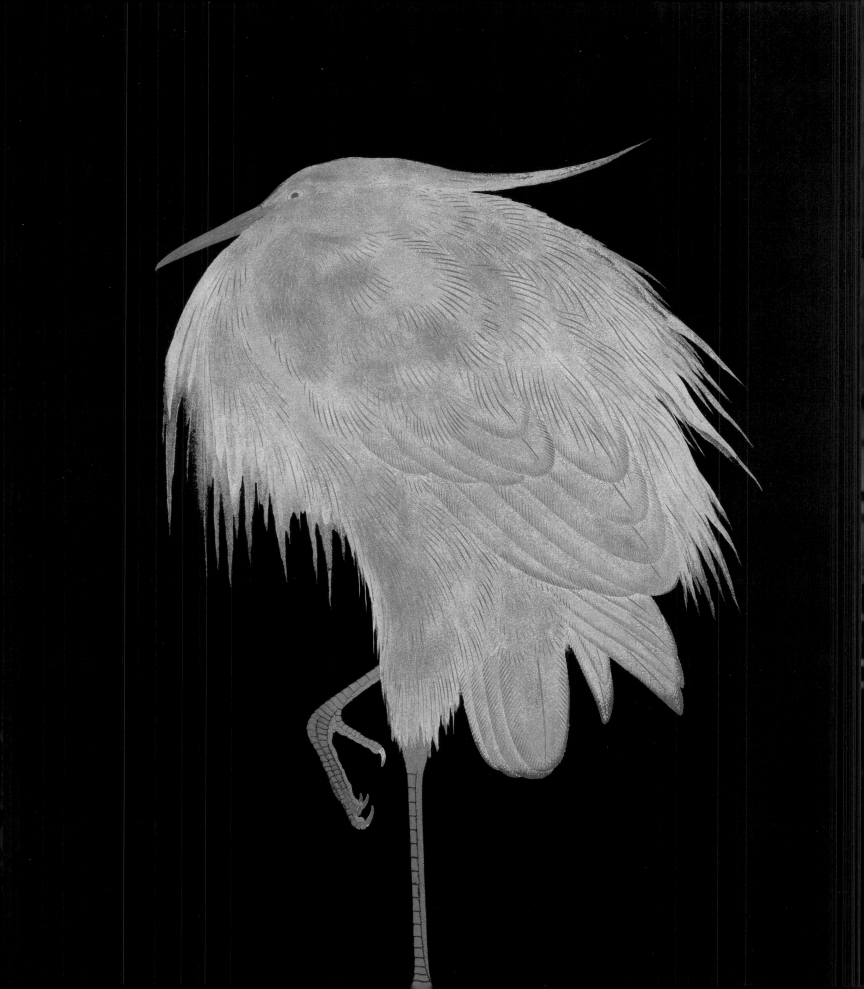

日本の芸術

4

LACQUER

RACHEL PEAT

L ACQUER is a costly varnish made from the sap of the *Toxicodendron vernicifluum* tree (formerly known as *Rhus verniciflua*). Since the Early Jōmon period (*c.*4000–3000 BC), it has been prized in Japan for its resistance to water, heat and woodworm as well as mild acids and alkalis. This viscous substance is known as *urushi* (lacquer), which can be coloured a range of shades (traditionally black, red, brown, green and yellow) or embellished while wet with metal powders or inlay. It has long been used as a durable and attractive finish for temple architecture and luxury household goods such as *saké* bottles, document boxes, bowls, trays and cabinets.

Lacquer preparation and execution is an expensive and painstaking process. The sap is tapped via horizontal incisions in the trunk of the tree and then purified by filtering. Excessive moisture must then be removed by heating. The lacquer is applied in numerous thin preparatory layers – sometimes as many as 20 – to a base made of wood or cloth. Each layer must be allowed to dry completely and rubbed smooth before the next layer is added. During application of the uppermost layers, decorative elements are introduced and the lacquer is usually rubbed to a gleaming polish.

The most distinctive Japanese lacquer decorative technique is *makie* (literally 'sprinkled picture'), in which metallic powders are scattered onto wet lacquer to create a variety of designs. Particles of the required size and shape are carefully selected and sprinkled from a tube fitted with a cloth mesh over one end, a process which requires the greatest precision and dexterity. The simplest form is *hiramakie* ('flat sprinkled picture'), in which the design lies just above the surface. In *takamakie* ('high sprinkled picture'), the motifs are carefully built up in relief with clay or charcoal powder. The most complex is *togidashi makie* ('polished-out *makie*'), whereby an initial low-relief design is covered in black lacquer which is then polished until the design reappears, flush with the new ground. When gold particles of different shapes are suspended

in clear or yellowish lacquer, usually for backgrounds, the effect is called *nashiji* ('pear-skin ground'), since the resulting texture resembles the skin of the Asian pear. Some of the most ambitious wares combine all these techniques.

Japanese lacquer wares began to arrive in Europe from around 1560 and were immediately admired for their exoticism, quality and refinement. Among the first imports were coffers and chests densely inlaid with thick pieces of mother-of-pearl (cat. 34). This style, distinct from anything made for the domestic market, combined western forms with Korean and Chinese decorative elements. It was known as *nanban* ('southern barbarian') after the westerners who reached Japan from the south and to whom it particularly appealed. By the early seventeenth century, a new pictorial style had become popular, characterised by gold-sprinkled scenes, usually landscapes, on a black lacquer ground. Expensive two-door cabinets of drawers decorated in this way became imposing centrepieces in the grandest houses and palaces, where they were often used for the display of porcelain (cats 35–37).

Lacquer panels were so sought-after in Europe that they were frequently cut up for re-use in different pieces of furniture as fashions changed (cat. 39). Despite its desirable status, trade in lacquer never exceeded that of porcelain and it remained costly and difficult to ship to Europe. From 1693 the VOC ceased to place official orders for large items of lacquer (although private trade continued) and began to focus on smaller wares, such as plates, bowls and cups, some decorated with European motifs (cat. 44).

During the Edo period (1615–1868), lacquer artists enjoyed the patronage of wealthy *daimyō* and samurai families, for whom they created lavish incense boxes (cat. 147), writing sets (cat. 145) and numerous other items, large and small, often as part of a bride's trousseau (see cat. 53). Many incorporated poems or subtle allusions to classical literature, such as the eleventh-century *Tale of Genji*. As the purchasing power of the urban merchant classes and *chōnin* (townspeople) increased, the range of wares expanded to include fashionable picnic sets, *inrō* and other goods. It was not until the mid-nineteenth

century, when Japan reopened to the West, that objects of this high quality arrived in Europe in large quantities.

Lacquer artists temporarily suffered following the return to imperial rule in 1868, which deprived them of their traditional patrons, the shōgun and *daimyō*. Nevertheless, the Meiji period (1868–1912) brought fresh opportunities. Between 1886 and 1889 the interior of the new Imperial Palace in Tokyo was decorated by the prominent lacquerers Shibata Zeshin (1807–91), Kawanobe Itchō (1830–1910) and Shirayama Shōsai (1853–1923). By the turn of the twentieth century, the imperial family had also begun to commission lacquer presentation boxes as prestigious gifts for high-ranking officials and foreign royalty. These lavish objects were especially suited for diplomatic exchange since *urushi* wares represented a distinctly Japanese medium and therefore offered an opulent expression of national identity following the rapid westernisation of the Meiji period.

During the Taishō period (1912–26), lacquer artists such as Akatsuka Jitoku (1871–1936) pioneered bold and increasingly modern designs as they campaigned for recognition by the Imperial Art Academy, which had hitherto excluded the applied arts from its prestigious national exhibitions (see cats 117–118). Success came in 1927, by which date lacquer wares had reached new heights of creativity and originality.

34

JAPAN

CHEST, 1600–30

Wood, partly ebonised, black, gold and red lacquer,
mother-of-pearl, gilt bronze

25.5 × 49.5 × 33.8 cm

RCIN 39244

PROVENANCE: First recorded at Carlton House
on 22 November 1817

This chest is decorated with *nanban* lacquer, a type developed specifically for the Portuguese Jesuits working in Japan during the sixteenth century and the first type of Japanese lacquer to be exported to Europe. It is distinctive for its black ground, inlaid with mother-of-pearl and decorated with dense designs of plants, flowers and animals. The combination of materials and the richness of the motifs was probably inspired by European taste; it can also be seen on objects produced for Europe in Gujarat on the western coast of India at that time.[1]

At the beginning of the seventeenth century, *nanban*-style coffers were gradually replaced by chests of relatively small size.[2] This chest, fitted with a flat, hinged lid and a drawer in the bottom, represents that shift in production.[3] The most conspicuous elements of the design are the large *mon* (heraldic crests) of sizes rarely seen on lacquerware from this period (see the view of the top of the lid, below left). Prominent are those originally associated with the imperial family (the 16-petalled chrysanthemum), the Toyotomi clan (the paulownia), the Fujiwara clan (the wisteria) and the Nasu family (a fan with a rising sun). A *tomoe* crest and a wood sorrel crest also appear on the lid.[4] Any one of these *mon* was not necessarily unique to one family. They could for instance be bestowed upon loyal subjects, exchanged as signs of respect or adopted through marriage, which is how some families came to have multiple *mon*, used on different occasions.[5]

While *mon* were in later centuries more commonly used as decoration on commercial objects, they were still restricted to familial use at the time this chest was made for export. The chest was therefore possibly commissioned as a gift by a member of an important Japanese family who used these various *mon*, intended for someone possibly connected to the royal family or alternatively for the VOC or EIC. *Nanban* lacquer was certainly held in high esteem in Europe, and is known to have been used for official gifts.[6] ICVB

INVENTORIES: Jutsham Dels & Recs, I, p. 268; Brighton Pavilion 1829A, p. 49; Brighton Pavilion 1847, p. 678; WC '1866', p. 1608r; BP 1911, x, p. 268

LITERATURE: Strange 1927b, pp. 164, 172; Ayers 2016, III, no. 2150, pp. 962–3

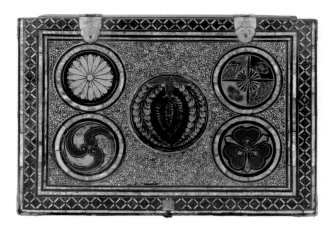

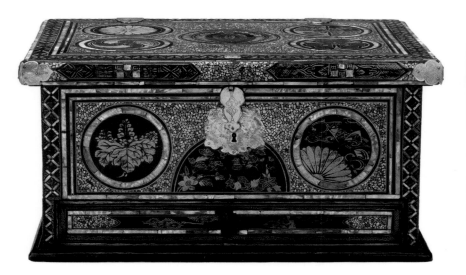

35
JAPAN
CABINET, 1640–90

Wood, black and gold lacquer, gilt bronze
96.5 × 99.5 × 52.0 cm
RCIN 35273
PROVENANCE: First recorded in The King's Gallery
at Kensington Palace in 1816

The design of this cabinet represents a type of Japanese export lacquer popular for its decoration of landscapes with mountains and temples overlooking water. Its shape is adapted from earlier export cabinets with a fall-front concealing drawers of various sizes, cabinets which were probably inspired by Portuguese and Spanish *escritórios* or *bargueños*.[7] European collectors may have been unfamiliar with some of the decorative elements, such as detailed allusions to specific seasons. Here, the animals and plants on the doors and drawers evoke autumn. The geese (*kari*) on the outer doors are about to land after their celebrated migration southwards, signalling the start of the harvest season in the eighth lunar month, which was traditionally known as *kanraigetsu* ('the month of the geese's return'). The ten drawers and the sides of the cabinet are decorated with a combination of the 'seven grasses of autumn' (*aki no nanakusa*) and other autumn-blooming flowers such as the gentian (see the view of the cabinet with its doors open, below right).[8]

This cabinet closely resembles one depicted in an 1816 watercolour of The King's Gallery at Kensington Palace (cat. 40): it may have been acquired by Queen Caroline, consort of George II, who formed a valuable collection of Japanese lacquer.[9] Alternatively, the cabinet could have been placed in The King's Gallery as early as 1695, when William III remodelled the State Apartments following a fire there.[10] ICVB

INVENTORIES: WC '1866', p. 1563

LITERATURE: Pyne 1819, II, pl. facing p. 78; Laking 1905, p. 40, plate 18; H. Roberts 2001, pp. 240–41, no. 711, pp. 246, 257, fig. 315

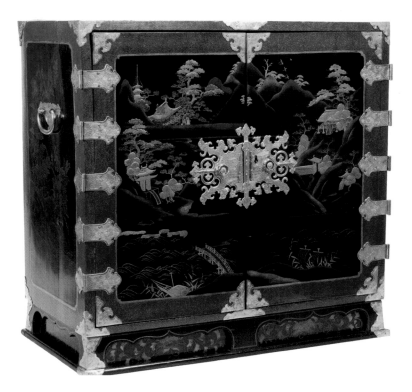

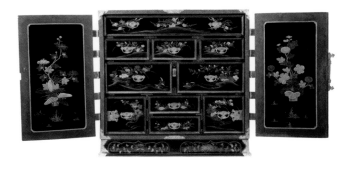

36

JAPAN; PROBABLY THOMAS AND RENÉ
PELLETIER (ACTIVE 1702–12)

CABINET ON STAND, 1640–90 (CABINET);
1704/5 (STAND)

Wood, black and gold lacquer, gilt bronze, gold

88.5 × 101.4 × 53.7 cm (cabinet); 87.5 × 112.5 × 58.5 cm
(stand)

RCINS 35274 (cabinet), 31186.a–b (stand)

PROVENANCE: First recorded at St James's Palace in 1704/5

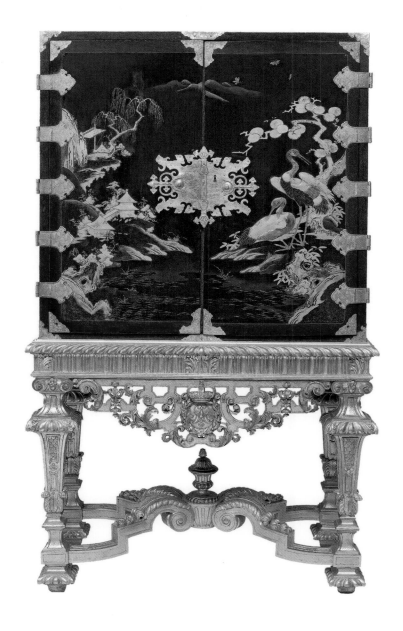

In 1704–5 Gerrit Jensen, cabinetmaker to the Great Wardrobe, was
paid £10 'ffor taking the tops backs and inside of the Doores of
two large Indian Cabinetts, and the Drawers out & making three
shelves and quilting the Inside with crimson Sarsnett.'[11] He was to
use this reclaimed lacquer as tops for two new tables, eventually
acquired by Henry Greville (1779–1853), 3rd Earl of Warwick and
Gentleman of the Bedchamber to George IV, sometime before
1853.[12] The alterations visible on this cabinet are consistent with
the work described in Jensen's bill. The interior drawers have been
replaced by three shelves. The lacquer on top of the cabinet and
the inside of the doors has been removed and seems to correspond
with the measurements of the lacquer on the Warwick tables.[13] Such
alterations were not uncommon at the time; Jensen had cut lacquer
into wall panels for the Japan Closet at Chatsworth House in 1692.[14]

According to Jensen's bill, the cabinets were at St James's Palace,
Queen Anne's principal residence. After her accession, the queen
introduced an ambitious scheme for enlarging and refurbishing
the State Apartments there.[15] The relatively small payment of £10
indicates that Jensen probably did not supply the cabinets, but
re-worked ones already in the queen's collection, either purchased by
her or inherited as part of Mary II's collection. The cabinet is recorded
in a watercolour of the King's Writing Closet at Hampton Court
Palace, c.1819 (Fig. 4.1), placed there possibly by either George I or
George II, who embarked on the completion of Mary II's apartments,
left unfinished after her death in 1694. **ICVB**

INVENTORIES: WC '1866', p. 1563

LITERATURE: Pyne 1819, II, pl. facing p. 58; Laking 1905, p. 41;
Strange 1927a, pp. 96–7; H. Roberts 2001, pp. 240–41, no. 711,
pp. 246, 257, fig. 316; Shawe-Taylor 2014 (exh. cat.), p. 180, no. 96

4.1 (facing) Richard Cattermole
(1795?–1868), *The King's Writing
Closet, Hampton Court* (detail),
c.1819. Watercolour, 20.7 × 26.2 cm,
RCIN 922133

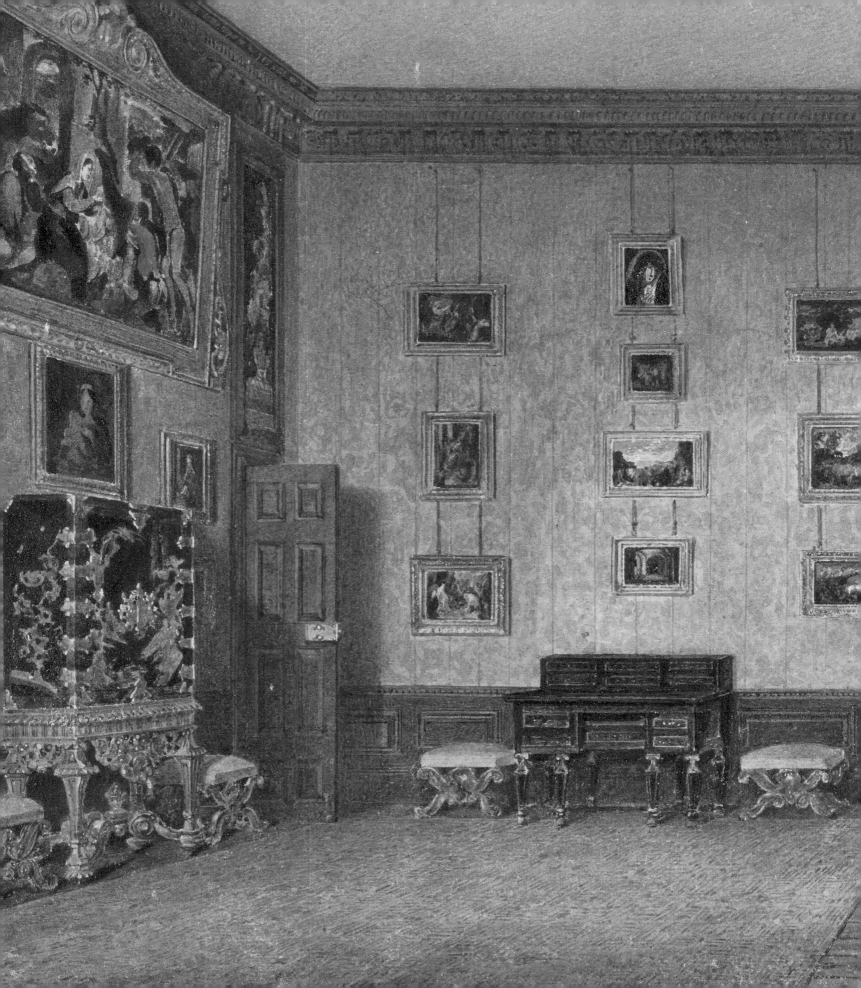

37

JAPAN; ENGLAND

CABINET ON STAND, 1640–90 (CABINET);
1810–18 (STAND)

Wood, black and gold lacquer, gilt bronze, gold

77.3 × 93.5 × 54.2 cm (cabinet);
79.4 × 97.8 × 56.3 cm (stand)

RCINS 21627.2 (cabinet), 90582.2 (stand)

PROVENANCE: First recorded in the Second Drawing
Room at Buckingham House in 1818

4.2 Japan, *Repaired crack on a fan-shaped panel*,
1640–90. Wood, black and gold lacquer, gilt bronze,
77.3 × 93.5 × 54.2 cm, RCIN 21627.1

By 1660, the VOC tended to order Japanese lacquer cabinets in
pairs.[16] This cabinet is one of two decorated with mirror images of
an almost identical design. The fan-shaped panels on the front of
the doors are decorated in high-relief gold lacquer (*takamakie*) with
dragonflies, butterflies, grasshoppers, geese, peacocks, nightingales,
deer, cockerels, bamboo, chrysanthemums and bellflowers. One of
the scenes depicts two lions: a larger one on land and a smaller cub
in the water. This motif refers to a Chinese legend in which a lioness
tosses her cubs off a bridge at Mount Tiantai to test their strength in
the water. Further flowers on the inside of the cabinet possibly refer
to the 'Ten Friends of the Literati', representing the Japanese love
of cultivating and discussing flowers.[17] To the European collector,
however, these scenes probably merely represented the exotic
landscape of a far-off land.

 The cabinets were first recorded in the Royal Collection in 1818,
in a watercolour of the Second Drawing Room at Buckingham
House (cat. 42). Following the transformation of the house into
a palace from the late 1820s, the cabinets were moved to Jeffrey
Wyatville's newly built Grand Corridor at Windsor Castle. This
became the principal space in the castle for the display of great
works of art. George IV's arrangement there included 16 cabinets
and chests decorated with lacquer.[18]

 In 1829, George IV's principal furniture suppliers, Morel &
Seddon, gilded, restored, re-japanned and polished five 'Indian'
cabinets at the castle. This cabinet was probably among them.
Morel & Seddon were paid for 'rejapanning [*sic*] them in a very
superior style with landscapes & other devises'.[19] Such changes are
evident in the lions and a landscape scene on RCIN 21627.1. Two
large mountains in the middle must have been added at a later
date to cover up a large crack down the front of the cabinet door
(Fig. 4.2). ICVB

INVENTORIES: WC '1866', p. 2020, no. 33

LITERATURE: Pyne 1819, II, pl. facing p. 16; Laking 1905, pp. 52–3,
plate 21; H. Roberts 2001, pp. 240–41, no. 711, pp. 247, 257,
fig. 317; Impey and Jörg 2005, pp. 129, 131, fig. 260

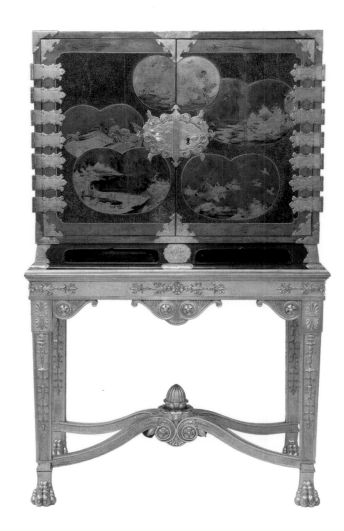

38
JAPAN; ENGLAND

PAIR OF COFFERS ON STANDS, 1700–80
(COFFERS); 1780–1800 (STANDS)

Wood, black and gold lacquer, bronze (formerly gilt)

52.7 × 91.7 × 42.0 cm (coffers); 72.2 × 96.6 × 46.9 cm
(stands)

RCINS 78379.1.a–b (coffers), 78379.2.a–b (stands)

PROVENANCE: Possibly first recorded in The Queen's
Drawing Room at Windsor Castle, *c*.1816

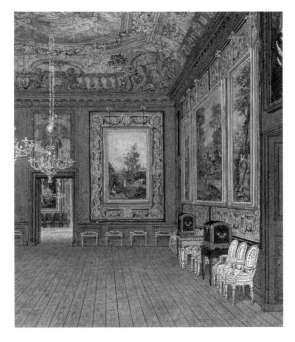

4.3 Charles Wild (1781–1835), *Windsor Castle: The Queen's
Drawing Room* (detail), *c*.1816. Pencil and watercolour with
touches of bodycolour, 20.0 × 25.3 cm, RCIN 922102

By the end of the seventeenth century, the high prices asked by
Japanese lacquerers combined with fierce competition in trade
led the VOC to cease importing lacquered cabinets and chests
from Japan.[20] Eighteenth-century Japanese lacquered furniture
still reached Europe however, mostly through private trade or via
the Chinese, who sold examples to European merchants at other
Asian ports.

These coffers, decorated with bamboo, plum, camellia,
chrysanthemums and *nashiji* borders, resemble examples made in
the seventeenth century.[21] However, they are more likely to date
from the eighteenth century,[22] for their decoration is somewhat
flatter and less detailed, and the lacquer seems to have been more
thinly applied. The contrast between the borders and the black
lacquer has disappeared over time, but is clearly visible on a pair
of coffers in a watercolour of The Queen's Drawing Room at
Windsor Castle of *c*.1816 (Fig. 4.3).[23] It is not possible to say
definitively whether these coffers are the ones depicted there,
but the watercolour does give a good sense of how they might
originally have appeared. Those coffers, on simpler stands with
tapered legs, are likely to have been given to or bought by
Queen Charlotte, consort of George III.

Since at least 1872, the coffers and stands have been part of the
furnishings of Cumberland Lodge (formerly Windsor Lodge), a
house historically occupied by the Ranger of Windsor Great Park.
It is possible they were moved here by Queen Victoria and her
daughter, Princess Helena (1846–1923), when the Princess and her
husband, Prince Christian of Schleswig-Holstein (1831–1917), who
was then Ranger, moved into the reconstructed lodge after a fire
had devastated the interior in November 1869.[24] ICVB

INVENTORIES: Cumberland Lodge 1873, room 10, no. 19, room 23,
no. 25; Cumberland Lodge 1907, Principal Chamber Floor,
rooms 32–33

LITERATURE: Pyne 1819, I, pl. facing p. 106

39

FRANCE; JAPAN

BUREAU À CYLINDRE, 1775–90 (DESK);
1580–1620 (LACQUER)

Wood, black, gold, silver and red lacquer, mother-of pearl,
leather, gilt bronze

110.5 × 95.5 × 55.4 cm

RCIN 31187

PROVENANCE: Purchased by George IV when
Prince of Wales in 1802, £68 5s. 0d.

In the eighteenth century, Japanese export lacquer remained highly luxurious, but the shapes of the old coffers and cabinets incorporating it were considered unfashionable. This led Parisian *marchand-merciers*, sellers of furniture and *objets d'art*, to supply cabinetmakers (*ébénistes*) with old lacquer that could be cut up and incorporated into entirely new pieces of furniture.[25] This French *bureau à cylindre* (roll-top desk) is an example of the practice.

The ebonised oak and mahogany bureau is inlaid with *nanban*-style lacquer of the Momoyama period (1573–1615). Good quality early lacquer like this was rare in the eighteenth century.[26] The lacquer used here probably originally came from the domed lid of a large coffer, like that in Fig. 4.4.[27] This is confirmed by the fact that the underside of the roll-top is decorated with plants which cannot readily be seen in either the open or closed position, but which would have been visible on a coffer when the domed lid was opened. The curve of the coffer lid meant it could be incorporated into the roll-top without the need to steam and bend the fragile lacquer.

Further remnants of lacquer from the original domed coffer can possibly be identified on another bureau, formerly in the collections of the Comtesse du Pont de Gault and latterly Luigi Anton Laura.[28] That desk is of the same shape and size, and has almost identical mounts. Even the japanning on the back of each bureau seems to be by the same hand. The two desks were almost certainly made by the same cabinetmaker, or workshop, at roughly the same time. They may have been ordered as a 'pair', but it is not impossible that the *ébéniste* made a second desk with some of the lacquer that remained after the first one had been made.[29]

Furniture such as this, from important French collections, entered the market after the French Revolution and could be bought by English collectors at heavily reduced prices. This is how George IV, when Prince of Wales, was eventually able to purchase this bureau for Carlton House at Mr Philips's sale in 1802.[30] ICVB

INVENTORIES: Jutsham Dels & Recs I, p. 68; Jutsham Dels III, p. 1;
Brighton Pavilion 1829A, p. 194; Brighton Pavilion 1847, p. 256;
Brighton Pavilion 1847–8, 17 March 1848; WC '1866', p. 1407

LITERATURE: Strange 1927b, pp. 164, 170

4.4 Japan, *Coffer*, c.1600. Wood, black and gold lacquer,
mother-of-pearl, 47.5 × 93.8 × 40.1 cm, Rijksmuseum
Amsterdam, AK-RAK-2009-1

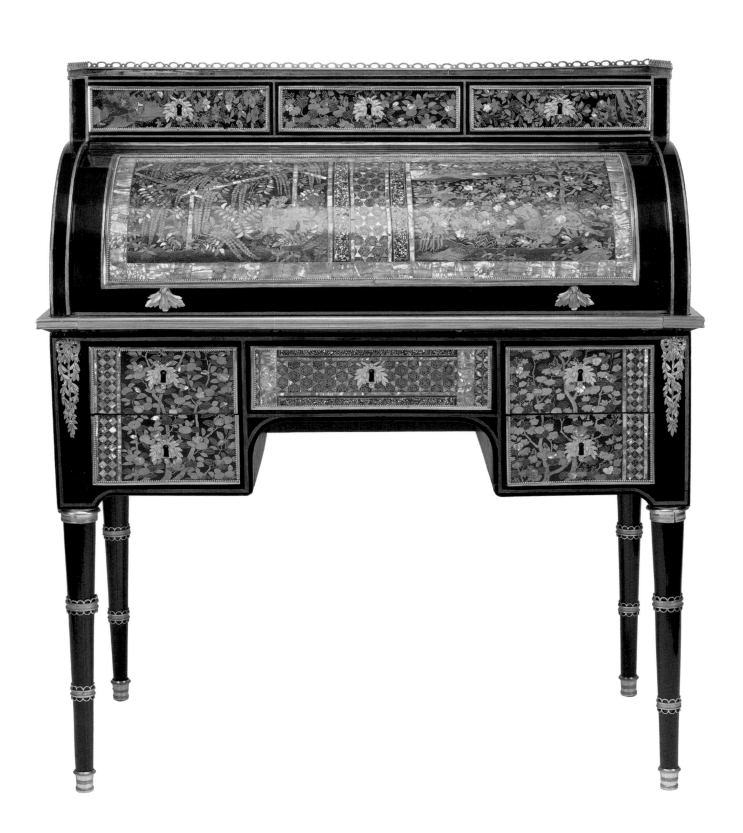

40
CHARLES WILD (1781–1835)
KENSINGTON PALACE: THE KING'S GALLERY,
1816

Watercolour with touches of bodycolour over etched outlines
19.8 × 25.0 cm
RCIN 922158
PROVENANCE: Probably acquired by George IV

The King's Gallery at Kensington Palace was built as a picture gallery
for William III and Mary II in 1695–6. Wild's view shows the changes
made to the interior by William Kent (*c.*1685–1748) for George I
between 1725 and 1727, including a new ceiling, chimneypiece and
doorcases. However, the function of the room remained the same. In
addition to paintings and sculpture, three Japanese lacquer cabinets
(probably dating from the mid-seventeenth century) can clearly be seen
on gilt stands at intervals within the room.[31]

The Japanese cabinets between the windows display groups of
blue-and-white porcelain. Mary II's porcelain collection at Kensington
was given away by William III in 1699, and so the vases depicted in
Wild's view are likely to have been from the period of George II and
Queen Caroline's occupation. After George II's death in 1760, the State
Apartments remained unused, looked after by the Housekeeper, who
maintained the contents and showed around visitors.[32]

Charles Wild was one of a number of artists commissioned by
William Henry Pyne (1769–1843) to depict the interiors of various
royal residences. The watercolours were reproduced as illustrations
for his three-volume *History of the Royal Residences*, published in
parts in 1816–19. The resulting watercolours were probably acquired
by George IV and may have been used as colour guides for the
prints. This watercolour may be an exception, as it was created over
etched outlines. RW

LITERATURE: Pyne 1819, II, *Kensington Palace*, facing p. 78; Watkin 1984,
pp. 72–3; Waterfield 1991 (exh. cat.), no. A2; J. Roberts 2002–3 (exh. cat.),
no. 435, pp. 469–70; J. Roberts 2004 (exh. cat.), no. 103, pp. 110–12

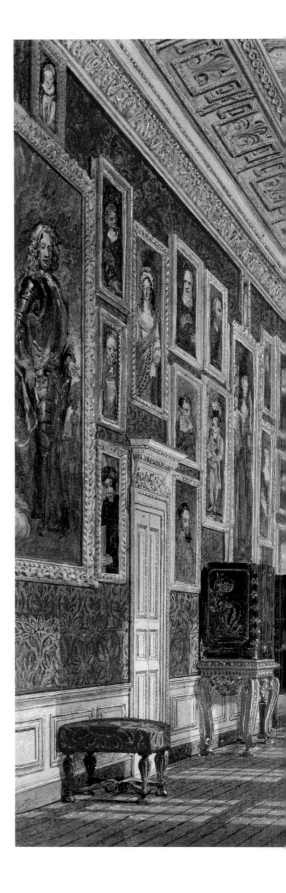

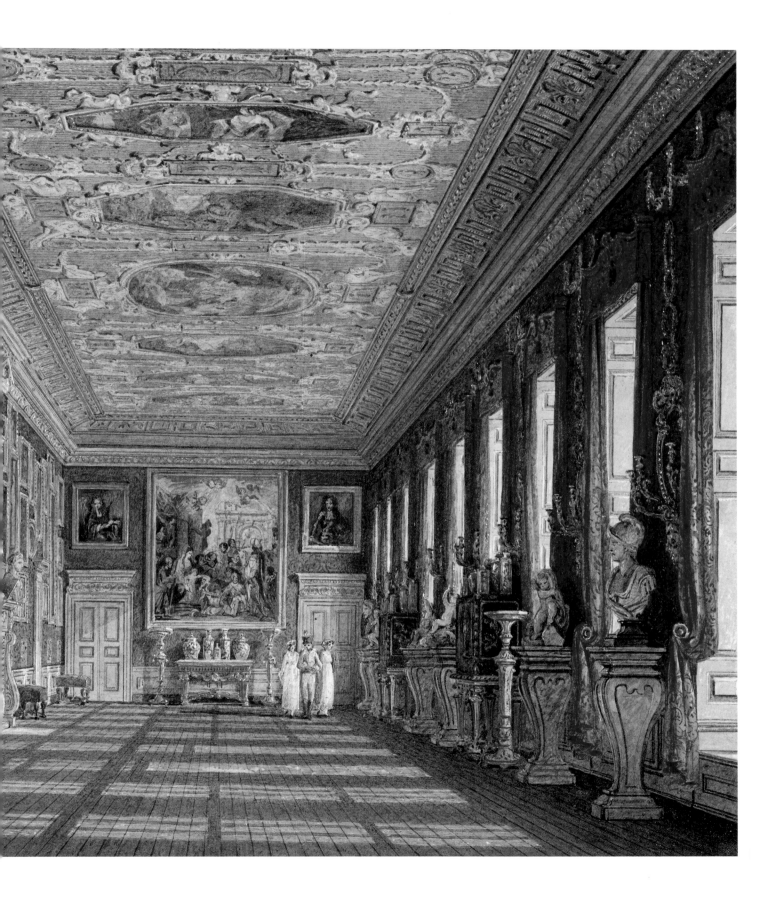

41

CHARLES WILD (1781–1835)
FROGMORE HOUSE: THE GREEN CLOSET,
c.1819

Watercolour and bodycolour over pencil
25.1 × 20.0 cm
RCIN 922123
PROVENANCE: Probably acquired by George IV

Frogmore House, in the grounds of Windsor Castle, was purchased by Queen Charlotte in 1792 to use as a daytime retreat. The Green Closet was a small room at the north-western corner of the house, looking onto the garden. The interior decoration evinced East and South Asia in a comfortable, domestic setting, and included Chinese ceramics and Indian cane chairs. Charles Wild's detailed watercolour of the interior of the closet was reproduced as an engraving by W.J. Bennett in Pyne's *Royal Residences* (see cat. 40) in June 1819, and must have been created before Queen Charlotte's belongings were sold in May of that year, following her death in 1818.

Pyne describes the lacquer in this room as 'original Japan', presumably referring to the four large rectangular panels on the left, built out from the wall, allowing the top to be used as a ledge on which to display porcelain, in addition to the smaller rectangular panels above and on the far wall. The whole is reminiscent of a seventeenth-century 'cabinet', including the way in which the ceramics are displayed.

Against the back wall, the two small cabinets on stands might possibly be lot 117 from the sale of Queen Charlotte's goods by Christie's on 8 May 1819: 'A pair of square cabinets of raised gold Japan, brass bound, with seven drawers in each, on stands.' The large cabinet may be lot 124 on the same day: 'A raised gold Japan bureau and cabinet, fitted up with drawers, pigeon holes, &c. six feet eight inches high.'[33] Such items of furniture may have been made with lacquered panels imported from Japan or China, or have been 'japanned' with an imitation varnish in Britain. RW

LITERATURE: Pyne 1819, I, *Frogmore*, facing p. 21;
Watkin 1984, pp. 92–3

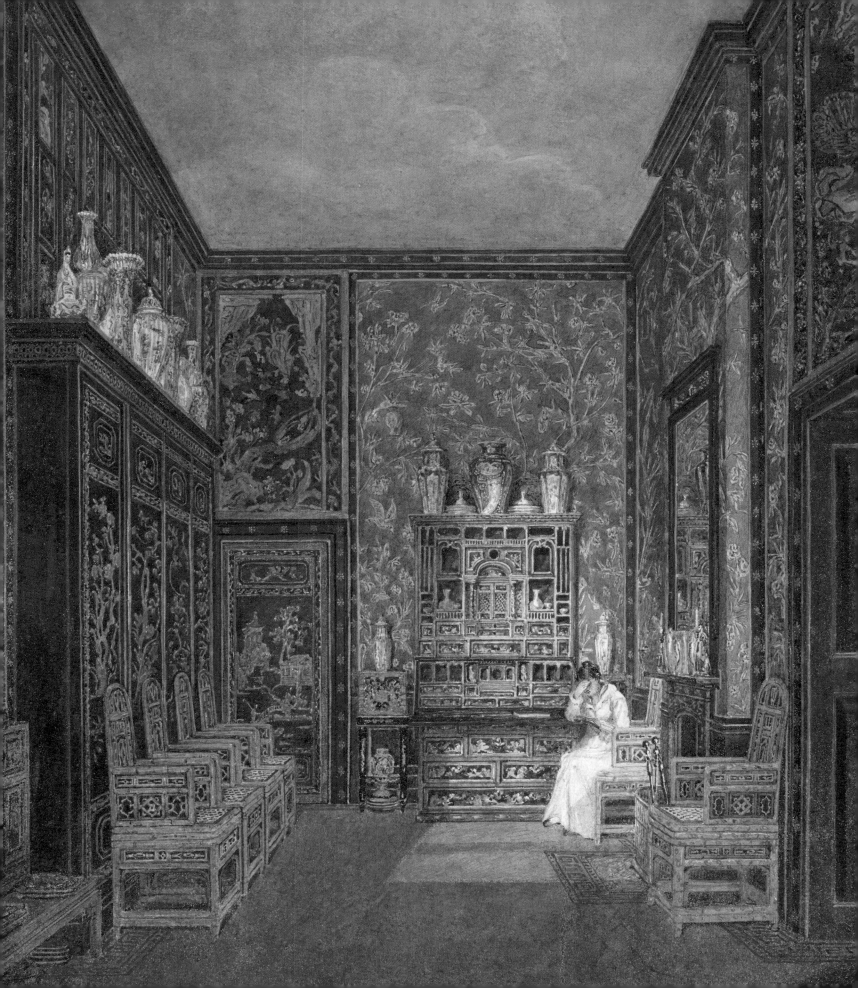

42

JAMES STEPHANOFF (1789–1874)
BUCKINGHAM HOUSE:
THE SECOND DRAWING ROOM,
c.1818

Watercolour and bodycolour over pencil

19.8 × 24.9 cm

RCIN 922143

PROVENANCE: Probably acquired by George IV

Buckingham House was bought by George III in 1761, and became the preferred London residence of the king and his consort, Queen Charlotte. The second drawing room was one of the queen's apartments on the first floor of the west or 'garden front' of the house. However, by the time of this watercolour the building was hardly in use: the king was confined to Windsor, the Prince Regent was based at Carlton House and the queen died at Kew that same year.

Stephanoff's watercolour was created for W.H. Pyne's *History of the Royal Residences* (see cat. 40) and depicts a pair of seventeenth-century Japanese lacquer cabinets, each with gold *takamakie* decoration and distinctive gilt clasp hinges, in pride of place on either side of the chimneypiece; these cabinets remain in the Royal Collection today (RCIN 21627.1, and cat. 37). They were the height of luxury in Britain, and carved gilt stands were made to fit, setting them at a useable height. They were displayed in a room decorated with works by the best artists: the ceiling was painted by Giovanni Battista Cipriani to a design by Sir William Chambers, and the paintings included portraits by Anthony van Dyck, and works by the Italian artists Andrea del Sarto and Carlo Maratta. A painting from 1765 (RCIN 404709) by Johan Zoffany of George, Prince of Wales (later George IV) and Prince Frederick (1763–1827) is also set in the same room, but the lacquer cabinets are not visible at this date, when it was in use as the queen's dressing room. RW

LITERATURE: Pyne 1819, II, *Buckingham House*, facing p. 16; Watkin 1984, p. 83; Jackson-Stops 1993, pp. 50–52; J. Roberts 2004 (exh. cat.), no. 114, pp. 121–2

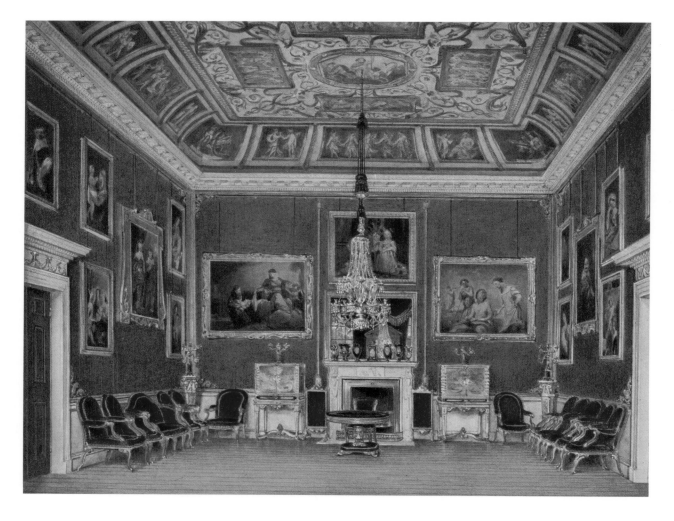

43

JAPAN

PORTABLE SHRINE (ZUSHI),
1700–1800

Wood, black and gold lacquer, gilt bronze

33.0 × 15.5 × 12.5 cm

RCIN 26008

PROVENANCE: Probably acquired by George IV

Buddhism was introduced to Japan from mainland Asia in the sixth century and had a profound impact on all modes of cultural expression, including philosophy, literature and art. During the eighth century, numerous Buddhist temples were built across the country, often on the same sites as Shintō shrines. It was at this time that miniature shrines for private devotion known as *zushi* also began to appear.[34] Their small scale made them portable as well as suitable for domestic use.

Here, a gilt figure of Amida Buddha (*Amitabha*), the great saviour in Mahayana Buddhism and lord of the Western Paradise, sits cross-legged on a lotus throne. His right hand is raised in *abhaya mudra*, signifying reassurance and safety. The plain hinged doors protect the sculpture during travel. Sometimes, the insides of the doors were adorned with polychrome scenes from the Buddhist scriptures or with further Buddhist deities.

This *zushi* may be the 'chinese [*sic*] Deity with Sceptre in a black Japan case folding doors, the inside gilt' which was sent from the Royal Pavilion, Brighton, to Buckingham Palace in June 1848.[35] If so, it is likely that it was acquired by George IV, whose interest in East Asia extended beyond decorative art to the region's customs and traditions more broadly. In 1813, for example, he purchased a print of an 'Indian Idol', and he acquired specimens of Chinese daily life including musical instruments and tobacco.[36] The *zushi* may therefore have appealed as much for its expression of Japanese religious practice as for its aesthetic quality. RP

INVENTORIES: Brighton Pavilion 1829A, p. 52; BP 1911, IX, p. 268

LITERATURE: Ayers 2016, III, no. 2211, p. 1005

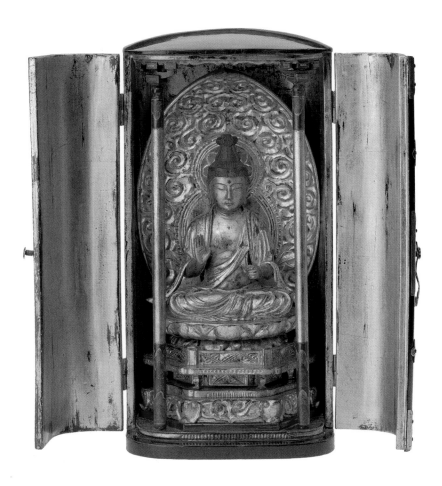

44

JAPAN (LACQUER); EUROPE
(GOLD PAINTED DESIGNS)
DISH, 1700–50

Wood, black and gold lacquer

52.7 × 52.7 × 5.7 cm

Inscribed in the rim of the oval panel on the left:
CHARLES R.I, and in the rim of the oval panel on the right:
H.M.D.F.E.D.C.I.

RCIN 3281

PROVENANCE: Probably purchased by George IV, 15 May 1820

This lacquer dish is of a shape more commonly seen in European pewter, and was probably commissioned through the VOC rather than directly by an English or Scottish patron. Decorated with *CHARLES R.I* (for Charles I) and *H.M.D.F.E.D.C.I.* (for Queen Henrietta Maria), it was almost certainly prepared for a Jacobite sympathiser; Charles II had been in exile in Holland for nine years and the country remained a sanctuary for exiled Jacobites. Comparable examples include those with Dutch coats of arms made for merchants, some of which also combine spouses' arms or monograms.

This dish is probably that in an invoice submitted by George IV's confectioner, François Benois, on 15 May 1820, where it is erroneously described as bearing the royal coat of arms of England.[37] It was certainly at the Royal Pavilion, Brighton when the residence's contents were sent back to London in 1848 following the building's sale by Queen Victoria.[38] Its acquisition reflects George IV's interest in his Stuart predecessors. SG

INVENTORIES: Brighton Pavilion 1829A, p. 52; BP 1911, IX, p. 269

LITERATURE: Clifford Smith 1931, p. 244; Impey and Jörg 2005, pp. 39–40; Ayers 2016, III, no. 2165, pp. 972–3

45
JAPAN
MODEL OF A JUNK, 1750–1800

Wood, black and gold lacquer
38.5 × 52.5 × 14.0 cm
RCIN 26011
PROVENANCE: Probably acquired by George IV

Like many wares destined for the European market, this table caster combines Chinese and Japanese elements. The form is of a Chinese junk. Such vessels were a romantic symbol of East Asia for orientalists in eighteenth-century Europe. By the end of that century, Chinese craftsmen at Canton (Guangzhou) were producing ivory junks with clockwork mechanisms as souvenirs for Europeans based there.[39] Other models arrived in Britain via EIC ships. George IV purchased both ivory and lacquer pieces of this form.[40] His great-uncle, William, Duke of Cumberland (1721–65), had a Chinese-inspired vessel constructed for him, which he moored on Virginia Water, at the southern extremity of Windsor Great Park (Fig. 4.5).

This model functions as a table caster, for the attractive display of condiments at meals. It is decorated around the sides with gold *takamakie* (lacquer in high relief) sprays of peonies, chrysanthemums and camellias. The lower sides of the boat bear a design of two dragons confronting one another over the sea, and the careful placement of the waves suggests that the junk is in the water.

When the table caster was displayed at the Royal Pavilion, Brighton, in 1829 it was described as having 'clock work'.[41] On the flat underside are slots for an axle and two protruding wheels – one of wood, and the other a western metal replacement. The junk was one of a pair, and the two were displayed together in the Lacquer Room at Buckingham Palace in 1930; the second no longer survives.[42] RP

INVENTORIES: Brighton Pavilion 1829A, p. 54
LITERATURE: Clifford Smith 1931, p. 247, fig. 319; Ayers 2016, III, no. 2188, p. 989

4.5 John Haynes (active 1730–53), *A View of the Mandarine Yacht and Belvedere belonging to HRH the Duke of Cumberland at Windsor* (detail), 1753. Etching, 28.7 × 38.7 cm, RCIN 700787

46

JAPAN

TABLE STAND, 1750–1820

Wood, black and gold lacquer

14.4 × 30.2 × 30.2 cm

RCIN 26012

PROVENANCE: Probably acquired by George IV

Murasaki Shikibu (978–1016) is said to have composed her masterpiece of Japanese literature, the *Tale of Genji* (*Genji Monogatari*), at Ishiyama Temple on Lake Biwa. The gold-sprinkled scene on this table stand shows the temple pavilion on its distinctive supporting beams. The lake was a popular subject for later woodblock print artists producing 'Eight views of Ōmi' (now Shiga Prefecture), a series of scenes modelled after the iconic Chinese 'Eight views of the Xiao and Xiang rivers'.[43] Landscape views such as these dominated export lacquer wares from the early seventeenth century onwards.[44]

This table may be the 'black and gold Japan tray with four shaped legs' sent from the Royal Pavilion, Brighton, to Kensington Palace in June 1848. If so, it was probably acquired by George IV. It was later recorded with other Japanese cabinets and stands in the Privy Purse Corridor at Buckingham Palace in 1911. **RP**

INVENTORIES: Brighton Pavilion 1829A, p. 54; BP 1911, IX, p. 270

LITERATURE: Ayers 2016, III, no. 2190, pp. 990–91

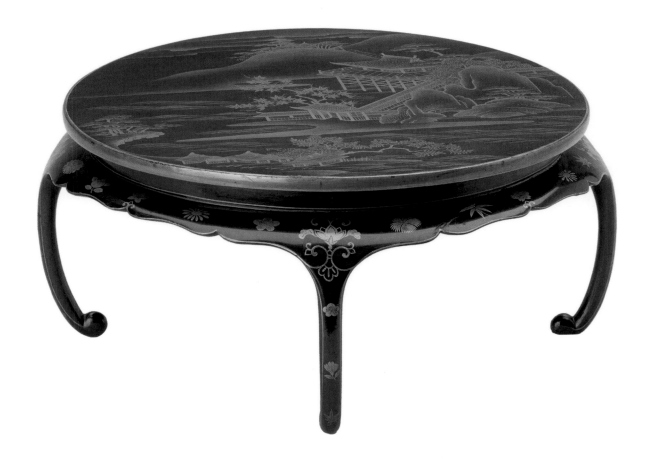

47

JAPAN (LACQUER); FRANCE (MOUNTS)
BOWL AND COVER WITH MOUNTS, 1680–1720
(LACQUER); 1740–1860 (MOUNTS)

Wood, black and gold lacquer, gilt bronze
29.8 × 38.7 × 31.4 cm
RCIN 3152.a–b
PROVENANCE: Probably purchased by George IV
when Prince Regent in 1816

The Chinese had drunk chrysanthemum wine for its health-giving properties since the Han dynasty (206 BC–AD 220), and it is likely that the plant was first imported to Japan for medicinal purposes. Chrysanthemums soon appeared in a variety of decorative arts as symbols of purity and long life. During the reign of Emperor Go-Toba (1180–1239), the 16-petalled chrysanthemum *mon* was adopted as the Japanese imperial crest.[45] In the centuries that followed, the *mon* was awarded to certain individuals for outstanding service or loyalty, and it was not until 1869 that the government reserved the symbol for exclusive use by the imperial household. Its appearance here may indicate that the bowl was originally intended for a wealthy patron, for the lacquer is of a magnificent quality not usually made for export.

The bowl was almost certainly acquired in France from the dealer Rocheux by George IV's agent, François Benois, in November 1816.[46] Originally it would probably have served as a rice bowl, but its lavish European mounts have transformed it into a primarily decorative piece. The mounts themselves are an extraordinary feat of delicacy and vigour, styled in the form of scrolling acanthus leaves whose tips appear to bear the full weight of the bowl. MW & RP

INVENTORIES: Brighton Pavilion 1829A, p. 44; 1829B, p. 1231
LITERATURE: Clifford Smith 1931, p. 192; Harris *et al.* 1968, p. 171; J. Roberts 2002–3 (exh. cat.), no. 311, pp. 350–51; Impey and Jörg 2005, p. 103; Ayers 2016, III, no. 2168, pp. 974–5

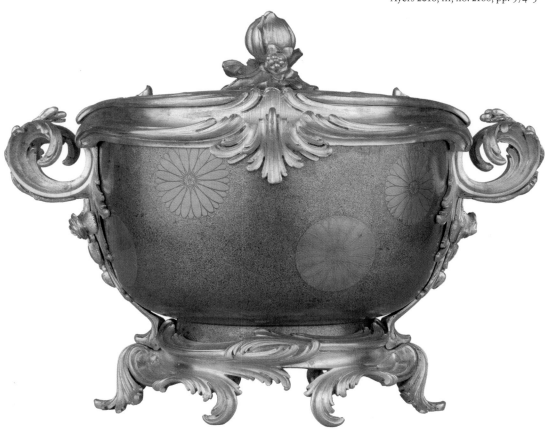

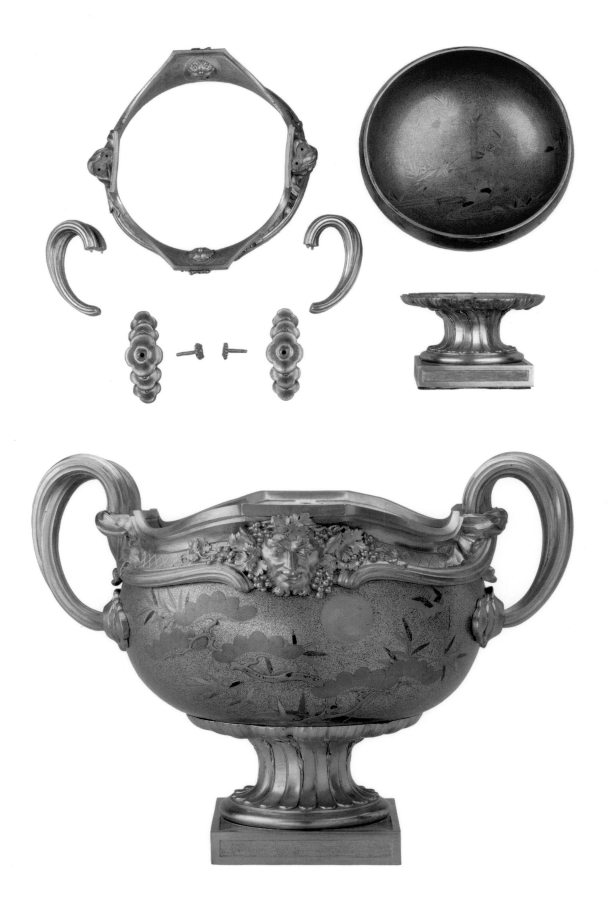

48

JAPAN (LACQUER); FRANCE (MOUNTS)

PAIR OF MOUNTED BOWLS, 1680–1720
(LACQUER); 1750–75 (MOUNTS)

Wood, black and gold lacquer, gilt bronze

31.7 × 39.6 × 38.1 cm (RCIN 3154.1);
29.8 × 39.6 cm × 38.1 cm (RCIN 3154.2)

RCIN 3154.1–2

PROVENANCE: Probably acquired by George IV

RCIN 3154.1

RCIN 3154.2

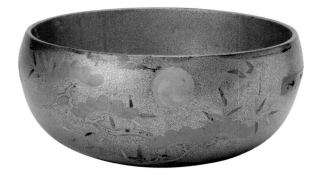

These bowls combine Japanese lacquer and French mounts of equally high quality. Wares of this class were not made for official export, and their arrival in Europe is testament to the largely undocumented private trade which took place among members of the EIC and VOC. One bowl is decorated with designs derived from Buddhist iconography: the lotus is the seat of the meditating Buddha and represents purity and enlightenment amid the swirling mists and swamp.[47] The second bowl is replete with symbols of longevity, including cranes, pine trees and the mythical *minogame* tortoise. The *tomoe* (triple comma) *mon* appears on both sides. This symbol was used to decorate domestic wares and shrine architecture from the Kamakura period (1185–1333) onwards, and was also incorporated in numerous crests, making it difficult to link the bowl to a specific family.[48]

The bowls originally functioned as water basins (*mimidarai*) with wooden handles. Perhaps inspired by Japanese motifs, the French mount designer has incorporated stylised clouds or petals where the new gilt-bronze handles join the bowl. However, the dominant forms are large masks of Bacchus, the Greco-Roman god of fruitfulness, who is associated with wine and ecstatic pleasure. One of Bacchus's personal attributes was a deep two-handled goblet with loop-shaped handles called a *kantharos*: the mounts here are a clear reference to this form, subsuming a Japanese lacquer piece within the classical canon beloved of eighteenth-century Europe.

George IV acquired the mounted bowls before 1826, when they were depicted in the Library at the Royal Pavilion, Brighton.[49] RP

INVENTORIES: Brighton Pavilion 1829A, p. 43; 1829B, p. 61; Brighton Pavilion Clocks and China 1828, p. 95

LITERATURE: Clifford Smith 1931, pp. 191–2; Johnson and Norman 1962–3 (exh. cat.), no. 3; Harris *et al.* 1968, p. 170; J. Roberts 2002–3 (exh. cat.), no. 310, pp. 349–50; Ayers 2016, III, nos 2166–7, pp. 973–4

49, 50

JAPAN

TWO COMBS, 1800–1900

Wood, gold lacquer

5.1 × 11.25 × 0.9 cm (RCIN 29460);
3.7 × 9.5 × 1.5 cm (RCIN 29461)

RCINS 29460, 29461

PROVENANCE: Probably in the Royal Collection by 1911

Lacquered wood combs were produced in Japan as early as the Middle Jōmon period (*c.*2500–1500 BC). By the late Edo period, they had became increasingly ornate and were an essential component of fashionable female dress. These accessories were worn in the hair, often in combination with ornamental hairpins. Their popularity owed much to the revival of tied (as opposed to loose) hairstyles during the Momoyama period (1573–1615), as well as the new appetite for luxury goods spreading from the samurai to the merchant classes. The range of designs and motifs was vast, spanning simple flower sprays to intricate figure scenes. Fine examples were sometimes signed by the artist.[50]

The design on the smaller of these crescent-shaped combs evokes Japan's long coastline. It is decorated with a minute beach scene of two barrels, a package, sea-shells and a fish beside a fishing rod. The cherry blossoms on the larger comb are fair less intricate; the two are unlikely to have been made by the same hand.

Shops such as Liberty's, which opened on Regent Street in London in 1875, began stocking hair ornaments like these as the fashion for Japanese accessories spread across Europe in the second half of the nineteenth century.[51] Three lacquer combs – two of which may be these – were recorded in the Privy Purse Corridor at Buckingham Palace in 1911, where they were stored in a black and gold lacquer box (RCIN 70104.a–b). RP

INVENTORIES: ?BP 1911, IX, p. 270

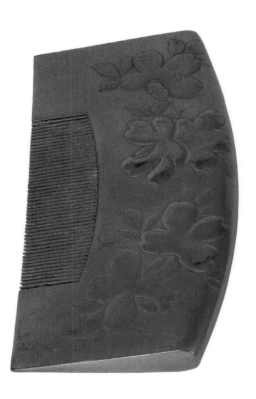
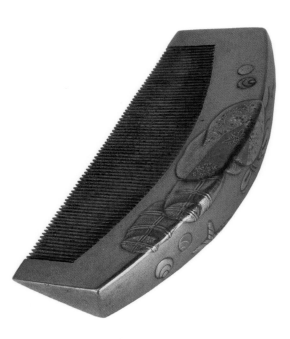

JAPAN

INRŌ WITH NETSUKE, 1800–1900

Wood, black and gold lacquer, amber, silk

8.5 × 5.5 × 2.6 cm (*inrō*); 2.1 × 4.3 × 3.0 cm (netsuke)

RCIN 107127.a–b

PROVENANCE: Presented to Lady Elizabeth Bowes-Lyon by the Marquess and Marchioness of Northampton on the occasion of her marriage to the future King George VI, 1923

This black and gold lacquer *inrō* is the only example of its kind in the Royal Collection. It comprises five stacking compartments and would be worn suspended from the waist sash (*obi*) of a man's kimono using the woven silk cord on either side. The amber sliding bead (*ojime*) joins the two ends of the cord to keep the nested sections together. These fashionable accessories emerged in the late sixteenth century as practical carrying containers for medicine and seals, but they soon provided an opportunity for ostentatious personal expression within Japan's strict sumptuary laws. Lacquer artists in particular favoured this form as an opportunity to showcase strikingly original designs.

This *inrō* is decorated with scenes of a lake surrounded by mountains and pavilions. A boxwood carved netsuke of a rat nibbling a mushroom serves as a toggle, keeping the cord of the suspended *inrō* tucked in place beneath the sash. The rat is the first animal in the twelve-year cycle of the East Asian zodiac calendar (*jūnishi*): this example may have been worn by a man born in that year, or during New Year celebrations.

Numerous *inrō* were sold to collectors in Europe from the late-nineteenth century, when the adoption of western dress made these traditional forms seem outmoded in Japan.[52] Queen Mary collected several *inrō* in the early twentieth century, but all these she seems later to have sold or given away as gifts.[53] The present example is probably the '18th C. Japanese Medicine case' presented to Lady Elizabeth Bowes-Lyon (later Queen Elizabeth The Queen Mother) by the Marquess and Marchioness of Northampton for her wedding in 1923.[54] RP

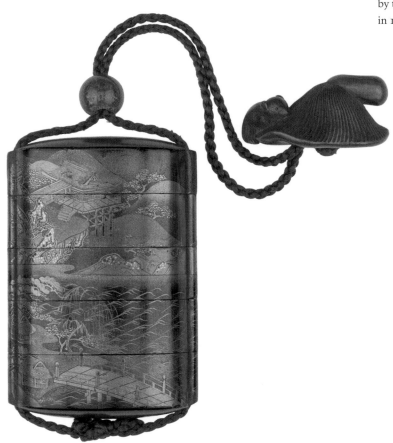

52
KAKYŌSAI SHŌZAN (ACTIVE 1850–65)
CUP FOR SAKÉ (SAKAZUKI), c.1850–65

Wood, red, gold and silver lacquer

56.0 × 56.0 × 13.0 cm

Signed in gold lacquer on the base: 可夾斎松山
('Kakyōsai Shōzan')

RCIN 26154

PROVENANCE: Sent to Queen Victoria by Shimazu Tadayoshi, *daimyō* of Satsuma domain, 1865

The elderly couple on this red lacquer cup represent longevity and conjugal harmony. They are Jō and Uba, who after a long and happy marriage came to dwell in spirit form in two ancient pine trees – one at Takasago in Hyōgo and one at Sumiyoshi in Osaka. According to a *Nō* adaptation of the legend by Zeami Motokiyo (1363–1443), the pair are reunited on moonlit nights at Takasago Beach. Despite their age, they greet one another exuberantly. The meeting was a popular subject among print artists, including Katsushika Hokusai.[55] In this composition, the couple appear in *takamakie* (lacquer in high relief) surrounded by symbols of longevity such as cranes and seaweed-covered tortoises. The figures hold a broom and rake for sweeping the needles of the pine tree, which remains evergreen even in the harshest of winters.

Envoys of Shimazu Tadayoshi of Kagoshima (1840–97) brought this dish to Britain in 1865 'as a sign that … cause for enmity was removed'.[56] Conflict had erupted between the Satsuma domain and British forces two years previously, after the Japanese failed to pay reparations for the murder of an Englishman, Charles Richardson, at Namamugi near Yokohama. According to a note received by Sir Charles B. Phipps, Queen Victoria's unofficial private secretary, 'it was the custom in Japan, when peace was made between persons who had been at enmity and had fought, for the vanquished person to offer a bowl to his adversary'.[57] The cup is an oversize *sakazuki* (cup for *saké*). Queen Victoria was in Coburg for much of the envoys' visit, so the vessel was delivered to the Foreign Office for safekeeping. It was probably presented by Matsuki Kōan (1832–98), who had been taken captive by the British during the 1863 conflict. He subsequently led a group of 15 Satsuma students who travelled illegally to Britain to learn from their recent adversaries.[58] RP

INVENTORIES: Osborne 1876, p. 342; Osborne 1901, p. 204; Osborne 1904, no. 862

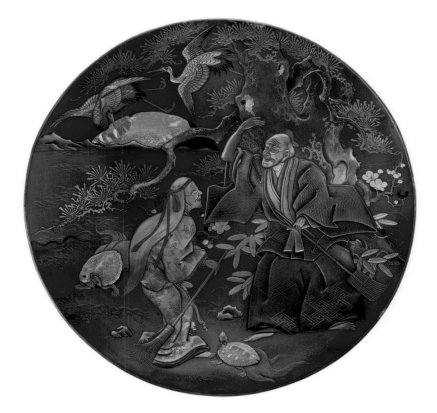

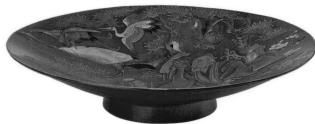

53, 54

JAPAN

CABINET WITH SHELVES (ZUSHIDANA)
AND BOX, c.1850–59

Wood, black and gold lacquer, silver gilt, silver, silk, paper

79.0 × 102.3 × 49.0 cm (cabinet);
9.0 × 44.6 × 16.4 cm (box)

RCINS 10451 (cabinet), 41541.a–f (box)

PROVENANCE: Sent to Queen Victoria by
Shōgun Tokugawa Iemochi, 1860

Furniture as it is known in the West was almost entirely absent from Japanese interiors before the Meiji period. The exception to this rule was the *kazaridana*, an open cabinet with an assortment of asymmetrical cupboards and shelves. Until the late Edo period, these lavishly decorated units were reserved for the very wealthiest families. They were grouped in sets of three, known as *santana* ('three shelves'), for a bride's trousseau. A set comprised a *kurodana* (for cosmetic boxes), a *shodana* (for writing equipment and books) and a *zushidana* (for incense equipment and small boxes). By the sixteenth century, the relative size and arrangement of each of the three units had become standardised.[59]

This lacquer cabinet is a *zushidana*, recognisable for the upward curving ends of the top shelf and two sets of double doors. The contrasting decoration of gold scrollwork and roundels of peonies on black lacquer matches a *kurodana* and *shodana* in the Royal Collection (RCINS 26049 and 26051). They almost certainly correspond to three items received by Queen Victoria from Shōgun Tokugawa Iemochi in 1860 and described by Sir Rutherford Alcock (1809–97), the British Consul-General in Japan, on 27 September 1859, as:

1 Kocladama (a sort of cabinet)	[a *kurodana*, RCIN 26049]
1 Dioesu (a sort of cabinet)	[the present *zushidana*]
1 Siodama (a bookcase)	[a *shodana*, RCIN 26051][60]

The association with Iemochi is strengthened by the fact that smaller boxes from his gift, sent by Queen Victoria to the South Kensington Museum in 1865, bear an identical scrolling foliage design.[61] A co-ordinating dressing case, dispatch case and pair of round incense boxes remain in the Royal Collection.[62] The silk tassels on the matching case shown here have evidently been stored within the box, for their striking red hue has not faded over time. RP

INVENTORIES: Osborne 1876, p. 341 (box); Osborne 1904, p. 149 (box)
LITERATURE: Ayers 2016, III, nos 2206 (box) and 2207 (cabinet), pp. 1000–02

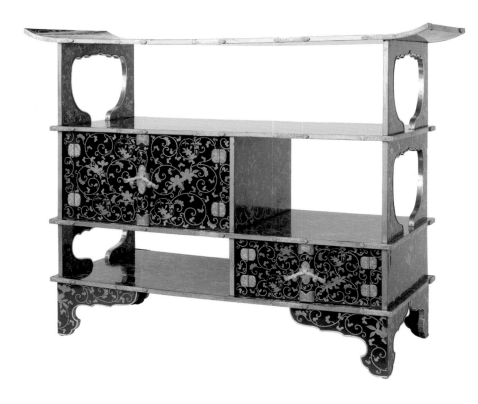

55, 56

JAPAN

CABINET WITH SHELVES (KURODANA)
AND MATCHING BOX WITH COVER,
c.1850–69

Wood, black and gold lacquer

71.0 × 78.0 × 38.0 cm (cabinet);
4.6 × 12.1 × 12.1 cm (box and cover)

RCINS 26050 (cabinet), 29452.a–b (box and cover)

PROVENANCE: Acquired by Prince Alfred,
Duke of Edinburgh in 1869

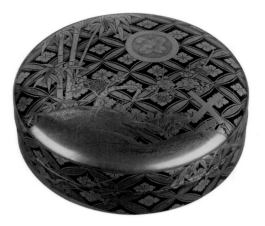

Bamboo is the most prominent motif on this open-sided lacquer cabinet and matching box. The plant appears on almost every surface, rendered in gold *takamakie* (lacquer in high relief), growing among plum trees by rocks. It is an auspicious symbol since it can endure the severest weather. The stalks bend in the wind but do not break, signifying strength and resilience.[63]

The stand is a *kurodana*, designed for the display of cosmetic boxes and personal effects, particularly equipment for tooth blackening (*ōhaguro*), which was a mark of feminine beauty. Originally it would have formed part of a matching set of three shelves known as a *santana* (see cat. 53). *Kurodana* are distinguished from the other cabinets in the arrangement by their open sides, a single compartment on the second level from the bottom, the flat top shelf and slightly smaller size (about 70 cm high).[64] The round box would originally have held a mirror.

In 1872 the box was exhibited at the South Kensington Museum as part of a loan exhibition of objects collected by Prince Alfred, Duke of Edinburgh during his five-year world tour aboard HMS *Galatea*. The cabinet must have been acquired at the same time: it bears the same design, including *mon* of crossed hawks' feathers and crossed timbers, signifying the union of two families in marriage. A matching writing box is also in the Royal Collection (RCIN 29447.a–c). By the mid-nineteenth century, it was not uncommon for *sandana* and their accompanying accessories to be separated and sold or presented separately. RP

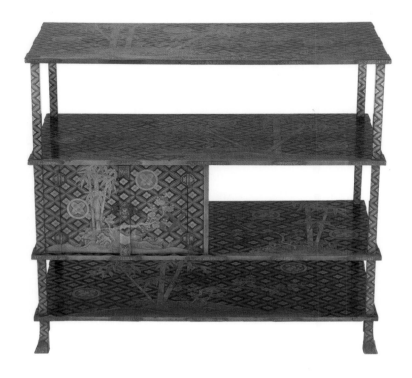

INVENTORIES: BP 1911, IX, p. 267

LITERATURE: South Kensington Museum 1872, no. 553, p. 43;
Ayers 2016, III, no. 2213, pp. 1006–7

57

JAPAN

CABINET WITH SHELVES (SHODANA),
1850–97

Wood, black and gold lacquer, silver fittings inlaid with gold

70.6 × 75.5 × 31.0 cm

RCIN 26044

PROVENANCE: Sent to Queen Victoria by the Emperor Meiji
for her Diamond Jubilee, 1897

The rich decoration on this gold lacquer cabinet evokes the transition
from summer to autumn. Summertime iris, morning glory (*asagao*) and
lilies bloom on the three drawers at the base. They grow by a river which
extends onto the sliding panels and two-door cabinet above, where two
quails stand surrounded by maple leaves and chrysanthemums. The
latter are all associated with September, which is the dominant theme
of the design.

Seasonal imagery of this kind has pervaded Japanese art since
ancient times. Painters and writers have long used the flora and fauna
visible at different months of the year as models of natural beauty, but
also as philosophical and emotional cues. Depicting multiple seasons
in a single scene, as here, evokes both Buddhist and Shintō ideas about
the transience of nature and its cyclical rhythm.

This *shodana*, a suitably splendid imperial gift, was a present from
the Emperor Meiji (1852–1912) for Queen Victoria's Diamond Jubilee in
1897. It was exhibited in the North Gallery at the Imperial Institute in
1897–8 alongside other Jubilee gifts, including an embroidered screen
also sent by the emperor (cat. 136). Both items attracted favourable
comment. *The Morning Post* judged them 'extremely artistic' and
noted that the cabinet was 'delicately constructed'.[65] By 1901, it was
displayed in the New Wing (Durbar Corridor) at Osborne House on
the Isle of Wight. This seaside retreat, one of Queen Victoria's favourite
residences, seems to have been her preferred location for displaying
East and South Asian works of art. RP

INVENTORIES: Jubilee 1897, no. 32; Osborne 1901, p. 362;
Osborne 1904, p. 253; BP 1911, X, p. 267

LITERATURE: Imperial Institute 1897, no. 37, p. 10;
Ayers 2016, III, no. 2208, pp. 1002–3

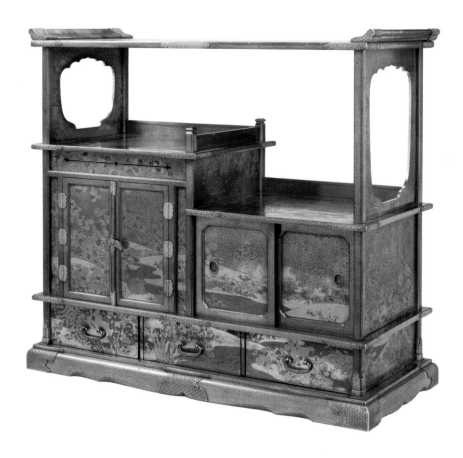

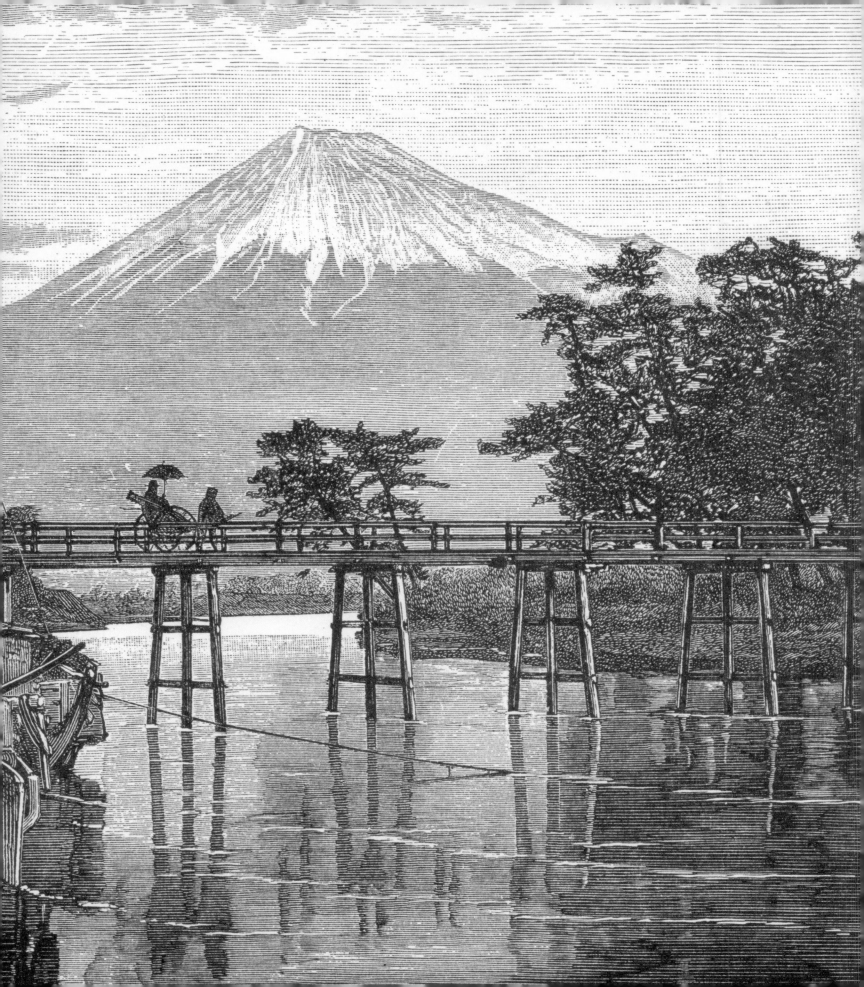

日本の芸術

5

TRAVEL

CONTACT IN PERSON

1854–1901

RACHEL PEAT

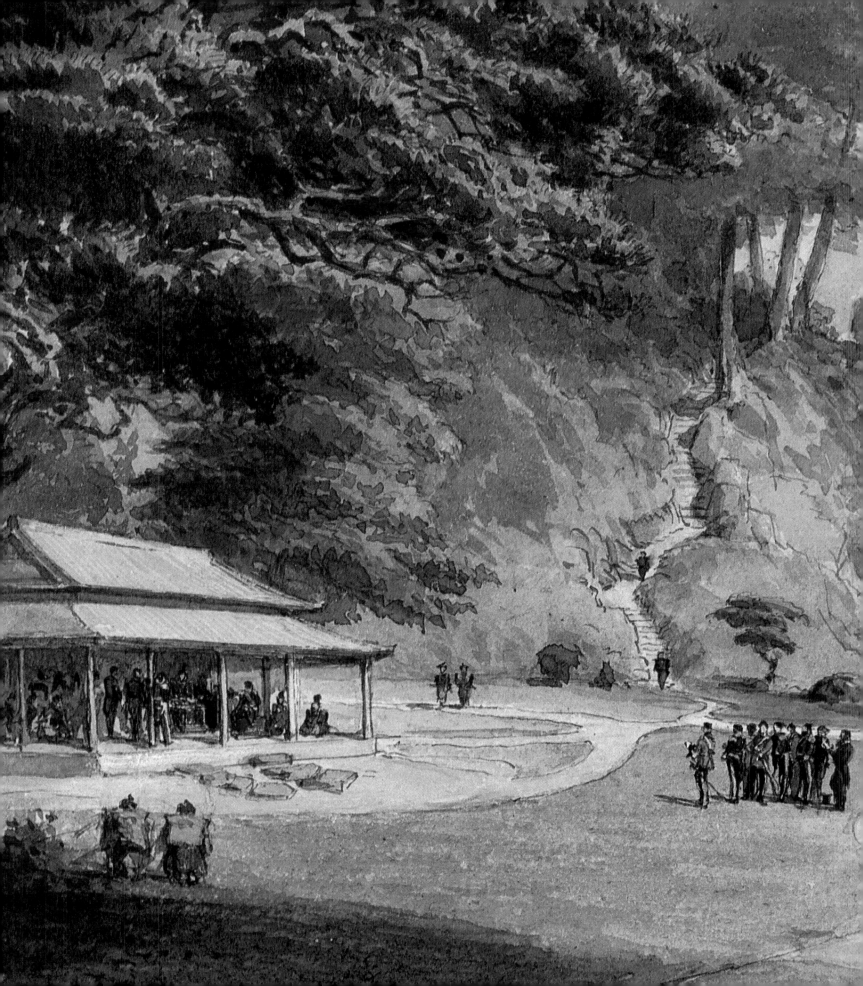

*It would be perfectly impossible for me to describe [Edo]
or indeed any other town in Japan in a letter, it is so
utterly different from anything I have seen before, so
I must wait till I get home & explain it all to you with
the pictures & photos which I have collected.*

Letter from Prince Alfred, Duke of Edinburgh
to Queen Victoria, 3 October 1869 [1]

I N August 1869, Queen Victoria's second son,
Prince Alfred, Duke of Edinburgh (1844–1900)
became the first foreign royal visitor to Japan. His
arrival at Yokohama, south of Tokyo, signalled
a new era of direct princely contact between
Japan and Britain. The visit was possible thanks
to the country's dramatic 'reopening' to the West
15 years previously. Now, royals, ambassadors,
artisans and tourists could travel between the
two countries, fostering diplomatic and artistic exchange at
all levels of society. The result was a growing understanding
and appreciation of Japanese decorative art in Europe, and
the first royal accounts of a country hitherto imagined and
mythologised.

REOPENING TO THE WEST

Japan's formal reopening to the West in the 1850s was triggered
in part by foreign gunboat diplomacy. In 1853, the American
Commodore Matthew C. Perry (1794–1858) arrived in Edo
Bay with a squadron of ships demanding establishment of
commercial and diplomatic relations with the United States.

5.1 Nicholas Chevalier (1828–1902), *The Mikado's Palace Gardens,
Yedo* [Tokyo] (detail), 1869. Watercolour, 20.0 × 13.4 cm, Museum
of New Zealand, Te Papa Tongarewa, 1975-0001-6

His successful negotiation of the Treaty of Kanagawa in
1854 prompted the British, Dutch, Russians and French to
follow suit. In 1858, these powers signed treaties that opened
Japanese ports to trade, fixed low customs duties and gave
extraterritoriality to foreign residents. The agreements became
known as the 'unequal treaties', resented by the Tokugawa
elites, who lacked the military means to refuse them.

The British had in fact begun discussions with the Japanese
as early as 1854, dispatching Admiral Sir James Stirling
(1791–1865) to ensure Tokugawa neutrality during the Crimean
War (1853–6). Stirling secured an Anglo-Japanese Friendship
Treaty, which allowed British ships to stop at Nagasaki and
Hakodate for repairs, but failed to include any formal trade
agreements, to the chagrin of his superiors at home. However,
he received from Perry two Japanese Chins (spaniels) for
Queen Victoria, and advised that she send the shōgun a steam
yacht to promote 'friendly relations with his Government'. [2]
The shipbuilders R. & H. Green of Blackwall duly produced
the yacht *Emperor*, modelled on the queen's own, with 60 h.p.
engines. [3] The yacht's delivery to Japan by Lord Elgin (1811–63)
in 1858 gave opportunity for negotiation of a Treaty of Amity
and Commerce which secured the gradual opening of seven
ports and cities to British trade: Edo (Tokyo), Osaka, Kanagawa
(Yokohama), Hakodate, Nagasaki, Hyōgo (Kōbe) and Niigata.
Crucially, the agreement allowed a British diplomat to reside at
Edo for the first time. [4]

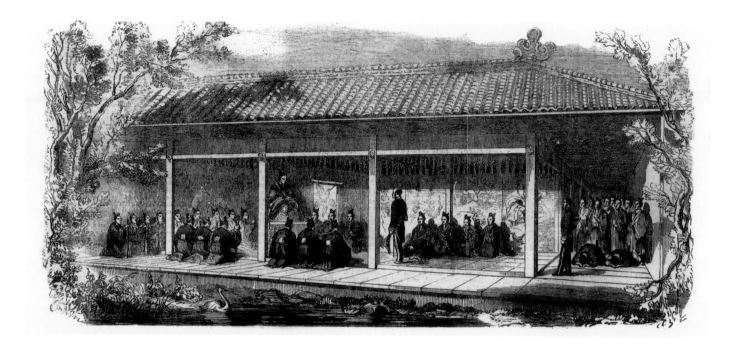

5.2 Unknown artist, *First Audience of a British Minister with the Tycoon of Japan at Yeddo*, 1860. Photolithograph, *Illustrated London News*, 15 December 1860

The new Consul-General, Rutherford Alcock, arrived in Japan in June 1860. On 25 August he was granted an audience with Tokugawa Iemochi – the first British minister to be received by the shōgun (Fig. 5.2). In the autumn, he reported that a group of presents from Iemochi were ready to be sent to the queen. The gifts included an armour, *saké* bottles (cat. 29), spears (*yari*, cat. 83), swords (cats 91 and 95) and eight pairs of gilded screens (*byōbu*, cat. 135).[5] The costly assortment was the first documented diplomatic gift from Japan to Britain in almost 250 years.

The arrival of Iemochi's gift and other specimens of craftsmanship paved the way for new awareness of Japanese art in Britain. Small numbers of Japanese wares had been displayed at the 1851 Great Exhibition and the 1857 Manchester *Art Treasures of the United Kingdom* exhibition – including a 'suit of armour in lacquered ware' lent from Windsor by Queen Victoria[6] – but in 1862 an unprecedented 600 items were supplied by Alcock for the London International Exhibition. Alcock's collection, which included paintings, lacquerware and bronzes, brought Japanese art to the attention of the British

public for the first time (Fig. 5.3).[7] Other goods were sent by merchants in Yokohama.

The fact that this assortment did not reflect the best or oldest Japanese manufacture seems to have gone unnoticed by all but the visiting Japanese embassy, the 'Takenouchi Mission', who were in Europe to request postponement of the opening of Japanese ports (cats 58–60). In their eyes, the Japanese exhibits were 'odds and ends that looked exactly like a junk shop'.[8] Nevertheless, public enthusiasm for the goods prompted British manufacturers like Elkington, Minton and the Royal Worcester Company to mimic Japanese motifs such as fans, birds and bamboo in their designs.[9] In this period the South Kensington Museum also started seriously expanding its Japanese collection, assisted in 1865 by a gift from Queen Victoria of lacquerware, horse trappings, swords, porcelain, blinds and screens.[10] Many of the items donated by the queen

5.3 Unknown artist, *The International Exhibition of 1862 – Japanese Court*, 1862. Photolithograph, *Illustrated London News*, 20 September 1862

were from the 1860 Iemochi gift, but others cannot firmly be linked to it and may have already entered the Royal Collection by other means.[11]

On 4 December 1867, Queen Victoria received Shōgun Tokugawa Yoshinobu's 14-year-old half-brother, Tokugawa Akitake (1853–1910), at Windsor Castle – her first documented encounter with a Japanese person (Fig. 5.4). Akitake wore samurai dress, which the queen described as 'a long petticoat, belt & sword, & sandals', and presented gifts of a lacquer cabinet and table, an earthenware teapot and a ball of rock crystal.[12] Earlier that year, Akitake had led the Japanese delegation at the Paris *Exposition Universelle*, the first time Japan had participated officially in an international exhibition. There, displays were mounted not only by the Tokugawa government but also by the disaffected Satsuma and Hizen domains. These exhibitions provided ample opportunity for Japanese producers to expand into new markets – though international customers of this period still often romanticised Japan as immutable and mysterious, its crafts unchanged since ancient times.[13]

The early years of diplomatic engagement between Japan and Britain were not without conflict. The Tokugawa *bakufu* (military government) viewed treaties with western powers as the best response to an overwhelming foreign threat, but the Imperial Court in Kyoto considered their signing a gross overstretch of shogunal authority. Emperor Kōmei (1831–67) roundly condemned foreign intrusion onto Japanese soil, calling for the 'expulsion of the barbarians'.[14] Small-scale attacks on Europeans took place throughout the 1860s, aimed at embarrassing the *bakufu* and intimidating westerners. In 1861, the British Legation at Edo was attacked by anti-foreign Japanese, who wounded the First Secretary, Laurence Oliphant (1829–88), and sought to assassinate Alcock. Then, in 1862, Satsuma samurai killed a British merchant named Charles Richardson at Namamugi near Yokohama for failing to show adequate respect to Shimazu Hisamitsu, the father of the local *daimyō* (feudal lord). When the Satsuma domain failed to pay the reparations demanded by the British Government, British and Japanese forces exchanged fire at the port-town of Kagoshima the following August. While Queen Victoria agreed to 'measures of reprisal', she expressed doubts about demanding an indemnity, 'which the Government of Japan may have no power to enforce'.[15] For a moment, Japanese-British relations teetered on the brink of war.[16] Nevertheless,

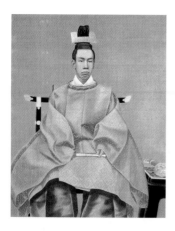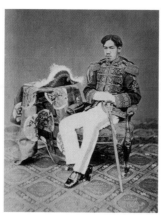

5.5 (left) Goseda Hōryū, *The Emperor Meiji*, 1873. Ink and colour on silk, 127.0 × 85.2 cm, Meiji Jingū, Tokyo

5.6 (right) Uchida Kuichi, *The Emperor Meiji*, 1873. Hand-tinted albumen print, 25.7 × 20.8 cm, Kanagawa Prefectural Museum of Cultural History. These portraits, produced in the same year, are clear signs of Japan's changing orientation. The right-hand image, with its European-style dress and pose, was intended specifically for presentation to foreign monarchs

the Satsuma powers capitulated, later sending gifts to the queen in token of friendship (cats 52 and 98).

Within Japan, the conflict was far from over. In January 1868, the discredited *bakufu* was formally overthrown in favour of a return to direct imperial rule: the Meiji Restoration. Under the Emperor Meiji (1852–1912), the new regime sought to modernise rapidly to achieve parity with foreign powers, eschewing Japan's feudal past and adopting military, political and economic reform along western lines (Figs 5.5 and 5.6). In 1871, the 262 existing domains were replaced by 72 prefectures, and in 1876 the samurai class was abolished. Government officials were dispatched to Europe to request revision of the unequal treaties and to study all aspects of western industry, policy and culture. One delegation, led by Iwakura Tomomi (1825–83), was received by Queen Victoria at Windsor Castle on 5 December 1872.[17] At home, the emperor once again entered public life and wielded de facto power, rather than delegating to the shōgun.

In April 1868, the new British minister, Sir Harry Parkes (1828–85), was invited to the Imperial Palace in Kyoto. Parkes and his interpreter, A.B. Mitford (1837–1916), were received by the 15-year-old Emperor Meiji 'dressed in a white coat with long padded trousers of crimson silk', his eyebrows 'shaved off and painted in high up on the forehead … his lips painted with red and gold'.[18] 'We were standing', recalled Mitford, 'in the presence of a sovereign whose ancestors for centuries had been to their people demigods'.[19] It was possibly the first time a foreigner had seen the emperor's face.[20]

THE FIRST BRITISH ROYAL VISITS TO JAPAN

Prince Alfred, Duke of Edinburgh was the first foreign royal visitor to Japan (Fig. 5.7). The 25-year-old prince was on the second leg of a world tour as captain of the frigate HMS *Galatea* when he arrived at Yokohama on 29 August 1869. The political situation seemed unclear. As recently as June, fierce fighting between Tokugawa loyalists and Meiji forces had taken place on the northernmost island of Ezo (Hokkaidō), and news of these events reached Britain just as the prince's visit was under way.[21] The trip was nevertheless a resounding success. The young prince landed in state on 31 August and proceeded to his guesthouse in Tokyo,[22] the appropriately named *Enryōkan* ('building to welcome people from afar'). He found his accommodation prepared 'in half European, half Japanese style' with lacquer tables, hanging scrolls and bamboo mats intermingled with furniture of western form.[23] Over the next four weeks, the prince enjoyed an array of cultural demonstrations including sumo wrestling, swordplay and acrobatics. There was also ample opportunity to buy works of art. The prince paid £80 for two swords 'made by an extinct artist' and invested $800 [*sic*] in bronzes following an excursion to Tokyo's popular tourist thoroughfare, 'Curio Street'.[24]

The central moment of the prince's visit was his meeting with the Emperor Meiji on 4 September. Travelling by carriage, the prince was borne to the Imperial Palace through streets

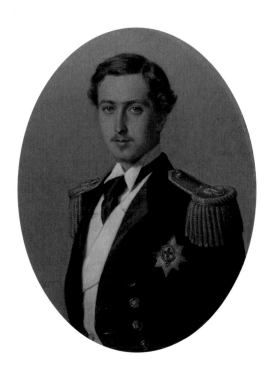

5.8 Nicholas Chevalier (1828–1902), *Blind Musicians Performing at the Imperial Palace*, 1873. Oil on canvas, 61.3 × 91.5 cm, State Art Collection, Art Gallery of Western Australia

5.7 Franz Xaver Winterhalter (1805–73), *Prince Alfred*, 1865. Oil on canvas, 74.4 × 61.4 cm, RCIN 404833

crowded with spectators. Mirroring a custom usually reserved for the emperor, the shutters of the upstairs buildings were papered over so that no member of the public could dishonour the visitor by looking down on him en route. 'As the Duke's carriage went by', Mitford recalled, 'the people who thronged the road and streets fell prostrate, touching the earth with their foreheads.'[25] At the palace an official reception took place in the audience chamber; afterwards, the emperor invited the prince to meet with him more privately in the gardens. Tea and 'all manner of delicacies' were served in the Maple Tea House before the pair retired to the nearby Waterfall Pavilion to talk (Fig. 5.1).[26] The prince gave the Emperor Meiji a diamond-encrusted snuff box. No doubt knowing that the emperor was an accomplished poet, he requested an autograph copy of one of his compositions for Queen Victoria. The Emperor Meiji consented, and later sent the prince an appropriately diplomatic *tanka* written on gold-sprinkled paper:

'If one governs the land / And benefits the people / Heaven and earth / Will surely last together / For all eternity.'[27] The prince left Japan on 26 September, reflecting that he had been received 'with the greatest civility and attention'.[28]

Prince Alfred amassed a handsome collection of art during his visit to Japan, and after his return to Britain in 1871 it was exhibited widely with other souvenirs from his five-year world tour. At his suggestion, a loan exhibition of some 700 decorative objects, paintings and hunting trophies opened in the North Court of the South Kensington Museum on 24 January 1872. Among the 73 Japanese works of art were lacquer writing boxes, netsuke, *tantō* (daggers), books of paintings, bronzes and porcelain. Highlights included a complete samurai armour (cat. 71) and a silk screen delicately painted with a procession of grasshoppers.[29] Nearby were five screens of paintings by the artist Nicholas Chevalier (1828–1902), who accompanied the prince for part of his voyage and captured scenes in Japan of sumo wrestlers, Mount Fuji and a performance by blind musicians (Fig. 5.8).[30]

The two-month South Kensington exhibition received 30,000 visitors in its first week and attracted praise from *The Graphic* for its 'unrivalled' exhibits.[31] A reviewer for *The Architect* noted

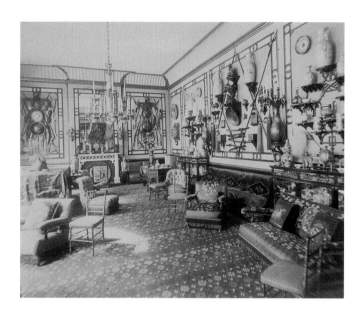

5.9 Horatio Nelson King (1828–1905), *The Indian Room, Clarence House* (detail), *c.*1870–80. Albumen print, 22.5 × 27.7 cm, RCIN 2102090. Prince Alfred's Japanese collection can be seen on the right-hand wall

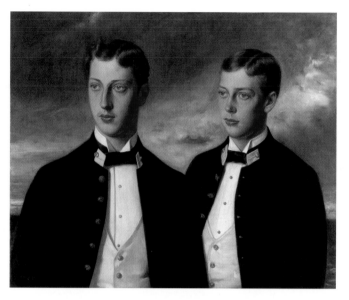

5.10 Carl Rudolph Sohn (1845–1908), *Prince Albert Victor of Wales and Prince George of Wales*, 1882. Oil on canvas, 72.8 × 88.0 cm, RCIN 402311. This double portrait was probably painted to celebrate the young sailors' return from their voyage aboard HMS *Bacchante*

the high quality of the Japanese crafts in particular, including 'rich specimens' of cloisonné enamel and 'choice' examples of lacquerware.[32] Portions from the loan exhibition were later displayed at the Crystal Palace at Sydenham (1872), in Dublin (1872) and in Glasgow (1881–2). While in Scotland, the designer and Japanophile Christopher Dresser (1834–1904) used the exhibits to illustrate a lecture on Japanese art. The prince's collection eventually came to rest at his London residence, Clarence House, where *wakizashi* and lacquer boxes were deposited in the 'Indian Room' alongside South Asian mail and Chinese porcelain (Fig. 5.9).[33] By this date, the prince had gained a reputation as a 'most distinguished collector and patron of Japanese art'.[34]

The next British royal visitors to Japan were Princes Albert Victor (1864–92) and George of Wales, who arrived there in 1881 (Fig. 5.10). The teenage princes were serving as midshipmen aboard HMS *Bacchante* when they 'steamed up Yedo [Edo] bay in the grey of early dawn' on 21 October.[35]

Granted five days' leave ashore, they went in full uniform to meet the Emperor Meiji and Empress Shōken (1849–1914) on 25 October. They informed the imperial couple that Queen Victoria was sending her portrait 'in token of friendship'.[36] As the interview concluded, Prince Albert Victor expressed his solemn hope that their stay would 'draw closer the tie of friendly feeling that already united the two countries'.[37] The following day, the princes dined at the Imperial Palace, where they noted a 48-piece Minton dessert service commissioned by the Imperial Household Ministry in 1875 – an 'almost exact facsimile' of that made for their parents in 1863, with the addition of the imperial chrysanthemum crest.[38] On 27 October, the emperor visited the princes at their accommodation bearing gifts of four 'beautiful bronze vases, each three feet high' and rolls of silk brocade.[39]

Their remaining time in Japan included rickshaw rides, acrobatics demonstrations and a foray into the sport of duck-netting. The official diary of the tour (cat. 66) and a more

5.11 Prince George of Wales (1865–1936) and Kubota Beisen (1852–1906), *Hanging scroll with fireflies*, 5 November 1881. Ink and colour on paper, 193.0 × 76.0 cm, British Museum, BM 2011,3032.1

5.12 Unknown photographer, *Prince Albert Victor of Wales and Prince George of Wales with group on the steps of the Enryōkan, Tokyo*, 29 October 1881. Albumen print, 16.3 × 20.0 cm, RCIN 2580966. Seated in the centre is Prince Higashi-Fushimi (later known as Prince Komatsu Akihito), who had travelled to England in 1871 to study

private album of photographs (cat. 67) compiled by their chaperon and tutor, John Dalton (1839–1931), paint a vivid picture of their busy schedule. At one dinner, Prince George was invited to pepper a hanging scroll with blotches of ink in any arrangement he chose; the painter Kubota Beisen (1852–1906) then transformed them 'with most marvellous skill' into a picture of fireflies (Fig. 5.11). Both princes were also tattooed on their arms, Albert Victor with 'a couple of storks' and George with a dragon and a tiger.[40]

Shops and markets catering for tourists had sprung up in great numbers in Yokohama, Tokyo and Kyoto since the 1860s, offering a bewildering range of souvenirs made from lacquer, ivory, bronze or silk, often of dubious antiquity. Like many European visitors to Japan at this time, the boys were enthusiastic shoppers for 'curios'. A typical entry in Prince George's diary reads: 'we went to the bazaar & bought a few small things for Mama & sisters'. Their purchases included netsuke and bronzes.[41] A metal teapot and pair of cups purchased for the princes' father, Albert Edward, Prince of

Wales (1841–1910, later King Edward VII), may also have been acquired in this way (cats 103–104). When the princes returned home, Japanese souvenirs were among the 'photographs & all sorts of things' which they showed their grandmother Queen Victoria aboard the *Bacchante* (Fig. 5.12).[42]

NEW ARTISTIC EXCHANGE AND RECOGNITION

By the late nineteenth century, increased travel and artistic exchange had given rise to a new fashion in Europe for *japonisme* – Japanese aesthetics and styles derived from them. The large-scale import of woodblock prints, and wares such as kimono and fans, inspired a generation of artists and designers in France and Britain. Painters like James McNeill Whistler, Claude Monet and Edgar Degas began to incorporate elements of Japanese art in their work, including its stylisation, vivid palettes and flattened perspective. Christopher Dresser travelled to Japan in 1876–7, and his subsequent book, *Japan, Its Architecture, Art and Art Manufactures* (1882), also helped generate a vogue for the Japanese style. As a result, restrained forms and natural motifs began to appear in European decorative arts such as metalwork (cats 123–124). The ever-fashionable Prince and Princess of Wales (later King Edward VII and Queen Alexandra) filled their rooms at Marlborough House in London and Sandringham House in Norfolk with cloisonné enamel trays, bronze figures and *saké* cups.[43]

At the same time, more frivolous representations of Japanese art and life were entering popular culture. A reconstructed 'Japanese Village' which opened at Knightsbridge in January 1885 offered Londoners the chance to observe almost 100 Japanese men and women in traditional costume, lacquering, painting and dancing (Fig. 5.13). Visitors could take tea in the specially constructed teahouse, buy fans at the sales counter or get a tattoo.[44] In March the same year, theatrical partners W.S. Gilbert and Arthur Sullivan staged their comic opera, *The Mikado*, which followed the fictional romantic exploits of the emperor's son. Queen Victoria thought the story 'rather silly' when it was performed at Balmoral in 1891, but enjoyed

5.13 Unknown artist, *Making cloisonné enamel*, 1885. Photolithograph, *Illustrated London News*, 21 February 1885

the 'witty remarks' and 'Japanese dresses'.[45] Other members of the royal family embraced the vogue for appropriating Japanese costume for photographs and fancy dress balls (cat. 68).

The last British royal visitor to reach Japan in the nineteenth century was Queen Victoria's third son, Prince Arthur, Duke of Connaught (1850–1942). In the spring of 1890 he made an unofficial visit with his wife, Princess Louise Margaret (1860–1917), following the end of his tenure as Lieutenant-Governor of Bombay. The trip inspired a deep love for Japan and its art which would remain with them for the rest of their lives. Both avid sightseers, the royal couple eschewed the imperial carriages offered them and instead explored the country in rickshaws, covering so much ground that Mary Fraser, wife of the British minister, thought the duchess had 'managed to

see more in her short visit than hundreds of people who have stayed months and years in the country'.[46] Their expeditions included visits to Nagasaki, Kōbe and Nikkō.

The royal couple also attended the Third National Exhibition for the Encouragement of Industry at Tokyo, one of five trade fairs (*Naikoku Kangyō Hakurankai*) organised by the Meiji regime between 1877 and 1901 to promote domestic arts and manufacture. There, the duke bought 'two splendid vases' for Queen Victoria.[47] Throughout the trip he filled his diary with pressed flowers, menu cards and hand-coloured photographs, writing home that he was 'delighted' with all he saw (cat. 69).[48] Embroideries, kimono and other souvenirs were also added to their luggage. 'Both he and the Duchess have spent so much on curios in both Tokyo and Kyoto', remarked Fraser, 'that their visit will long be remembered'.[49] Shortly after their return to England, these purchases took centre stage in a *tableau vivant* (living picture) performed by the duke and his family for Queen Victoria at Osborne House (cat. 70).

Though the visit had been an unofficial one, the duke and duchess dined with the emperor and empress at the Imperial Palace in Tokyo on 7 May. They ate in a handsome dining room, 'beautifully lit' and hung with silk embroideries. 'Both of them asked us a good deal about our travels in Japan & what we thought of the country', the duke recalled.[50] The following day, Prince Komatsu Akihito (1846–1903) called on the duke and duchess to bestow on them, on behalf of the emperor, the badges and stars of the Orders of the Chrysanthemum and of the Precious Crown respectively (see cats 152–153).[51]

CONCLUSION

By the end of Queen Victoria's reign, a sea change was under way in Japanese-British relations. In 1894, a Treaty of Commerce and Navigation at last replaced the unequal treaty of 1858 so resented by the Japanese. Founded on 'principles of equity and mutual benefit', the new agreement abolished extraterritoriality for the British and prevented unequal duties being imposed on Japanese goods.[52] The following year, Japanese victory in the Sino-Japanese War impressed on European powers the country's

growing military power.[53] Changes in the British perception of Japan were clear at royal events in this period. During Queen Victoria's Golden Jubilee celebrations in 1887, the Japanese representative, Prince Komatsu, had felt snubbed by the British: delays meant his carriage could not join the main procession and he was received by the queen 'in quick succession' with the minor powers of Siam, Persia and Hawaii.[54] By contrast, for the Diamond Jubilee in 1897, Prince Arisugawa Takehito (1862–1913) was accorded the same treatment as European royalty and entertained to an exclusive lunch with the queen two days after the State Dinner (cats 57 and 137).[55]

By the start of the twentieth century, royal relations between Britain and Japan had moved from the impersonal to the personal. Reciprocal princely visits gave both human face and royal gravitas to the new diplomatic channels which evolved in this period. Central to these trips were not only experiences of Japanese art and craftmanship but also the exchange of official gifts, which helped cement cordial relations. Always of the highest quality, fine specimens of armour, porcelain and lacquer were considered by both parties 'fit presents from a prince to a prince'.[56] These early encounters had a tangible impact on British royal artistic taste, expressed in the gifts they exchanged at home and the way they furnished their residences. In the decades that followed, this royal relationship became a crucial symbol of the partnership between East and West.

58
P. BIEGNER & CO. (ACTIVE 1860s)
TACHI KŌSAKU (1845–79), 1862

Albumen *carte-de-visite*

8.8 × 5.5 cm

Photographer's credentials printed on mount, inscribed in ink, on verso: *Tatsi-ko-saku*

RCIN 2915301

PROVENANCE: Probably acquired by Queen Alexandra when Princess of Wales

59
MELTZER (ACTIVE 1860s)
KAWASAKI DŌMIN (1831–81), 1862

Albumen *carte-de-visite*

9.0 × 5.5 cm

Photographer's credentials printed on mount, inscribed in pencil, on verso: *Kawasaki*

RCIN 2915302

PROVENANCE: Probably acquired by Queen Alexandra when Princess of Wales

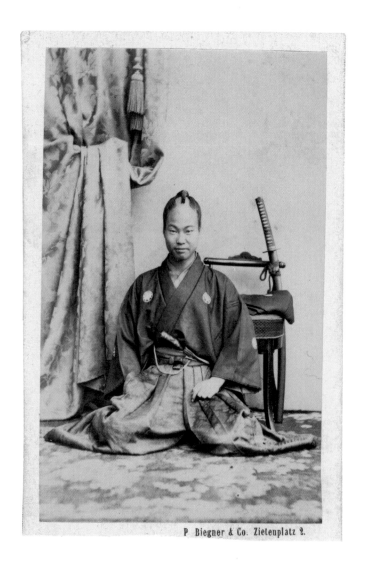

P. Biegner & Co. Zietenplatz 2.

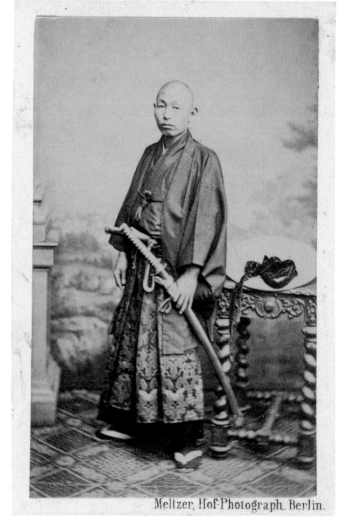

Meltzer, Hof-Photograph. Berlin.

60

LEONIDA CALDESI & CO. (ACTIVE 1860s)
GROUP OF JAPANESE AMBASSADORS:
KAWASAKI DŌMIN (1831–81), SAITŌ DAINOSHIN
(1822–71), OKAZAKI TŌZAEMON (1837–?),
ŌTA GENZABURŌ (1835–95), 1862

Albumen *carte-de-visite*

8.8 × 5.7 cm

Photographer's credentials printed on mount

RCIN 2914637

PROVENANCE: Possibly presented to
Queen Victoria, after 1862

LITERATURE: Dobson and Isherwood 1998
(exh. cat.), plate 44, p. 35

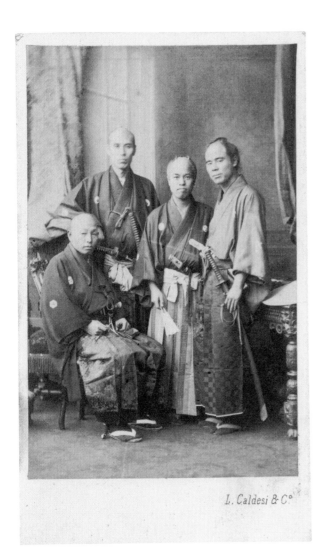

L. Caldesi & Cº

In 1862, when the Takenouchi delegation arrived in Europe to renegotiate treaties between Japan and five European countries, the *carte-de-visite* industry was reaching its zenith; it has been suggested that up to 105 million British *cartes* were commissioned that year alone.[57] Patented in 1854 by the French photographer André Adolphe Eugène Disdéri (1819–89), the *carte* consisted of a photographic portrait roughly 6.0 × 9.0 cm pasted on a piece of marginally larger board.[58] The success of Disdéri's invention is largely attributed to the fact that up to eight different portraits could be taken using a single negative plate, making the entire process cheaper, quicker and easier to control.[59] Initially, middle- and upper-class individuals would share their *cartes* on the basis of acquaintance, but the format soon became central to a mass trade that made images of well-known public figures available for purchase.

Such was the demand for celebrity *cartes* that photographers would often photograph popular actors, artists and politicians free of charge in return for permission to distribute their image.[60] It is not clear whether the Japanese ambassadors exploited this photographic fad to increase their visibility and influence, or whether the photographers used *cartes* of the ambassadors to enhance their own repertoire. Whatever the case, a number of senior members of the mission visited leading photographic houses in Paris, London, Amsterdam and Berlin to have their portraits taken.[61] Their sittings resulted in numerous *cartes* that spread throughout Europe, three examples of which survive in the Royal Collection.

These *cartes* are typical of the genre in depicting full-length figures, framed by sumptuous furniture and fabrics, against a painted backdrop. Apart from one kneeling samurai (cat. 58), the diplomats adopted formulaic western poses (cats 59 and 60), presumably as directed by the photographer. In spite of this overt regularity, their samurai dress clashes with the ostentatiously decorated Victorian studio, capturing the tension between Japanese and western visual culture at the time.

The Takenouchi mission, and three subsequent Japanese embassies to Europe in 1864, 1865 and 1867, met with limited diplomatic success. Indeed, the final one, dispatched to the Paris *Exposition Universelle*, was rendered ineffective by the announcement that the government it represented had been overthrown and its power shifted to the emperor.[62] Despite the failure of the shōgun's ambassadors fully to achieve their objectives, the reproduction and circulation of their *cartes-de-visite* at a time when the *cartes* craze was at its peak was important in consolidating the West's burgeoning interest in samurai manners and codes of honour. For the first time, the general public could scrutinise photographs of samurai, propelling this relatively inaccessible warrior class – soon to become obsolete – to celebrity status. AK

PRINCE ALFRED, DUKE OF EDINBURGH
(1844–1900)
LETTER TO QUEEN VICTORIA (1819–1901),
EDO [TOKYO], 3 SEPTEMBER 1869

Manuscript
18.0 × 11.5 cm (each page)
RA VIC/ADDA20/1294

Queen Victoria's second son, Prince Alfred, became the first foreign royal visitor to Japan when he arrived at Yokohama on 29 August 1869. The prince sent only four short letters to his mother describing his four-week stay, and he asked her to excuse his brevity since he had not had 'a minute to call my own'.[63] In this note, written shortly after his arrival, he describes his first impressions of the country: 'To give you any account of this country, I feel quite at a loss. Every thing is so new & so quaint that I am quite bewildered.'

Though the prince was an experienced sailor, Japan was different from anything he had yet encountered. Having travelled by road to Tokyo, he found his accommodation at the *Enryōkan* a mixture of European furniture and 'walls painted "a la Japonaise"'. Heavy rain had prevented any real sightseeing thus far, but his anticipation at meeting the Emperor Meiji is tangible: 'Tomorrow I go to be presented to the Mikado [emperor] who has only very recently been allowed to see a soul but his personal attendants.' No account of the meeting in the prince's own words survives, but he later sent Queen Victoria a sketch of the interview – most likely by the Swiss-Russian artist Nicholas Chevalier, who accompanied him for part of the voyage and later produced a watercolour of the scene.[64] RP

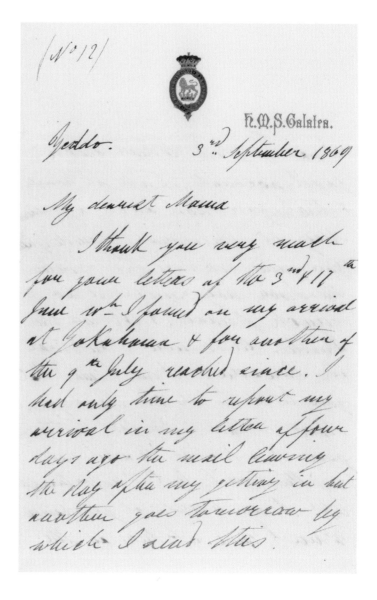

PRINCE ALFRED, DUKE OF EDINBURGH
(1844–1900)

LETTER TO QUEEN VICTORIA (1819–1901),
PEIKO [HAI HE] RIVER, CHINA,
3 OCTOBER 1869

Manuscript

18.0 × 11.5 cm (each page)

RA VIC/ADDA20/1296

Shortly after his departure from Japan on 26 September, Prince Alfred wrote again to his mother to describe his stay. He was evidently impressed by the hospitality shown him, for he concludes that 'the Japanese Govt … rec^d me with the greatest civility and attention'. The newly established Meiji regime had gone to considerable lengths to accommodate their guest and bore the full cost of his visit.[65] Crucially, the emperor had departed from precedent by receiving the prince as an equal – a move which reflected European ideas about the equality of sovereigns, rather than long-cherished Japanese beliefs about the exalted status of their imperial family.

The young traveller does not ruminate here on the political significance of the visit. More prominent in his mind is the 'charming little palace' in which he stayed, the demonstrations of juggling and sport, and Japan's natural beauty. The prince declares the scenery in the Inland Sea 'most beautiful', while 'Nagasaki is the most picturesque town in Japan that I have seen … a splendid harbour surrounded by high hills'. In common with many early European visitors to Japan, he found his experience difficult to articulate, reinforcing a sense of the country's mysteriousness. 'It would be perfectly impossible for me to describe Yeddo [Edo] or indeed any other town in Japan in a letter, it is so utterly different from anything I have seen before'. He promises on his return home to 'explain it all to you with the pictures & photos which I have collected'. These photographs do not appear to survive. RP

ALGERNON BERTRAM MITFORD,
1ST BARON REDESDALE (1837–1916)
TALES OF OLD JAPAN, 1871, 2 VOLS

London: Macmillan & Co.
20.8 × 14.0 × 3.0 cm (vol. I, closed);
20.8 × 14.1 × 2.9 cm (vol. II, closed)
Bookplate of Queen Victoria inside front boards
RCINS 1085239, 1085198
PROVENANCE: Acquired by Queen Victoria, 11 July 1871

A.B. Mitford served as an interpreter at the British Legation in Japan between 1866 and 1870, including for the watershed visit of Prince Alfred, Duke of Edinburgh in 1869. In the early years of his posting, civil war between the Tokugawa shogunate and supporters of the emperor posed a significant threat to foreigners on Japanese soil. Confined to Kyoto for his own safety for five months from November 1867, Mitford spent his leisure time mastering the Japanese language and collecting 'a quantity of legends of Old Japan which throw an entirely new light upon the manners and customs which have astonished travellers so much'.[66]

Published in 1871, his two-volume *Tales of Old Japan* provided the first glimpse for many Britons of Japanese life beyond official government accounts. The work is remarkable for its inclusion of folk tales and accounts of particular Japanese customs, some of which Mitford had witnessed, most notably marriage ceremonies, the ritual suicide *seppuku* and the forging of swords, illustrated here. Heavily edited to appeal to western audiences, Mitford's *Tales* provided his readers with a romantic view of 'Old Japan', a remote country yet to be affected by modernisation. AB

64
FREDERICK VICTOR DICKINS (1838–1915)
CHIUSHINGURA, OR THE LOYAL LEAGUE: A JAPANESE ROMANCE, 1880

London: Allen & Co., new edition

25.2 × 15.7 × 2.5 cm (closed)

RCIN 1085226

PROVENANCE: Acquired by Queen Victoria,
14 February 1887

Frederick Dickins, a member of the Royal College of Surgeons, first travelled to Japan in 1862 with the ships HMS *Euryalus* and HMS *Coromandel*. Arriving in 1863, he transferred to a post as naval surgeon at Yokohama. He remained in Japan until 1867, acquiring a knowledge of the language and a lifelong interest in Japanese culture. This prompted him to translate several pieces of Japanese literature into English and to make important advances in the study of Japanese arts, including writing one of the first scholarly works on the artist Katsushika Hokusai. Dickins returned to Japan in 1871 to practise law at the consular courts, staying another seven years until ill health forced him back to England.[67]

In 1880, Dickins published a new edition of his translation of *Chūshingura* ('The Treasury of Loyal Retainers'), a play based on the tale of the 47 *rōnin*. The story focuses on the Akō Incident of 1701–3, in which 47 *rōnin* (masterless samurai) sought to avenge the death of their leader. To avoid the censors, who forbade any depiction of recent history in the arts, the playwright Takeda Izumo (1691–1756) and his two associates had changed the timings of the events, placing them in the mid-fourteenth rather than the early eighteenth century. The play's themes of bravery and unerring loyalty made it one of the most popular stories in Japan, and it remains so to the present day.[68]

The story was first published in English in Mitford's *Tales of Old Japan* in 1871 (see cat. 63). This edition, purportedly transcribed from a Japanese source to 'supply the *lacunae* to Mr Mitford's version', is notable for the addition of fashionable *aizuri-e*, blue-coloured woodblock prints 'drawn and executed by Japanese artists, and printed on Japanese paper'. **AB**

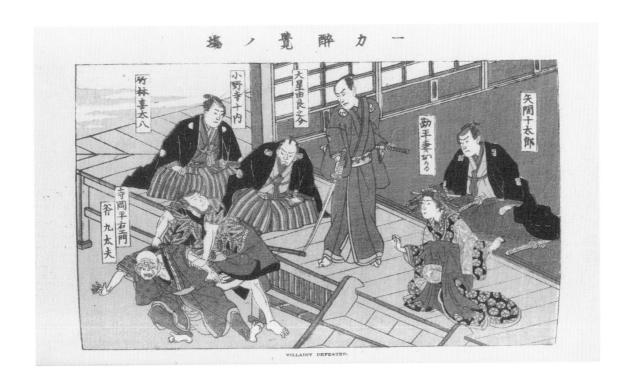

VILLAINY DEFEATED.

KING GEORGE V (1865–1936)
DIARY, 20 OCTOBER–12 NOVEMBER 1881

Manuscript
19.5 × 13.0 × 5.0 cm (closed)
RA GV/PRIV/GVD/1881

Prince George of Wales (later King George V) visited Japan with his brother Prince Albert Victor in autumn 1881. 'It is a beautiful night, a dead calm & you can see [Mount Fuji] quite plain', he wrote from their mooring at Yokohama on 22 October. The pair, aged 16 and 17 respectively, were serving as midshipmen aboard HMS *Bacchante* supervised by their tutor, the Reverend John Dalton. Prince George had begun his diary on 3 May 1880 and he kept it without intermission until 17 January 1936, three days before his death. The portion written aboard the *Bacchante* reflects both the monotony of naval training and the unique opportunities afforded to princes visiting distant shores.

The prince's narrative is sparse, and he is circumspect when describing unfamiliar aspects of Japanese culture. On 28 October he writes vaguely that they 'drove to a place where there were some more temples' and later watched 'some Japanese dancing'. Nevertheless, he clearly relished the history and beauty of the country. On 8 November he describes 'some beautiful suits of armour' they had seen in Kyoto, 'one of which I tried on[;] it fitted exactly'. On 10 November, at Nara, they visited 'a museum of some beautiful old things made in the year 750 AD'. The prince enjoyed the novelty of rickshaw rides and eating with chopsticks. He was 'very sorry' to leave Tokyo, 'as I have spent a very pleasant time' (29 October). Similarly, after their stay in Nara and Kyoto, 'we saw a great deal in the time, but we were not long enough, it was too hurried' (12 November). RP

66

JOHN NEALE DALTON (1839–1931)

THE CRUISE OF HER MAJESTY'S SHIP
"BACCHANTE", 1879–1882, COMPILED FROM
THE PRIVATE JOURNALS, LETTERS AND
NOTE-BOOKS OF PRINCE ALBERT VICTOR
AND PRINCE GEORGE OF WALES WITH
ADDITIONS BY JOHN N. DALTON, VOL. II:
THE EAST, 1886

London: Macmillan & Co.

22.9 × 15.7 × 7.0 cm (closed)

Bookplate of Queen Mary when Duchess of York inside
front board

RCIN 1191274

PROVENANCE: Presented to Queen Mary by King George V
when they were Duke and Duchess of York, 1 January 1895

During their three years aboard HMS *Bacchante*, Dalton encouraged
Prince Albert Victor and Prince George to keep journals 'written up
every evening before turning in, both at sea and ashore'. These diaries
purportedly formed the basis of the published accounts of the voyage,
which appeared in 1886. Despite Dalton's assertion in the introduction
that the words in the two volumes were entirely the princes' own, the
long passages alluding to classical literature and excerpts from history
imply that Dalton heavily edited the work.[69] Both volumes contain
several illustrations and plates, such as this of Mount Fuji, after
photographs collected throughout the voyage (see cat. 67).

Like much travel literature of the period, the narrative of the princes'
time in Japan combines anecdotes of 'exotic' customs with comparisons
to familiar British scenes, presenting a romantic yet instantly recognisable
version of the country to the reading public. On a hill outside Tokyo,
for instance, the princes sit in tea-sheds admiring the 'magnificent view'
and drinking cherry blossom tea from small cups without handles. The
landscape, however, 'is most carefully cultivated, just like a garden in
England'. Later, when visiting the temples at Nara, the gardens remind
them 'of the quieter corners of Greenwich Park' – yet the deer found
here are sacred, 'fed from the hand with rice balls' and are said to be
descended 'from one of the old Shinto gods'. AB

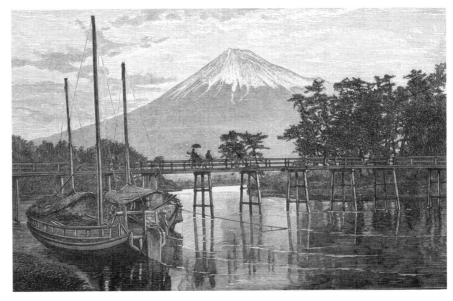

67

FELICE BEATO (c.1834–1907),
BARON RAIMUND VON STILLFRIED (1839–1911),
UCHIDA KUICHI (c.1844–75) AND OTHERS
THE CRUISE OF HMS BACCHANTE: 1879–1882.
VOL. V: JAPAN, c.1881

Leather-bound photograph album containing
219 albumen prints

47.5 × 34.5 × 7.0 cm (closed)

RCINS 2580920 (album), 2580972–5, 2580980–83
(photographs shown)

PROVENANCE: Probably presented to King George V
by John Neale Dalton

Following Prince Albert Victor and Prince George's world tour
aboard HMS *Bacchante*, a series of nine albums was compiled with
photographs that their tutor, John Dalton, had collected during the trip.
The fifth volume is devoted to a single country: Japan.

By far the majority of the images in these albums are topographical
views and architectural studies, loosely arranged according to the
group's itinerary. Sparsely pasted among these are photographs of
artefacts, local people and public figures, as well as portraits of the
princes taken during the tour. The bottom right image shown here
captures Prince Albert Victor at Nishi Hongan-ji, a Jōdo Shinshū
Buddhist temple in Kyoto. The attempt to recreate the experience of a
journey through such a heterogeneous collection of images is common
to many amateur travelling albums of this period.

The *Japan* volume includes works by numerous well-known
photographers, both western and local, such as Felice Beato, Baron
Raimund von Stillfried and Uchida Kuichi. However, the majority of
the plates are yet to be attributed, largely because the output of various
photographic studios from this period remains to be researched fully.
In addition, negative plates often changed hands as photographic firms
amalgamated.[70] It was not unusual for photographers to acquire other
studios' negatives from which they would reproduce prints as part of
their own repertoire.

The album's two-part thematic structure parallels that of Beato's
innovative souvenir albums. In 1868, having settled in Japan five
years earlier, Beato launched luxurious two-volume sets, in which one
album was usually formed of hand-coloured photographs of Japanese
people, while the other focused on views of the country.[71] In the same
way, the first section of Dalton's *Japan* contains generic hand-coloured
portraits of local people taken in studios or outdoors. Sitters include
conventional figures, such as men in armour and women in kimono,
as well as representatives from across the Japanese social order, from
prisoners and porters to Buddhist monks and Shintō priests.

Similarly, the album's second, longer section comprises photographs
of natural and historic sites, almost all of which, aside from Nikkō's
shrines, were visited by the princes. This group begins with two images
of *Enryōkan*, the western-style building where the princes stayed on
arrival in Japan. Moving southwards, next come the Shiba temple
complex, Ueno Park and Edo Castle in Tokyo, followed by Osaka
Castle, Mount Fuji and Kōbe. The subsequent views of Kyoto form an
important part of the volume. Another significant section is dedicated
to images of Nara's seven great temples and the Kasuga Grand Shrine,
together with Nikkō's shogunal gateways and pavilions. Towards
the end of the volume, and after a spell of pages with photographs
of artefacts and interiors of Nara's temples, is a group of large-scale
prints.[72] These high-quality final photographs feature Tokyo's Imperial
Palace and gardens, Zōjō-ji in Shiba Park and Kanazawa.

To suggest that Dalton intended to base *Japan* upon Beato's
popular model is nevertheless problematic. King George V's undated,
handwritten inscription on the first page of the first album reads: 'These
9 volumes contain photographs mounted by the Revd J.N. Dalton.' Yet
it seems that the digit '9' was not part of his inscription: another hand
has written '9' in place of '12'.[73] This indicates a later restructure of the
series that most likely reduced the quantity of the volumes. Indeed,
the bindings in their current form are not contemporary with the
photographs; they were created in the 1920s or 1930s.[74] Although it is
unclear precisely to what extent the Japanese material was revised, the
photographs remain important souvenirs that present an intriguing
jigsaw of what Dalton considered to be the two princes' perception
of Japan. AK

LITERATURE: Dobson and Isherwood 1998 (exh. cat.), pp. 36, 52

68

EDUARD UHLENHUTH (c.1853–1919)
PRINCESS ALEXANDRA OF EDINBURGH
(1878–1942), OCTOBER 1889

Albumen prints mounted on album page
13.7 × 8.8 cm (each image)
RCINS 2904828–9
PROVENANCE: Probably presented to Queen Victoria
by Prince Alfred, Duke of Edinburgh, 1889

Victorians used dressing up for entertainment purposes, but also as a means of exploring their own identity along with other cultures.[75] Central to the donning of non-western attire was their perception that such clothing revealed ethnic origin and established a sense of cultural belonging.[76] Assuming various national identities through elaborate costumes, the wearers would often commission a portrait and distribute it to their immediate circle. Thus the photographic studio was transformed into a space for fantasy, offering a variety of backdrops and props as well as a comprehensive costume box.[77] During the second half of the nineteenth century, sitting for and exchanging fancy dress photographic portraits became extremely popular amongst the British upper and middle classes, including the royal family.

These two playful photographs of Princess Alexandra, granddaughter of Queen Victoria, were taken in Coburg by the German court photographer Eduard Uhlenhuth. As part of a group of portraits depicting the four daughters of Prince Alfred in guise, both prints share the same page in volume 38 of Queen Victoria's *Portraits of Royal Children*, a series of 44 albums featuring photographs of her descendants from the mid-1840s to the late 1890s.[78] The series was particularly important to the queen, and it is therefore likely that Prince Alfred presented the resulting images to her with the albums in mind.[79]

In this pair of portraits, Princess Alexandra appears in a striped kimono-style garment tied with a sash, a floral paper fan in her right hand. Interestingly, while in one portrait the princess is depicted as if performing a traditional fan dance, in the other she is cross-legged, in contrast to the more usual Japanese kneeling position. Equally, her conspicuous bloomers and slippers belie her Japanese persona. The dissonance of both clothing and pose demonstrates the shaky understanding of Japanese culture in mid-nineteenth-century Europe. Yet, the allure of the kimono persisted.

In 1889, when the sitting took place, the Japanese had abolished the kimono as official court attire because its traditional associations hindered Japan's new image as a modern country.[80] In reality, the adoption of western clothing in the Meiji period was mainly limited to men, and only in the public sphere of urban areas.[81] For westerners, the kimono was reminiscent of a nostalgic ideal of Japan and, as it continued to be worn by many Japanese women, it became associated with feminine beauty and elegance.[82] It is easy to view this symbolism, along with the duke's well-recorded fascination with Japan, as a decisive factor in his daughter's portrayal in a kimono. AK

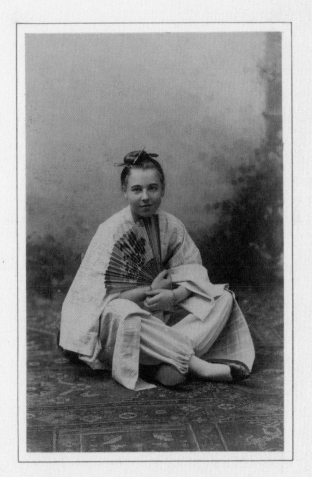

Princess Alexandra

3ʳᵈ daughter of the Duke & Duchess of Edinburgh

Octʳ 1889

Uhlenhuth

69

PRINCE ARTHUR, DUKE OF CONNAUGHT
(1850–1942) AND PRINCESS LOUISE MARGARET,
DUCHESS OF CONNAUGHT (1860–1917)

DIARY, 1 APRIL–21 JUNE 1890, VOL. IX

Manuscript

22.0 × 19.0 × 8.0 cm (closed)

RA VIC/ADDA15/8445

Highly evocative and deeply personal, the Duke and Duchess of Connaught's joint account of their time in Japan in the spring of 1890 reflects their status as tourists rather than official guests of the Meiji government. The royal couple were touring China, Japan and Canada following the duke's tenure as Lieutenant-Governor of Bombay. Though they undertook a small number of official engagements, they largely spent their time as they pleased. Their exuberant descriptions of sightseeing are in stark contrast to the weariness produced by gruelling State Visits in the preceding and succeeding decades. Japan was evidently a highlight of the tour: a 'charming + wonderfully attractive country', wrote the duchess.

The diary is as much a miniature archive as a written document, for the royal couple filled it with ephemera: the menu from their dinner at the Imperial Palace on 7 May, an engraved map of Kamakura, hand-coloured photographs of women dressed as *geisha*, English-language newspaper clippings and even pressed flowers from Lake Chūzenji in Nikkō. Though disappointed to find Yokohama 'drizzly and raining, quite an English climate', the duke and duchess were generally effusive. There were 'wonderful acrobatic feats' during one visit to the theatre. On 17 April, they saw some 'quite beautiful things, in china + cloisonné especially' at the Third National Exhibition for the Encouragement of Industry in Tokyo. A visit to the temples at Nikkō prompted raptures of delight: 'It made such an imposing and peaceful impression – one felt quite awed by it'. RP

Carbon print

16.0 × 22.8 cm

RCIN 2810107

PROVENANCE: Probably commissioned
by Queen Victoria, 1891

The early nineteenth century witnessed the rise of the *tableau vivant*, a static performance inspired by art or literature that could be enacted in public theatres and private drawing-rooms alike.[83] Around 1848, the genre was introduced to the royal family by Queen Victoria and Prince Albert as a form of entertainment for birthdays and Christmas.[84] The royal tableaux were revived after a hiatus following the death of the Prince Consort in 1861 and flourished as the years passed and the children grew older.[85]

This playful photograph, depicting Prince Arthur, Duke of Connaught with his family in *Japanese Scene*, is one of the few surviving images of the seven tableaux performed before the queen at Osborne House on 8 January 1891.[86] As was common practice in the Royal Household,

the actors later re-enacted the scene specifically for the camera.[87] On this occasion, the firm Hughes & Mullins was invited the next day to photograph the tableaux. This particular firm was probably commissioned because of its proximity to Osborne and founder Cornelius Jabez Hughes's (1819–84) experience working for the royal family since the 1860s.[88]

Unlike the other six tableaux, which explicitly referenced a well-known work of art, literature or legend, it seems that the *Japanese Scene* did not require specific knowledge to be understood. Instead, this scene was almost certainly inspired by the duke and duchess's visit to Japan nine months earlier. The composition is reminiscent of the staged 'customs and costumes' photographs produced to satisfy western demand for 'exotic' Japanese subjects, such as Fig. 5.14, which the couple acquired in Miyanoshita (Hakone) on 24 April and pasted into their joint diary of the tour (cat. 69). The fact that they chose Japan – of all the countries they visited on their return from India, including China, Ceylon (now Sri Lanka) and Canada – as the subject of their performance speaks of their fascination with the country. AK

5.14 Unknown photographer, *Music scene*, c.1885–90. Hand-coloured albumen print, 9.1 × 13.6 cm, RCIN 2958270

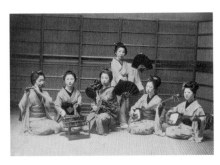

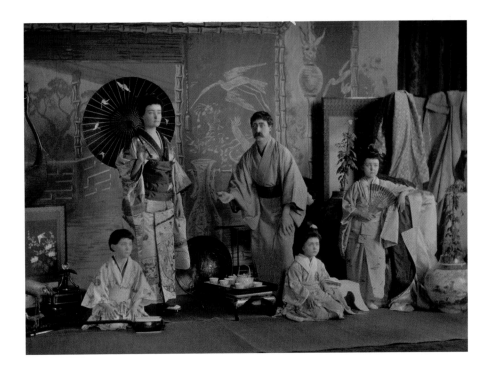

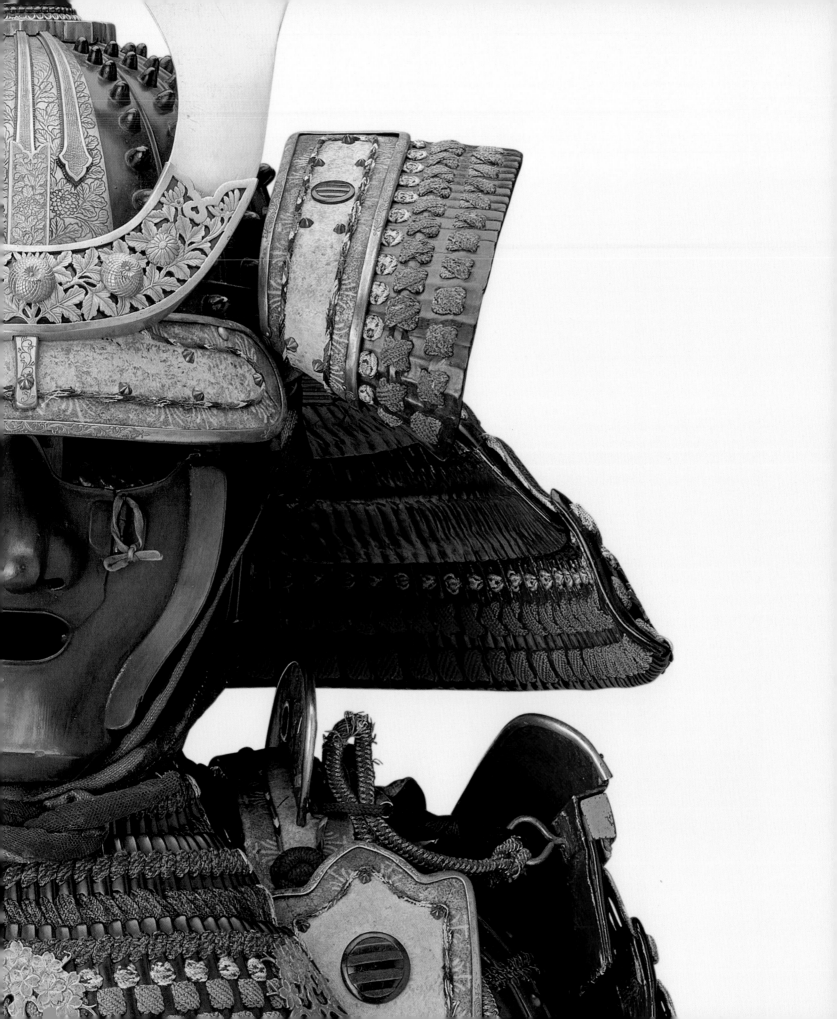

日本の芸術

6

SAMURAI, ARMS AND ARMOUR

GREGORY IRVINE

FROM the middle of the tenth century, groups of warriors known as *bushidan* emerged in Japan's provinces far from the Imperial Court in Kyoto. They were retained as fighting units only so long as a military campaign required. By the eleventh century, they had become more permanent and clearly defined groups affiliated to regional feudal lords. It is from these allegiances that the samurai (literally 'one who serves') began to emerge as a distinct class.

SAMURAI

In 1185, following years of civil war, the warrior Minamoto Yoritomo (1147–99) defeated his enemies, the Taira. The emperor accordingly appointed Yoritomo supreme military leader or shōgun (*seiitai shōgun*, 'barbarian-conquering general') in 1192. Thus began almost 700 years of samurai rule in Japan by various families who acted, at least nominally, in the name of the emperor. Members of this ruling military elite were expected not only to master the arts of war, but also to acquire literary and administrative skills. Many senior samurai were well versed in poetry and were patrons of art, attending the literary salons held by imperial court nobles, shōguns and regional lords as well as monks.

Japan was nevertheless frequently plunged into civil war as rival *daimyō* (feudal lords) fought to expand their territory. This lasted until 1615, when the warlord Tokugawa Ieyasu, who had been appointed shōgun in 1603, defeated the last of his enemies and Japan finally became unified under one powerful family. Under the Tokugawa shogunate, codes of behaviour evolved that centred on the tradition of absolute loyalty to one's master. This led to a more philosophical approach to *bushidō* ('the way of the warrior'), by which the samurai maintained their moral and military values through training with the sword.

By the nineteenth century, the samurai had all but lost their original function and faced growing pressure for their replacement by an emperor restored to full power. Fighting between Tokugawa forces and the imperial army took place around Kyoto; the Tokugawa were defeated, and in 1868 imperial restoration was declared. Samurai status was abolished in a series of measures culminating in the Haitōrei Edict of 1876, which ended the samurai privilege of bearing swords, the weapons that had been central to their rule.

SWORDS

The sword was the indispensable weapon of the samurai and a symbol of his authority. He was to combine his physical strength with his inner spirit, ready to kill or be killed in the service of his master. For the Japanese, 'the sword is the soul of the samurai', a phrase taken from the 1615 *Buke Shohatto* ('Laws of the Military Houses') laid down by Tokugawa Ieyasu. Perhaps no other society has produced a weapon held in such high esteem – revered both for its effectiveness in battle and for its legendary spiritual qualities.

The unique method of creating a Japanese blade involves repeatedly folding, hammering and combining billets of high and low carbon steel to form many layers. The result is a sword with a resilient core and a hard outer layer, capable of cutting without breaking or bending. Many are signed by the swordsmith on the tang (*nakago*). After polishing, the distinctive features of the manufacturing process become visible, such as the grain and tempering pattern (*hamon*).

The blade is the most important part of the sword, and family heirlooms were often remounted in different styles (see cat. 88). A blade might also be shortened to suit the fighting style of the owner (see cat. 92, *katana*). There are four main kinds of mounting for a blade. The *tachi* is a long sword used both on horseback and with armour, worn suspended from the belt by two loops on the scabbard with the cutting edge of the blade downwards (see cat. 94). The *katana* and *wakizashi* are long and short swords respectively, both worn thrust through the sash with the cutting edge uppermost and worn exclusively by the samurai in matching pairs known as *daishō* (see cat. 92). The *tantō* is a dagger or short sword, usually under 30 cm in length (see cats 87–89).

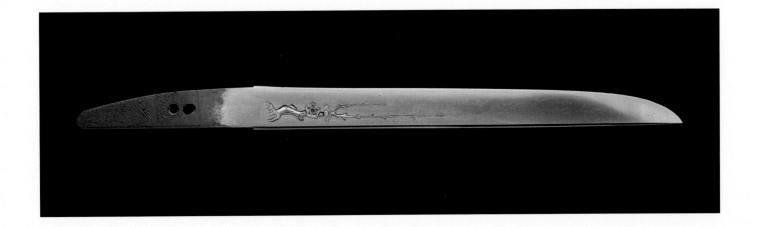

Sword fittings, such as the scabbard, hilt and sword guard (*tsuba*), are also works of art in their own right. Many demonstrate the finest metalwork and lacquer techniques and are decorated with auspicious symbols or family crests (*mon*). After Japan's 'reopening' to the West in the 1850s, fine blades in lavish mountings formed important diplomatic gifts (cats 88 and 96).

ARMOUR

By the twelfth century, battles were carried out mostly by cavalry. In action, warriors stood up in the saddle on large, comma-shaped stirrups (see cat. 76) to shoot with the bow (see cat. 78) or slash downwards with the long *tachi*. Armour developed into the flexible *ō-yoroi* ('great harness') and later into the *dōmaru* ('body-wrapped'), whose primary purpose was protection against arrows. The cuirass (*dō*) was formed of lamellar plates linked together in a flexible way, with a solid upper plate giving increased protection. Two shoulder pieces (*sode*) fell into position when the arms were raised and protected the exposed underarm area. The skirt (*kusazuri*) was also made from linked flexible plates that protected the thighs and lower abdomen. The arms were protected by mail gauntlets (*kote*) with solid plates attached for increased defence. Helmets (*kabuto*) were formed of iron plates riveted vertically, with a

decorated opening at the top to provide ventilation during battle. Armour's prestige and expense meant that it formed a central component of the diplomatic gifts sent to Europe by the shōguns in the late sixteenth and early seventeenth centuries, including that given to James I in 1613 (cat. 1).

As strategies of war evolved from an emphasis on cavalry to massed ranks of foot soldiers, so armour styles changed and became lighter and more flexible (see cats 72 and 73). However, after the advent of peace in Japan from around 1615, armour was used predominantly for ceremonial occasions. These included *sankin kōtai* ('alternate attendance') processions from a *daimyō*'s regional domain to the capital, Edo, where provincial rulers were required to reaffirm their submission to the shōgun. These parades were an opportunity for a *daimyō* to display his status and personal taste through the size and splendour of his entourage, many of whom carried lavishly decorated polearms and *yari* (see cats 81–86).

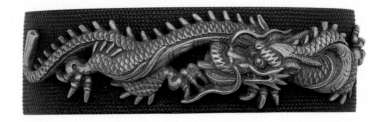

71

ARMOUR (DŌMARU), 1537–1850

Iron, lacquer, *shakudō*, gilt copper, gold filigree, enamel, silk,
brocade, leather, doe-skin, horsehair, bear fur

147.0 × 80.0 × 55.0 cm (overall, approx., when mounted)

Helmet (*kabuto*), signed and dated on applied gold plaques on
the central front and rear plates of the interior: *Myōchin Nobuie
Tenbun go nen ni gatsu* ('Myōchin Nobuie Tenbun 5th Year 2nd
Month' [1537])

Sleeves (*kote*) signed and inscribed: *Nihon yui-itsu katchū ryoko*
('Japan's unique and skilled armour maker'); *Hōreki juni nen
ni gatsu kisshin* ('12th year of Horeki 2nd month lucky day'
[1762]); *Masuda Myōchin Shikibu Ki no Munetora saku*
('Masuda Myōchin Munetora made this')

Greaves (*suneate*) signed: *Myōchin Ki no Munetora saku*
('Made by Myōchin Munetora')

RCIN 61765

PROVENANCE: Presented to Prince Alfred, Duke of Edinburgh
by the Emperor Meiji, 22 September 1869

The Myōchin school of armourers formed part of a family line said to
reach back to the twelfth century. By the Edo period, they were among
the most prolific makers of armour. They also produced iron sword
fittings and superb articulated iron animals such as dragons and snakes.
In the early sixteenth century, Myōchin Nobuie made outstanding
armour, including 62-plate helmets like the one seen here. His helmets
were simple and efficient defences, and perhaps the most important
part of an armour. Because they were so desirable, helmets and other
armour parts carrying his 'signature' were frequently faked. The helmet
on this armour, though remounted with later parts, such as the neck
protector (*shikoro*), is of fine enough quality to be Nobuie's work.

The armour comprises elements from at least two, and probably
three, different armours. They were perhaps brought together and
remounted specifically for presentation to Prince Alfred, Duke of
Edinburgh in 1869. The helmet (*kabuto*) is certainly not from the same
armour as the other pieces. The rims (*fukurin*) of the helmet are of
shakudō (an alloy of copper and gold) and those of the armour are
of gilt copper; all are finely carved with a pattern of scrolling grasses.
The helmet bears a family crest (*mon*) of three horizontal bars, and
this motif is also found on the protective fittings (*gyōyō*) on the cuirass
(*dō*). The sleeves (*kote*) and shin guards (*suneate*) carry the signature
and other details of Myōchin Munetora, who worked in the late Edo
period and was perhaps son of the renowned Myōchin Muneakira
(1673–1745). The half-mask (*menpō*) is of black lacquered iron with a
horsehair moustache. Attached to the lower edge is a throat defence
(*yodare-kake*) and beneath this is a separate throat guard (*nodowa*).

The armour is of the body-wrapped (*dōmaru*) type. The *dō* is
constructed mainly of black lacquered leather formed in one piece to
give the appearance of individual lamellae. The solid plates at the top
front (*muneate*) and back are of iron covered in stencilled doe-skin. The
armour is laced with dark blue silk and mounted on blue silk brocade.
The rims (*fukurin*) of the armour and helmet are of *shakudō* or gilt and
are finely carved with scrolling grasses. The mail sleeves (*sode*) with
hammered iron plates are additionally decorated with the head of the
fearsome mythical lion–dog (*shishi*) and iron plates pierced in the form
of cherry blossom. The boots are of leather and brocade silk covered in
black bear fur. GI

INVENTORIES: Clarence House 1875, p. 77

LITERATURE: South Kensington Museum 1872, no. 463, p. 38;
Huish 1888 (exh. cat.), p. 77; Japan Society 1905 (exh. cat.),
no. 4, p. 55; Japan-British Exhibition 1910 (exh. cat.), p. 25;
Dufty 1965 (exh. cat.), no. 40, p. 9

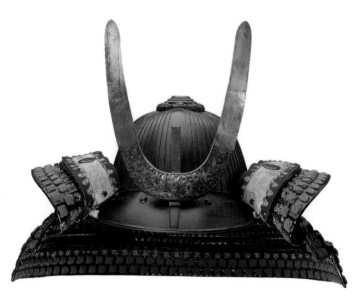

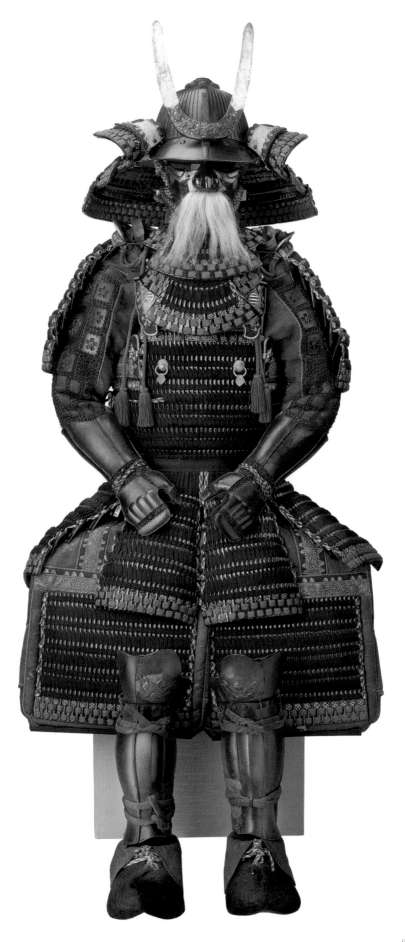

JAPAN

ARMOUR (DŌMARU), 1600–1750

Steel, iron, lacquer, gilt bronze, gilt-copper alloy, silk, horn, stencilled doe-skin, leather

152.5 × 60.0 × 66.0 cm (overall, approx., when mounted)

RCIN 64124.a–j (excluding 64124.b)

PROVENANCE: Possibly first recorded at Sandringham House in 1910

This unsigned armour is of the 'body-wrapped' (*dōmaru*) type introduced in the late Kamakura period (1185–1333). Thanks to its relative lightness, the style soon became popular with higher-ranking samurai. Warfare in Japan had changed radically by the fifteenth century, with battles by this time fought mostly on foot. This required lighter and more flexible armour, so the large shoulder protectors (*sode*) of earlier styles were dispensed with, as were wide neck-protectors (*shikoro*) on helmets. The present armour has small shaped shoulder-guards known as *tōsei sode*. Over time, the large curved features at the sides of the helmet (known as *fukikaeshi* or 'turn-backs') too were reduced in size and function, being retained mainly to bear the family crest, as here. The fifteenth century also saw the gradual introduction of a further lower limb protector: a split apron called a *haidate*, which was worn under the hanging tassets (*kusazuri*). This complete and matching light armour was the *tōsei gusoku* ('armour of the times').

This elegant, simple and functional example has a peach-shaped (*momonari*) helmet with a tightly fitting neck protector called a *Hineno shikoro*. This style was said to have been created by an armourer with the title *Hineno Oribe-no-Kami* and was extremely popular in the second half of the sixteenth century. Many helmets of this type have a bowl formed of lacquered leather, but this helmet was fashioned entirely from iron: it would have required great skill to create such an elegant form. The back of the armour has a metal fitting to carry a banner called a *sashimono* which bore the family crest (*mon*): in battle, this flag identified friend from foe. The *mon* of orange blossom and crossed fans which decorate this fine armour are yet to be positively identified.

This armour, with cat. 73, is possibly one of the two catalogued but not illustrated in King Edward VII's collection at Sandringham House in 1910. Both were described as eighteenth-century 'Suit[s] of Plate-Armour (*Roku-gusoku*)' – one in the Armoury Passage and another in the Smoking Room. The latter was mounted on a standing figure.[1] GI

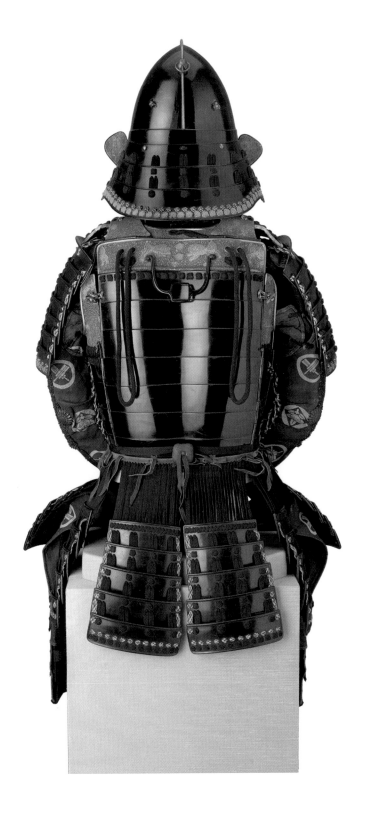
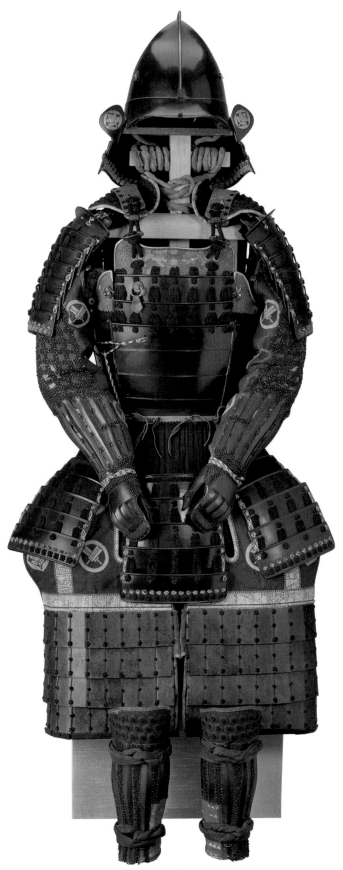

JAPAN

ARMOUR (DŌMARU),
1750–1850

Steel, lacquer, gold, *shakudō*, iron, gilt bronze, gilt and silvered copper, cotton, silk brocade, stencilled doe-skin, gilt-leather linings, horn toggles

151.0 × 71.0 × 70.0 cm (overall, approx., when mounted)

Illegible signature on the underside of the helmet visor

RCIN 64125.a–n

PROVENANCE: Possibly presented to King George V when Prince George of Wales by the Emperor Meiji, 1881

Like cat. 72, this armour is of the 'body-wrapped' (*dōmaru*) form prized by higher-ranking samurai for its lightness and flexibility. One major difference from earlier, heavier armours was the removal of the doe-skin covering (*tsurubashiri*) on the cuirass (*dō*). Another change was the replacement of the two protective fittings for the cuirass toggles known as *sendan-no-ita* and *kyūbi-no ita* by smaller fittings called *gyōyō*. Curiously, this armour has the earlier fittings rather than the *gyōyō*. This perhaps reflects the revival around 1800 of a nationalistic spirit in Japan that harked back to the 'Golden Age' of the samurai in the Kamakura (1185–1333) and Nambokuchō (1333–92) periods. In the early nineteenth century, swords and armour were produced which reflected the styles and tastes of those periods, but parade armours used in *sankin kōtai* at this time also incorporated defensive features that would not have been found on early armours. These additional defences were ornamental rather than functional, and historical accuracy was not of prime importance: the antiquarian style of the armour was enough to invoke the samurai's glorious military heritage.

The heavy helmet with visible rivets and wide neck protector (*shikoro*) is in the Kamakura-period style called 'star' helmet (*hoshi kabuto*). It carries a three-bar family crest, possibly of the Sakuma clan, and this device is also found on the cuirass toggle protectors. Both the helmet (*kabuto*) and shoulder-guards (*sode*) are lined with gilded leather. The *dō* is constructed mainly of black lacquered individual iron lamellae (*kozane*) laced together in a flexible manner: this is known as *hon-kozane* ('real' *kozane*) and is an indicator of a high-quality armour. The other parts of the armour are of lacquered leather formed in one piece to give the appearance of individual lamellae.

The decorative metalwork is of fine quality and includes fittings of intricately carved and gilt-copper alloy and *shakudō*. Of particular note is the superb metalwork detail on the *shikoro*, the throat protectors (*yodare-kake* and *nodowa*), toggle protectors (*sendan-no-ita* and *kyūbi-no ita*) and tassets (*kusazuri*), which are of gilt-copper alloy and take the form of cherry trees with visible roots. While the armour

may never have actually been worn, it would certainly have been displayed in the *tokonoma*, the alcove in the traditional Japanese house where seasonal objects are displayed, to be admired by honoured guests.

At the 1965 'Exhibition of Japanese Armour' at the Tower of London, this armour was described as having been given to Prince George of Wales by the Emperor Meiji during his visit to Japan in 1881.[2] Although a gift of armour is not mentioned in the official accounts of the tour, there is no strong reason to doubt this provenance: the Emperor Meiji had given the prince's uncle, Prince Alfred, Duke of Edinburgh, an armour during his visit in 1869 and such objects were a traditional and impressive diplomatic gift. It is even possible that cat. 72 was given to the prince's brother, Prince Albert Victor, on the same occasion. GI & RP

LITERATURE: Dufty 1965 (exh. cat.), no. 37, p. 8

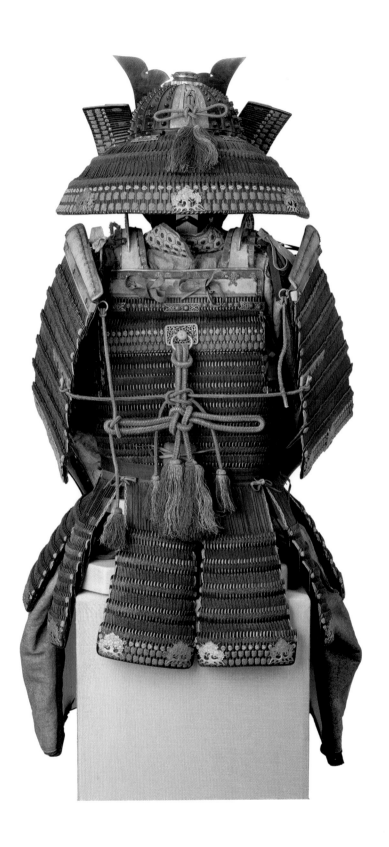
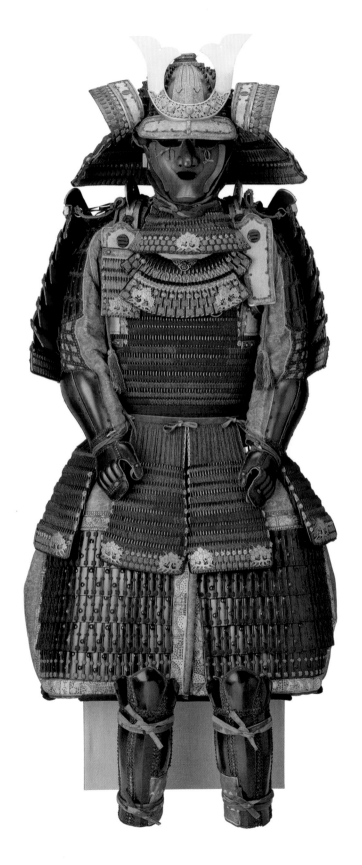

JAPAN

FACE MASK (SŌMEN),
1700–1800

Iron, lacquer, hemp liner, gilded leather trim, horn buttons, silk cords, horsehair whiskers

35.0 × 37.5 × 13.0 cm

RCIN 37816

PROVENANCE: First recorded at Sandringham House in 1910

A full-face mask (*sōmen*) provided both protection for the face and a means of securing the helmet to the head by tying the cords under the chin of the mask. The interior was often lacquered red, as here, to make the face appear ruddier and more fearsome. On some full-face masks, the upper face area or nosepiece can be pinched for removal, but this unsigned mask only gives the appearance of this function – the nose, despite the fixing hooks, is not removable. The addition of the iron mail throat-piece (*yodare-kake*) provides further protection to this vulnerable area and can be buttoned onto parts of the main armour. It would also serve to absorb or dispel sweat which drained from the underside of the chin of the mask. GI

LITERATURE: Clarke 1910, no. 623, p. 45

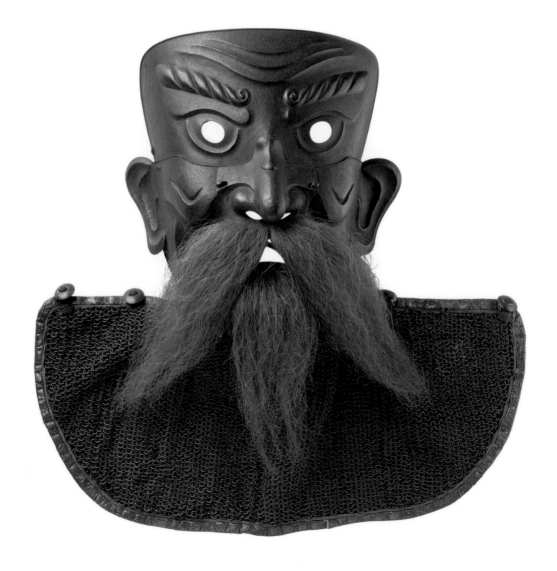

75, 76

JAPAN

SADDLE TREE (KURA) AND PAIR OF
STIRRUPS (ABUMI), 1580–1650

Wood, lacquer, lead foil (saddle tree); iron, lacquer,
lead foil (stirrups)

28.0 × 39.0 × 45.0 cm (saddle tree);
27.0 × 19.0 × 14.0 cm (stirrups)

RCINS 71609 (saddle tree), 71610.1–2 (stirrups)

PROVENANCE: Probably sent to James I by Shōgun
Tokugawa Hidetada, 1613

Between the twelfth and fifteenth centuries, warfare was mostly
carried out by cavalry using the long, deeply curved *tachi* and
the bow (*yumi*). While the sword was always carried in battle, the
bow was in fact the principal weapon of the mounted warrior.
Over time, the samurai developed and mastered 'the way of the
horse and the bow' (*kyūba-no-michi*) – a warrior tradition which
eventually evolved into the philosophical and practical martial
concept, *bushidō* ('the way of the warrior').

 In action, the warrior stood up in the saddle to aim and fire his
bow or to cut down with his *tachi*. Solid, comma-shaped stirrups
were crucial in facilitating this. Curiously, these stirrups, rather
than being of solid iron, as usual, only have an iron frame with a
lacquered wood base, thereby rendering them impractical for use.

 Although mass infantry were increasingly used in warfare during
the Muromachi period (1392–1573), cavalry were still used as shock
troops. The shape of the saddle tree and stirrups hardly changed
throughout this time, so dating is difficult and relies more on the
style of decoration. The lacquer and lead overlay depicting gourds
and vines on this matched set of saddle and stirrups suggests they
date from the Momoyama period (1573–1615). This dating has led
to speculation that they formed part of Tokugawa Hidetada's gift to
James I in 1613, although they do not seem to be mentioned in any
contemporary accounts.[3] GI

INVENTORIES: WC North Corridor, no. 2072

LITERATURE: Dufty 1965 (exh. cat.), no. 42, p. 9;
Bottomley 2013, p. 11; Bottomley 2017, p. 11

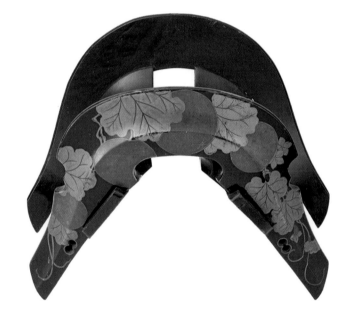

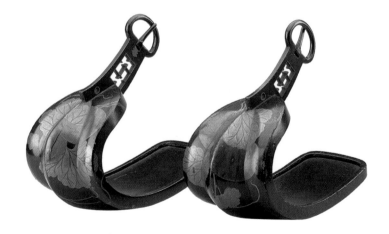

DAIKUHARA MUNETAKE (ACTIVE 1860–65);
SHISHIDA HIDECHIKA (ACTIVE 1860–65)
PAIR OF CARBINES, c.1860–65

Steel, iron, mahogany, lacquer, brass, gold, silver

103.3 × 15.5 × 6.5 cm (RCIN 38453.1);
103.1 × 15.2 × 6.3 cm (RCIN 38453.2)

Each signed on the barrel: *Dai Nippon Daikuhara Tosa-no-suke Munetake saku* ('Made by Daikuhara Munetake, Governor of Tosa Province [modern-day Kōchi Prefecture], Great Japan') and in a gold cartouche: W ('Shishida Hidechika')

RCIN 38453.1.a–2.a

PROVENANCE: Presented to King Edward VII when Prince of Wales by Shibata Takenaka, 1865

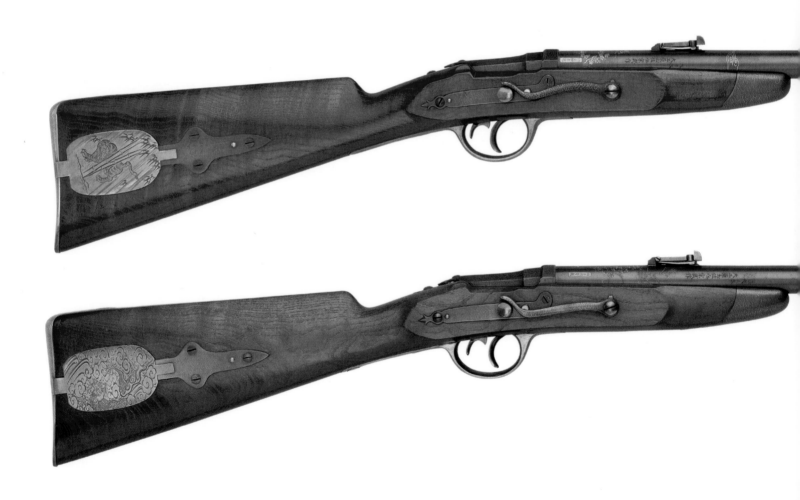

Firearms were all but unknown in Japan prior to the arrival of the Portuguese in 1543. The matchlocks they brought with them were quickly adopted, adapted and used in huge numbers by the feuding warlords of the period. However, with the advent of peace after 1615, guns fell out of use and few developments were made in this area. Following the 'reopening' of Japan in the 1850s, the Japanese were eager to find out about new forms of weaponry to begin their own territorial expansion and to protect themselves from foreign encroachment. These carbines represent some late-Edo-period efforts to bring firearms technology up to date.

The barrels are delicately inlaid, that of RCIN 38453.1 with a design of gold geese and spring flowers and that of 38453.2 with gold deer and summer grasses. Each has an applied gold plaque signed 'Shishida Hidechika', presumably the artist who carried out the decoration. The calibre is approximately ½ inch (1.27 cm), and the barrels have been adapted to use needle-fire cartridges. The butts of the rifles bear brass

plates decorated with a dragon in clouds (RCIN 38453.2) and a tiger in bamboo (RCIN 38453.1). This combination, borrowed from Chinese painting, was said to signify East and West, or celestial and earthly powers, respectively. While the dragon's flight brought rain, the tiger's roar produced wind.[4] A tiger prowling among thick stalks of bamboo was a symbol of strength and resilience.

The guns were brought to Britain by Shibata Takenaka (1823–77), who in May 1865 led a small Tokugawa mission aimed at obtaining 'instruction on the military sciences of your country'. Among their gifts for the Queen, Foreign Secretary and Prince of Wales were these 'carabine [sic] of the Japanese manufacture ornamented with gold and silver', as well as another pair 'polished in eight angles'.[5] All four guns were subsequently displayed in the Gun Corridor at Sandringham House. **GI & RP**

LITERATURE: Baker 1989, no. 27, p. 100

78

BOW (YUMI), 1912–22

Bamboo, rattan, lacquer, deerskin

213.0 × 3.0 × 1.0 cm

RCIN 79906

79

SET OF ARROWS (YA), 1912–22

Bamboo, lacquer, wood, ivory, steel, gold foil, feathers

100.0 × 4.5 × 4.5 cm (each arrow)

RCIN 79915.a–e

80

OPEN QUIVER (EBIRA), 1912–22

Wood, bamboo, lacquer, silk

33.0 × 18.5 × 12.0 cm (excluding fittings)

RCIN 79914

PROVENANCE: Presented to King Edward VIII
when Prince of Wales by Shimazu Tadashige
in Japan, May 1922

With the advent of peace in Edo-period Japan, the samurai class were instructed to maintain their warrior spirit through continued practice of archery (*kyūdō*) and the sword (*kendō*). This Japanese bow (*yumi*) is over two metres long. The grip is located one third of the way up from the bottom, enabling the mounted warrior to pass the bow more easily over the horse's head to aim and fire. The bow is made of laminated bamboo and is strung in a reverse curve with an asymmetrical grip. It can be strengthened with rattan binding and, as here, coated with flexible lacquer.

Arrows (*ya*) vary in length according to the physical stature of the user. They have a simple iron or steel tip (*ya-no-ne*), slightly blunted for use on a straw or paper target, and are traditionally fletched with eagle or hawk feathers. Arrowheads of different shapes were available depending on the arrows' purpose. The open quiver (*ebira*) here is of wood with bamboo slats into which the arrows can be slotted. It is lacquered all over in deep red and carries the *mon* of the Shimazu family.

On his final day in Japan in May 1922, Edward, Prince of Wales was entertained by Prince Shimazu Tadashige (1886–1968), son of the last feudal lord of the Satsuma domain. Lunch was served at Prince Shimazu's villa, followed by an archery demonstration (Fig. 6.1).[6] Afterwards, the Prince of Wales was presented with a complete set for archery practice, including an archer's glove, arm guard and reel for spare bowstrings, as well as the items here.[7] **GI & RP**

6.1 *Archers at Prince Shimadzu's [sic] Villa, Kagoshima,* n.d. Photograph, reproduced in Percival Phillips, *The Prince of Wales's Eastern Book,* 1922, RCIN 1092273

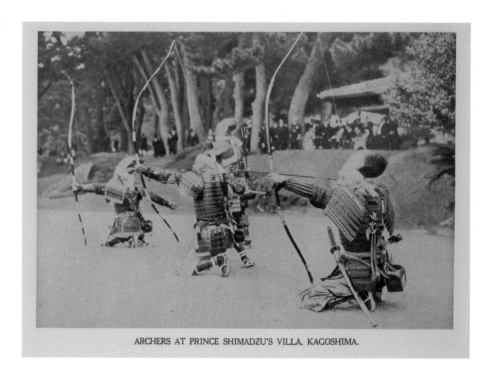

ARCHERS AT PRINCE SHIMADZU'S VILLA, KAGOSHIMA.

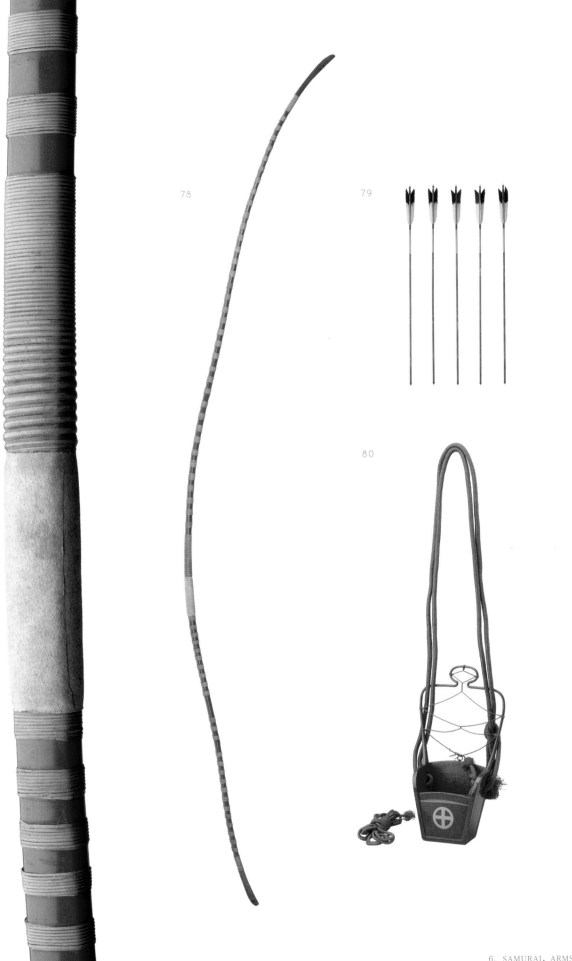

78

79

80

JAPAN

POLEARM (NAGINATA), ?1550–1650 (BLADE);
1750–1850 (MOUNTS)

Steel, iron, wood, rattan, copper alloy, red lacquer

241.0 × 4.0 × 3.0 cm

RCIN 62620

PROVENANCE: Probably acquired by Prince Alfred,
Duke of Edinburgh

82

FUJIWARA YASUTSUGU (ACTIVE 1860)

POLEARM (NAGINATA), 1850–60

Steel, lacquered wood, *shakudō*, gold, mother-of-pearl

230.0 × 5.3 × 3.8 cm

Blade signed and dated: *Ansei shichi nen ni gatsu hi*
('A day in the second month of the seventh year of Ansei
[March 1860]'); *Mo taimei Higo Daijō Jūichi-dai Fujiwara
Yasutsugu kin tan* ('Respectfully made by Eleventh Generation
Fujiwara Yasutsugu, Assistant Lord [honorary title] of
Higo Province [modern-day Kumamoto Prefecture]')

RCIN 71616

PROVENANCE: Sent to Queen Victoria by
Shōgun Tokugawa Iemochi, 1860

Among the most significant events of the middle Kamakura period
(1185–1333) were the unsuccessful Mongol invasions of Japan in 1274
and 1281. The Japanese cavalry were confounded by the Mongols' use
of massed archery, and by the hordes of Mongol infantry armed with
long spears and other polearms. One consequence of these invasions
was a shift in Japanese battle tactics from cavalry to infantry, together
with increased production of spears (*yari*) and halberds (*naginata*).

By the Muromachi period (1392–1573), polearms had become the
principal weapon of the foot soldier (*ashigaru*); the *naginata*, which
was primarily for cutting, was an efficient weapon against massed ranks
of infantry and against cavalry. The blades could be up to one metre
long. *Naginata*-style blades were also sometimes mounted on shorter
handles and used in a manner akin to swords.

Cat. 81 has an excellent forged blade, and the simple mounting,
with an unidentified family crest, suggests it was more of a practical
weapon than a ceremonial or processional one. By contrast, cat. 82 is
of the elegant type used in *sankin kōtai* processions to and from the
shōgun's court during the peaceful Edo period. It is one of two sent to
Queen Victoria by Shōgun Tokugawa Iemochi in 1860. A translated
list of the gifts to be presented, dated 21 March 1860, includes 'Two
naginata or spears.' GI

INVENTORIES: WC North Corridor, no. 2291 (cat. 81)

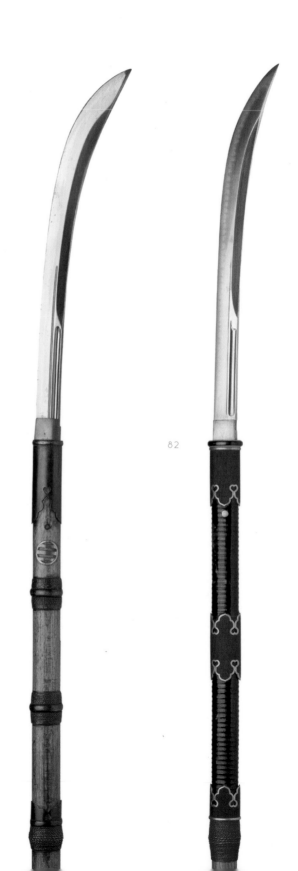

81 82

JAPAN

SET OF SPEARS (YARI), 1750–1850 (BLADES); 1800–50 (MOUNTS)

Steel, lacquered wood, mother-of-pearl

Various, approx. 390.0 × 3.1 × 3.1 cm

RCINS 71797, 71798, 71802, 71803, 71804, 71807

PROVENANCE: Sent to Queen Victoria by
Shōgun Tokugawa Iemochi, 1860

Spears (*yari*) were widely used in Japan during the 'Period of Warring Provinces' (*Sengoku Jidai*, 1467–1568). They were an effective and cheap means of arming the ever-expanding armies of foot soldiers (*ashigaru*). The simplest *yari* had shafts made from bamboo or oak. The shape of spearheads varied: these examples have three-sided straight steel blades (*sankaku yari*), which originally would have had short lacquer scabbards. They are attached to the shaft by a tapering tang which is slotted into the top of the spear and fixed with a bamboo peg. A metal sleeve at the top of the shaft prevents the wood from splitting, and reinforcing rings are found at intervals along the rest of the length.

During the peaceful Edo period, *yari* were carried by large numbers of lower-ranking samurai in the *sankin kōtai* processions to and from the shōgun's court. To add to the splendour of the procession, the *yari* were frequently remounted with shafts decorated with small pieces of mother-of-pearl inlaid into lacquer.

These *yari* form part of a set of 50 sent to Queen Victoria by Tokugawa Iemochi in 1860.[9] Ten were given by Queen Victoria to the South Kensington Museum in 1865.[10] The spears which remain in the Royal Collection vary in length, which suggests that some have been cut down, probably for the purpose of display. Four were mounted on the south wall of the Grand Vestibule at Windsor Castle in *c.*1905–10, where they formed part of a larger display of Japanese arms and armour.[11] **GI & RP**

RCIN 71798

84, 85
JAPAN
TWO SHORT-BLADED SPEARS (YARI),
1750–1850

Steel, hardwood, rattan, mother-of-pearl

282.0 × 14.0 × 3.0 cm (RCIN 62619);
118.8 × 3.0 × 3.0 cm (RCIN 62617)

RCINS 62619, 62617

PROVENANCE: Probably acquired by Prince Alfred,
Duke of Edinburgh

The spear (*yari*) was used as a thrusting and slashing weapon,
primarily by samurai fighting on foot. Despite its length, it was also
used by cavalry as a lance. There were many variants in the shape and
configuration of the blade: the straight, double-edged version ranged
in length from 5 cm to over 60 cm, excluding the tang (*nakago*). In
cross-section, the most common type of blade presented a shallow
triangular profile with a broad flat side backed by a shallow ridged rear.
This was called *sankaku-zukuri*, 'three cornered form'. Many blades
of the *sankaku-zukuri* type had a central groove (*hi*) running from the
nakago almost to the point. Sometimes this groove was filled with red
lacquer, as on cat. 84, although this was possibly added to the blade at
a later date.

These *yari* were originally made as functional weapons and may
once have had plainer shafts. They were probably remodelled around
1800 for use in *sankin kōtai* processions, in which provincial *daimyō*
travelled to Edo in alternate years to attend the shōgun's court. This
system required that *daimyō* maintain both their provincial estates and
residences in Edo, where their families were effectively held hostage
to ensure their co-operation. The size and splendour of the *daimyō*'s
entourage when travelling to and from Edo was an outward indication
of his status, and these processions were frequently grand and dazzling
affairs. GI

INVENTORIES: WC North Corridor, nos 2288–9

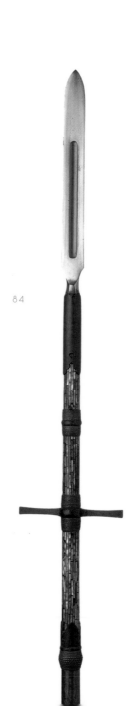

84

85

86

JAPAN

POLEARM (JŪMONJI-YARI) AND SCABBARD,
1750–1800

Steel, lacquered wood, mother-of-pearl, copper, brass, iron,
rattan

209.0 × 22.0 × 3.5 cm

RCIN 71661.a–b

PROVENANCE: Probably acquired by Prince Alfred,
Duke of Edinburgh

Among the less common polearms is the *jūmonji-yari*, which has a
central blade with two shorter horizontal spurs. The resulting cross
shape resembles the Japanese character for the number ten, *jū*, from
which this polearm takes its name. *Jūmonji-yari* are found in various
configurations and lengths, but when the cross-blades are curved they
are called *magari-yari* (curved spears).

Examples of *jūmonji-yari* date from around 1500 onwards. Though
an impractical weapon, they served as a means of deflecting the thrust
of a longer spear with a single blade. They were sometimes made by
well-known swordsmiths and were occasionally signed by them on the
tang (*nakago*). Some older blades were remounted on shafts decorated
in mother-of pearl and were then used in parades and processions such
as *sankin kōtai*. As an ornate form of spear, they were well suited to the
drama and pomp of such processions. GI

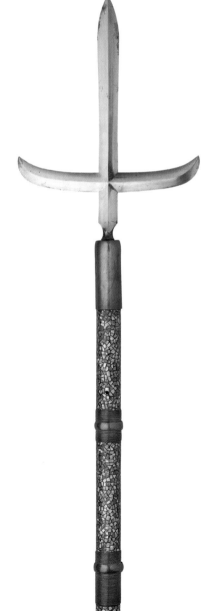

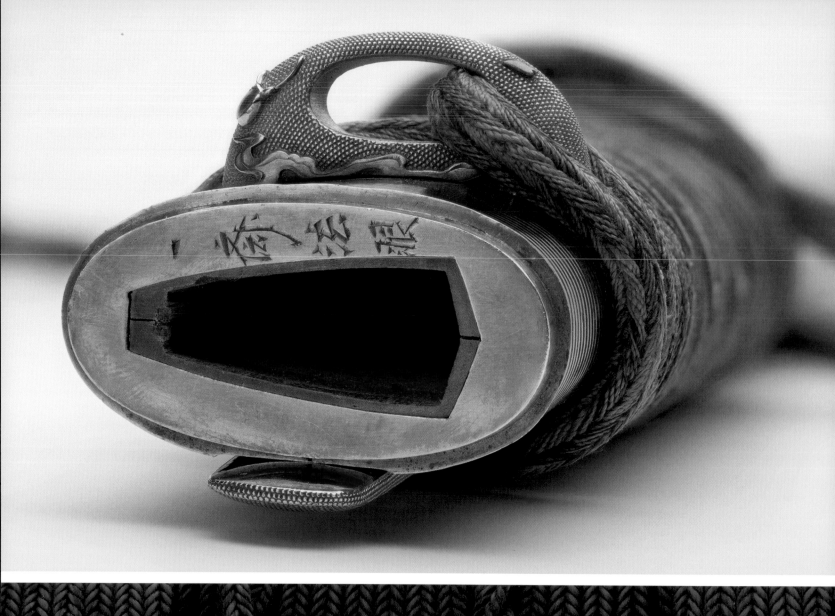
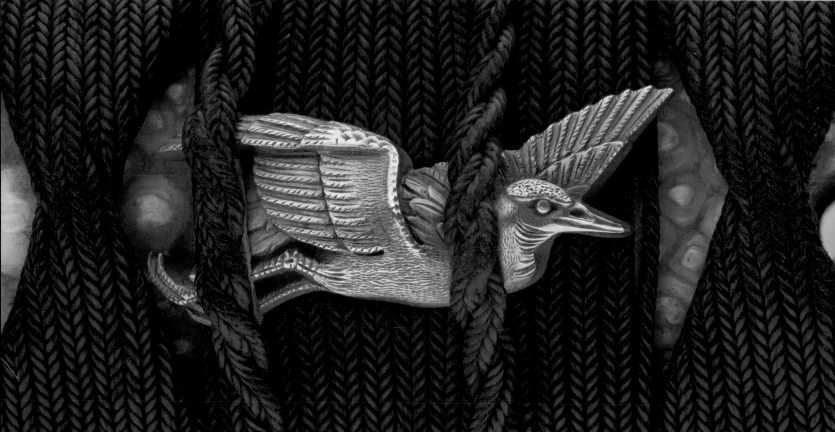

87

RAI KUNITOSHI (ACTIVE 1280–1315);
ISSAI TŌMEI (1817–70)

DAGGER (TANTŌ), *c*.1300 (BLADE);
1750–1850 (MOUNTS)

Steel, lacquered wood, gold, silver, copper alloy, silk, ray skin

37.5 × 4.0 × 3.0 cm

Blade signed on the tang: *Rai Kunitoshi*

RCIN 62626.a–c

PROVENANCE: First recorded at Windsor Castle in the late nineteenth or early twentieth century

The simple yet elegant mounting of this dagger hides the fact that the blade is extremely early. The ray skin hilt is wrapped in black silk braiding with a small fitting (*menuki*) of gilt-copper alloy on each side in the form of a crane in flight. The pommel (*kashira*), collar (*fuchi*), silk cord fitting (*kurikata*) and chape (*kojiri*) are of gilt-copper alloy and silver with a decoration in relief of magnolia and cherry blossom on a *nanako* ground (a pattern of small dots thought to resemble fish roe). The side-knife (*kogatana*) is of similar alloy, but the decoration shows butterflies in relief. The *fuchi* is signed *Issai Hōgen*; *hōgen* is an honorific Buddhist title which here recognises Issai as a master of his craft. This is possibly Issai Tōmei, who worked in the late Edo period.

The elegant blade is signed *Rai Kunitoshi* and has three fixing holes in the tang, one plugged with gold. The Rai Yamashiro school of Kyoto swordsmiths was renowned for its high quality and effective blades. According to tradition, it was founded by a smith named Kuniyoshi, but there is much unresolved confusion as to his successors, all of whom used *Rai* and the first character *Kuni* in combination with a second character when signing blades. One smith simply used the two characters *Kunitoshi*, but there are also blades signed *Rai Kunitoshi*, giving rise to debate about whether they are the same person. Nonetheless, Rai Kunitoshi has long been considered one of the top three *tantō* makers of all time. Blades bearing his signature are considered to have achieved perfection and are the archetype used to describe late Kamakura-period daggers. GI

INVENTORIES: WC North Corridor, no. 2113

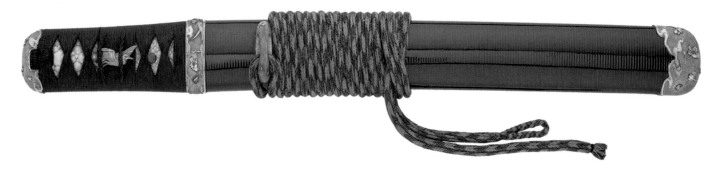

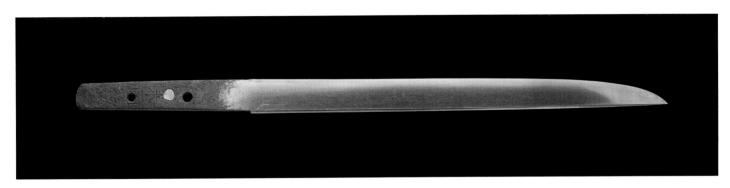

88
KANEHISA (ACTIVE 1490–1504); CHIKANORI II (ACTIVE 1868–1912)
DAGGER (TANTŌ) AND SCABBARD, c.1500 (DAGGER); 1868–71 (SCABBARD)

Steel, lacquered wood, gold, ray skin, silk

37.5 × 3.5 × 3.3 cm

Tantō blade signed on the tang: *Kanehisa*; scabbard collar signed *Nori tsukuru* ('Made by Nori')

RCIN 62631.a–c

PROVENANCE: Sent to Prince Alfred, Duke of Edinburgh by the Emperor Meiji, 1871

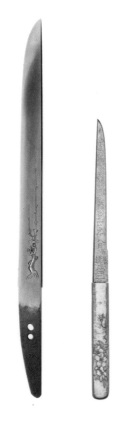

Remounting a good older blade with high quality contemporary mounts for a diplomatic gift follows a long tradition of presenting swords. The Emperor Meiji had many old blades, some as old as the Nara period (710–794), remounted by contemporary makers. According to the South Kensington Museum catalogue of 1872, Meiji designed the mounts for this blade himself.[12] They bear remarkable similarity to those on a *tachi* given by the Emperor Meiji to Sir Harry Parkes, the first British minister in Japan, in 1871 (V&A nos M.13:1, 2-1949). This *tantō* was a gift for Prince Alfred, Duke of Edinburgh, but it was not complete at the time of the prince's stay in Japan, and instead sent to him after his return to England. It was presented at Marlborough House by Prince Higashi-Fushimi on 15 June 1871, 'in remembrance of his Royal Highness's visit'.[13]

The dagger is mounted without a hand guard, a style known as *aiguchi* ('meeting of mouths'). The lacquered scabbard is of the finest quality gold *makie* (sprinkled) lacquer with low-relief decoration of flowering cherry blossom. The solid gold fittings, including the side-knife (*kogatana*), are likewise decorated with cherry blossom. The collar (*fuchi*) of the scabbard carries the signature *Nori tsukuru* ('Made by Nori'). This may be the abbreviated signature of Sekizenjō Chikanori (Chikanori II), a swordsmith and goldsmith of the Meiji period.

The blade is signed on the tang (*nakago*) with the two characters for *Kanehisa*. Although there were a great number of smiths who signed this way, the dagger is most likely by one of two smiths who operated in Seki in Mino Province (part of modern-day Gifu Prefecture) who worked around the period 1490–1504. The tang also has two fixing holes, which indicate that the blade has had several mountings. The blade is decorated with a carving (*horimono*) of a flowering branch of plum blossom and has a gold collar (*habaki*) decorated with fine and broad carved lines. There is evidence of fine grain on the blade and the tempering pattern (*hamon*) is an almost straight (*suguha*) misty line. GI & RP

INVENTORIES: Clarence House 1875, p. 69; WC North Corridor, no. 2143

LITERATURE: South Kensington Museum 1872, no. 91, p. 14; Japan Society 1905 (exh. cat.), no. 1, p. 55

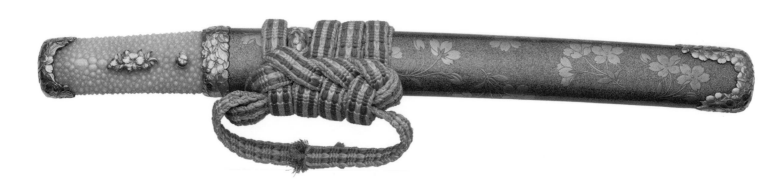

TSUNAIE (ACTIVE 1532–55); ?TAKAHASHI YOSHITSUGU (ACTIVE 1842–73)

DAGGER (TANTŌ) AND SHEATH, *c.*1550

Steel, wood, copper, gold, silver

35.4 × 3.5 × 3.0 cm

Tantō blade signed on the tang: *Tsunaie saku* ('Made by Tsunaie')

RCIN 62625.a–c

PROVENANCE: Acquired by Prince Alfred, Duke of Edinburgh in Japan, 1869

6.2 Photograph in South Kensington Museum, *A Guide to the Works of Art and Science Collected by Captain His Royal Highness the Duke of Edinburgh, K.G. During his Five-Years' Cruise Round the World in H.M.S. 'Galatea' (1867–1871) and Lent for Exhibition in the South Kensington Museum*, 3rd edn, London, 1872, unpaginated

This elegant dagger has a side-knife (*kogatana*) with decoration of bamboo, a theme which extends into the other silver fittings. Further silver and gold fittings are of a snail and a mythical lion–dog (*shishi*). The silver collar of the hilt is signed *Yoshitsugu han* ('seal mark of Yoshitsugu') and we may assume that all the silver fittings are by the same maker. This is probably Takahashi Yoshitsugu of the Tanaka–Tōryūsai school of sword-fitting makers, who worked in Edo during the period 1842–73. His involvement suggests that the earlier blade was remounted in the taste of the late Edo or early Meiji period.

Little is known of the swordsmith Tsunaie, except that he was working in the castle town of Odawara in Sagami Province (part of modern-day Kanagawa Prefecture) from about 1532 to 1555 and had the given name of Heisaburō. The blade is double-edged in the style known as *moroha-zukuri* with a central ridgeline, but with little visible tempering pattern (*hamon*). The dagger's collar (*habaki*) is of copper with applied gold.

The *tantō* and sheath appear in one of the few photographs of objects loaned by Prince Alfred, Duke of Edinburgh to the South Kensington Museum in 1872, after his visit to Japan three years previously (Fig. 6.2). In 1910, they were loaned with other arms and armour at Windsor to the Japan-British Exhibition at White City.[14] GI

INVENTORIES: Clarence House 1875, p. 69; WC North Corridor, no. 2145

LITERATURE: South Kensington Museum 1872, no. 606, p. 45

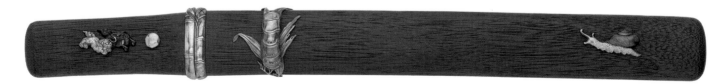

Steel, lacquered wood, *shakudō*, copper, gold leaf, silver

79.1 × 4.3 × 4.6 cm

Blade signed on the tang: *Sōshū ju Hirotsugu saku*
('Made by Hirotsugu of Sōshū province')

RCIN 72783.a–b

PROVENANCE: Presented to George IV when Prince Regent
by James Duff, 4th Earl Fife, 23 April 1813

The presentation of this sword to the Prince Regent in 1813 may be the earliest documented arrival of a Japanese blade in Britain. It was given by James Duff, 4th Earl Fife (1776–1857) on 23 April that year and subsequently displayed in the Armoury at Carlton House. Duff had fought in the Napoleonic Wars in Spain between 1808 and 1811, and may have acquired the sword there, for it was originally thought to be 'A Curious Old Sword of one of the Moorish Kings of Spain.'[15]

Between 1853 and 1855 it was photographed by Charles Thurston Thompson (1816–68), who went on to become the South Kensington Museum's first official photographer (Fig. 6.3). By this date the sword was known to be Japanese, and it may have been an appealing subject because of its 'exotic' workmanship.[16] One of the resulting prints was included in an album of photographs belonging to Prince Albert that showed arms and armour at Windsor Castle (RCIN 2369573).

There are few remaining forging details on the blade but the elegant curvature and the groove (*hi*) near the upper edge all indicate good workmanship. There were several smiths who used the signature *Hirotsugu*, but this is most likely to be the one working in Sōshū (Sagami) Province (part of modern-day Kanagawa) around 1550. The blade is decorated on both sides with a carving (*horimono*) of a dragon wrapped around a Buddhist ritual sword (*ken*). The tang (*nakago*) is pierced with two holes indicating that it has been remounted on at least one occasion. It is now mounted as a short sword with no hand guard (*koshigatana*) in a dark brown, perhaps once black, lacquered scabbard.

The decoration of the fittings suggests that the sword was mounted for the export market. In the seventeenth and eighteenth centuries, a style of metalwork known as *sawasa* was produced for the Dutch East India Company in and around Nagasaki and, following Japan's closed country (*sakoku*) edicts, from around 1639 by exiled Japanese craftsmen working in Batavia, where the market for *sawasa* was a profitable one. The idea of *sawasa* was that objects made from a copper alloy were given gilt relief decoration with black lacquered highlights to achieve the appearance of *shakudō*, but at a much cheaper price. The extensive metalwork here resembles *shakudō*, but is likely to be *sawasa* with

highlights in gold and silver. The ground is covered with fine punch marks in a pattern resembling fish roe (*nanako*), although the punch marks are not completely uniform. The wooden hilt is covered on each side with panels of copper, hammered in imitation of ray skin and overlaid with gold leaf; the metalwork which covers this simulates silk braids. Overall, the fittings are incredibly detailed and seem to be the work of several craftsmen. The scabbard has a slot for a side-knife (*kogatana*) which is now missing.

The decorative scheme includes discreet paulownia leaves in relief, a motif normally reserved for high-ranking samurai and aristocrats. Other relief elements include phoenixes, wild boars, birds of various types, flowers and grasses, cherry blossom, pine, horses, long-tailed squirrels, deer, goats, chickens, wasps, dragonflies, monkeys, cranes, ducks, fish and butterflies. The attention to detail and the extensive decoration create an impressive overall effect. **GI & RP**

INVENTORIES: CH AA, III, no. 2345; WC North Corridor, no. 1659
LITERATURE: Thomas 1995, p. 69

6.3 Charles Thurston Thompson (1816–68), *Japanese Swords*, 1856. Albumen print, 22.9 × 17.9 cm, RCIN 2369586. Cat. 90 appears centre and right; the short sword (*wakizashi*) on the left is also in the Royal Collection (RCIN 67469)

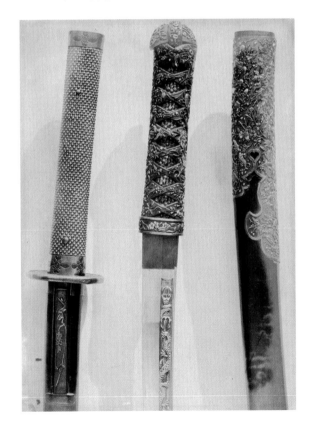

FUJIWARA YASUTSUGU (ACTIVE 1860)
SWORD (KATANA), 1860

Steel, lacquered wood, *shakudō*, gold, mother-of-pearl, ray skin, silk

106.1 × 8.0 × 7.2 cm

Blade signed and dated: *Ansei shichi nen ni gatsu hi* ('A day in the second month of the seventh year of Ansei [March 1860]'); *Mo taimei Higo Daijō Jūichi-dai Fujiwara Yasutsugu kin tan* ('Respectfully made by Eleventh Generation Fujiwara Yasutsugu, Assistant Lord [honorary title] of Higo Province [modern-day Kumamoto Prefecture]')

RCIN 62623.a–d

PROVENANCE: Sent to Queen Victoria by Shōgun Tokugawa Iemochi, 1860

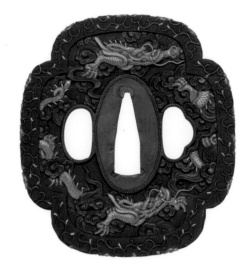

The blade of the *katana* is finely forged with a strong tempered-edge pattern (*hamon*) called *gunome* (horse teeth). The black lacquer scabbard has alternate bands of mother-of-pearl and the hilt is bound in ray skin with black silk braiding. Under the binding is a gold fitting (*menuki*) in the form of a dragon. A *menuki* is said to improve the user's grip in combat, fitting strategically in the palm of the hand. The pommel (*kashira*) and collar (*fuchi*) are of *shakudō* with gold dragons in relief. The sword guard (*tsuba*), side-knife (*kogatana*) and bodkin (*kōgai*) are also of *shakudō* with relief gold dragons; all the metal fittings have a *nanako* (fish roe) ground and are typical of the Gotō school, the official court makers to the shōgun.

The tang of the blade carries the same date and signature as cat. 82. GI

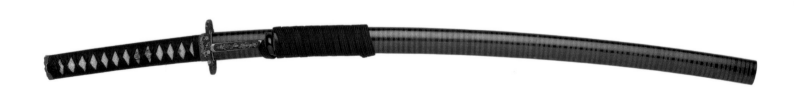

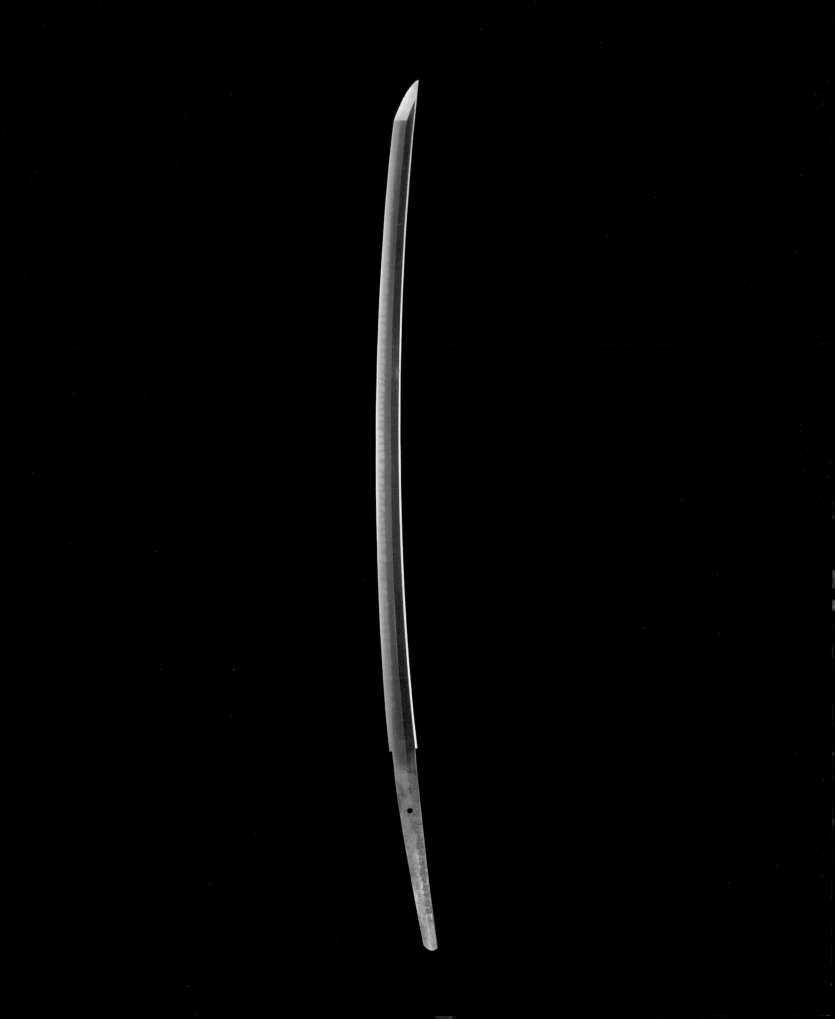

92

RAI KUNIMITSU (ACTIVE 1326–51);
HON'AMI FAMILY

PAIR OF LONG (KATANA) AND SHORT (WAKIZASHI) SWORDS, TOGETHER FORMING A DAISHŌ

Katana 1300–50; *wakizashi* 1600–1700; *mounts* 1700–1800

Steel, lacquered wood, gold, *shakudō*, gilt-copper alloy, silk, ray skin

92.0 × 7.4 × 7.4 cm (*katana*); 68.0 × 6.5 × 6.5 cm (*wakizashi*)

The *katana* with gold inlaid inscription *Rai Kunimitsu*, gold inlaid appraisal signature *Hon'ami* and art mark (*kaō*). The *wakizashi* unsigned

RCINS 72786.a–b (*katana*), 62627.a–d (*wakizashi*)

PROVENANCE: Probably acquired by Prince Alfred, Duke of Edinburgh

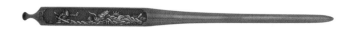

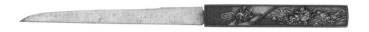

In the Momoyama period (1573–1615), paired swords became more prevalent and it was around this time that the fashion for *daishō* mounted as a matched pair became fully established. The metal fittings of the swords were often decorated with a regular theme or design. Only the samurai were permitted to carry the *daishō* – which they were required to wear at the shōgun's court – and this became the defining style of sword mounting for those who could afford such fine quality lacquer and metalwork.

The decorative theme on the lacquer scabbards and metal fittings of this *daishō* is the dragon, a powerful creature in Japanese mythology with links to both Buddhism and Shintō. The fine gold *makie* lacquer scabbards feature a dragon in low relief (*hiramakie*) chasing the Buddhist pearl of enlightenment. All the fine copper alloy mounts by the Gotō school are of high-quality *shakudō* with a *nanako* (fish roe) ground and highlights in gold. Of significance is the use of the paulownia (*kiri*) crest highlighted in gold on the metal fittings. This crest was, apart from a brief period in the late sixteenth century, reserved exclusively for the imperial family.

It is not uncommon for the two *daishō* blades to be by different makers, and indeed it is rare to find both by the same maker. The *wakizashi* blade here is unsigned but dates to the early Edo period, with a strong tempering pattern (*hamon*) known as clove flowers (*chōji*) and horse teeth (*gunome*). However, the *katana* is a heavily shortened blade of the early fourteenth century. It bears the gold inlaid signature of Rai Kunimitsu (active 1326–51), who is thought to have been the son (or student) of Rai Kunitoshi (see cat. 87). The grain of the steel and the refined, straight tempering pattern (*suguha*) are indicative of his work.

In the remounting process, the *katana* blade would have been shortened at the tang (*nakago*), resulting in the loss of the original signature. The remounting was undertaken by the Hon'ami family, who were awarded the title *Tenka no Tōken Mekikijo* ('National Office for Sword Appraisal') during the Edo period. As well as providing certificates of authenticity for blades, the family cut down long early swords and remounted them in the style and taste of current period. They would often inlay the name of the original smith (although not copying his signature), as well as their own name, or simply the character 'Hon', together with their art seal (*kaō*) in gold on the tang of the blade. Ownership of a blade by Kunimitsu would have been extremely desirable. GI

INVENTORIES: WC North Corridor, nos 2144 (*wakizashi*) and 2147 (*katana*)

LITERATURE: Japan Society 1905 (exh. cat.), no. 10, p. 56[17]

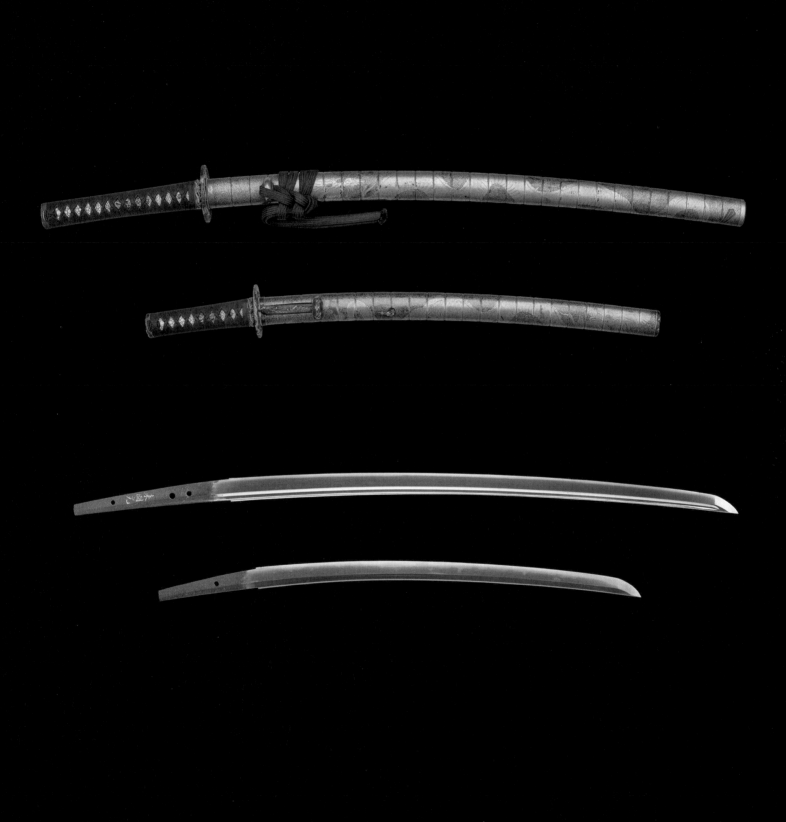

93

SAKYŌNOSUKE YASUMITSU (YASUMITSU II)
(ACTIVE 1421–44)
**COURT-STYLE SWORD (KAZARIDACHI) AND
SCABBARD**, 1421–44 (BLADE); 1750–1850
(MOUNTS)

Steel, lacquered wood, *shakudō*, gold, turquoise, enamel,
ray skin, leather

93.8 × 12.8 × 5.0 cm

Blade signed on the tang: *Yasumitsu*

RCIN 62628.a–b

PROVENANCE: Presented to King Edward VIII when Prince of
Wales by Count Matsudaira of Takamatsu, Inland Sea, and by
him to King George V, 1922

Elaborately mounted swords of this kind were worn from the tenth century until the late nineteenth. They were purely ceremonial, rather than being used in combat, and were carried by imperial courtiers and high-ranking samurai. The lacquer decoration of the scabbard includes numerous instances of the Tokugawa family crest – three leaves of the *aoi* (wild ginger) plant, often erroneously referred to as 'hollyhock' leaves. The use of *aoi* continues into the superb *shakudō* openwork metal fittings which are also decorated with engraved scrolling Chinese grasses (*karakusa*) and gold lotuses in relief. The hilt is of the finest ray skin and has gold fittings in the form of auspicious rice-bales.

The Tokugawa crest is testament to the links between the ruling Tokugawa family and that of the Matsudaira clan, the traditional rulers of the Takamatsu domain (now Kagawa Prefecture). The fine sword was very likely a Matsudaira family heirloom and so deemed a worthy gift for so important a guest as the Prince of Wales. During the prince's visit in May 1922, Count Matsudaira gave a banquet in his honour which was said to have taken 300 people over a week to prepare. A *Nō* play was performed, followed by a dance by twelve *geisha* wearing 'silk kimonos especially woven for the occasion, in which Union Jacks and the Rising Sun were intermingled'.[18] On his return to Britain, the prince in turn presented this superb sword to his father, King George V.[19]

The steel blade is signed *Yasumitsu* (Sakyōnosuke Yasumitsu, known as Yasumitsu II) of Bizen Province in western Japan. His father, Uemonnojō Yasumitsu, was one of the most renowned smiths of the Bizen school. The tang (*nakago*) has several holes, indicating that it has been remounted several times. The present lacquer and metal mounts probably date to about 1750–1850. **GI & RP**

INVENTORIES: WC North Corridor, no. 2440

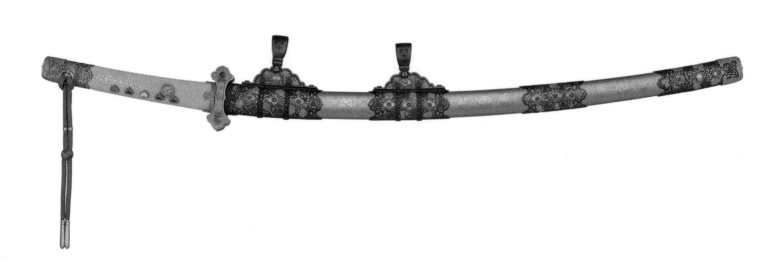

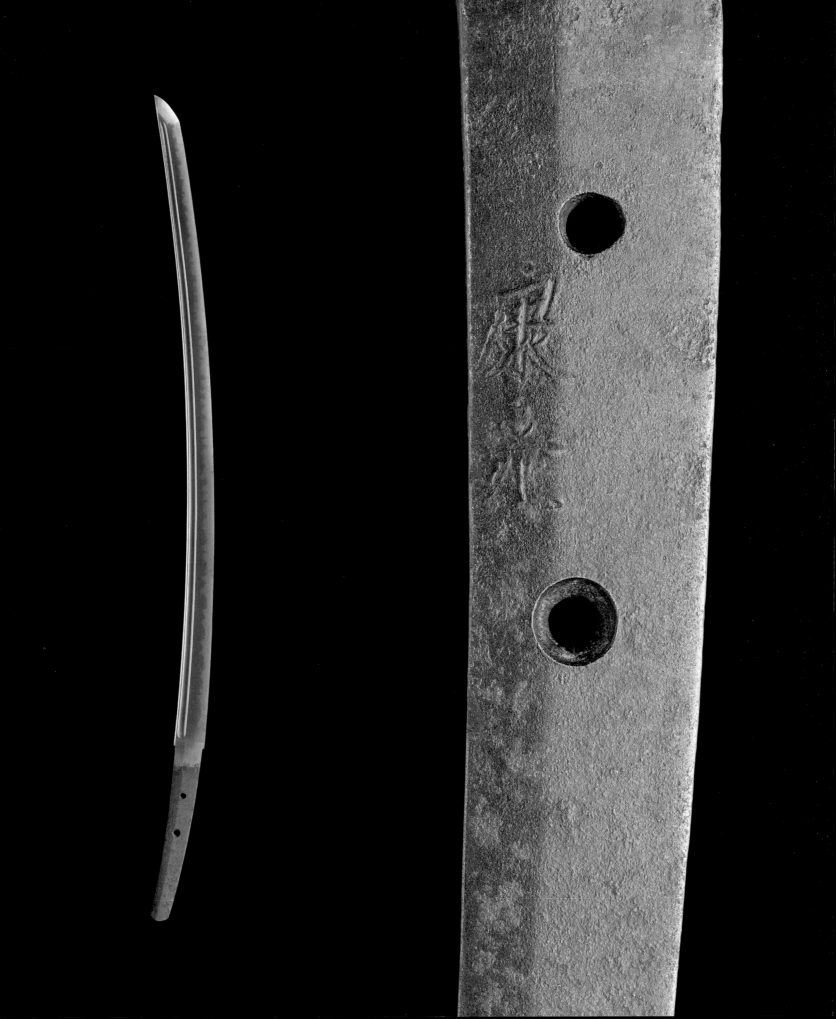

GOTŌ SCHOOL (FITTINGS, PROBABLY)
SWORD (TACHI) AND SCABBARD, 1700–1800

Steel, copper alloy, lacquered wood, *shakudō*, silk, leather
100.0 × 7.9 × 7.0 cm
RCIN 72787.a–b
PROVENANCE: First recorded in the current reign (1952–)

Before 1400, many swords were mounted in rugged and practical leather mountings which were ideally suited to long periods of campaigning. Around this time, however, a new and distinctive form of mounting was introduced. This was the *itō-maki no tachi* (cord-wrapped *tachi*), where the area of the lacquered scabbard between the two suspension fittings was wrapped in silk braiding to prevent the expensive lacquer from rubbing and abrading against armour.

The scabbard for this sword is of fine gold-sprinkled (*makie*) lacquer decorated with two *mon*. The stylised flower under an unidentified structure may be the crest of the Itō clan; the flower with three petals separated by stylised Buddhist sword blades (*ken*) remains unidentified. The silk cords which protect the scabbard and secure the sword when worn are woven in the hexagonal pattern known as turtleshell (*kikkō*).

The metal fittings are an alloy of copper and gold known as *shakudō*, which patinates to a rich purple-black. The warlord Toyotomi Hideyoshi (1537–98) once likened the colour of *shakudō* to that of 'raindrops on a crow's wing'.[20] The sword guard (*tsuba*) is of the typical *tachi*-style four-lobed *mokkō* shape with the intersections in the form known as boar's-eye (*inome*).

The unsigned blade dates from the period 1700–1800. It has an elegant tempering pattern (*hamon*) of the shape known as *notare* and has slight, though quite visible, metal crystalline structures emanating from the edge in the effect known as *sunagashi* ('drifting sand'). GI

95

**PAIR OF SLUNG SWORDS
(ITŌ-MAKI NO TACHI)**, 1860

Steel, lacquered wood, *shakudō*, gold, copper alloy,
silk with silver and gold thread, leather

103.1 × 7.8 × 12.8 cm (RCIN 62622.1);
103.5 × 7.4 × 11.7 cm (RCIN 62622.2)

RCIN 62622.1. Blade signed and inscribed on the tang:
Mo Taimei Ishidō Fujiwara Korekazu Sei-tan kore o tsukuru
('Ishidō Fujiwara Korekazu respectfully forged this at your
honourable request') and *Ansei shichi nen, shō-gatsu hi*
('Seventh year of Ansei, a day in the first month' [1860]).

RCIN 62622.2. Blade signed and inscribed on the tang:
Ishidō Korekazu kore o tsukuru ('Ishidō Korekazu made this')
and *Man'en gannen hachi gatsu hi* ('A day in the eigth month
of the first year of Man'en' [1860])

RCIN 62622.1–2

PROVENANCE: Possibly sent to Queen Victoria by
Shōgun Tokugawa Iemochi, 1860

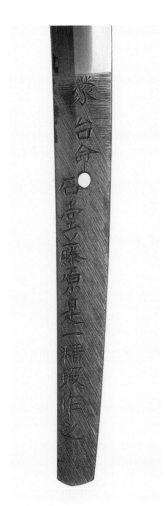

The signature on each blade, 'Ishidō [Fujiwara] Korekazu', denotes
Unju Korekazu, a pupil of Chōunsai Tsunatoshi who was regarded as
the seventh-generation master of the Ishidō school. He was retained
in the capital by the shogunate and was therefore in an excellent
position to produce swords for diplomatic gifts towards the end of the
Edo period. The first sword of this pair (RCIN 62622.1) has an identical
signature and date to a *tachi* blade in the V&A which was part of the
1860 diplomatic gift to Queen Victoria from Tokugawa Iemochi.[21] Both
blades have a similar tempering pattern (*hamon*) of clove flowers (*chōji*)
and strong horse teeth (*gunome*). The V&A has another blade from
the same gift with a similar *hamon*, signed with a simpler signature
by Korekazu.[22] These similarities suggest that the present swords may
also have been from the 1860 gift, though it is possible that they could
be undocumented gifts from the 1862 Japanese diplomatic mission to
the West.

The swords are almost identically mounted in the *itō-maki no tachi*
(cord-wrapped *tachi*) style. The silk cords are woven in the hexagonal
pattern known as turtleshell (*kikkō*). All the metal fittings are made
of *shakudō*, and their ground is finely hammered in tiny regular dots
(*nanako*), with details in gold. They are all decorated with various forms
of cherry blossom in high relief, delicately carved and with details in
gold. These metal fittings are typical of the type of work produced by
the Gotō school, official makers to the Tokugawa shogunate. GI

INVENTORIES: WC North Corridor, no. 1865

LITERATURE: Japan Society 1905 (exh. cat.), nos 6–7, p. 56[23]

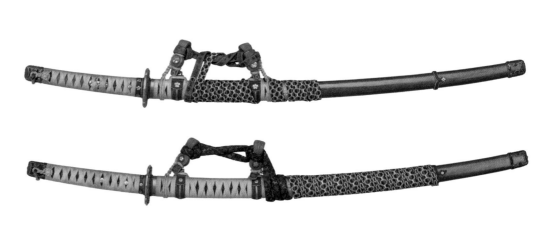

GASSAN SADAKAZU (1836–1918)
FIELD MARSHAL'S SWORD (GENSUITŌ), SCABBARD AND STORAGE BOX, 1918

Steel, *shakudō*, *shibuichi*, gold, silver, leather

93.0 × 6.5 × 7.0 cm (sword and scabbard, overall);
13.2 × 106.0 × 18.3 cm (storage box)

Blade signed and inscribed on the tang: *Teishitsu Gigei'in Gassan Sadakazu hachijūsai kin saku* ('Gassan Sadakazu, Imperial Household Artisan, respectfully made this at age 83') and *Taishō shichi nen san gatsu kichi jitsu* ('[On] a lucky day in the third month, seventh year [of the reign of Emperor] Taishō [1918]')

RCIN 62630.a–d

PROVENANCE: Presented to King George V by Prince Higashi-Fushimi Yorihito on behalf of the Emperor Taishō, 29 October 1918

This is the only known sword of its kind outside Japan. It is a *Gensuitō* – a formal sword given by the emperor to those of the rank of Field Marshal (*Dai Gensui*) or Admiral. In the Meiji period there were only eight such awards; in the Taishō period there were 12.[24] This example was a diplomatic gift to King George V from the Emperor Taishō, carrying with it the honorary rank of *Dai Gensui*.

The elegant blade has a straight, misty-edged tempering pattern (*suguha hamon*). It is made in the style of the earliest recorded Japanese blade to have a deliberately forged curve. That blade, known as *Kogarasu Maru* (the 'Little Crow'), is in the collection of the Japanese Imperial Household. It is believed to have been forged by the semi-legendary smith Amakuni, who may have lived in Yamato Province during the eighth century.

The scabbard and mounts are of the finest quality, and both the scabbard and hilt have a wooden core covered with the copper–silver alloy *shibuichi*. The borders of the scabbard and hilt are of gold, engraved with scrolling chrysanthemums. The hilt is of the style called *kenuki-gata* ('tweezer-shaped') and the 'tweezers' are inset with the 16-petalled imperial chrysanthemum, which can also be seen on the scabbard between the suspension fittings. Originally the hilt would be cut through with a longitudinal slot, which may have been a device to absorb some of the shock received by the sword when cutting.

The blade is inscribed with the signature of Gassan Sadakazu, who in 1906 was appointed Imperial Household Artist (*Teishitsu Gigei'in*). The only published account of this blade speculates that it was in fact made by his son, Gassan Sadakatsu. This is based on the rather slim speculation that one stroke of the first character '*Sada*' has been cut in a style more like that of Sadakatsu.[25] However, it seems highly unlikely that a blade for such an important diplomatic gift would have been entrusted to the son and not made by the Imperial Craftsman himself. GI

INVENTORIES: WC North Corridor, no. 2488
LITERATURE: Siong 1998, pp. 8–15; Sinclaire 2008, pp. 4–6

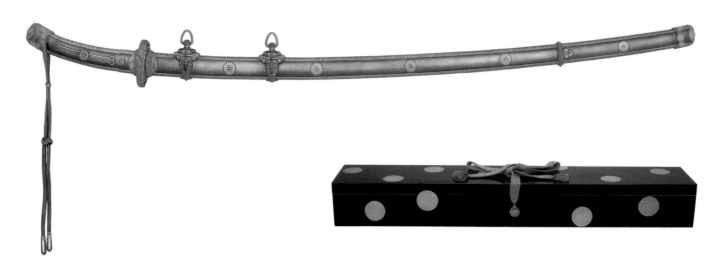

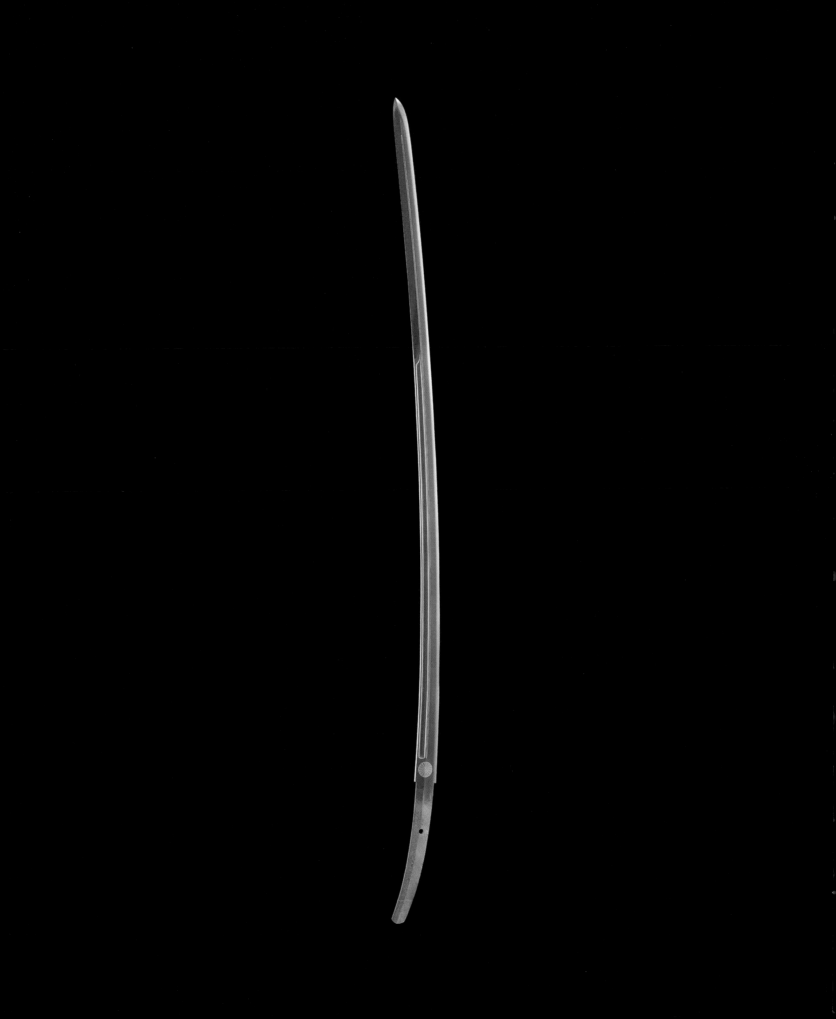

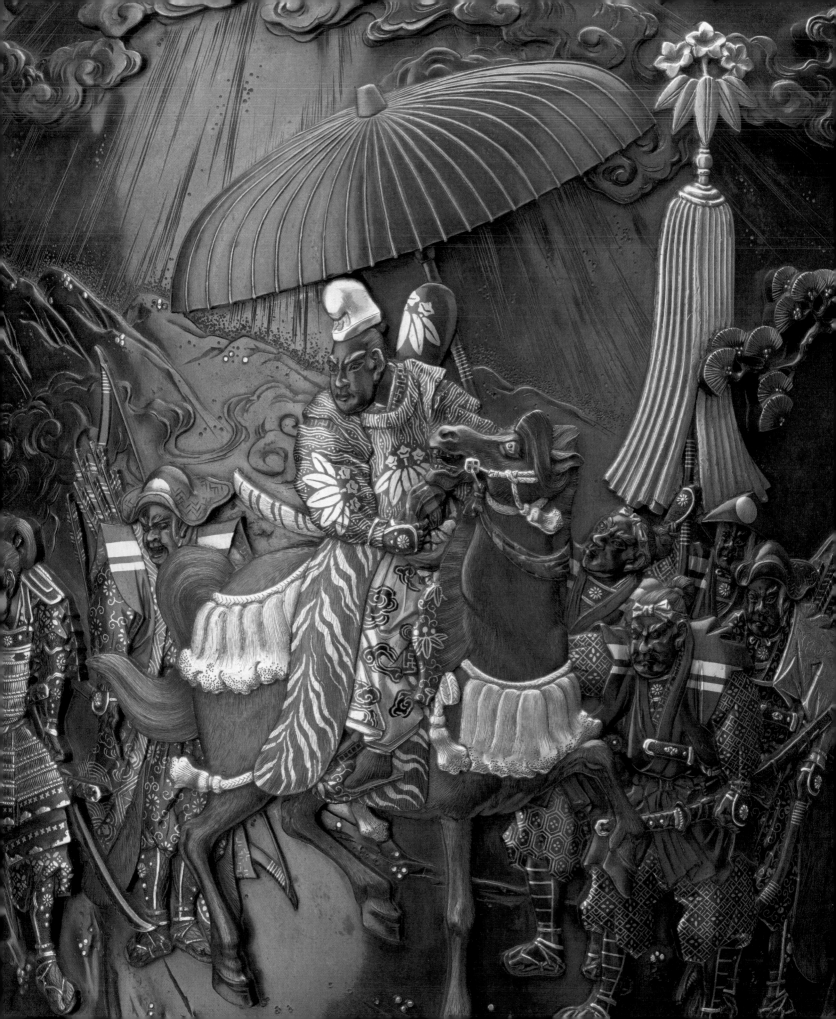

日本の芸術

7

METALWORK

KATHRYN JONES

METALWORK in Japan was traditionally concerned with objects cast from iron or bronze, largely to create works for Buddhist ritual, utilitarian wares for tea gatherings and elements of arms and armour, though decorative objects were produced as well. With the suppression of the samurai and the ban on wearing swords in 1876 (see p. 132), many metalworkers turned their skills to the creation of decorative objects, particularly for the export market. Many of these were embellished with inlays, enamelling or areas of patination, producing colourful effects on the surface of the metal. At the same time, they began experimenting with enamelling to produce new decorative finishes. All these techniques were derived from mainland Asia, and had been well known in Japan from at least the seventh century, but were continually developed and refined so that by the time of the Meiji Restoration highly complex and sophisticated works were being produced.

The casting of iron or bronze was achieved using the lost-wax method, whereby an object would be created from a core material and covered in wax, the outer surface of which would then be modelled and coated in clay. The whole was then heated so that the wax melted away, creating a hollow into which the molten metal was poured. At its simplest, such a technique was used to produce objects used in traditional tea gatherings, such as cat. 97. The iron bears a relief design integrated into the surface through casting, with no further enhancement other than a russet-coloured patination of rust. Rusting was considered a desirable decorative feature, fitting with the aesthetic of *wabi sabi*, an appreciation of rustic simplicity and transience.

One of the more common decorative techniques on Japanese metalwork is *zōgan* or inlay, produced with either narrow wires (*ito zōgan*) or broader areas (*hira zōgan*) of a

contrasting metal laid into an iron or bronze base. Such inlays were traditionally used to decorate the fittings of swords, each individually designed and inlaid in minute detail. When these *zōgan* techniques were transferred to decorative objects, they were often used to create pictorial designs such as the scenes from the legend of Yamato on cat. 99, on which tiny elements of plants, landscape or figures have been picked out in silver and gold. Inlaid areas were often hammered to sit flush with the base metal of the object but they might also be produced in relief, such as the flowers on a pair of vases (cat. 102).

Precious metal inlays of gold or silver were common, as was lead to give a duller finish, but various alloys were also used to create a subtly colourful design. These included copper alloys, which often produce red shades; *shakudō*, an alloy of copper and gold, which is a rich purple-black colour; and *shibuichi*, an alloy of silver and copper, which produces grey tones. In turn, these inlays could be treated by applying chemicals to produce a patination that darkened or altered the surface of the metal. The patina might be derived from materials like daikon radish or *saké*, or the inlaid object could be submerged in tea at the final stages to allow the tannic acid to react with the metals. This subtle palette may be seen in the decoration on several vases in the Royal Collection (cats 100 or 101, for example),

often in the portrayal of natural objects such as fruit or flowers. Alternatively, the inlays might be decorated using hammered or chiselled surface finishes, creating dense and complex patterns, such as those found on the table cabinet (cat. 106). The cabinet is associated with the firm of Komai, one of the most renowned producers using this technique.

A few works presented to members of the royal family in the late nineteenth and early twentieth centuries were produced in silver, perhaps seen as more acceptable to a European recipient. Such pieces include the model of a recumbent stag (cat. 98) and the cockerel on a drum (cat. 107). Nevertheless the latter work displays traditional Japanese metalworking techniques – the drum is inlaid with an alloy which forms the *tomoe* motif symbolising permanence.

(FIRM OF) NIZAEMON
VASE, 1900–1910

Cast iron

27.3 × 23.0 × 23.0 cm

Signed on the base: 仁左エ門釜 (*Nizaemon-gama*; 'Made by Nizaemon')

RCIN 42343

PROVENANCE: Probably acquired by King Edward VIII when Prince of Wales in Japan, 1922

This vessel, with a discreet moulded band encircling the shoulder, its purposely unpolished surface and simple outline, perfectly characterises the aesthetic of *wabi sabi* and *shibui*. The first two terms derive from Buddhist philosophy and encapsulate an understated elegance or rustic simplicity (*wabi*) and the beauty or serenity that comes with age, such as the impermanence evident in surface patina and wear (*sabi*). The two concepts are often combined to describe acceptance of the transience of life and an appreciation of imperfection, impermanence and incompleteness. *Wabi sabi* is complemented by *shibui*, the appeal of simplicity, subtlety and unobtrusive beauty. Cast iron is an ideal material to embody such an aesthetic – its surface naturally liable to patina. In places, the ribs which flank the central band of scrolling foliage and fruit on this vessel are interrupted, enhancing the sense of impermanence.

This object has traditionally been associated with the gifts received by the Prince of Wales during his visit to Japan in 1922, although it does not appear in any of the official lists. KJ

JAPAN

STAG, *c*.1860–65

Silver, patinated silver alloy, bone, enamel

10.8 × 22.0 × 13.5 cm

RCIN 41631

PROVENANCE: Sent to Queen Victoria by Shimazu Tadayoshi, *daimyō* of Satsuma domain, 1865

This stag was a gift to Queen Victoria from the Satsuma domain, indicating a new era of friendship after the British bombardment of Kagoshima in August 1863. In 1865, 15 students from Satsuma came to study in Britain – an extremely risky venture, since legally the borders of Japan remained closed and its people faced severe punishment, even death, if they departed. The voyage was seen, however, as a crucial opportunity to gain information on industrialisation and engineering, knowledge which was felt to be lacking in Japan at the time, and to strengthen diplomatic ties between Britain and Satsuma. To this end, two gifts were presented by the delegation shortly after their arrival (see also cat. 52). During the subsequent three years until the Meiji Restoration, the Satsuma domain was considered an ally of Britain.

Deer were traditionally considered divine messengers, holding sacred status, and a model of a stag was therefore perhaps a suitable diplomatic gift. It was also reminiscent of the deer around the queen's beloved Highland home in Balmoral. Figures of recumbent deer were produced in Imari porcelain for export from the late seventeenth century. A pair was recorded, for instance, at Burghley House in 1688.[1] The form remained popular in Japan, with porcelain versions being created throughout the nineteenth century, often with a matt glaze applied to the nose and hooves. A cream-glazed version was also produced in Satsuma ware in the 1850s.[2] The pose of this stag closely resembles those porcelain versions. The silver body has been engraved and burnished to give the appearance of the distinctively spotted hide of the sika deer native to Japan. KJ

INVENTORIES: Osborne 1876, no. 863, p. 342

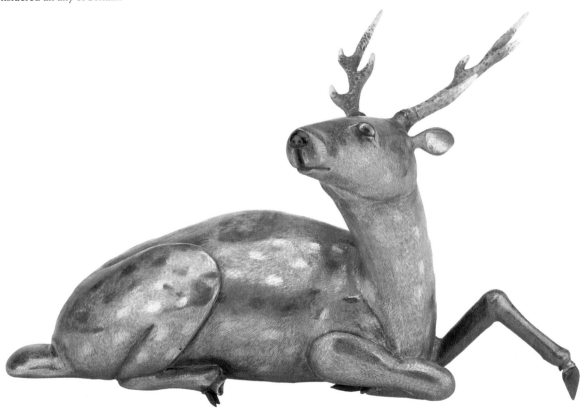

JAPAN
PAIR OF VASES, c.1880

Bronze, gold, silver
55.5 × 27.5 × 26.5 cm
RCIN 7798.1–2
PROVENANCE: First recorded at
Sandringham House in 1889

These vases use the full array of metalworking techniques and a
palette of subtly coloured inlays to present four dramatic scenes
from the legend of Prince Yamato (Yamato Takeru No Mikoto).
Each vase has been cast in deep relief, then chased and inlaid with
gold, silver and copper alloys to produce minute details, including
patterned textiles and individual pine cones, as well as broader
areas such as snow on the peak of Mount Fuji.

The legend of Yamato Takeru describes the hero as a youth,
'great of stature, strong and fearless and skillful in the use of arms',
who determines to kill the demon boar rampaging through the
forest of Hakone.[3] Accompanied by huntsmen who help him to
flush out the beast, startling hares as they do so, Yamato attacks the
boar. Warned by a high priestess that the demon's only vulnerable
spot is its tail, he manages to leap on its back and slice off its tail
with a sacred sword. Maddened by pain, the boar demon plunges
into an abyss. One vase shows huntsmen beating the ground with
bamboo canes and hares running into the undergrowth; the reverse
shows Yamato riding backwards on the boar, his hand grasping its
tail as he raises the sword to strike. The other vase shows warriors in
forest landscapes, with trails of smoke rising. These may also relate
to the story of Yamato, who, after defeating the boar, is invited to
hunt deer in Sagami (modern-day Kanagawa Prefecture), where
a fire overtakes his party. The hero saves the day by cutting the
surrounding grasses and kindling a counter fire to draw the flames
away.[4] The mythical quality of the vases is enhanced by the handles
and decorative heads around the bases, which are cast in the form
of phoenixes. **KJ**

LITERATURE: Ayers 2016, III, nos 2239–40, p. 1028

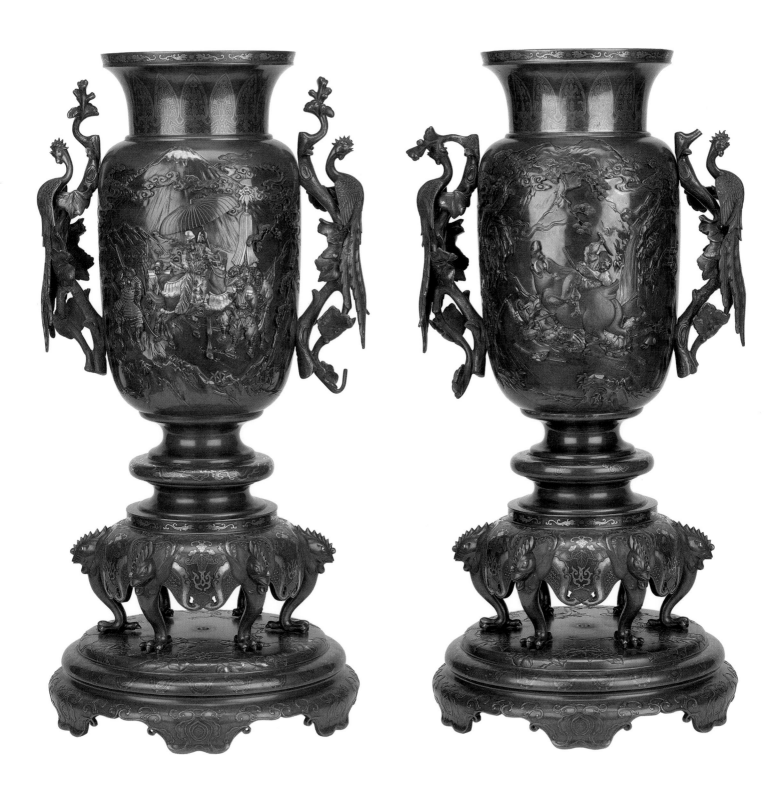

Brass (copper alloy), gold, silver, *shibuichi* and copper,
partly patinated

51.0 × 28.0 × 28.0 cm

RCIN 70174.1

PROVENANCE: Presented to Queen Victoria by
Prince Arisugawa Taruhito on behalf of the
Emperor Meiji, 25 November 1882

This vase, one of a pair, appears to have been among the gifts
sent to Queen Victoria by the Emperor Meiji and presented by
his envoy Prince Arisugawa Taruhito on 25 November 1882.
The prince was a member of the Japanese Council of State and a
general in the Imperial Japanese Army. The purpose of his 1882
voyage was ostensibly to negotiate with Alexander III of Russia,
but he also visited Britain before travelling to the United States
of America to meet President Ulysses S. Grant. Queen Victoria
described his visit to Windsor in her Journal, noting that 'The
Prince is very small, but a great personage in Japan. He made a
speech in a very low voice … and presented me with 2 beautiful
closionné enamel vases & an inkstand'.[6] The *Illustrated London
News* similarly recorded the visit but noted only that 'his Imperial
Highness' [brought] 'presents of Japanese workmanship'.[7]
Queen Victoria may have misunderstood the techniques used
on these objects or perhaps mistook the colourful surface of
the inlaid metals for enamel. Whatever the reason, the historic
inventories certainly list the vase as one of the emperor's gifts,
and its provenance may be confirmed by the incorporation of the
chrysanthemum *mon* into the design on either side of the neck,
indicating an imperial commission. KJ

INVENTORIES: WC Bronzes, no. 168

LITERATURE: Ayers 2016, III, no. 2238, p. 1027

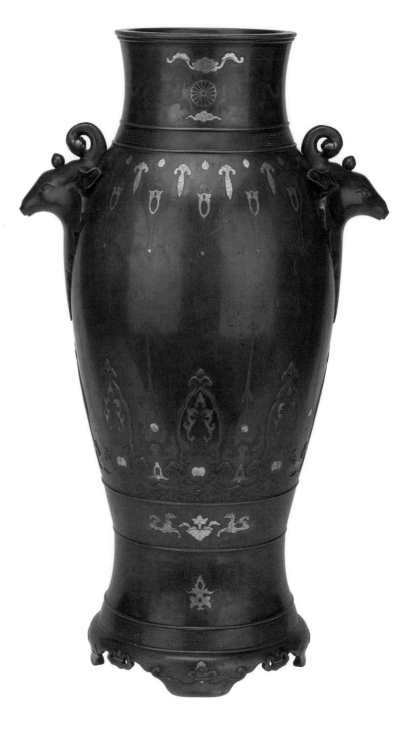

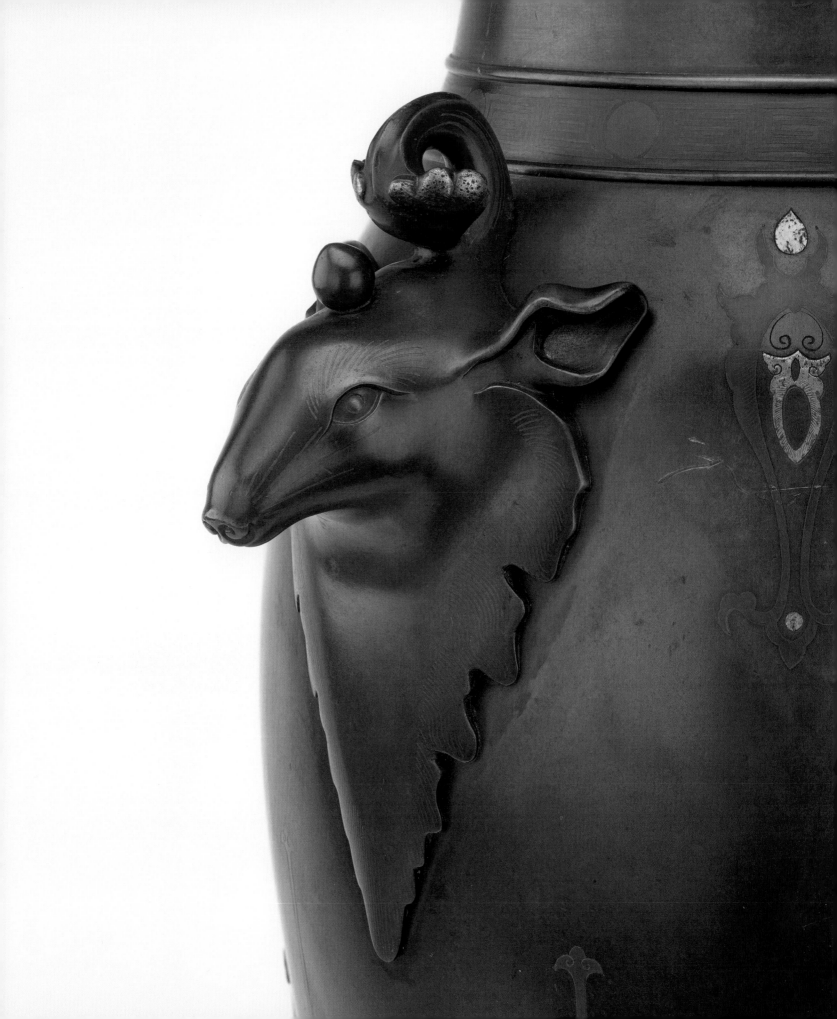

101

HIRAOKA CHŪZŌ AND YAMAKAWA KŌJI
OF THE KANAZAWA BRONZE COMPANY
(EST. 1877), KAGA
PAIR OF VASES, 1877–82

Copper alloy, silver, gold and copper alloys, partly patinated

53.5 × 25.5 × 25.5 cm

Each inscribed on the base: 大日本[帝国石]川縣加賀国金澤
(*Dai-Nihon Teikoku Ishikawa-ken Kaga no kuni Kanazawa*;
'The Empire of Japan, Ishikawa Prefecture, Kaga Province,
Kanazawa') and [銅]器會[社], 平岡忠蔵, 山川孝次
('*Dōki Kaisha, Hiraoka Chūzō, Yamakawa Kōji*')

RCIN 7797.1–2

PROVENANCE: First recorded at Sandringham House in 1934

Founded in 1877, Dōki Kaisha changed its name to the Kanazawa
Bronze Company in 1882. The firm concentrated on export ware and
in the 1880s employed around 50 specialist metalworkers. They were
renowned particularly for their *zōgan* (metal inlay) techniques, often
named *Kaga zōgan*, after the province in which the firm was based.
Characteristically, both *hira zōgan* (flat inlay) and *ito zōgan* (thread-
like inlay) have been used in the decoration of this pair of vases: one
shows chrysanthemum, peony and camellia flowers, and the other,
lychee, lemons and persimmons, the surface of each bloom or fruit
carefully varied. Thus, the lemon skins and bark of the branches
are slightly textured and stippled, whereas the persimmon fruits
are highly polished and the lychee fruits have been created with a
complex pattern of gold and copper alloys intricately inlaid together.
Ito zōgan has been used on the ribs and feet of each vase to create fine
geometric decoration.

The provenance of these vases is not recorded, although they were
evidently converted for use as lamps by 1934, when they were first
photographed in the Dining Room of Sandringham House. KJ

LITERATURE: Ayers 2016, III, nos 2241–2, p. 1029

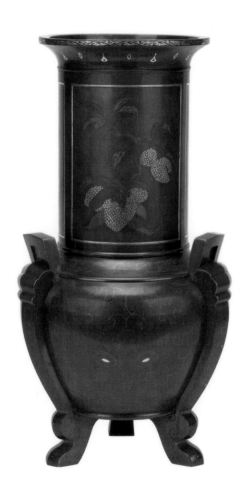
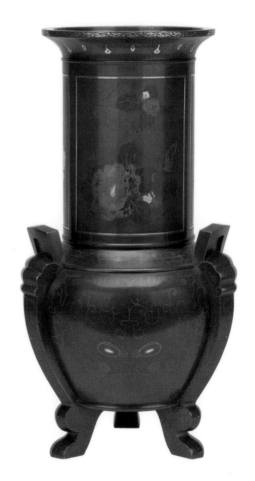

102

JAPAN, WITH LATER ADDITIONS BY
HINK & SONS, BIRMINGHAM
PAIR OF VASES, c.1880–1900

Bronze, copper alloy, silver, *shakudō*, partly gilded and
patinated

43.5 × 23.5 × 17.5 cm

RCIN 7322.1–2

PROVENANCE: In the Royal Collection by 1920

The relief and inlay on this pair of vases includes sprays of morning
glory, their stems made of *shakudō*, with gilded blooms and mottled
silver leaves. Morning glory plants (*asagao*) are one of the seven grasses
traditionally associated with autumn in Japan,[8] their flowers blooming
only for a short period each day. The deliberate patination of the leaves
alludes to the poignancy of this brief blossoming and suggests the
beginnings of autumnal decay. This emphasis on the passing seasons
reflects Japan's deep respect for nature.

The history of these vases is not known, but they must have arrived
in Britain before 1920, because they were mounted as lamps by the
Birmingham firm of James Hink & Sons, which ceased trading in that
year. The mounts have obscured any marks on the bases, but the form
and decorative style of the vases are strongly reminiscent of objects
produced in the large Kyoto workshops run by Shōbi (Jomi) Eisuke I
(1839–99) and his son, Shōbi Eisuke II (active 1881–1911); see
cats 103–104. **KJ**

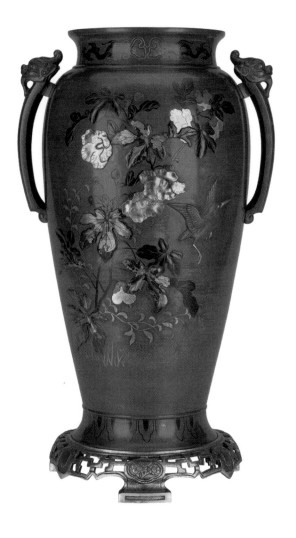
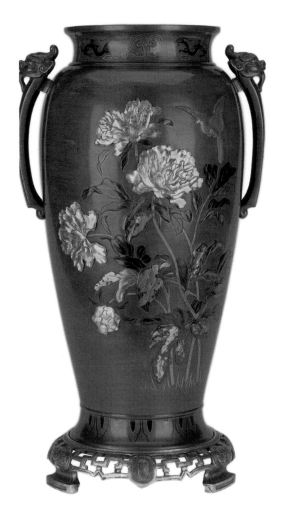

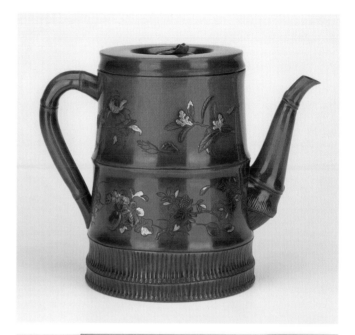

103, 104
SHŌBI (JOMI) EISUKE I (1839–1899), KYOTO
TEA OR COFFEE POT AND PAIR OF CUPS,
1880–81

Copper alloy, gold, silver, partly patinated

6.5 × 20.0 × 12.3 cm (pot); 9.0 × 10.4 × 7.4 cm (cups)

Base of coffee pot marked: 「惺々堂 紹美」 ('Shōshōdō Shōbi'); each cup marked: 「惺々堂 紹美造」 ('Made by Shōbi', 'Shōshōdō')

RCINS 54952.a–b, 54953.1–2

PROVENANCE: Presented to King Edward VII when Prince of Wales by Prince Albert Victor and Prince George, 1881

Clearly created for the export market, these objects bear little resemblance in form to the tea wares of Japan; the vertical, cylindrical shape of the teapot is entirely European and the cups have handles, which are not seen on Japanese examples. The decorative vocabulary, however, of iris and lotus flowers, crabs and bamboo, and the techniques of patination and inlay, are in the Japanese idiom.

Shōbi Eisuke, known in the West as Jomi, was an extremely successful bronze worker based in Kyoto. He received commissions from the Imperial Household Agency and exhibited frequently at international fairs, winning prizes in Paris in 1878 and 1889. The Shōbi workshops employed more than 85 independent craftsmen in and around Kyoto, and Eisuke also worked with his son, also named Shōbi Eisuke (active 1881–1911).

These objects were gifts to Albert Edward, Prince of Wales from his sons Albert Victor and George, selected during their two-week stay in Japan in October and November 1881. The published accounts of their voyage record several encounters with Japanese metalworkers and dealers. In Tokyo on 28 October the brothers 'started off to some curio shops … we got some very nice old ivory carved netsukes … and little pieces of old bronze and modern metalwork at Mikawaya's'.[9] A week later in Kyoto, they 'visited the metalworkers, and saw some beautiful specimens of bronze and silver work with small raised flowers on the surface … There are two or three in Kiôto [sic] whose modern work is as good as the best antique, only of course expensive, as the workmanship is first-rate and takes much time and patient skill'.[10] They were also visited at their accommodation by salesmen from Kyoto and Nara who displayed their wares, among them specimens of bronze, and from whom Prince George wrote 'we choose some of these to take home as presents'.[11] KJ

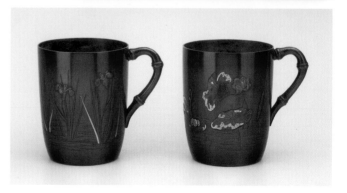

105
ATTRIBUTED TO NEMOTO
INKSTAND, 1868–1912

Silver, partly gilded, enamel, ivory

12.5 × 23.5 × 6.5 cm

RCIN 17723.a–b

PROVENANCE: Possibly acquired by King Edward VII

Sculptures of birds are typical of the output of Japanese metalworkers in the Meiji period, and the pheasant is an especially common subject. Here the bird has been turned into an inkstand, with a small well hidden in its back. The pheasant lends itself to the enamelling technique, with jewel-like colours used to pick out the detailed plumage of its head, wings and tail. The term in Japanese for enamelling is *shippō*, or 'seven precious stones', suggesting the brilliance of the colours achievable. Traditionally, *shippō* was applied to a work using the cloisonné technique, whereby a small field or *cloison* was marked out by wire and flooded with an enamel colour to create the design. It would then be fired to achieve a bright, glassy surface. Japanese metalworkers of the late nineteenth century also introduced a form of 'wireless' cloisonné (*musen*) in which the wires were removed before the enamel was fired. This inkstand has been created using the wireless technique – the tail of the bird in particular showing a painterly quality in the enamelling.

Similar bird models were often made for the export market but they rarely appear on bases. It is possible that the ivory on this piece was added in Britain. The inkstand has traditionally been displayed at Sandringham House, and may have been a gift to King Edward VII, who acquired the Norfolk estate for the breeding and shooting of pheasants. KJ

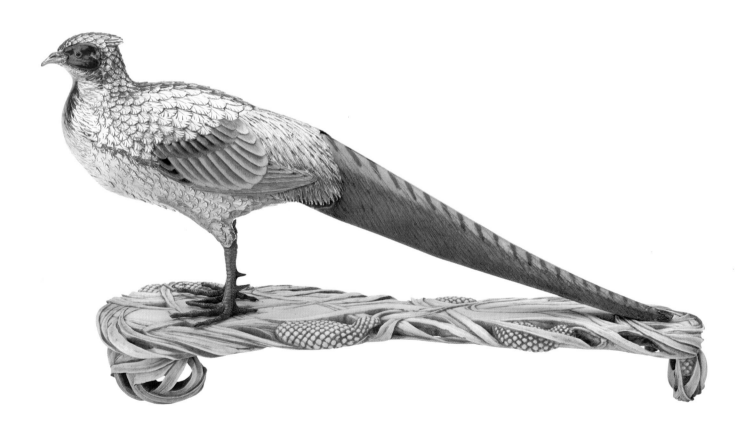

106

MINIATURE CABINET (KODANSU),
*c.*1880–1900

Copper alloy, gold, black organic coating

13.9 × 15.5 × 8.1 cm

Inscribed on the base: 藤 ('Fuji')

RCIN 100753

PROVENANCE: Purchased by Queen Elizabeth from
Spink & Son, 31 October 1941

Komai Otojirō (1842–1917) started producing distinctively decorated
metalwork of this type in Kyoto around 1873, expanding into new
premises in 1901. His firm specialised in small objects such as miniature
temples and table cabinets for export, and European visitors to Kyoto
would flock to his shop. Each surface on Komai's works was densely
decorated in gold wire and gold leaf inlaid into a copper alloy ground
with a black coating. Objects in this style are often now known as
'Komai wares', although other workshops achieved similar effects.

This example is densely inlaid with landscape scenes, waterfowl
and dragons, with borders of flowerhead motifs. In places the gold
has been engraved or burnished to give a more elaborate and dynamic
textured finish. Although not marked by Komai, the 'Fuji' mark on the
base appears to have been associated with the workshop during the late
nineteenth century. KJ

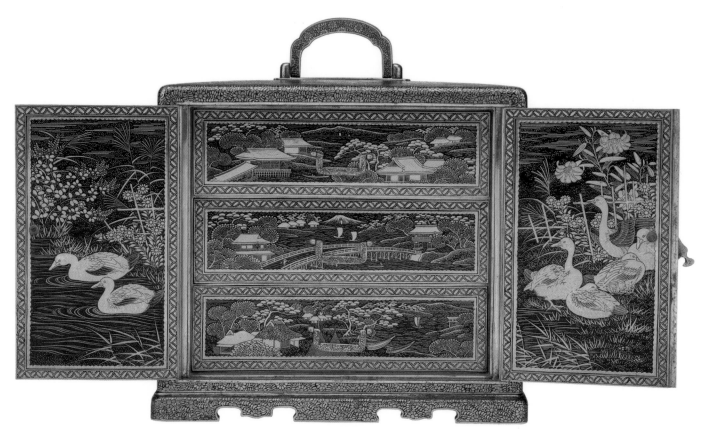

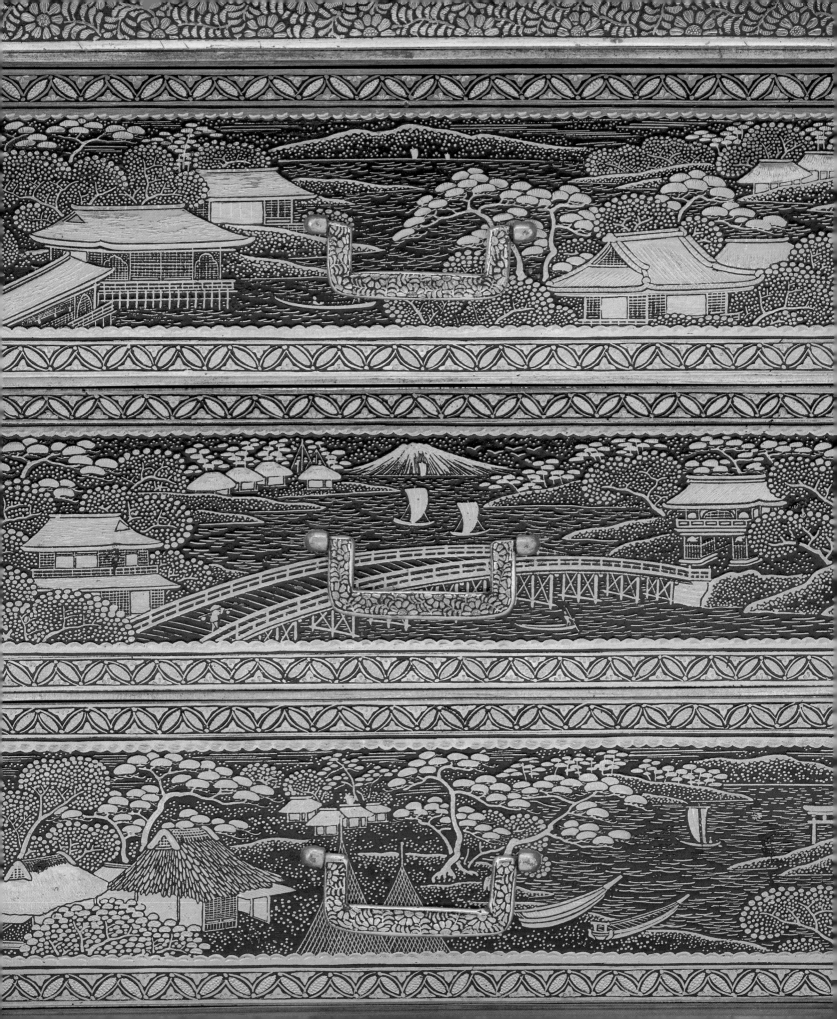

107

JAPAN

MODEL OF A COCK ON A DRUM (KANKODORI), 1929

Silver, partly gilded, copper

41.0 × 19.5 × 19.0 cm

RCIN 17722.a–c

PROVENANCE: Presented to Prince Henry, Duke of Gloucester by Baron Sakatani Yoshirō, May 1929

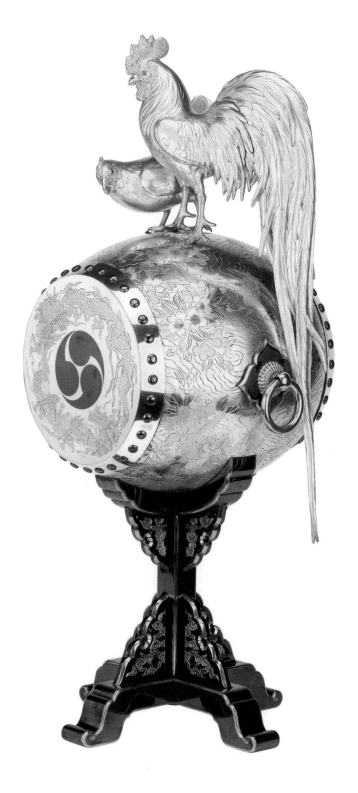

The motif of the 'cock on a drum', known as *kankodori*, comes from a legend in which a wise ruler placed a *taiko* drum at his gate to be sounded as a warning in the event of an attack, or for disgruntled citizens to strike when they wanted counsel or judgment from the ruler. However, a period of prolonged peace meant that the drum fell into disuse, plants grew over it, and hens and cockerels began to take up residence. The cock on a drum thus became a symbol of peace, harmony and good government.

The symbolism of this gift is deliberate; the object was presented to Prince Henry, Duke of Gloucester during his 1929 visit to cement goodwill between Japan and Britain. A note with the gift, from Baron Sakatani Yoshirō (1863–1941), President of the League of Tokyo Students' Welcome Association, explained that the *kankodori* represented 'peace and friendliness'. The symbolism is enhanced by the engraving on the drum, showing cherry blossoms for Japan, roses for Britain, and dragons for the Imperial Household. It also bears an inlaid *tomoe* motif symbolic of permanency. The purpose of the duke's visit was to present the Order of the Garter to the Emperor Shōwa, although he also took the opportunity to visit a number of Tokyo institutions including, on 4 May, the university. It was apparently on this occasion that the gift was presented. KJ

108

NAMIKAWA SŌSUKE (1847–1910)
TRAY WITH DECORATION OF A COCKEREL,
c.1910

Cloisonné enamel on copper body

25.5 × 30.4 × 1.4 cm

Sakigake mark of Namikawa Sōsuke on the base

RCIN 8586

PROVENANCE: First recorded in the Royal Collection
during the current reign (1952–)

Namikawa Sōsuke was both an important, innovative cloisonné artist and an entrepreneur. He originally worked for the Nagoya Cloisonné Company and around 1880 moved to run the company branch in Tokyo, but then set up his own studio *c.*1887. He was an active contributor to both national and international expositions, winning prizes at the 1883 Amsterdam Universal Exposition, the 1885 Nuremberg International Metalwork Exhibition and the 1889 Paris *Exposition Universelle*.

Sōsuke perfected a distinctive style of enamel decoration in which his enamels appeared to reproduce ink paintings. The two techniques he used, *shōsen* (few, or limited wires) and *musen* (literally 'no wires'), depended on high-quality enamels that would not bleed into each other when not separated by wires. In the case of *shōsen*, the number of wires was kept to a minimum and they were used only to delineate small details, whereas in *musen* the wires were removed prior to the final firing.

At the World's Columbian Exposition of 1893, Sōsuke exhibited *Mount Fuji among the Clouds*, a large plaque in wireless shaded enamels. It was at about this time that Sōsuke, a man not shy to tell the world about his achievements, began to use the character *sakigake* ('pioneer') as a seal on his work. In 1896, along with Namikawa Yasuyuki (no relation), he was appointed *Teishitsu Gigei'in* (Imperial Household Artist) under the Emperor Meiji. This was an important position and guaranteed a domestic market for his work while simultaneously increasing its value. Sōsuke's superb enamels were often given as gifts by the emperor and the Imperial Household. The quality of this fine *musen* enamel depiction of a cockerel would have been appreciated by both the domestic and international markets. GI

109
ANDŌ COMPANY
OCTAGONAL BOWL ON A STAND, c.1915

Enamel, wood, copper
11.7 × 22.7 × 22.7 cm (bowl); 6.8 × 20.5 × 20.5 cm (stand)
Bowl with the mark of Andō Jūbei on the underside; stand
with 16-petalled imperial chrysanthemum on the base
RCIN 41530.a–b
PROVENANCE: Probably acquired by King Edward VIII when
Prince of Wales in Japan, 1922

Nagoya and the surrounding area was the major centre of cloisonné manufacture in Japan during the Meiji period. The most influential, innovative and productive of the many companies there was the Andō Company, founded in 1880 by Maeda Matsukichi and later run by Andō Jūbei (1876–1953). The firm won numerous prizes at world exhibitions, including the 1893 World's Columbian Exposition in Chicago. In the early 1900s, the Andō Company began producing enamels using a technique called *shōtai-shippō*, generally known by its French name, *plique-à-jour* ('open to light'). Andō Jūbei had seen examples of this technique at the Paris Exposition of 1900 and brought a piece by Fernand Thesmar back to Japan. This was analysed by Kawade Shibatarō (1856–1921), Andō's chief foreman, who had introduced and developed the many technical innovations on which the Andō Company's success was based, and who then developed and perfected this technique.

In *shōtai-shippō*, an object is prepared as for cloisonné enamelling but, crucially, the interior is not enamelled. Once the piece has been completed, clear lacquer is applied to its polished exterior to protect it from the acid that is then used to dissolve the copper body. The result is an object consisting of semi-transparent panels of enamel held together by a pattern of fine wires. The popularity of *shōtai-shippō* led many other manufacturers to adopt this technique.

Around 1900, the Andō Company was appointed official supplier of cloisonné to the Imperial Household Agency. Although none of Andō's employees was ever given the title of 'Imperial Craftsman', the firm became the main provider of high-quality enamels for imperial gifts. These presentation pieces were often given by the emperor or empress to important individuals and dignitaries on special occasions. This octagonal bowl is decorated with phoenixes in flight on a background of stylised clouds, rabbits on stylised waves (*seigaiha*) and a stylised angular dragon motif around the rim. GI

LITERATURE: Laking 1933, no. 90

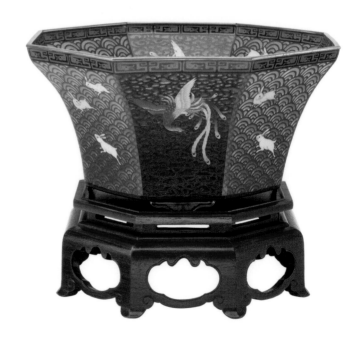

110

ANDŌ COMPANY

LIDDED CASKET AND STAND IN THE FORM OF A SUTRA BOX, 1922

Enamel, gilt bronze, copper, gold wire, silk

13.9 × 37.1 × 15.6 cm (whole object)

The underside of the casket bears the four-character seal *Kinsei Andō* ('Respectfully made by Andō') in gold wire and the mark of the Andō Company. The interior of the lid bears the inscription *Taishō 11, 4th month* ('April 1922') and *Tokyo shi* ('Tokyo City') and the crest of the City of Tokyo in gold on blue enamel

RCIN 42593.a–f

PROVENANCE: Presented to King Edward VIII when Prince of Wales by Baron Gotō Shinpei, Mayor of Tokyo, 17 April 1922

This casket is in the form of an eighth-century Buddhist *sutra* box of the type held in the *Shōsōin*, the Japanese Imperial Repository at Nara. It is decorated in fine cloisonné and *moriage* ('piled up') enamels in gold wire and contains a lengthy scroll from the citizens of Tokyo City dedicated to Edward, Prince of Wales on his visit to the city. The scroll refers to Crown Prince Hirohito's visit to Britain the previous year and expresses a wish for stronger bonds between the two countries, saying 'It is particularly fortunate that Your Royal Highness has chosen for your visit a time of the year when all nature joins in the national joy and welcome' – cherry blossom season. It is signed by Baron Gotō Shinpei, Mayor of Tokyo, 17 April 1922.

In 1900 the Andō Company of Nagoya had been appointed as one of five Purveyors to the Imperial Household (*Goyōtatsu*) for cloisonné enamel. As the only two enamel artists with the title of *Teishitsu Gigei'in* (Imperial Household Artist) were no longer working at the time of the prince's visit, it fell to the company to provide this high-quality gift. The foreman of the Andō Company since around 1900 had been Kawade Shibatarō, whose major enamelling development – sometimes credited to Hattori Tadasaburō, another Nagoya-based maker – was the *moriage* technique used in this casket. This painstaking method of enamelling required extreme care, especially at the polishing stage, and involved the building up of layers of enamel to produce a subtle three-dimensional effect. This method is ideally suited to subjects such as the lion and unicorn seen on the British royal coat of arms on the lid of the casket. GI

LITERATURE: Laking 1933, no. 88

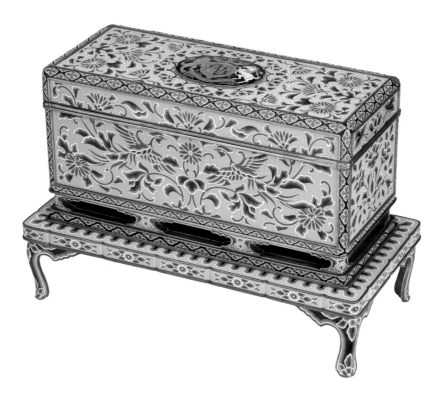

日本の芸術

8

TREATY

CONTACT AS PARTNERS
1901–1937

RACHEL PEAT

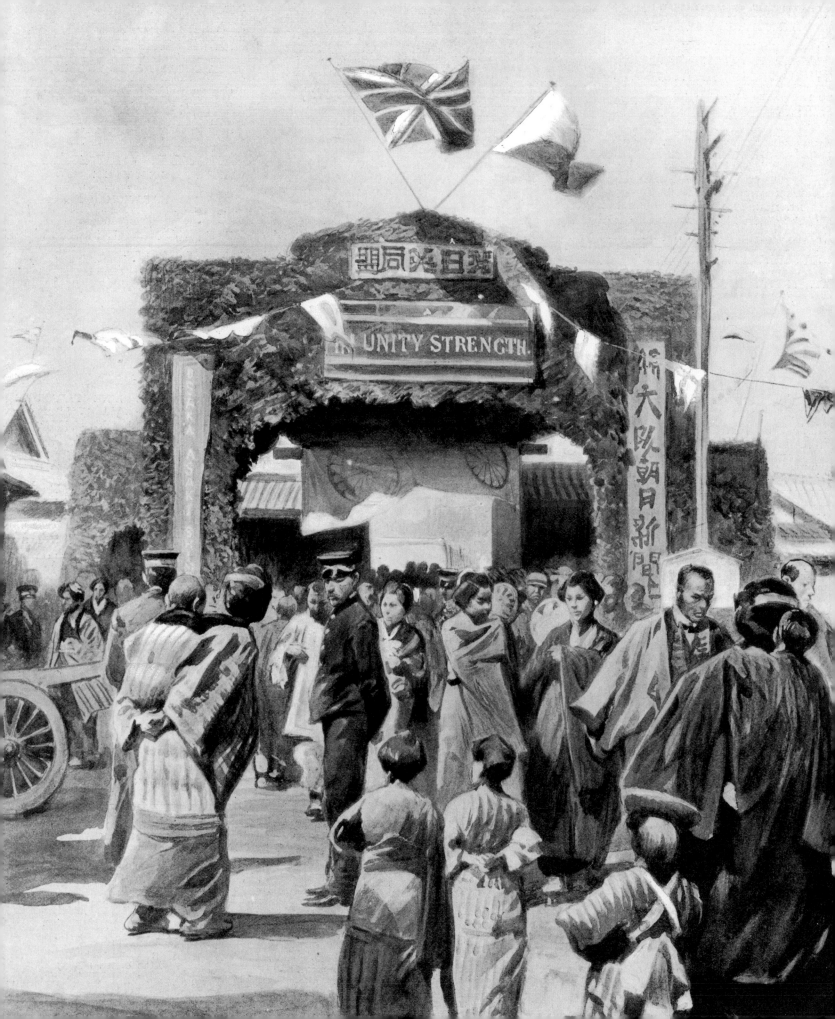

The exchange of courtesies between the courts of our two nations is bound to cement still more strongly our friendly relationship, and to enhance the happy co-operation of the Island Empires of the East and West.

Governor of Osaka, Address to
Edward, Prince of Wales,
5 May 1922 [1]

URING the first four decades of the twentieth century, the royal families of Britain and Japan enjoyed a uniquely close relationship. This friendship was unusual, not merely in light of the simultaneous decline of other European royal houses after the First World War, but also because it was Britain's closest bond with a non-European, non-Christian dynasty with which it had no ties through blood or marriage.[2] The two royal houses frequently spoke of one another as counterparts, two 'Island Empires' governing East and West. Exchanges between the two courts became a central component of a new Anglo-Japanese Alliance, which was first sealed in 1902, then twice expanded and enlarged before its termination in 1923. In fact, the royal relationship took on a symbolic power that would both aid and outlive the treaty itself. In this context, high-profile visits between members of the two families acquired new political significance. The gifts that were exchanged on these occasions likewise reflected the perceived intimacy and value of the imperial friendship.

8.1 Unknown artist, *The Triumphal Arch Erected at Nagasaki in Honour of the Alliance*, 1902. Photolithograph, *Illustrated London News*, 20 May 1902

Honours and their accompanying insignia were of particular importance. In addition, public exhibitions of Japanese art in Britain as well as private royal collecting indicated growing aesthetic interest in the nation's latest ally – and the role of cultural diplomacy in cementing political bonds.

THE ANGLO-JAPANESE ALLIANCE

The roots of the Anglo-Japanese Alliance (1902–23) lay in the increasing acceptance of Japan as a modern world power. The nation had proved its political reliability and military prowess in 1900 during the Boxer Rebellion in China, when some 22,000 of its troops helped western powers to suppress the uprising and safeguard foreign treaty rights. As one memorandum received by Queen Victoria acknowledged, 'For urgent purpose of saving Legation [in China], Japan is the only Power which can act with any hope of success.'[3] At the same time, both Britain and Japan increasingly feared Russian expansion in East Asia, which threatened their interests in China and Korea respectively. The result was a defensive alliance, signed on 30 January 1902, in which each nation promised to come to the other's aid in the event of a war with more than one power.

For the Japanese, the treaty was momentous: an indication of their status as an equal partner with the world's greatest imperial power (Fig. 8.1).[4] In Britain, the new king, Edward VII

8.3 Unknown artist, *Prince Arthur of Connaught offering the Order of the Garter to the Emperor Meiji, on behalf of King Edward VII*, Bijutsu Jiji Gaho No. 6 [series], 1906. Lithograph print, 38.6 × 53.9 cm, British Museum, BM 1936,0930,0.1.2

8.2 W. & D. Downey (active 1860–early 1900s), *King Edward VII*, c.1905. Watercolour on ivory laid on card, 16.2 × 12.1 cm, RCIN 421046

(Fig. 8.2), was similarly enthusiastic, for he wrote a short minute about the 'extreme importance' of 'doing all that was possible to support Japan' when the alliance was first mooted.[5] Japan's new standing was evident at the celebrations for his Coronation in August 1902. The Japanese imperial battlecruiser *Asama* – which had been built on the River Tyne – formed part of the Coronation naval review at Spithead. On the quarter-deck stood a 'sweet little English girl dressed in an "obi" and wearing cherry blossom in her hair' who attracted particular attention from Queen Alexandra.[6] The Japanese representative for the Coronation, Prince Komatsu Akihito, was offered a large suite of staff and received an official welcome from the Mayor of Dover, who referred warmly to the new alliance. The prince, 'greatly pleased' with this reception, brought gifts for the king of 'two magnificent gold inlaid vases' and an embroidered folding screen (cat. 137).[7]

Anglo-Japanese relations reached their zenith in 1905–6. In August 1905, the alliance was renewed and considerably expanded to include explicit consent for Japanese imperial activity in Korea. This in part reflected Japan's remarkable success in the 1904–5 Russo-Japanese War, which had been closely followed by an admiring British press and which was the first time an East Asian nation had defeated a western power. Shortly afterwards, the British elevated their legation in Tokyo to an embassy – a symbolic step acknowledging Japan as a leading power. At the same time, King Edward VII agreed to appoint the Emperor Meiji to the Order of the Garter, Britain's highest Order of Chivalry. The honour had been suggested as early as 1880, but Queen Victoria thought it 'preposterous' for a non-Christian ruler to receive it, and similar doubts had been expressed as recently as 1902.[8] The change of attitude in 1905 was a powerful indication of Japan's new status.

A 'Garter Mission' was accordingly dispatched in 1906, led by the king's nephew, Prince Arthur of Connaught (1883–1938). When the prince arrived at Yokohama, he found children lining the streets, each waving a Japanese and a British flag and raising

an almighty cry of 'Banzai!'[9] In Tokyo, the Emperor Meiji came to meet him in person – an unprecedented honour. A.B. Mitford once again accompanied the British delegation and recalled, 'When the Emperor so warmly shook hands with the Prince it was a message to his people which said in unmistakeable terms, "This is my friend".'[10]

The Garter ceremony took place on 20 February 1906 in the presence of the blood princes and all the nobility and statesmen of the Imperial Court, who had long-since adopted European dress (Fig. 8.3). Mitford wrote:

> Not a sound was heard as very slowly each one of us in turn, carrying the insignia on a red velvet cushion, advanced alone towards the throne … At the very moment when the Prince was buckling the Garter below the Emperor's knee, at a preconcerted signal, the invisible band struck up once more "God Save the King". The effect was electric.[11]

After the investiture, the emperor came to the prince's accommodation and bestowed on him the ribbon and star of the Order of the Chrysanthemum – the first time he had invested any recipient, foreign or Japanese, with his own hands.[12] The remainder of the visit was filled with tea ceremonies and *geisha* dances; the party also watched a play about William Adams and donned Japanese dress for a dinner given by the Mayor of Nara.

The 1906 Garter Mission inaugurated a series of reciprocal princely visits which characterised Japanese-British royal relations over the three decades that followed. The first return visit took place in 1907, when Prince Fushimi Sadanaru (1858–1923) was sent to Britain to express the emperor's gratitude for the Order of the Garter. This tour also had a political purpose, since the prince was accompanied by officials whose task it was to finalise a military agreement and observe British Army manoeuvres (see cat. 119). Relations at this date were still sensitive, and news that a production of *The Mikado* was to open shortly after the prince's visit led the Lord Chamberlain's Office to scramble to suppress it, hoping to 'avoid doing

8.4 Attributed to Akatsuka Jitoku (1871–1936), *Box and cover*, *c*.1900–1907. Wood, black and gold lacquer, mother-of-pearl, 13.1 × 26.0 × 21.4 cm, RCIN 29465, cat. 118

anything prejudicial to the good feeling now existing between England and Japan'.[13] Military bands were likewise prohibited from playing music from the operetta during the prince's stay.[14]

A central element of this and other princely tours was the presentation of works of art specially commissioned by the Imperial Household Agency. Many such pieces bore the imperial chrysanthemum crest (*kikumon*) (Fig. 8.4). Among them were vases, writing boxes and miniature cabinets, often made by leading contemporary artists such as Akatsuka Jitoku (cat. 117). The range of Japanese art in the Royal Collection consequently expanded from mainly export and Edo-period historical pieces to specimens of the finest modern craftsmanship.

Naturally there were cultural exchanges at court level in both directions, and Meiji Court officials continued to look to British precedent for ceremonial matters. In the late nineteenth century

this had included imitating uniforms, Orders of Chivalry and the Royal Standard. In 1909, the Japanese also received permission to model their royal carriages and liveries on Britain's.[15]

CULTURAL DIPLOMACY

The Anglo-Japanese Alliance coincided with a period of concerted Japanese-British cultural exchange. Popular and specialist exhibitions of Japanese craftsmanship signalled a growing public interest in Britain's new ally and each government's determination to use such events to promote political ties. Inevitably these activities traced the long history of British royal encounters with Japan. In July 1905 the Japan Society opened its first exhibition, 'Arms and Armour of Old Japan', at the Royal Society of Painters in Water Colours in Pall Mall East. The display featured specimens of Japanese militaria throughout the ages, including 22 pieces from Windsor Castle. Sir Guy Laking, Keeper of the King's Armoury, commented that the royal loans were of particular interest 'for their *provenance*, as in some cases they represent the gift of one great sovereign to another'.[16] Among them was the armour sent to Queen Victoria by Tokugawa Iemochi in 1860 and a *tantō* given to Prince Alfred, Duke of Edinburgh by the Emperor Meiji (cat. 88).[17] Like many of their contemporaries, the curators drew a sharp contrast between 'old' and 'new' Japan, emphasising the country's rapid modernisation but consigning pre-Meiji objects to a distant and primeval past.[18] King Edward VII himself visited the gallery somewhat unexpectedly on a rainy Thursday morning and toured the exhibits with Prince Arisugawa Takehito, who was visiting England at the time.[19]

The largest and most important cultural event of the treaty period was the Japan-British Exhibition of 1910 (Fig. 8.5). Held between May and October at a purpose-built venue in White City, London, this joint project was intended to promote grassroots understanding of and enthusiasm for ties between the two nations. It was the first exhibition in which Japan was represented on an equal footing with a western nation, and the largest that the Japanese Government had ever undertaken abroad. Japanese officials accordingly

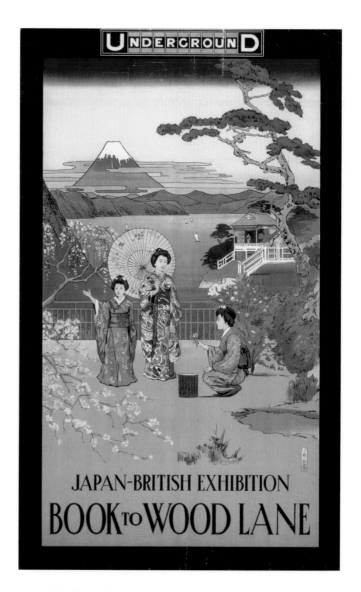

8.5 John Henry Lloyd (active 1910–11), *Japan-British Exhibition*, 1910. Poster, 101.6 × 63.5 cm, London Transport Museum, 1995/564

seized the opportunity to portray themselves as a modern power, showcasing their military organisation, health services and educational programmes as well as the latest art and design. Among the 2,271 Japanese exhibitors were leading craftsmen of the day such as Namikawa Sōsuke (cat. 108) and

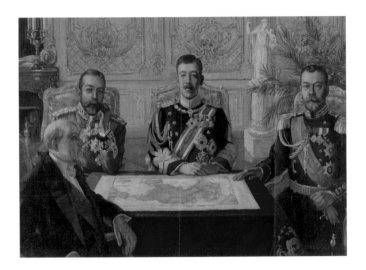

8.6 Kaishindo [publisher] after Wada Eisaku (1874–1959), *Fictional group portrait of the allied leaders, King George V, the Emperor Taishō, Tsar Nicholas II of Russia and President Poincaré of France, 1 January 1917*, 1917. Lithograph print, 38.8 × 52.4 cm, British Museum, BM 2005,0121,0.2

8.7 W. & D. Downey (active 1860–early 1900s), *Queen Mary when Victoria Mary, Princess of Wales*, c.1902. Watercolour on ivory laid on card, 8.8 × 6.7 cm, RCIN 421083

Andō Jūbei (cats 109–110). In addition, there were Japanese gardens, a model tea house and demonstrations of sport, music and drama. 'Each of the Island Empires', promised the Official Guide, 'is here given a chance of understanding the other in character and work. This should lead to the happiest commercial and political results.'[20] Indeed, nearly 8.35 million people visited the exhibition, and London shopkeepers almost immediately reported increased demand for Japanese wares.[21]

Numerous members of the British royal family were involved in the exhibition. Prince Arthur of Connaught served as Honorary President, the king lent specimens of Japanese arms and armour for the Japan Society's exhibit (including cats 71, 88–90 and 92), and Queen Alexandra and Queen Mary offered royal fans and examples of work from the Technical Schools at Sandringham. All visited the exhibition on several occasions. When the king and queen attended on 6 August, *The Times* reported that they 'displayed a lively interest in all they saw'.[22] After the exhibition closed, the king was presented with an extraordinary one-tenth scale model of the Taitokuin Mausoleum, the resting place of Tokugawa Hidetada, which

had been specially commissioned by the city of Tokyo (RCIN 92903; see Chapter 12).

Since distance and time prevented visits to or from Japan by a reigning sovereign, King George V's Coronation on 22 June 1911 was attended by Prince Higashi-Fushimi Yorihito (1867–1922). The Emperor Meiji and Empress Shōken sent gifts in their absence (cat. 117). Three weeks later, the Anglo-Japanese Alliance was renewed for a second time. Japan's participation with the Allies in the First World War (1914–18) was a direct result of this agreement (Fig. 8.6). New military and cultural unity was expressed in 1915 by an exhibition of 'Japanese Works of Art and Handicraft from English Collections', held in aid of the British Red Cross Society and to which Queen Mary lent a lacquer box and cabinet (cats 117–118).[23]

The symbolic relationship between the two Courts was deployed to greatest effect towards the end of the war. In 1918, the British Government elected to make the Emperor Taishō a

8.8 Arthur Reginald Smith (1871–1934), *The Lacque [sic] Room, Buckingham Palace*, c.1912. Watercolour, 26.2 × 39.3 cm, RCIN 926107

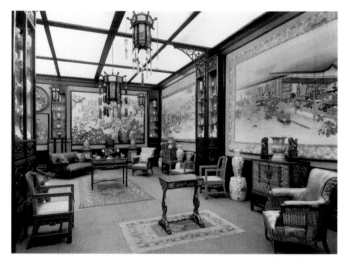

8.9 Attributed to Alfred E. Henson (1885–1972) for *Country Life* magazine, *The Chinese Room, Sandringham*, 1934. Gelatin silver print, 15.6 × 20.6 cm, RCIN 2102388

Field Marshal of the British Army, both in recognition of Japan's military support and to encourage its continuation.[24] Prince Arthur of Connaught was once again dispatched to Japan to oversee the ceremony, which was an appeal to Japanese-British intimacy in the face of an uncertain post-war world. Prince Higashi-Fushimi Yorihito returned the visit in October that year and bestowed on King George V the sword and badge of a Field Marshal of the Japanese Army (cats 96 and 154).

In this period, Queen Mary (Fig. 8.7) did much to expand and re-organise the Japanese holdings in the Royal Collection. A quiet and methodical woman, she was a discerning collector of East Asian art. Her particular interest was lacquer, and she frequently dispatched agents to buy *inrō*, boxes and small cabinets at auctions. Handwritten annotations in the margins of catalogues – such as that for the 1927 C.H.T. Hawkins sale – indicate a discriminating eye and careful budgeting.[25] The queen herself regularly visited exhibitions in London, including shows by Japanese artists such as Urushibara Yoshijirō (1889–1953), whose works she acquired (cats 126–130). She was also a patron of Yamanaka & Co., one of London's most prestigious dealers in East Asian art, whose fashionable

shop had opened at 68 Bond Street in 1900. New acquisitions were carefully recorded in the queen's catalogues of 'bibelots, miniatures and other valuables', with small photographs glued beside them. These inventories reveal a broad collection neatly arranged in dedicated showcases, and also a tendency to give away small pieces as gifts. Two *tsuba* (sword guards) were for example given to her son Prince Henry, Duke of Gloucester (1900–74).[26]

Queen Mary's collecting represented a growing scholarly appreciation of Japanese art, both among the royal family and nationally. One of her many advisers was H. Clifford Smith (1876–1960), of the Victoria and Albert Museum, who helped catalogue the important lacquer collection at Buckingham Palace.[27] A 1911 inventory indicates the proliferation of Japanese material there, including large porcelain vases in the Marble Hall and lacquer tables and cabinets in the Privy Purse Corridor (cat. 55).[28] The queen also created a series of interiors specifically dedicated to East Asian works of art, such as the Lacquer Room at Buckingham Palace (Fig. 8.8) and a 'Chinese Room' at Sandringham House. A photograph of the latter taken by *Country Life* magazine in 1934 shows three magnificent

Japanese silk tapestries on the walls (Fig. 8.9). By this date, Sandringham was also home to two Japanese armours which had been placed in the Armoury Passage during the reign of King Edward VII.[29]

TWO CROWN PRINCES:
ROYAL VISITS AT THE END OF
THE ALLIANCE PERIOD

TWO CROWN PRINCES: ROYAL VISITS AT THE END OF THE ALLIANCE PERIOD

In 1921, Crown Prince Hirohito (1901–89, later the Emperor Shōwa) visited Britain, ostensibly for educational reasons but also to signal Japanese amity at a moment when the future of the Anglo-Japanese Alliance was under discussion (see cats 111–112). By this date the treaty's political usefulness was in decline, in part thanks to Britain's new closeness with the United States, Japan's rival in the Pacific. Arriving at Spithead on 7 May, the prince described himself as a 'courier of friendship and goodwill from the people of Japan to the British people'.[30] His itinerary included a State Banquet at Buckingham Palace (cat. 111), wreath-laying at the Cenotaph and a tour of the State Apartments at Windsor, where he took 'special pleasure in inspecting some old Japanese armour and arms in the grand vestibule'.[31] Contemporary photographs indicate that the displays there included swords, lacquer shields and mother-of-pearl *yari* mounted a hair-raising 10 ft (3 m) off the ground – along with the armour sent to James I in 1613 (Fig. 8.10, cat. 1).[32] The visit was the first time a Japanese crown prince had travelled overseas. Nevertheless, the alliance was quietly abandoned by the British Government shortly afterwards, at the Washington Conference of 1921–2. The unusual effect of this was that the royal relationship took on greater symbolic power in the absence of a specific political agreement.

Once again, a reciprocal visit of equal rank and significance was expected. The charismatic Edward, Prince of Wales (1894–1972, later King Edward VIII), returned the crown prince's visit in 1922 (cats 113–114). Travelling from India, he arrived at Yokohama in April, having been advised that '[it] is the best month in Japan (for the weather, Cherry Blossom, etc.)'.[33] The four-week tour included the traditional sport of duck netting,

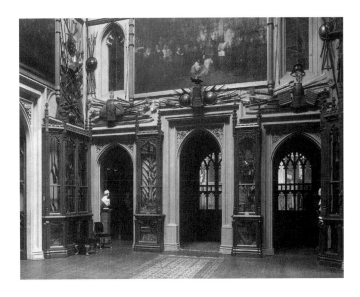

8.10 Russell & Sons (active *c.*1889–1908), *The Grand Vestibule, Windsor Castle, c.*1905–08. Platinum print, 24.0 × 28.8 cm, RCIN 2100853

visits to Shintō shrines at Nikkō and the unveiling of an Allied War Memorial at Yokohama. At Kagoshima, an exhibition of 'old-time archery' was given, and the prince was presented with an archery set of his own (cats 78–80).[34] He noted the rapid changes taking place across the country. 'Looking at the busy streets of your great city with their huge modern buildings storeys high,' he remarked, 'it is difficult to believe that 60 years ago this fair land of yours neither knew nor was known by the outer world.'[35]

The British press made much of the apparently close friendship between the two heirs to the throne. A particular treat for photographers was the remarkable sight of the Japanese crown prince (now Prince Regent) donning plus fours for a round of golf with his guest (cat. 114). The Prince of Wales later sent him a set of golf clubs for his birthday.[36] At the same time, political elites could not resist alluding to the special relationship between Japan and Britain. During a banquet at the Imperial Palace in Tokyo on 12 April, the Prince Regent praised 'the traditional friendship between our two Island Empires, which has been confirmed by the test of time'.[37] The

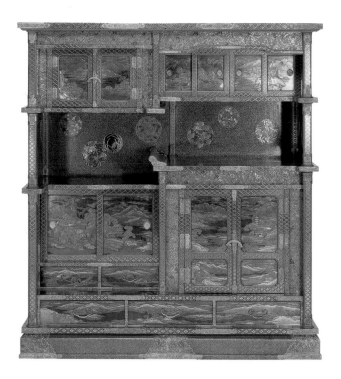

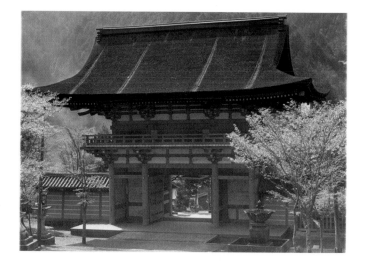

8.12 Okamoto Tōyō (1891–1969), *Spring Beauty of Kyoto*, c.1925–9. Gelatin silver print, 14.3 × 19.5 cm, RCIN 2862261

8.11 Harui Kōmin (1869–1936), *Cabinet*, c.1904–11. Wood, red and black lacquer, gold, silver, 110.0 × 51.5 × 103.0 cm, The Khalili Collection of Japanese Art, L 122. Presented to Edward, Prince of Wales by Baron Sumitomo during his visit to Japan, 1922

Governor of Kanagawa was effusive: 'It is … a most impressive event that the Heir of the reigning House of an Empire upon which the sun never sets should visit the Imperial House of the Land of the Rising Sun'.[38] Prime Minister Takahashi noted the significance of the 'exchange of courtesies between the [two] ruling houses'.[39] It was perhaps for this reason that the prince wrote so urgently to his father the king about the meagre number of decorations supplied for distribution to his hosts, in contrast to the many bestowed by Crown Prince Hirohito in England the previous year.[40]

The prince left Japan with more than 60 large cases of 'costly souvenirs', many 'of great historic worth' (Fig. 8.11).[41] Some had been purchased during shopping excursions in Nara and Hakone (Kanagawa Prefecture), but most were gifts from

officials, artists and well-wishers. Among them was a pair of cream-coloured vases decorated in the distinctive Satsuma style with gold and enamels representing spring and autumn (cat. 32).

THE POST-ALLIANCE WORLD

By the late 1920s, growing Chinese nationalism threatened British and Japanese interests in East Asia, prompting the two nations to signal their affinity through courtly ceremony once again. A final pair of reciprocal visits accordingly took place at the end of the decade. In May 1929, Prince Henry, Duke of Gloucester led a Garter Mission to bestow the Order on the new Emperor Shōwa. The prince evidently acquired a taste for Japanese art during the visit, for he subsequently assembled a collection of over 200 netsuke.[42] A photograph album of Kyoto cherry blossom that he received records the marvellous sights of Japan in the spring (Fig. 8.12, cat. 133).

The following year, the emperor's brother, Prince Takamatsu (1905–87), visited Britain during a 14-month world tour to convey his gratitude for the honour. He and his new bride stayed at Buckingham Palace from 26 to 28 June (cats 115–116). Princess Takamatsu gave Queen Mary a 'small present of

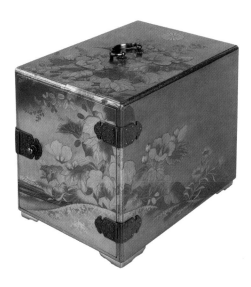

8.13 Japan, *Imperial presentation cabinet*, 1900–1930. Gold and silver lacquer on wood, 21.5 × 26.2 × 18.2 cm, RCIN 33969. Presented to Queen Mary by Princess Takamatsu in June 1930

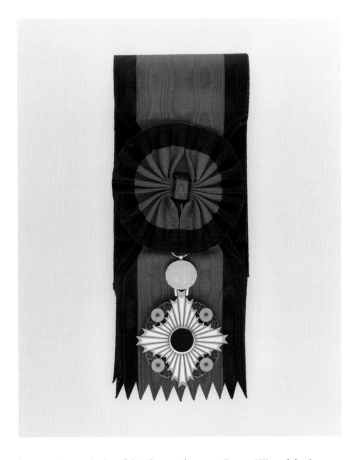

8.14 Japan, *Order of the Chrysanthemum: George VI's sash badge and sash*, 1937. Gold, enamel, silver, 12.4 × 7.8 cm, RCIN 441563

Japanese craftsmanship', as well as bringing gifts from the Empress Kōjun (1903–2000) (Fig. 8.13).[43] The Emperor Shōwa later sent his brother Prince Chichibu (1902–53) as his representative at the Coronation of King George VI on 12 May 1937. Much in the pattern of previous visits, gifts and insignia were exchanged (cat. 151 and Fig. 8.14).[44] Nevertheless the warmth of these royal engagements could not trump the increasingly chilly political climate, and the outbreak of the Sino-Japanese War in 1937 began a cooling of relations, sealed dramatically by Japan's entry into the Second World War in 1941.[45]

CONCLUSION

The royal relationship between Japan and Britain was stronger in the early twentieth century than at any time in the previous 300 years. Politically and artistically, Japan was increasingly treated as an equal partner on the world stage. Against the backdrop of the Anglo-Japanese Alliance, princely visits took on a symbolic value greater than the sum of their parts, giving human face to the *realpolitik* of international diplomacy. This personal bond – sometimes superficial, sometimes exaggerated, but nevertheless present – was inherited by successive generations of the two imperial families and indeed outlived the treaty period itself. The exchange of gifts, insignia and ceremony at court was a crucial expression of this relationship. This was also the era of growing royal connoisseurship, expressed particularly in the determined and sophisticated collecting activities of Queen Mary. More than ever before, Japanese art treasures in the Royal Collection were made accessible to the general public through loans, exhibitions and publications.

111

LORD CHAMBERLAIN'S OFFICE

CEREMONIAL, MENU AND PROGRAMME OF
MUSIC FOR THE VISIT OF HIS IMPERIAL
HIGHNESS THE CROWN PRINCE OF JAPAN,
9 MAY 1921

Ink on card

33.5 × 21.0 cm (ceremonial); 16.0 × 10.0 cm (menu);
16.5 × 11.0 cm (programme of music)

RA MRH/MRHSOV/MIXED/120/63, 77, 79

Crown Prince Hirohito's arrival in London on 9 May 1921 was marked
by all the ceremony due a guest of the monarch. Having travelled
by special train from Portsmouth, he was met at Victoria station by
King George V and the Prince of Wales. A guard of honour lined the
station platform, and the Japanese and British national anthems were
played. The royal party then drove to Buckingham Palace in a State
Coach drawn by six horses, accompanied by postilion riders wearing
scarlet and gold lace and a Sovereign's Escort of Household Cavalry.
In brilliant sunshine, the route of the carriage procession was lined by
spectators, many waving Japanese flags.[46]

That evening a State Banquet was held in the prince's honour in the
Ballroom, which was filled with pink tulips and mauve rhododendrons.
The six-course dinner included salmon, quail and ice cream, as well
as a nod to Japanese taste – lamb cutlets served 'à l'Orientale'. Making
a toast to the prince, the king commended 'our two Island Empires,
so analogous in geographical position, in political traditions, and in
national ideals'. He also acknowledged the 'signal compliment' made by
the Emperor Taishō in sending the prince to Britain, 'the first occasion
recorded by history in which the Heir-Apparent of the Throne of Japan
has ever left his native shores'. Of his own visit in 1881, he remarked,
'No one who has seen Japan can forget it. Nor can I forget the warmth of
the reception given to my brother and myself by the Japanese people'.[47]

The musical programme, performed by the Band of the Royal
Artillery, included selections from *Madame Butterfly*, the tragic opera
by Giacomo Puccini about a Japanese girl abandoned by the American
naval officer she loves. Later in his visit, the crown prince travelled to
Blair Castle in Scotland, where the Duchess of Atholl had the Japanese
national anthem, *Kimigayo*, performed for him on the bagpipes.[48] RP

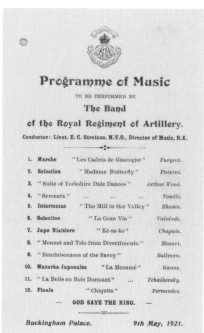

112

RICHARD N. SPEAIGHT (1875–1938)
GROUP PORTRAIT TAKEN DURING THE
VISIT OF CROWN PRINCE HIROHITO
TO BRITAIN, 11 MAY 1921

Gelatin silver print laid on card

22.2 × 19.7 cm

Photographer's credentials on the verso: *Speaight Limited.
Photographer & Portrait Painter at 157, New Bond Street, W.*;
number beneath the stamp in pencil: *54659*

RCIN 2809048

PROVENANCE: Probably acquired by King Edward VIII
when Prince of Wales

On 11 May 1921, the last day of Crown Prince Hirohito's official visit
to Britain, he attended a banquet at St James's Palace given in his
honour by Edward, Prince of Wales. More than 70 guests were invited,
including the crown prince's great-uncle Field Marshal Prince Kan'in
Kotohito (1865–1945) and Prince Arthur, Duke of Connaught, who
had visited Japan in 1890.[49] To mark the occasion, the host summoned
Richard Speaight to take a series of portraits of the four men just
before dinner.[50] A professional photographer with several clients from
European royalty, Speaight was well practised in setting up temporary
studios away from his premises in Bond Street, even in such unusual
spaces as a barn or a servants' corridor.[51] On this occasion, he set up his
camera in the cloakroom at the top of the palace's Grand Staircase.[52]

This photograph, of the four princes in white tie, is the sole
portrait from the session that survives in the Royal Collection. It is
also the image that the *Illustrated London News* printed in its 21 May
1921 issue.[53] No earlier publication featuring the crown prince in
civilian attire on an official tour has yet come to light. Many Japanese
newspapers subsequently published similar pictures; until then they
were limited to reproducing images of his formal processions during
a visit. While we cannot be certain that Speaight's work influenced
the Japanese Home Ministry's decision to relax image circulation
restrictions, this photograph is key to understanding the development
of the crown prince's public image.[54] AK

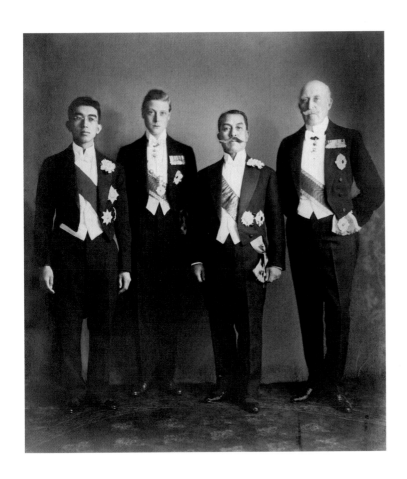

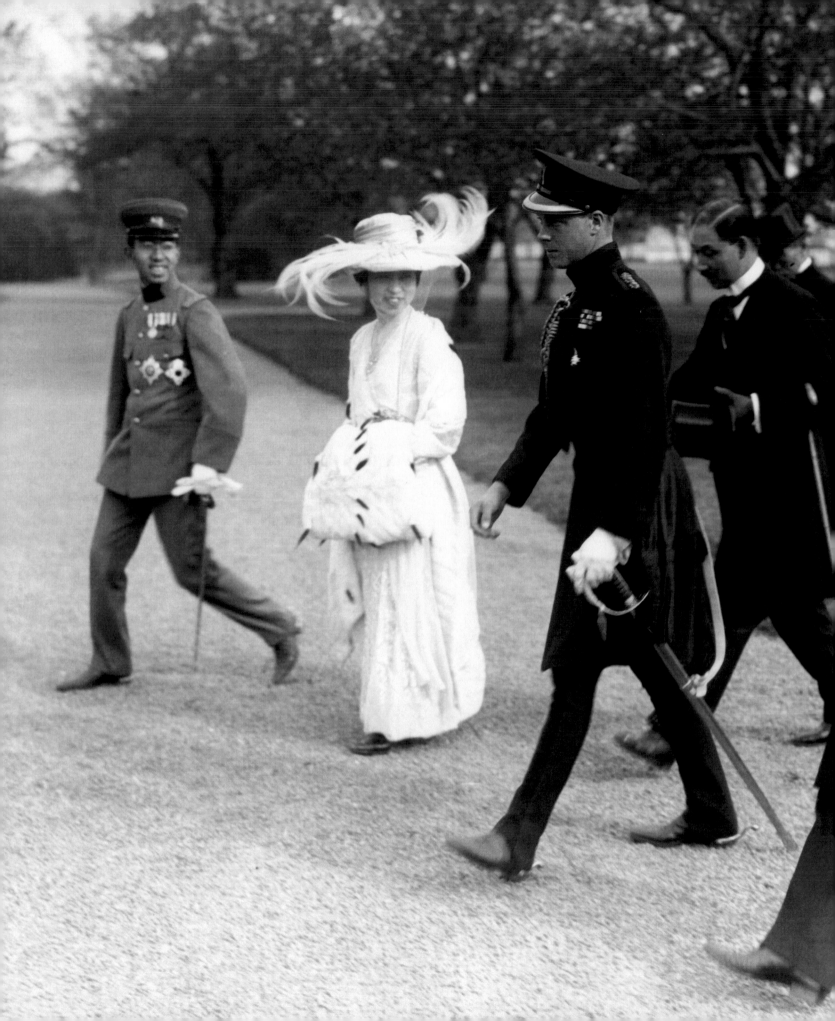

113

PRESS ASSOCIATION (EST. 1868)

GROUP PHOTOGRAPH TAKEN ON THE
OCCASION OF EDWARD, PRINCE OF WALES'S
VISIT TO JAPAN (DETAIL), 16 APRIL 1922

Gelatin silver print

15.1 × 20.4 cm

RCIN 2000493

PROVENANCE: Acquired during the current reign (1952–)

114

PRESS ASSOCIATION (EST. 1868)

EDWARD, PRINCE OF WALES (1894–1972)
AND CROWN PRINCE HIROHITO (1901–89)
AT TOKYO GOLF CLUB, 19 APRIL 1922

Gelatin silver print

20.4 × 15.1 cm

RCIN 2000448

PROVENANCE: Acquired during the current reign (1952–)

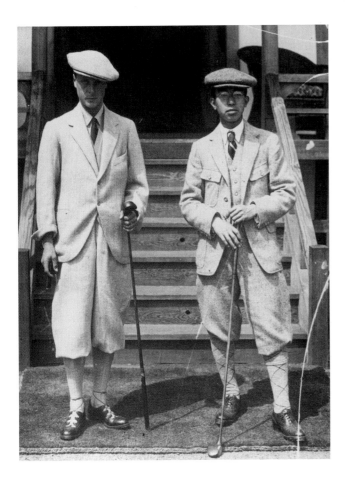

By the time Edward, Prince of Wales arrived in Japan for an official visit in 1922, the Emperor Taishō had retired from his royal duties due to ill health. Thus, the prince was mainly entertained by the Empress Teimei (1884–1951) and the Prince Regent. Many press photographs of the visit, such as cat. 113, demonstrate the warm hospitality he received. However, the Prince of Wales could communicate with the empress only through an interpreter, and even then their conversations were limited to subjects such as the weather and the cherry blossom.[55]

Unlike his mother, the Prince Regent was able to converse with the Prince of Wales in French and had also become acquainted with him during his visit to Britain the previous year, when he had noted the soaring popularity of golf among fashionable British society.[56] Perhaps it was this observation that inspired the Prince Regent to invite the Prince of Wales for a round of golf in Komazawa as a respite from their gruelling official engagements.

As a memento of their game, cat. 114 shows the two princes side by side in similar tweed suits with plus fours, paired with woollen socks and caps. The look had been popularised by the Prince of Wales and is emulated by the Prince Regent in a bid to fashion himself as an athletic, vigorous successor to his ailing father.[57] So popular was his casual style among the British press that a cropped version of the photograph, excluding the Prince of Wales, was used by the *Illustrated London News* to accompany subsequent articles on the Japanese crown prince. These included the announcement of his wedding to Princess Nagako (1903–2000) in 1924 as well as his father's death in 1926. When reproduced as a double portrait, the photograph also served to propagate the story of blossoming friendship between the two men. This ostensible relationship with a western prince, known for his progressive approach, allowed the Prince Regent to forge the image of a liberal-minded heir to the throne in touch with the times, keenly interested in diplomacy and open to change. AK

115

HERBERT VANDYK (1880–1943)

PRINCESS TAKAMATSU OF JAPAN (1911–2004) IN LONDON, 27 JUNE 1930

Gelatin silver print mounted on card

32.9 × 20.3 cm

Signed in ink by the sitter (lower left); signed in pencil by the photographer (on mount)

RCIN 2905573

PROVENANCE: Probably presented to King George V and Queen Mary

116

HERBERT VANDYK (1880–1943)

PRINCE TAKAMATSU OF JAPAN (1905–87) IN LONDON, 27 JUNE 1930

Gelatin silver print mounted on card

31.8 × 20.1 cm

Signed in ink by the sitter (lower right); signed in pencil by the photographer (on mount)

RCIN 2905574

PROVENANCE: Probably presented to King George V and Queen Mary

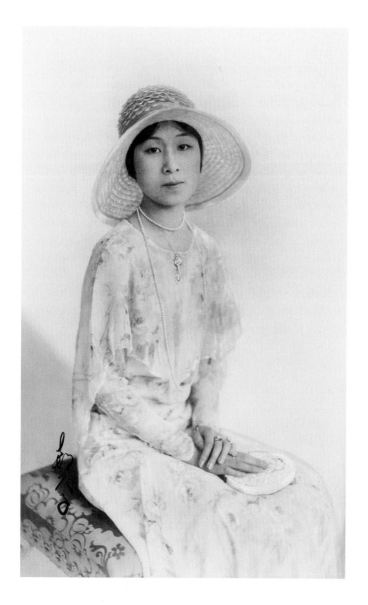

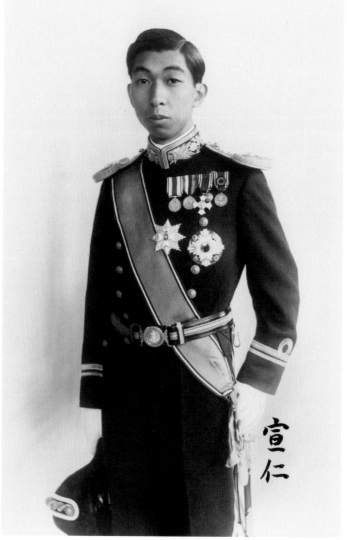

On 26 June 1930, Prince Takamatsu Nobuhito, younger brother of the Emperor Shōwa, arrived in Britain for a three-day official visit.[58] Accompanying him was Princess Takamatsu Kikuko, granddaughter of the last shōgun, who had married the prince a few months earlier. Not only did their trip form part of a honeymoon world tour, but it also returned the visit made by Prince Henry, Duke of Gloucester for his Garter Mission to Japan the year before.

In London, the prince and princess were the honoured guests of King George V at Buckingham Palace for two nights and then guests of the nation at Claridge's Hotel.[59] Amidst their official engagements, the couple had their portraits taken by Herbert Vandyk, a second-generation court photographer with a studio in close proximity to the palace.[60] Two individual portraits of the prince and princess from this sitting survive in the Royal Collection.

The prince appears in military attire with the star of the Royal Victorian Order, received upon his arrival at the palace, pinned centrally alongside his star of the Order of the Chrysanthemum. The princess wears an ethereal silk dress, her purse held elegantly on her lap. In keeping with western court conventions, the couple's wardrobe had been strategically selected to reinforce Japan's narrative of a reinvented and modernised monarchy: he is represented as a dutiful prince in western-style uniform, she as a dignified woman at the forefront of Parisian fashion.

Both photographs are undated and, curiously, there is no mention of the photographic session in the detailed records of the couple's itinerary kept at the Royal Archives.[61] However, the corresponding negative plates in the collection of the National Portrait Gallery bear inscriptions revealing that the portraits were taken on the second day of the couple's visit.[62] Another negative from the same sitting includes interior details of Buckingham Palace, indicating that the session took place there, rather than at the photographer's studio.[63] Despite this new evidence, it remains unclear whether Vandyk was commissioned by King George V or Prince Takamatsu. Nevertheless, the fact that each print has been autographed suggests that these two photographs were sent to the king as gifts. AK

LITERATURE: Dimond 1995 (exh. cat.), nos 33–4

117

AKATSUKA JITOKU (1871–1936)

MINIATURE CABINET OF DRAWERS, *c.*1905–07

Wood, black, gold and silver lacquer, mother-of-pearl, horn, shell

21.3 × 24.9 × 16.6 cm

Signed and marked on the inside of the right-hand door: *Akatsuka Jitoku* with *kaō*

RCIN 33967

PROVENANCE: Presented to Queen Mary by the Emperor Meiji and Empress Shōken as a Coronation gift, June 1911

This piece is the work of Akatsuka Jitoku, who has signed his name in gold and red lacquer inside the right-hand door. One of the most accomplished lacquerers of his generation, Jitoku was director of the Japan Artistic Craft Association (*Nihon kōgei bijutsu kyōkai*) and did much to promote the recognition of lacquer arts by the Imperial Art Academy, to which he was elected a member in 1930. His work was in high demand for imperial presentation pieces; and the dozen or so works by him known in collections outside Japan today were almost all official gifts.[64] This portable cabinet was selected as a Coronation present for Queen Mary by the Emperor Meiji and Empress Shōken in 1911. The imperial chrysanthemum crest (*kikumon*) appears on the top near the carrying handle, and the lock-plates of *shakudō* also have chrysanthemum bud knobs.

The decoration represents Jitoku's 'sunlight style', which characterised his artistic output in the years 1905–20. This period was distinguished by the lavish use of gold ground to evoke the impression of warm sunlight, in contrast to Jitoku's colder and sparser nocturnal designs of the preceding years.[65] Here, a resplendent *fundame* ground is embellished with a peacock taking flight over blooming azaleas. The peacock's feathers are studded with *aogai* (inlaid pieces of shell on lacquer) to form the green eyes. On the reverse is a peahen, and inside are seven drawers. In 1907, Jitoku won a gold medal at the Tokyo Exhibition for a casket similarly decorated with peacocks and azaleas, and it is possible it was this example. The cabinet may have been purchased later by the Imperial Household Agency and the chrysanthemum *mon* added before presentation, which might explain its unusual location on the upper surface.[66] **RP**

INVENTORIES: QMB, I, no. 524

LITERATURE: Joly and Tomita 1915, p. 6; Dees 1997a, pp. 3–12; Dees 1997b, pp. 5–6; Dees 2007, p. 38, fig. 67; Ayers 2016, III, no. 2223, pp. 1014–15

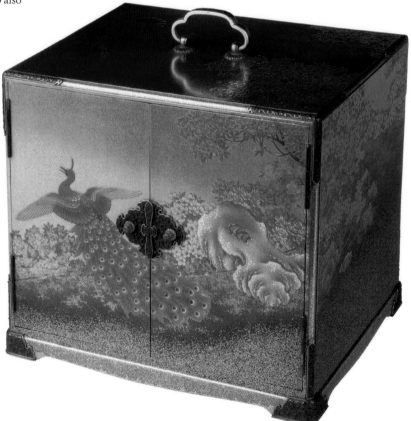

118

ATTRIBUTED TO AKATSUKA JITOKU
(1871–1936)
BOX AND COVER, c.1900–07

Wood, black and gold lacquer, mother-of-pearl

13.1 × 26.0 × 21.4 cm

RCIN 29465.a–b

PROVENANCE: Presented to Queen Mary when
Princess of Wales by Prince Fushimi Sadanaru, 1907

The large gold chrysanthemum crest (*kikumon*) on the cover of this
box identifies it as an imperial gift. Although unsigned, the piece can
confidently be attributed to Akatsuka Jitoku. The box bears all the
hallmarks of his bolder and proto-modernist work: an exuberant
design spilling over onto the sides of the box, a botanical subject,
rich *nashiji* ground and shell inlay.[67] Here, sagittaria plants grow by a
meandering stream, their blooms inlaid with mother-of-pearl and with
gold-spotted centres. The bronze-coloured stems and leaves appear
in *takamakie* (lacquer in high relief). The stylised stream recalls the
abstract wave patterns of the Rinpa school of painting associated with
Hon'ami Kōetsu (1558–1637), whose revival influenced lacquer artists in
the early twentieth century. An almost identical piece, signed by Jitoku,
is in the Freer Gallery of Art and Arthur M. Sackler Gallery.[68]

This box is typical of the high quality pieces selected as Meiji
imperial gifts: of rectangular form, with rounded corners and a bold
design. It was presented to Queen Mary when Princess of Wales
by Prince Fushimi Sadanaru, who visited Britain in 1907 to convey
the Emperor Meiji's thanks for the Order of the Garter. In 1915, the
queen loaned the box to an exhibition of 'Japanese Works of Art and
Handicraft from English Collections', which was held in aid of the
British Red Cross Society at the Yamanaka Galleries on New Bond
Street. Queen Mary visited the exhibition on 19 October and her
mother-in-law, Queen Alexandra, attended on 15 November.[69] RP

INVENTORIES: QMB, I, no. 520; QMPP, III, no. 266

LITERATURE: Joly and Tomita 1915, p. 6; Dees 1988, pp. 103, 105;
Dees 2007, p. 50, fig. 54; Ayers 2016, III, no. 221, pp. 1012–13

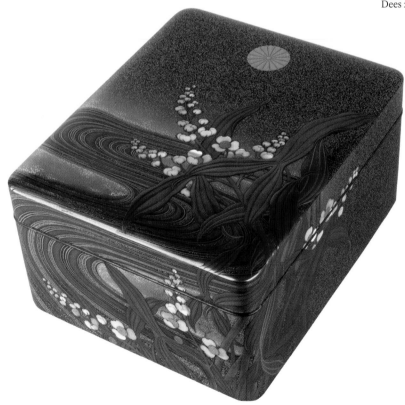

DOCUMENT BOX AND COVER (BUNKŌ),
c.1900–07

Wood, gold and silver lacquer

11.7 × 23.0 × 18.5 cm

RCIN 29450.a–b

PROVENANCE: Presented to King George V when
Prince of Wales by Admiral Yamamoto Gonnohyōe,
29 May 1907

Combining naturalistically rendered flowers with a plain ground was
one of the most distinctive innovations of the late Meiji period, when
lacquer artists began incorporating elements of western realism into
their work. Detailed silver and gold sprays of peony and hibiscus appear
here in high relief lacquer (*takamakie*), standing out dramatically as
though lit from behind. The blooms extend over the edges of the box,
giving the impression that they are observed at close quarters. The gold
ground is by contrast remarkable for its evenness. It is an outstanding
example of a *kinji* ground, created by densely sprinkling fine gold
powder and polishing it to a bright finish. This style was particularly
associated with Akatsuka Jitoku and his contemporaries.[70]

The box was a gift to George, Prince of Wales from one of the leading
Japanese naval officers of the Meiji period, Admiral Yamamoto
(1852–1933), who would later serve twice as Prime Minister of Japan
(1913–14 and 1923–4). In 1907, Yamamoto came to England ahead of
the visit of Prince Fushimi Sadanaru, who had been sent to express
the Emperor Meiji's gratitude for the Order of the Garter, received
the previous year. Yamamoto's duties included negotiating military
agreements relating to the Anglo-Japanese Alliance, which had been
renewed in 1905. During his visit, he viewed a military Field Day at
Aldershot with King Edward VII. Yamamoto later wrote to express his
thanks for the 'kindness and attention shown him', remarking 'how
greatly he admired the King's activity; that the King was an older man
than [the] Emperor, but that his activity both of mind & of body had
greatly impressed both Prince Fushimi & himself'.[71] RP

INVENTORIES: QMPP, III, no. 172

LITERATURE: Ayers 2016, III, no. 2222, p. 1013

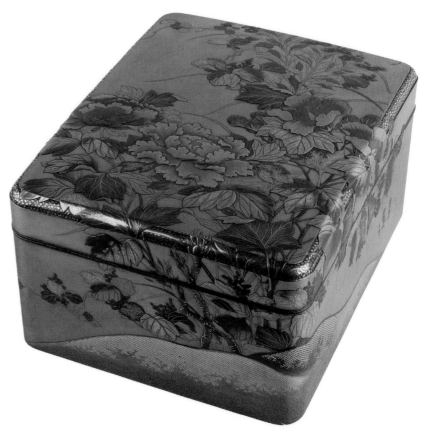

JAPAN

**BOX FOR LETTERS (FUBAKO)
AND ADDRESS**, 1922

Paper, brocade, wood, gold lacquer, silk

7.5 × 36.0 × 10.0 cm

RCIN 69623.a, c–d

PROVENANCE: Presented to King Edward VIII when
Prince of Wales by the Governor of Kagoshima
during his visit to Japan, 9 May 1922

The final day of Edward, Prince of Wales's visit to Japan in 1922 was
spent at Kagoshima. During his brief five hour period ashore on 9 May,
he received delegations from all parts of the prefecture. This *fubako*
contains an address from Nakagawa Nozomu, Governor of Kagoshima,
who noted that the prince was visiting on the anniversary of 'the
very day when Your Royal House entertained our Crown Prince in
Buckingham Palace last year'.

Fubako, or boxes for letters, were used in Japan from the sixteenth
century to transport and present scrolls in a suitably impressive
manner. The meticulous lacquer decoration reflects the significance
of the documents within. From the Edo period, such boxes were often
incorporated into a bride's trousseau, decorated with the *mon* of
the two families. Here, the artist has departed from Japanese motifs
to reflect the occasion of the prince's visit, adding Prince of Wales's
feathers in gold *hiramakie* (lacquer in low relief). No other *fubako* with
this design is known to exist. Prince of Wales's feathers also appear on
the red brocade which lines the back of the address, within a foliate
pattern of white chrysanthemums. RP

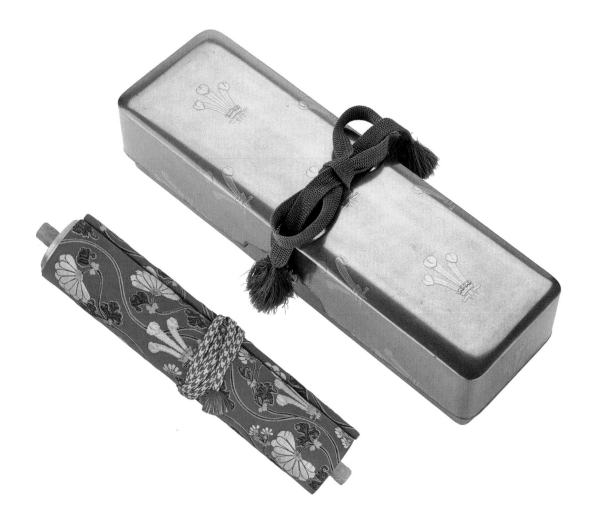

121
JAPAN
BOX FOR LETTERS (FUBAKO),
1900–30

Wood, gold, silver and black lacquer, mother-of-pearl, silk

7.0 × 29.4 × 9.9 cm

Marked on the base in gold: 滋賀縣 (*Shiga-ken*;
'Shiga Prefecture')

RCIN 79920.a–b

PROVENANCE: Probably presented to King Edward VIII
when Prince of Wales in Japan, 1922

The crane ranks among the most popular motifs in Japanese art, considered auspicious for its association with longevity and good fortune. It is traditionally thought to live for a thousand years.[72] Here, three cranes with mother-of-pearl wings fly over water towards a pavilion surrounded by pines. The grouping is itself auspicious, since odd numbers have been favoured in Japanese culture since at least the mid-Heian period, including in visual motifs and the dates for annual observances.[73]

The inscription 'Shiga Prefecture' in gold lacquer on the base suggests the box was an official gift. It was possibly presented to Edward, Prince of Wales during his visit to Japan in 1922. The prince travelled through Shiga on his way to Gifu, where he watched the ancient art of fishing with cormorants by torchlight. Having travelled from Kyoto by mountain road, the prince took a steamer across Lake Biwa which was 'dotted with sail boats beflagged as though for a regatta'.[74] RP

LITERATURE: Ayers 2016, III, no. 226, p. 1018

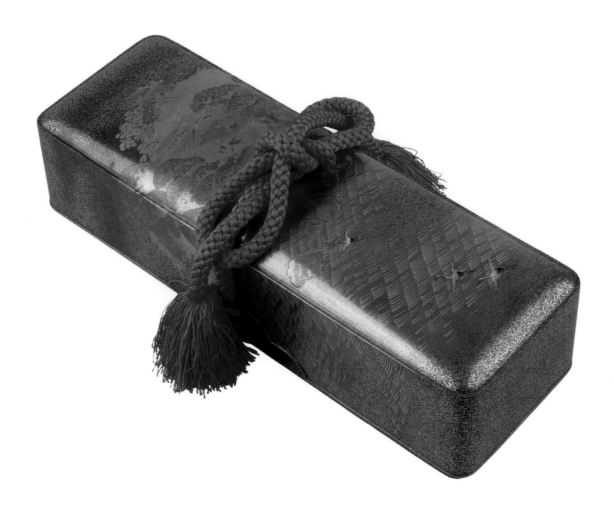

122
JAPAN
BOX FOR LETTERS (FUBAKO),
1900–30

Wood, black, gold and silver lacquer, silk

9.4 × 42.5 × 13.8 cm

RCIN 79921.a–b

PROVENANCE: Probably presented to King Edward VIII when Prince of Wales in Japan, 1922

Chrysanthemum stems in gold and silver lacquer relief comprise the main decoration on this *fubako*. This autumn flower remains in bloom for an extended period and as a result is associated with strength and long life. An anonymous poet writing *c*.961 AD declared, 'Every year with the ninth month / The chrysanthemum blooms again / Autumn must understand eternity.'[75] The undulating lines of the flowing stream below are a *tour de force* of precision and control. Each has been applied by hand with a single fluid movement, creating parallel curves which touch but never overlap. A box of this kind would almost certainly have been presented with an address within; the contents are now missing. **RP**

LITERATURE: Ayers 2016, III, no. 2225, p. 1017

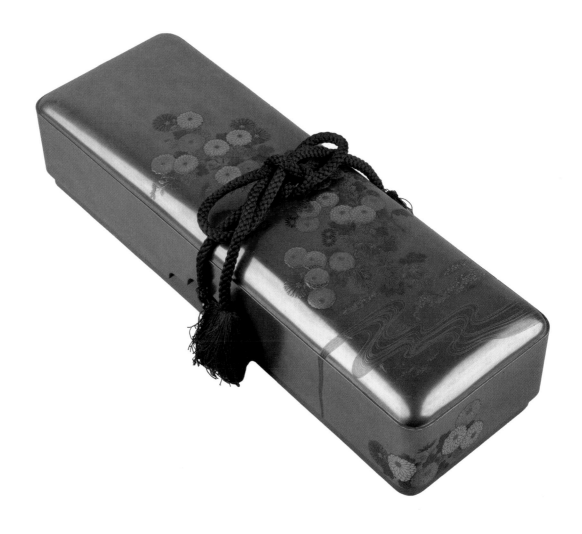

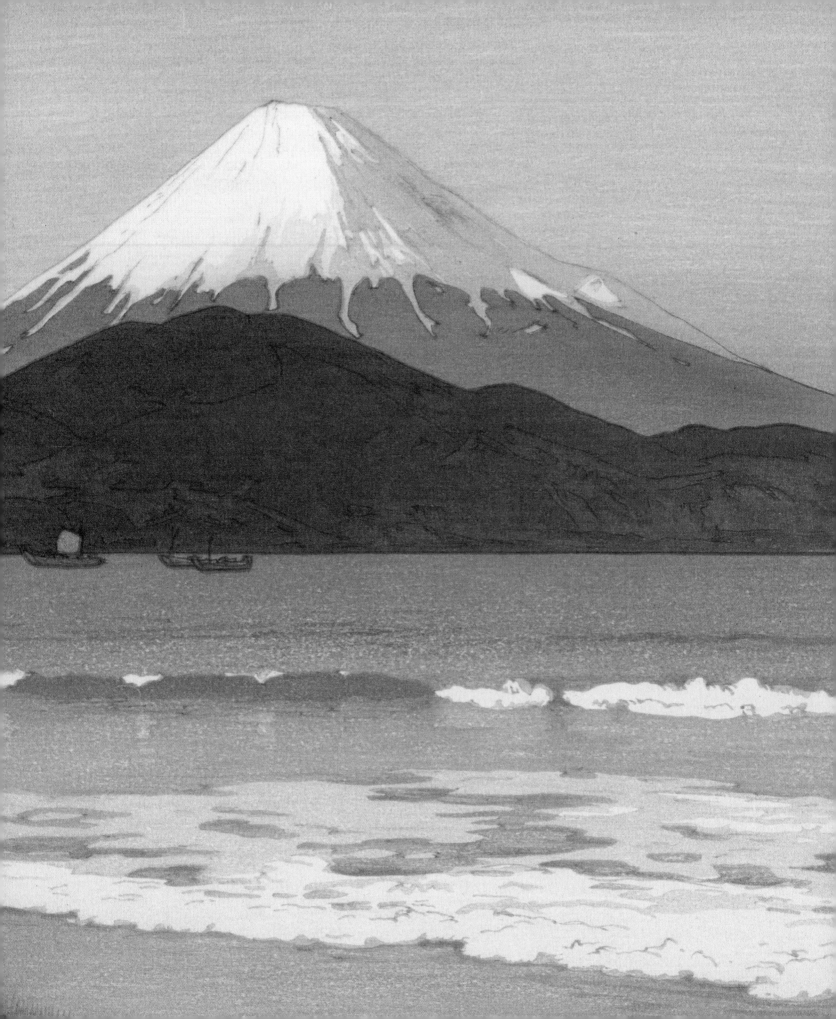

日本の芸術

9

ARTISTIC EXCHANGE

KATHRYN JONES

Fʀᴏᴍ the moment Japanese works of art reached the West, European artists sought to imitate their techniques, forms and decorative motifs. It was not, however, until the middle of the nineteenth century that there was any true sense of artistic exchange. At first, this was largely achieved through the display of Japanese works of art at a series of world fairs. In the 1850s, small numbers of objects were shown at European exhibitions, which usually mixed Japanese with Chinese art and failed to distinguish the two in the catalogues. At the London International Exhibition of 1862, Sir Rutherford Alcock displayed some 600 works of Japanese origin, which made people in both countries aware of the significant interest in the artistic works of Japan (see p. 108).

The turning point came at the Paris *Exposition Universelle* in 1867, when the Japanese for the first time exhibited as a nation, alongside displays by Satsuma and Hizen provinces. Conscious that their industrial output could not yet stand scrutiny beside its European counterparts, the Japanese chose instead to display traditional arts. Warmly received by the jury, they were awarded prizes for lacquerware, silks and ceramics. This allowed the Japanese to gauge more precisely which wares were popular in Europe. By the time of the Vienna fair in 1873, the Japanese confidently brought works that they knew would cause a sensation, many of them of enormous scale – such as a giant lantern four metres in diameter and a model of the Great Buddha (*Daibutsu*) of Kamakura. The success of these fairs spurred the foundation of companies such as Kiritsukōshōgaisha, which began to sell export wares in enormous numbers. Ceramic sales from Japan rose from ¥45,000 in 1872 to ¥116,000 in 1873, for example.[1]

In Europe in the 1870s, the availability of Japanese works of art inspired an artistic movement known as *japonisme*. In Britain, the designer Christopher Dresser (1834–1904), architect Edward Godwin (1833–86) and artist James McNeill Whistler (1834–1903) were inspired by motifs and techniques

found in Japanese decorative arts and particularly by *ukiyo-e* ('floating world') works, with their asymmetrical perspectives, interior views and colourful backgrounds. The movement was encouraged by publications like Siegfried Bing's periodical *Le Japon Artistique*, which was printed in French, German and English between 1888 and 1891, and by the spread of shops like La Porte Chinoise in Paris and Liberty's in London. However, the Royal Collection contains only a small number of works that might be characterised as *japoniste*. Among these is a silver bowl produced by the Danish goldsmiths, Michelsen, in the 1890s (cat. 124) which incorporates *koi* and crab motifs, and appears to imitate the *zōgan* techniques more typically found on Japanese bronze wares.

More focused exhibitions of Japanese art were held in London in the late nineteenth and early twentieth centuries, including shows at the Burlington Arts Club and the Royal Academy. Queen Mary was an inveterate visitor and lender to such exhibitions as well as a keen collector of lacquer and ceramics.[2] She built a network of advisers around her: curators from the Victoria and Albert Museum, dealers such as John Sparks (1854–1914) and enthusiasts such as Philip Sassoon (1888–1939), who all helped to form her collections. A high point of the queen's fascination with the country came at the Japan-British Exhibition held in White City, which she visited with King George V on 6 August 1910. The press noted that she viewed with 'marked interest' the 'sumptuous brocades and the lovely, tapestry-like fabrics that give such pictorial results'.[3] A number of the artists at the London exhibition remained in England after its close. Among them was the woodblock artist Urushibara Yoshijirō (Mokuchū), who later produced prints of flowers, which were purchased by Queen Mary (cats 126–130). By 1915, more than 40 Japanese artists were working in Britain.[4] One of the most celebrated was Makino Yoshio (Yoshio Markino) (1869–1956), who in 1928 presented Queen Mary with a woodcut of Buckingham Palace that combined western and Japanese styles (cat. 125).

British artists were equally keen to seek inspiration in Japan. A few examples of their work were collected by the British

royal family, among them seven prints by Elizabeth Keith (1881–1956), acquired by Queen Elizabeth The Queen Mother in 1937 (cat. 132). Keith had first travelled to Japan in 1915 and there spent two years learning woodblock printing techniques. She was also associated with *shin-hanga* ('new prints'), an early twentieth-century movement which had been inspired by European impressionism, adopting elements such as the effects of light into treatment of traditional Japanese subject matter. As the Japanese delegation at the 1862 exhibition had noted, 'the point ... is to teach and learn from each other, and to take advantage of each other's strengths. It is like trading intelligence and ideas.'[5]

123

SCHÜRMANN & CO., FRANKFURT

JAM OR HONEY POT WITH COVER, TRAY, SPOON AND LADLE, 1887

Silver, partially gilt and patinated, rose gold

23.0 × 22.0 × 2.0 cm (tray); 10.2 × 9.8 × 9.8 cm (pot and cover); 16.7 cm long (spoon); 8.6 cm long (ladle)

Each piece hallmarked: German state mark, fineness mark; the tray marked 'Schürmann'

Tray engraved: *1837 21 Juni 1887 / Gott segne diesen Tag* ('God bless this day'); *In Treue und Dankbarkeit* ('in loyalty and gratitude')

RCIN 13153.a–e

PROVENANCE: A Golden Jubilee gift to Queen Victoria, possibly from Lady Victoria and Lady Helena Gleichen, 21 June 1887

The German firm that produced this group of silver-gilt items has made use of colour and texture in the manner of Japanese metalwork. Each of the objects has been gilded, and then treated with the application of acid to give the ground a matt finish; the design has then been finely engraved to expose the silver beneath. In places, this has been patinated or a rose gold alloy applied to present a polychrome appearance. The overall effect was undoubtedly influenced by the *zōgan* (inlay) tradition in Japan, which placed little emphasis on the shiny surface of the metal but rather on the subtle range of colours produced by different alloys. The adoption of motifs drawn from nature – birds, insects and flowering grasses – may also have been influenced by similar decorative devices on Japanese sword guards (*tsuba*).

Queen Victoria's entry in her Journal for 21 June 1887, the day of her Golden Jubilee, describes the service of thanksgiving at Westminster Abbey, which was followed by a dinner at Buckingham Palace. In the interval between the service and the evening celebrations, the queen was presented with various gifts; among them, these objects.[6] The tray displays an 'HVG' cipher, possibly for Helena and Victoria Gleichen, granddaughters of the queen's half-sister, Feodora (1807–72), who attended the celebratory dinner. KJ

LITERATURE: Jones 2017, no. 92, pp. 176–7

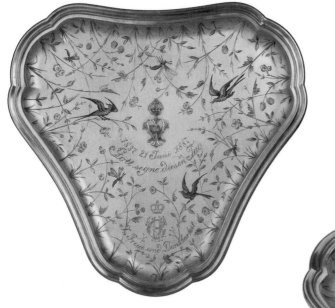

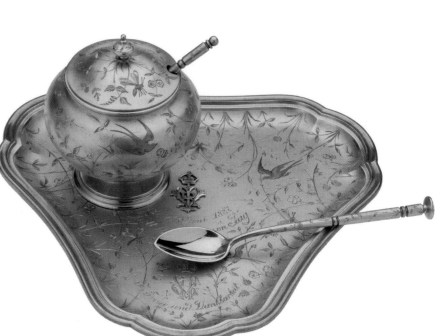

124
MICHELSEN, COPENHAGEN
BOWL, 1894

Silver, parcel gilt

6.6 × 11.9 × 11.9 cm

Marks: hallmarks for Copenhagen, 1894, assay mark,
maker's mark of Michelsen

RCIN 106051

PROVENANCE: Probably acquired by
Queen Elizabeth The Queen Mother

The Nordic Exhibition of Industry, Agriculture and Art held in
Copenhagen in 1888 was hugely influential on Danish design over
the following decades. The fair, which attracted more than one
million visitors, was thought by the press to show up the weakness
of Danish design at that date. By contrast, a French art dealer and
Japan enthusiast, Siegfried Bing (1838–1905), displayed woodblock
prints and other Japanese works of art at the exhibition, and these
caused something of a sensation among Danish craftsmen. Bing also
contributed around 100 Japanese works of art to the new Danish
Museum of Art and Design (*Det Danske Kunstindustrimuseum*), which
opened in 1895. The Japanese artists' emphasis on form, restrained
decoration and works inspired by nature became the basis of a new
movement in Danish design. The firm of Michelsen, producers of
silverware, was at the forefront of the adoption of this new style.

This bowl displays some of these new approaches, particularly in
its simple geometric outlines, broad areas of unadorned surface and
decorative motifs, which include carp, a small crab and fronds of water
plants, all common subjects in Japanese prints. The fish and crab on
this bowl have been cast and applied; they are perhaps intended to
resemble the complex *zōgan* inlay and relief decoration popular in
Japanese metalwork. KJ

LITERATURE: Jones 2017, no. 246, p. 379

125

MAKINO YOSHIO (YOSHIO MARKINO)
(1869–1956)

**BUCKINGHAM PALACE, LONDON,
SEEN ACROSS GREEN PARK**, *c.*1911

Colour woodcut

28.3 × 38 cm (sheet)

Inscribed lower left: 西むら刷 (*Nishimura suri*; 'Printed
by Nishimura'); はせ川刻 (*Hasegawa koku*; 'Carved by
Hasegawa'); よしを (*Yoshio*)

RCIN 702798

PROVENANCE: Presented to Queen Mary by the artist,
1 May 1928[7]

Makino Yoshio, known as Yoshio Markino, was a Japanese artist
and writer born in Koromo (Toyota City). In 1893, he travelled to
San Francisco where he trained at the Hopkins Art School, before
arriving in London in 1897, instantly falling in love with the city. He
spent hours walking the streets, fascinated by the effect of mist and
fog on the appearance of buildings, especially under gaslight. This
he captured in watercolour. His first and most important critical
success was the publication of *The Colour of London* by W.J. Loftie
in 1907, which contained reproductions of 48 of his watercolours,
together with his written observations on life in the capital. Here he
commented on the city, 'Age and the fogs have made the buildings
so beautiful ... The colour and its effect are most wonderful'.[8]

 This print shows the ghostly outline of Buckingham Palace
at dusk, and demonstrates the way in which Markino's work
combined his western artistic training with his Japanese heritage.
The scene is presented with the simplicity of a *ukiyo-e* print, but
the colours are muted and the winding path through Green Park
provides a strong sense of perspective. The Japanese printmaker
Urushibara Yoshijirō (see cats 126–130) created some of the
woodblocks for Markino's prints, but the woodblock for this print
was carved and printed by two separate Japanese craftsmen.

 At the height of his success, Markino became something of a
celebrity, but the outbreak of the Second World War, increasing
tensions between Japan and Britain and a stalling of his creativity
all contributed to a downturn in his career. Markino finally
returned to Japan in 1942, where he remained until his death. RW

LITERATURE: Rodner 2012, p. 175

126

URUSHIBARA YOSHIJIRŌ (MOKUCHŪ)
(1889–1953)

SWEET PEAS IN A VASE, c.1913

Colour woodcut

30.4 × 20.1 cm (image); 52.3 × 35 cm (frame)

Signed on print, lower right [in Japanese characters]:
'designed by Urushibara'; seal [in Japanese characters]:
'Urushibara'; inscribed in pencil on the lower left edge,
No. 113 and signed in pencil lower right *Y. Urushibara*

RCIN 502217

PROVENANCE: Probably purchased by Queen Mary

LITERATURE: Harvey-Lee 1994, no. 110 (light background);
Harvey-Lee 2007, no.128 (light background); Chapman
and Horner 2017, F40 (light background)

The woodblock artist Urushibara Yoshijirō, also known by his artist name Mokuchū, was born in Tokyo, where he was employed by the publisher Shinbi shoin. The firm produced high-quality colour prints following the traditional Japanese woodblock method. Urushibara was selected by the company to travel to Britain and demonstrate woodblock printing at the Japan-British Exhibition at White City in 1910. He remained in London after the exhibition and, through Shinbi shoin, was employed with a colleague to reproduce a Chinese handscroll, *Nushi zhen*, at the British Museum. Between 1912 and 1918, Urushibara worked on the mounting and restoration of prints and paintings, and subsequently taught traditional Japanese mounting techniques at the museum on a freelance basis. During this time and beyond, he printed his own works and interpreted in woodblock the drawings and watercolours of other artists, including those of the contemporary Japanese artist Yoshio Markino (cat. 125) and the British artist Frank Brangwyn (1867–1956). Brangwyn was a close friend with whom he produced portfolios of prints, as well as interpreting over 50 of his paintings and drawings in woodblock form.

When creating his own prints, Urushibara was responsible for all stages of their production: the drawing of the design, the carving of the woodblock and the printing of the block. In this he departed from the traditional system of woodblock print production for the creation of *ukiyo-e* prints. In Japan a publisher would separately employ an artist, carver and printer, and would oversee the process, working with each to create the desired result. By contrast, Urushibara kept total artistic control over each element, placing him within the *sōsaku-hanga* ('creative prints') movement that emerged in Japan at the start of the twentieth century.

These five flower prints are examples of this process, which relied on his 'precise and meticulous' approach.[9] Each impression was created by printing an initial design carved from a wooden block (the 'key block'), followed by printing separate carved woodblocks, each coated with their own ink colour, onto the same piece of paper. It was vital to make sure that each block lined up exactly on the paper, a process known as 'registration'. The vase in the *Carnations* print (cat. 127), for example, was printed from five separate blocks.[10] Paper made from mulberry fibre (*kōzoshi*) was imported from Japan and it is not unusual to find variations in colour for each impression of a print, particularly where the floral prints were concerned. Urushibara did not date his prints, but his works were signed with both a printed seal within the image and in pencil along the lower edge, together with the number of the impression, in the manner of western artists.[11]

On 26 June 1928, Queen Mary visited an exhibition of Urushibara's work at the Abbey Gallery, London,[12] where she purchased four of his prints, three of which are included here (the *Daffodils*, *Dahlias* and *Peonies*).[13] It seems highly likely that she also purchased the colour woodcuts of *Sweet Peas* and *Carnations*.[14] RW

127

URUSHIBARA YOSHIJIRŌ (MOKUCHŪ)
(1889–1953)

CARNATIONS IN A GINGER JAR, *c.1913*

Colour woodcut

30.3 × 20.2 cm (image); 52.4 × 39.5 cm (frame)

Signed on print, lower right [in Japanese characters]:
'designed by Urushibara'; seal [in Japanese characters]:
'Urushibara'; inscribed in pencil on the lower left edge,
No. 45 and signed in pencil lower right *Y. Urushibara*

RCIN 502218

PROVENANCE: Probably purchased by Queen Mary

LITERATURE: Campbell Fine Art 2003, no. 402; Harvey-Lee
2007, no. 130; Chapman and Horner 2017, F5

128

URUSHIBARA YOSHIJIRŌ (MOKUCHŪ)
(1889–1953)

PEONIES IN A VASE, *c.1925*

Colour woodcut

40.3 × 34 cm (image); 59.2 × 45.6 cm (frame)

Signed on print, lower right [in Japanese characters]:
'designed and engraved by Urushibara'; seal [in Japanese
characters]: 'Urushibara'; inscribed in pencil on the
lower left edge, *No. 140* and signed in pencil lower right
Y. Urushibara

RCIN 502219

PROVENANCE: Purchased by Queen Mary in 1928

LITERATURE: possibly Society of Graver-Printers 1925
(exh. cat.), no. 3; Deighton & Sons 1928 (exh. cat.), no. 7;
Harvey-Lee 2001, no. 91 (variant with fallen petals);
Chapman and Horner 2017, F35

129
URUSHIBARA YOSHIJIRŌ (MOKUCHŪ)
(1889–1953)

DAFFODILS IN A VASE, *c.*1928

Colour woodcut

38.5 × 26.9 cm (image); 58.9 × 45.3 cm (frame)

Signed on print, lower left [in Japanese characters]: 'designed and engraved by Urushibara'; seal [in Japanese characters]: 'Urushibara'; inscribed in pencil on the lower left edge, *No. 17* and signed in pencil lower right *Y. Urushibara*

RCIN 502220

PROVENANCE: Purchased by Queen Mary in 1928

LITERATURE: Deighton & Sons 1928 (exh. cat.), no. 4; Chapman and Horner 2017, F11

130
URUSHIBARA YOSHIJIRŌ (MOKUCHŪ)
(1889–1953)

DAHLIAS IN A VASE, *c.*1928

Colour woodcut

38.7 × 27.6 cm (image); 58.9 × 45.3 cm (frame)

Signed on print, lower right [in Japanese characters]: 'designed and engraved by Urushibara'; seal [in Japanese characters]: 'Urushibara'; inscribed in pencil on the lower left edge, *No. 19* and signed in pencil lower right *Y. Urushibara*

RCIN 502221

PROVENANCE: Purchased by Queen Mary in 1928

LITERATURE: Deighton & Sons 1928 (exh. cat.), no. 12; Chapman and Horner 2017, F13 (black background)

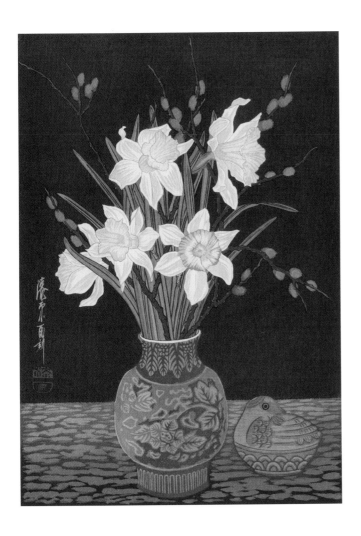

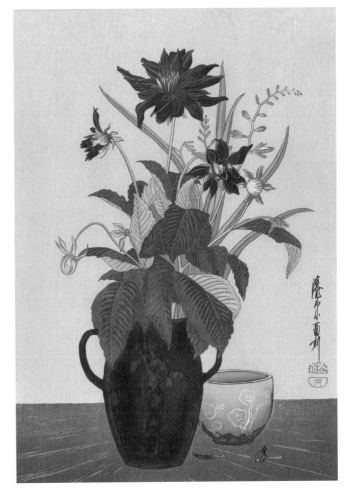

131

YOSHIDA HIROSHI (1876–1950)
MOUNT FUJI FROM MIHO, 1935

Colour woodcut

26.8 × 40.0 cm (sheet)

Inscribed in the left margin: 自摺 (*jizuri*; 'self-printed');
昭和拾年作 (*Shōwa jūnen saku*; 'Produced in 1935');
三保 (*Miho* [in Shizuoka Prefecture]); signed on print:
よし田 (*Yoshida*); inscribed on the lower left edge:
Fuji yama from Miho and signed in pencil on the
lower right edge: *Hiroshi Yoshida*

RCIN 507122

PROVENANCE: Possibly acquired by Queen Mary

Mount Fuji, a quiescent volcano on the island of Honshū and
Japan's highest mountain, has inspired artists for centuries. In this
woodcut, the peak (generally covered in snow between November
and May each year) is seen from Miho beach, on the western shore
of Suruga Bay. Yoshida had already created a series of ten views of
Mount Fuji between 1926 and 1928, inspired by Katsushika Hokusai's
36 views of the iconic mountain (*c.* 1829–33).

Born in Kurume, Fukuoka Prefecture, Hiroshi was adopted in
1891 by his art teacher Yoshida Kasaburō and took his name. He
studied western-style painting in Kyoto and became a landscape
painter. In 1920, aged 44, he produced his first print for Watanabe
Shōzaburō (1885–1962), a publisher of colour woodcut prints
and proponent of *shin-hanga* print production. *Shin-hanga* prints
were produced in the traditional four-part system associated with
ukiyo-e prints, of publisher, artist, woodblock carver and printer,
but reflected the influence of western-style perspective and shadows
within the compositions.

Between 1923 and 1925, Yoshida travelled with his wife Fujio
to the United States and Europe, painting and selling works. He
noted the enthusiasm for Japanese prints in the West and on
his return to Japan decided to set up his own print workshop,
largely for export to the western market. He employed his own
woodblock carvers and printers, but maintained artistic control
over the creation of the print, also learning the skills of the
woodcarver and printer. The subjects of his prints reflect his
travels and love of nature, and are known for their use of subtle
gradations of colour. RW

LITERATURE: Yoshida 1939, pl. VI, pp. 120–21; Tadao 1987, no. 206

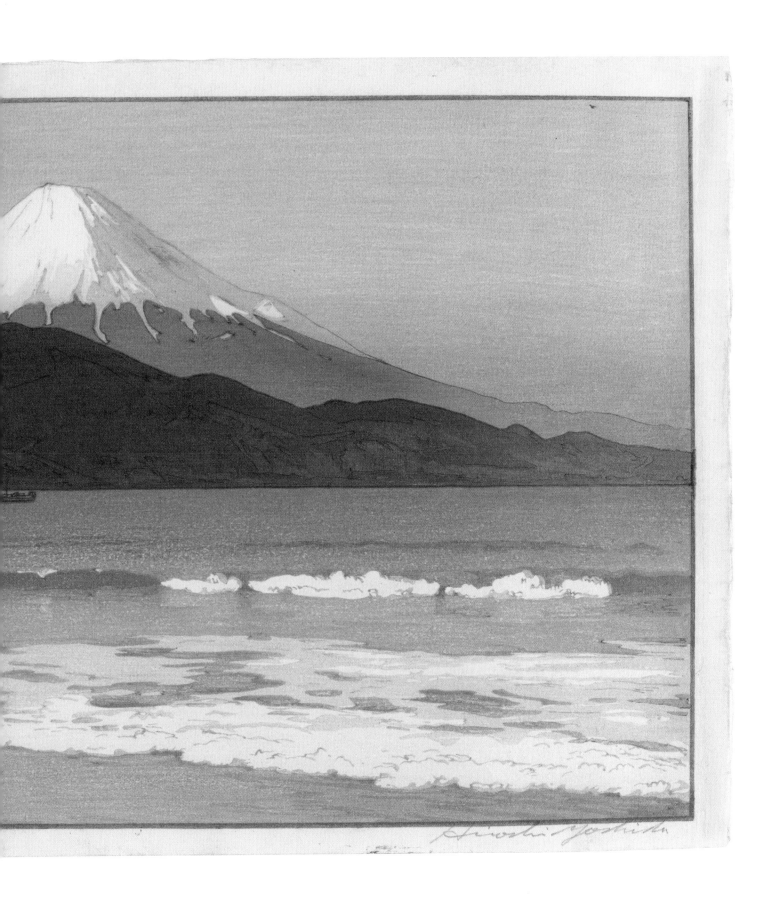

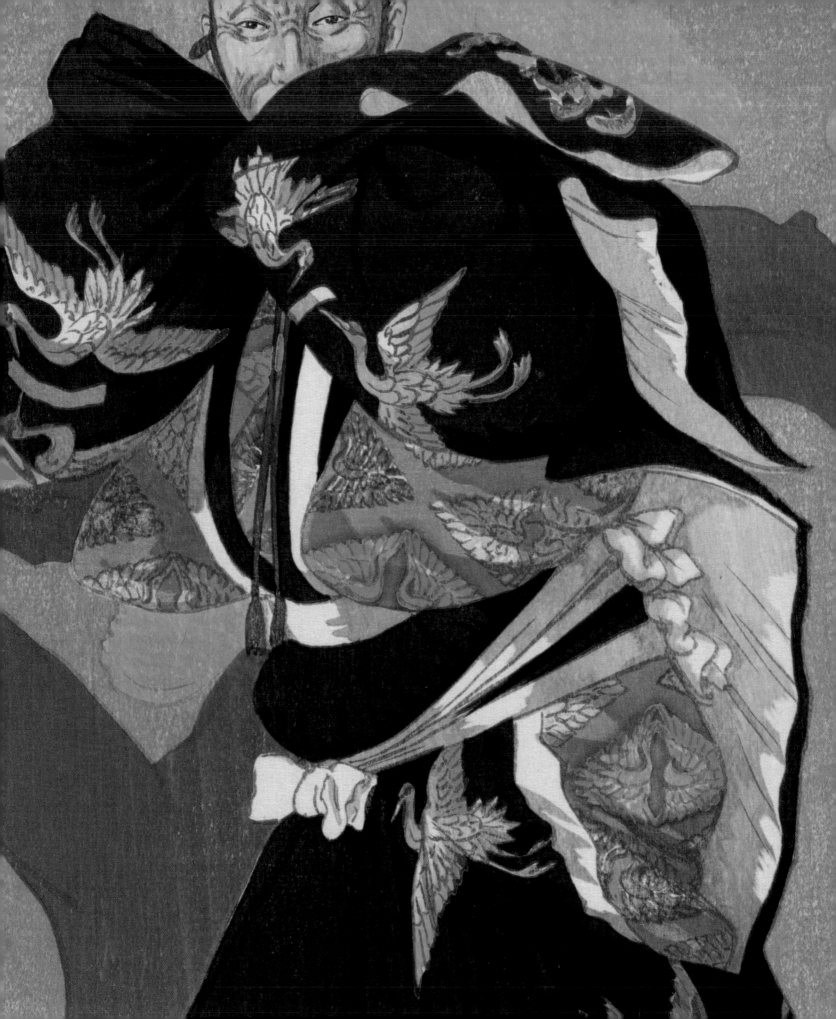

ELIZABETH KEITH (1881–1956)
SHIGEYAMA, KYŌGEN ACTOR
IN 'SAN-BA-SŌ', KYOTO, 1936

Colour woodcut

43.6 × 30.8 cm (image); 63.5 × 51.0 cm (frame)

RCIN 504348

Signed lower right: *Elizabeth Keith*

PROVENANCE: Purchased by Queen Elizabeth from
the Beaux-Arts Gallery, London, 26 November 1937,
£5 5s. 0d.[15]

Elizabeth Keith was a self-taught artist from Aberdeenshire, Scotland.
She first travelled to Japan in 1915 to visit her sister and brother-in-
law, the publisher J.W. Robertson-Scott, who lived in Tokyo. She
stayed for nine years and during this time visited China, Korea and
the Philippines. The publication of a number of caricature sketches
in 1917 brought her work to the attention of the *shin-hanga* publisher
Watanabe Shōzaburō (see cat. 131), who wanted to turn the drawings
and watercolours from her travels into colour woodblock prints
reminiscent of the *ukiyo-e* era. Keith spent two years learning the
Japanese arts of carving and printing woodblock prints, but also
made use of the skilled craftsmen working for Shōzaburō.[16]

This print of the actor Shigeyama was made during Keith's last
visit to Japan in 1935–6, when she planned to create a series of prints
of *Nō* theatre. In the end, it was one of only three prints produced.
Shigeyama was a performer of *kyōgen*, or comic interludes designed
to relieve tension within and between *Nō* plays. Here he dances the
Sanbasō, a lively sequence associated with *Okina*, the play which
always opens a *Nō* programme, and which is often also performed at
New Year or on other auspicious dates. The composition looks back
to the long tradition of *ukiyo-e* actor prints: one performer is seen
in the centre of the sheet, holding a pose in costume, as if the image
were captured during a performance.

Following Keith's return to Britain, a selection of her works from
travels in Japan, China, Korea and Malaysia were displayed at the
Beaux-Arts Gallery in London between October and November 1937.
Queen Elizabeth saw the exhibition and bought seven of her prints,
including this one.[17] The onset of war between Britain and Japan in
1941 brought an end to Keith's output. RW

LITERATURE: Beaux-Arts Gallery 1937 (exh. cat.), no. 52;
Miles 1991 (exh. cat.), no. 108

OKAMOTO TŌYŌ (1891–1969)

SPRING BEAUTY OF KYOTO, c.1925–9

Folding concertina album containing 24 gelatin silver prints

33.2 × 30.5 × 8.0 cm (closed)

RCINS 2862255 (album), 2862260, 2862277, 2862269 (photographs shown)

PROVENANCE: Presented to Prince Henry, Duke of Gloucester in Japan, 1929

The photographs in this silk-bound concertina album were taken by Okamoto Tōyō, a key, yet largely overlooked, figure in the evolution of Japanese photography during the interwar period.[18] Born in the Nakagyō ward of Kyoto, Okamoto Sadatarō, as he was originally named, was the second son of a prosperous textile artisan.[19] As his eldest brother was destined to inherit the family business, Okamoto assisted with day-to-day operations while dabbling in painting and drawing. However, in 1916, when he was 26, both his brother and father died and the business passed to him. The following year he took up photography as a hobby, and about ten years later he closed the family firm to establish a professional photography studio under his pseudonym Tōyō.

By the time Okamoto purchased his first camera, the amateur photography scene in Japan was dominated by pictorialism, a photography movement that had spread to Japan from Europe in the mid-1890s.[20] Pictorialists strove to elevate photography to a fine art through complex darkroom techniques that allowed the creation of unique prints with a painterly finish. In 1921, however, a group of non-professional photographers rebelled against the movement's artiness and self-absorption.[21] Advocates of this view rejected the technique-centred processes in favour of direct printing on bromide paper. They also replaced their deluxe soft-focus lenses with less sophisticated photographic equipment.[22]

Although there is evidence that Okamoto initially experimented with pictorialism, he quickly adopted a straight printing practice and a vest-pocket camera. In the mid-1920s, he contributed ruminative images of Kyoto to several journals that broke from pictorialism, such as *The Japan Photographic Annual* (*Nihon shashin nenkan*) and *Asahi Camera*.[23] Topographical studies of his home town also formed an important part of his later professional work, as did his animal and plant photography. While the former subject usually catered to the demands of the tourist industry for souvenir portfolios, the latter served as source material for painters including Yokoyama Taikan (1868–1958) and Kawai Gyokudō (1873–1957).[24]

Okamoto's *Spring Beauty of Kyoto* is a fine example of his fascination with both flowers and Kyoto. The album presents views of the former imperial capital during the cherry-blossom season. As the pages unfold, like panels of a Japanese screen, the viewer is taken on a meandering visual excursion through the blooming gardens of the city, including those at Kiyomizu-dera, Ninna-ji and Byōdō-in. Okamoto's images are pastoral scenes offering an escape from the urban transformation of Kyoto, and yet his straightforward technique is undeniably modern. Without departing from the fundamentally romantic contemplation of nature, Okamoto achieves a balance between pictorialism and modernism, the lyrical and the dynamic. His photographs are simultaneously straightforward records and visual poems that remain startling to this day. AK

Both western and Japanese pictorialists drew on theories and practices from Japanese art. Even after the movement's demise, photographers in Japan continued to look to local traditions for aesthetic cues. One such inspiration was the gradation and tonality of ink wash paintings (*suibokuga*); another the asymmetrical framing and flatness of woodblock prints (*ukiyo-e*). Okamoto incorporated these elements into his lyrical images, including plate 5 of a canopy of cherry blossoms juxtaposed with pine.

Plate 5

The vast majority of Okamoto's photographs in this album are devoid of human presence. Okamoto used this device to heighten the atmospheric quality of the scenery, transforming his views into imagined dreamscapes. Although this photograph is unusual for including a figure, the out-of-focus oarsman is subordinated to the branches and flowers. The emphasis on a foreground object, sharply represented and close-up, while enclosing the background in softness, sets Okamoto's work apart from the deliberately blurred images of pictorialism. Technically, it was achieved by the use of a shallow depth of field.

Plate 22

Aside from a limited number of luxurious albums, Okamoto made his work available through a number of beautiful but less expensive photobooks that combined text with mechanically reproduced illustrations. In 1930, a year after *Spring Beauty of Kyoto* was presented to the Duke of Gloucester, Okamoto produced his first such book. The six-volume publication, *The Photographic Illustrated Reference of Birds and Flowers*, presented his images alongside essays by authors such as the pioneer botanist Makino Tomitarō (1862–1957). Plate 14 is one of the seven images that appear in both the album and the 1930 publication.

Plate 14

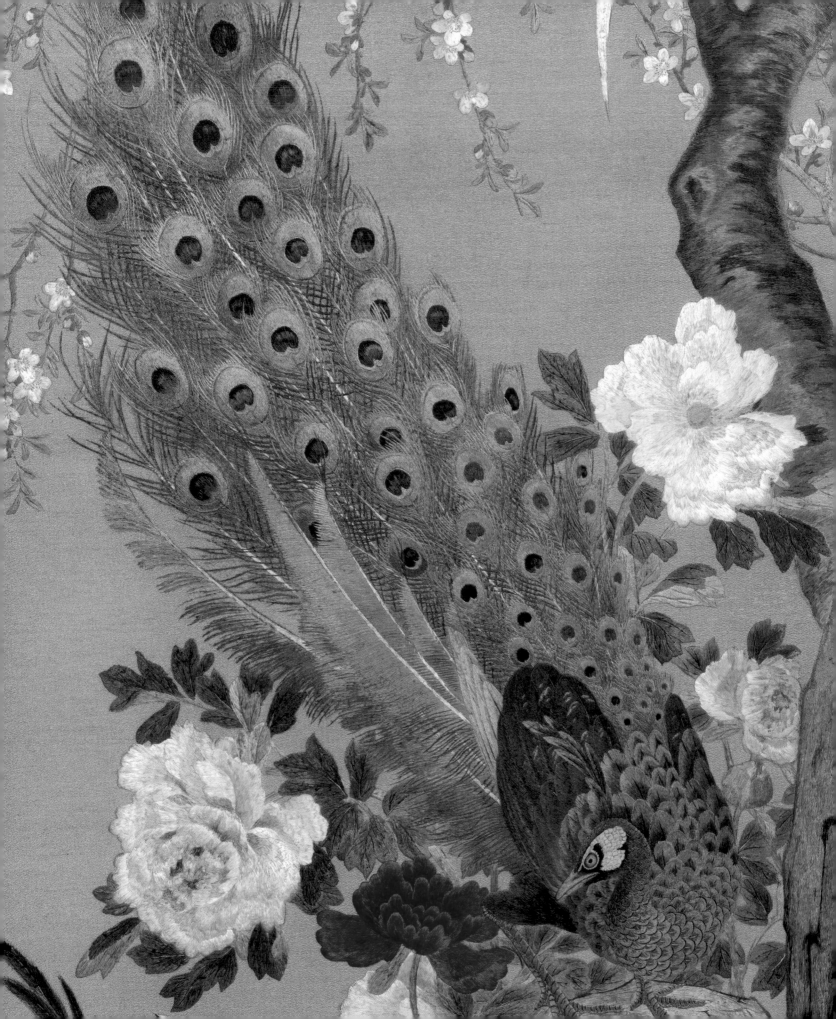

日本の芸術

10

COURTLY
RITUAL

CAROLINE DE GUITAUT

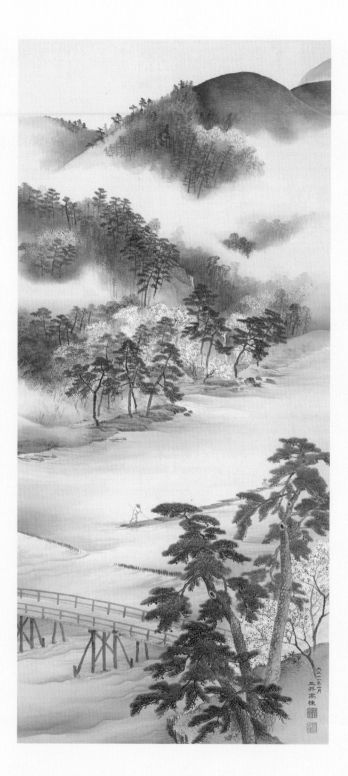

FOR over a thousand years, from the start of the Heian period in 794, the emperor and his household cultivated religion, visual art, literature and etiquette within the sheltered, rarefied environment of the imperial capital, Kyoto. Palace rituals were copied and adapted by the shogunate, as the ruling samurai class became powerful patrons of the arts. With the restoration of the Emperor Meiji in 1868 and the demise of the samurai class, Japan underwent political and social upheaval under 'Enlightened Rule' – the literal translation of *Meiji*. Some objects which had their origins in court etiquette and ritual became obsolete, while others found a new audience as Japanese art was seen around the world in the era of international exhibitions.

Poetry, literature and religious texts played an important role in courtly life and as a result calligraphy (*shodō*, 'the way of the brush') became one of its most refined arts, cultivated first by the Chinese and then, from the fifth century, in Japan. Excellence as a calligrapher was an essential requirement for courtiers and by the eighth century they worked in a scriptorium in the Imperial Palace.[1] Precious objects for the display and enjoyment of calligraphy included handscrolls (*emakimono*, cat. 134) and hanging scrolls (*kakemono*, cat. 140). Writing equipment itself became an expression of elegant scholarship, and writing tables (cat. 146) and boxes (*suzuribako*, cats 142 and 144–145) proved some of the most sophisticated forms of Japanese lacquer art.

The eleventh-century court classic, the *Tale of Genji* (*Genji Monogatari*), is one of the most important works of Japanese literature and considered to be the world's first novel. Written by the noblewoman and poet, Murasaki Shikibu, who served as tutor to the empress, its vivid description of courtly romance profoundly influenced Japanese artistic expression. Specific episodes and associated locations appear as subjects on folding screens (see cat. 155) and on lacquerware (see cat. 46). The appreciation of incense plays a central role in the story, and

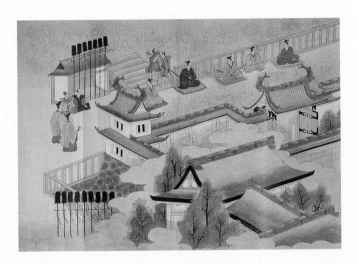

helped to cement its association with refined sensibilities and literary allusion (see cat. 147).

Buddhism came to Japan from China, and was adopted as the official religion of the Imperial Court during the Nara period (710–94). From that time onwards, many other aspects of Chinese culture were also rapidly absorbed into court life, including Confucian philosophy, garden design and tea gatherings. These influences intermingled with the indigenous Shintō belief system, which emphasised elegance, harmony and the veneration of nature. A keen appreciation of the changing seasons and the worship of local deities (*kami*) residing in plants and animals meant that courtly art was dominated by depictions of natural beauty. For example, seasonal themes appeared on folding screen paintings (*byōbu*), which first appeared in the eighth century and were used both as luxurious court furnishings and as important diplomatic gifts (cat. 135). Then the tenth-century imperial *waka* anthology, *Kokin Wakashū*, associated flora and fauna with different poetic moods, influencing a range of media such as 'bird and flower' pictures (*kachō-e*, see cat. 143) and textiles (cats 137–139 and 141).

Music and other performing arts were central to courtly life, and these exclusive entertainments were sometimes witnessed by British royal visitors. In 1869, Prince Alfred, Duke of Edinburgh watched a performance of *Nō*, a classical dance–drama characterised by slow movements and chanting, featuring the great actor Hōshō Kurō (1837–1917).[2] At Nara in 1922, Edward, Prince of Wales saw a ceremonial dance known as *kagura* performed by eight female shrine attendants (*miko*).[3] This was a form of *gagaku*, the classical music performed at the Imperial Court in Kyoto from the seventh century. Allusions to these arts appear on lacquerware (cat. 148) and in painting (cat. 149). Fans (*ōgi*) played an important role in ritual dances, as well as in processions and tea gatherings (*chanoyu*) (see cats 150–151). However, the Royal Collection lacks the ceramic tea caddies, bowls and jars associated with tea drinking at Court, first recorded in the time of Emperor Saga (r. 809–23).[4]

Imperial patronage of court artists was resurgent in the Meiji period, and in 1890 a system was instigated by the Imperial Household to give talented craftsmen honorific positions (*Teishitsu Gigei'in*) and guaranteed imperial commissions.[5] Many works by these artists bear the imperial chrysanthemum *mon*. At the same time, Japan looked to European royal and diplomatic precedent. This included the adoption from 1869 of an Imperial Flag and a national anthem, *Kimigayo*.[6] In 1871, the Emperor Meiji also prescribed European dress for his Court and officials.[7] Perhaps the greatest artistic expression of changing courtly ritual was the production of insignia for the newly created Japanese imperial award system, numerous examples of which are in the Royal Collection (cats 152–153).

134

BUNKEI (ACTIVE 1855)

THE PROCESSION OF EMPEROR GO-MIZUNOO
TO NIJŌ CASTLE, 4 NOVEMBER 1626
(KAN'EI SANNEN NIJŌ-JŌ GYŌKŌ). SCROLL 2:
THE ARRIVAL OF CHŪKAMON'IN AND
TŌFUKUMON'IN, 1855

Ink and colour on paper

37.9 × 168.5 × 5.6 cm (opening)

RCIN 1145973.a

PROVENANCE: Probably acquired by Queen Victoria

This hand-painted scroll depicts part of the imperial procession of Emperor Go-Mizunoo (1596–1680) to Nijō Castle in Kyoto in the autumn of 1626. Nijō Castle was the residence of Shōgun Tokugawa Iemitsu (1604–51), who used the imperial visit as a way to legitimise Tokugawa supremacy in the country. The shōgun and his father, Tokugawa Hidetada, treated the imperial family with suitable deference, presenting extravagant gifts and undertaking elaborate ceremonial over a five-day period.[8] After the visit, court artists produced illustrated handscrolls (*emakimono*) documenting the event to reinforce the message of accord between shōgun and emperor.[9] The lavish parade included an entourage of thousands, and so calligraphic captions were added to identify the most important figures. Visible here are retainers at the head of the procession of Empress Tōfukumon'in and the emperor's mother, Chūkamon'in. This scroll was produced in 1855 by an artist named Bunkei, probably copying a 1667 work by an artist of the Kanō school of painting.

Handscrolls provided a flowing narrative when telling stories or describing historical events. Reading from right to left, a reader would unroll the scroll with one hand, then roll it back up with the other as they worked through the text. Interestingly, this particular handscroll represents what was normally the second part of a three-volume set; but the itinerary of the emperor's visit, a feature normally found in the first volume, has been added at the beginning of this scroll, perhaps to make it intelligible when divorced from the other volumes. Editing the scroll to stand alone was perhaps intended to encourage its sale outside Japan. AB

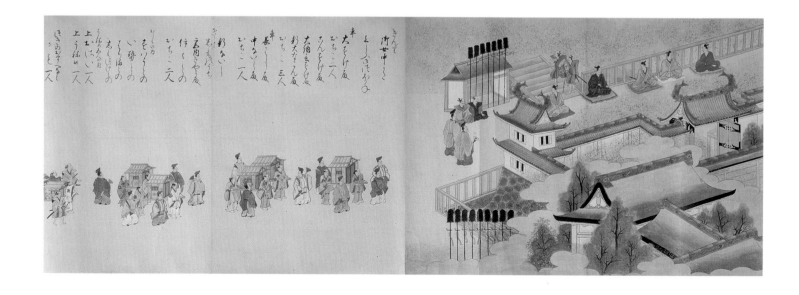

135

ITAYA HIROHARU (1833–82)

PAIR OF SIX-PANEL SCREEN PAINTINGS (BYŌBU), 1860

Ink, colour and gold on paper, with mount of silk brocade, ebonised wood and brass

175.2 × 64 0 × 1.8 cm (each leaf)

Each signed *Itaya Shū-i Sumiyoshi Hiroharu ga* ('Picture by Itaya Shū-I Sumiyoshi Hiroharu), with seal *Hiroharu no in*

RCINS 33530, 33544

PROVENANCE: Sent to Queen Victoria by Shōgun Tokugawa Iemochi, 1860

Nineteenth-century Japanese folding screen paintings (*byōbu*), each comprising several panels, were of a type and size usually intended for diplomatic gifts, continuing the tradition established in the sixteenth century. Screens were designed to be shown open, and the papered hinges and lightweight yet strong wooden core eliminated the need for intrusive frames separating the panels, thereby allowing horizontal orientation of a continuous image. These two screens, intended to be viewed together, show the changing seasons. The first screen (RCIN 33530, on p. 234) depicts Mount Fuji in the spring, with pine trees and cherry blossom in the foreground, which includes figures. It is painted from a high viewpoint looking across the Fuji Five Lake region (*Fujigoko*) at the northern base of the mountain. The second screen (RCIN 33544, on p. 235) is dominated by Miho-no-Matsubara, a spit of land covered by pine trees, the foreground filled with pine and maple trees in rich autumnal tones beneath cranes in flight.

The screens were almost certainly a late Tokugawa-period diplomatic gift, given their similarity – in style, subject matter and imagery – to examples sent to Dutch monarchs (Fig. 10.1).[10] In 1845, one pair was sent to King Willem II (1792–1849) in acknowledgement of his advice, delivered via Philipp von Siebold, former physician at the VOC factory at Deshima, that Japan should voluntarily open itself to foreign trade to pre-empt the use of force by western nations.[11] In 1856, ten pairs of screens were presented to King Willem III (1817–90) by Tokugawa Ieyoshi (1792–1858) as part of a larger gift in thanks for a steamship sent by the Dutch Government.[12]

Following the signing of an Anglo-Japanese Treaty of Amity and Commerce in 1858, Tokugawa Iemochi likewise sent Queen Victoria eight pairs of gold-leaf screen paintings as part of a lavish gift in 1860. Although '10 sets of gilded Bioboe [*byōbu*]' were originally intended for presentation, two pairs – including a scene entitled 'Playing in the Snow' from the *Tale of Genji*, Japan's most celebrated work of literature – were removed as they were considered unintelligible to foreigners.[13]

The screen paintings for Queen Victoria were to be designed by various artists, including Itaya Keishū Hironobu (1820–59), who had been among those responsible for the gifts sent to King Willem II, but he died and the work was passed to Kanō Shōgyoku Akinobu (1840–91).[14] This pair were signed by the artist Itaya Hiroharu, who was the sixth-generation head of the Itaya lineage. Itaya Hiroharu does not appear in the Japanese records of the commission for Queen Victoria, but the use of his art name 'Shū-i' securely dates their production to the first half of 1860, since he changed his art name to 'Kei-i' in June that year. Itaya Hiroharu had been a pupil of the late Itaya Hironobu, so it is likely that he was invited to join the commission. These screens must therefore surely have formed part of the gift.

What makes these objects of particular interest is that they indicate the image the Japanese wanted to project in a new era of commercial and diplomatic engagement. CDEG

10.1 Kanō Shōsen'in (1823–79), *Folding screen painting with scene of falconry*, 1844. Ink and colour on gilded paper, 159.0 × 356.4 cm (whole object), Collection Nationaal Museum van Wereldculturen, RV-4-29

Below: RCIN 33530, photographed during conservation process (without hinges and external lacquer frame)

Above, left and right: Details of RCIN 33530

Facing page: Detail of RCIN 33544

136

KYOTO, JAPAN

EMBROIDERED FOLDING SCREEN, 1880–97

Silk embroidery with silk thread, calamander wood
frame, metal

177.0 × 66.5 × 3.3 cm (each leaf)

RCIN 79563

PROVENANCE: Sent to Queen Victoria by the Emperor Meiji
for her Diamond Jubilee, 1897

Among the gifts received by Queen Victoria for her Diamond
Jubilee in 1897 was this four-leaf folding screen sent by the
Emperor Meiji. On 24 June, two days after the official Jubilee
celebration in London, which the queen described as a 'never to be
forgotten day', Prince Arisugawa Takehito was a guest at lunch with
the queen at Windsor Castle. Later that afternoon he presented
officers of the Japanese fleet who had travelled to Britain to take
part in the Jubilee naval review.[15]

The arrival of the screen is not recorded in Queen Victoria's
Journal but it was among the Jubilee gifts exhibited in the North
Gallery of the Imperial Institute later that year. According to the
Illustrated London News, 'Of Eastern screens there are beautiful
examples, particularly noteworthy being one with silk panels
representing wild mountain scenery where a foaming torrent is
rendered with exquisite power and fidelity. This treasure is the gift
of the Emperor of Japan.'[16]

The Japanese imperial family acquired textiles from the
Kyoto firms of Nishimura, Iida and Kawashima from the 1880s,
both to furnish the new Imperial Palace in Tokyo, completed
in 1889, and to present as gifts to foreign sovereigns and
rulers to mark important occasions and foster relationships.
The gift of this embroidered folding screen is recorded in
Meiji tennō ki, The Record of the Emperor Meiji, where it is
described as an 'embroidered Arashiyama scene *byōbu*'.[17]

The precise maker is unknown, but is almost certainly one of
the three most important firms mentioned above. The embroidery
is exceptionally fine – the subtle delicacy of the muted colours
revealing the majestic landscape of Arashiyama near Kyoto, with
its mountains, foaming river, rocks and trees. Many traditional
Japanese stitches are used, including foundation layers (*hira-nui*)
and long and short stitch (*sashi-nui*). Cotton wadding creates a
relief effect, particularly on the rocks and trees in the foreground.
Below each of the four panels of the screen is a smaller rectangular
panel embroidered on a black ground in silk, with leaves in green
and cream and red berries. The reverse of the screen is of silk
painted with a scene of ducks in flight. CDEG

LITERATURE: Imperial Institute 1897, no. 36, p. 10

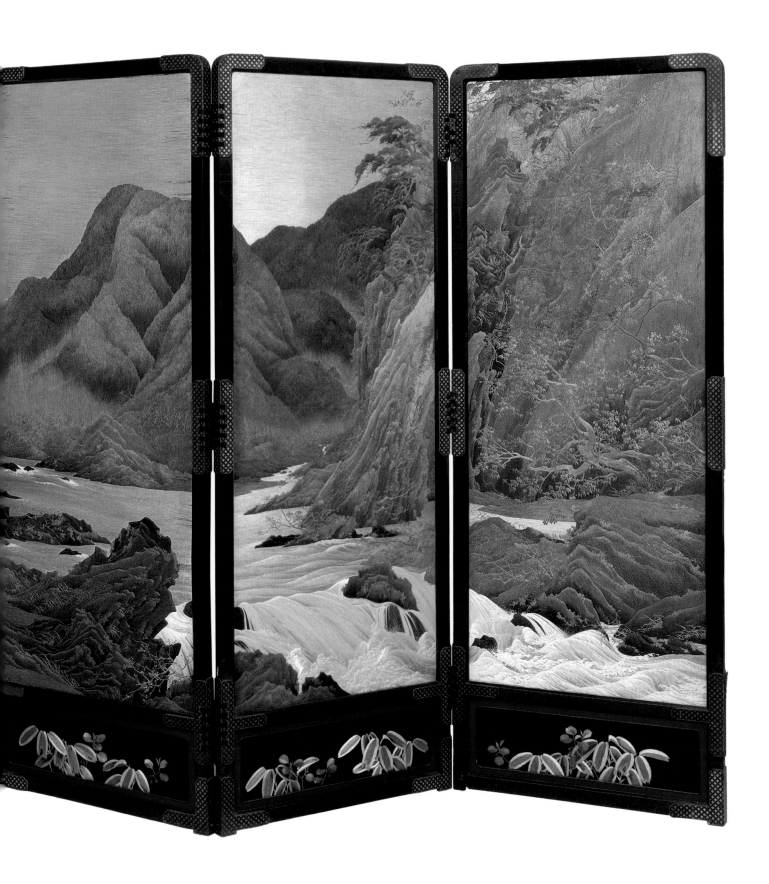

137
IIDA & CO., KYOTO, JAPAN
EMBROIDERED FOLDING SCREEN,
c.1880–1900

Wood, lacquer, silk and silk thread, leather, gilt-brass,
watercolour, paper, mother-of-pearl, copper alloy

192.5 × 73.7 × 3.4 cm (each leaf)

RCIN 42037

PROVENANCE: Presented to King Edward VII on the occasion
of his Coronation by Prince Komatsu Akihito, on behalf of
the Emperor Meiji, 1902

Each of the four panels is fitted with cream silk, which is richly
embroidered. The first panel features a pair of cranes standing on rocks
and grass, with a pheasant underneath tree peony and cherry-blossom
branches. The glossy feathers of the cranes are stitched with flat silk,
which is also used in the embroidery of the peony blooms and leaves.
The second panel depicts a pair of ducks nesting beneath a tree, peony
blooms and chrysanthemums, with a kingfisher and other birds in
flight. The third features a pair of pheasants with ducks by a gnarled
tree stump, with rich red tree peony above, and the final panel shows
a pair of peacocks, the male partly displaying his tail to the surprise of
the smaller birds around him. Associated with royalty and symbolising
beauty and immortality, peacocks are often depicted with peonies in
Japanese art. However, in Meiji textiles they were often paired with
cherry blossoms instead, as is the case on this screen.[18]

Taken as a whole, the four panels represent the four seasons. Crane
and ducks allude to winter; the pheasant, peacock and cherry blossom
indicate spring; the peony and kingfisher illustrate summer; while
chrysanthemums represent autumn.[19] King Edward VII is known to
have received two embroidered handscrolls as a Coronation gift from
the Japanese emperor,[20] but the presentation of this screen by Prince
Komatsu Akihito, who attended the king's Coronation at Westminster
Abbey on 9 August 1902, has only recently been confirmed for the first
time.[21] After presentation, the screen was moved to Osborne House,
where it was displayed in the Indian Corridor.[22]

Each panel elegantly combines a variety of Japanese embroidery
stitches, including long and short stitch (*sashi-nui*) for blending shades
of flowers and feathers, lines of staggered diagonals (*matsuri-nui*) on
the leaves and round knots (*sagara-nui*) at the ends of flower stamens.
The reverse of each screen panel is lined with paper and painted in
watercolour with a continuous image of the Shiraito Falls with Mount
Fuji behind. CDEG

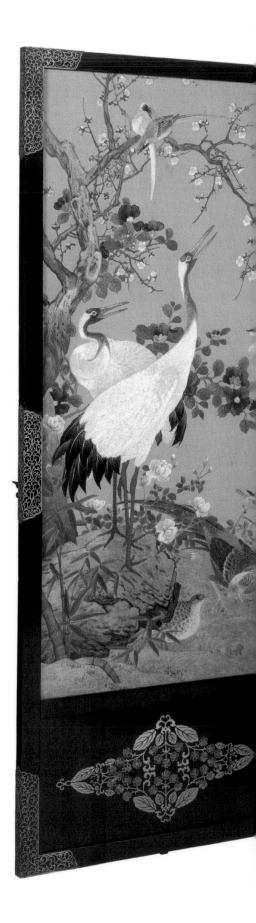

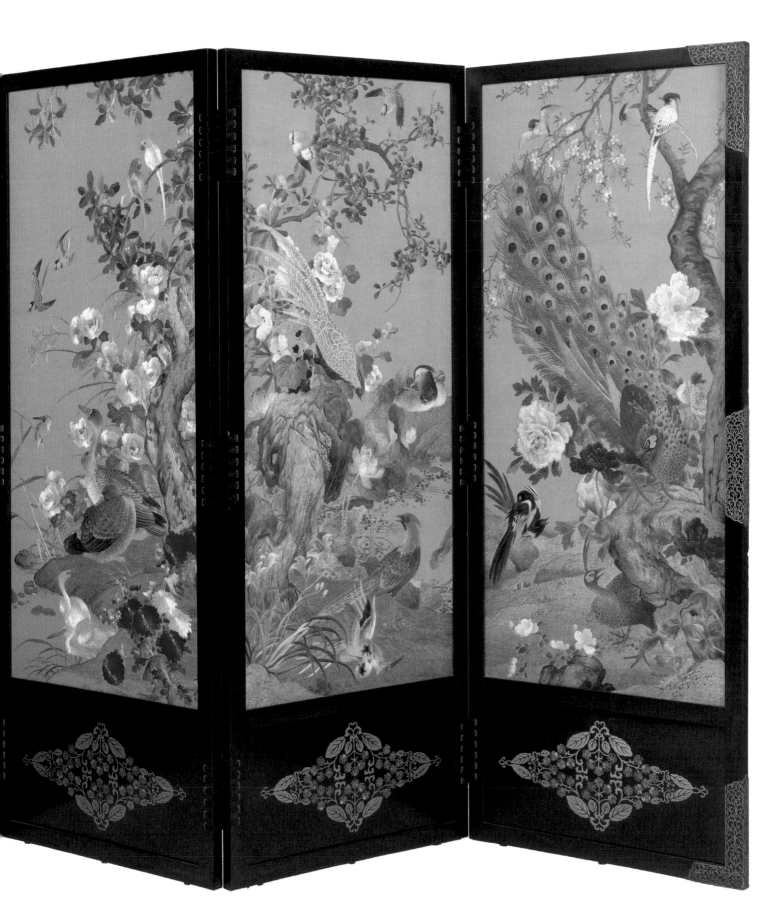

138

JAPAN

SILK PAINTING SET INTO A FIRESCREEN,
c.1880–1920

Silk, paint, ebonised hardwood, glass

136.0 × 104.0 × 35.3 cm

Marks: the silk and the back of the screen stamped
'Dai Nippon'

RCIN 202

PROVENANCE: Probably acquired by Queen Mary

The painted silk panel depicts peonies, chrysanthemums, trailing
foliage and wisteria, with a beetle and butterfly within a narrow
border of gold silk brocade. The bright blue silk fabric and the back
of the panel are both stamped *Dai Nippon* ('Empire of Great Japan'),
referring to the period between the Meiji Restoration of 1868 and
the enactment of Japan's modern constitution in 1947.

The panel has been fitted into a wooden frame painted black
and gold, a European technique in imitation of Japanese lacquer
known as 'japanning', which was common from the seventeenth
century. The frame is fitted to a wooden support carved in imitation
of bamboo and attached by metal fittings.

The silk panel may have been among the pieces from Queen
Mary's collection which she incorporated into her Japanese Room
at Buckingham Palace.[23] However, the screen appears to be more
closely associated with the chinoiserie-style interiors of the East
Wing of the palace, particularly the Centre Room, which was
redecorated by the firm of White, Allom & Co. in 1923.[24] CDEG

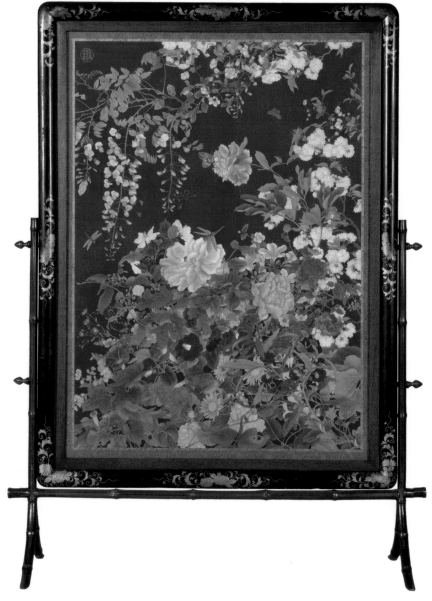

IMAO KEINEN (1845–1924)

PAINTING ON SILK OF PINE TREE, ROSES AND PEONY, 1921

Ink and colour on silk, with mount of silk brocade and wood

128.5 × 95.0 × 2.2 cm

Signed *Nanajū-nana sai Keinen* ('Keinen, in his 77th year'), with seals *Kon Kan shi in* and *Shiyū*

RCIN 36487

PROVENANCE: Presented to Edward VIII when Prince of Wales in Japan, 1922[25]

This painting on silk, mounted as a panel, depicts a gnarled pine tree with climbing roses, a tree peony and two small birds, probably Japanese bush warblers. In the genre of 'bird and flower pictures' (*kachō-e*), which combine flora and fauna to evoke specific seasons, this image indicates late spring or early summer.

Imao Keinen was born in Kyoto and, like many local artists, came from a family involved in the textile industry. His relatives were design co-ordinators of kimono material for the Mitsui family, the richest merchant house in Kyoto. In the Meiji period, many picture masters (*ekaki*) served as apprentices in Kyoto's textile industry before they received the title of painter (*gaka*), indicating a higher status of artist. Picture masters usually worked on many types of objects and surfaces, ranging from textiles, fans, scrolls and screens to porcelain and lacquerware.

Imao Keinen became one of the leading painters of the Kyoto textile school and worked with several of the principal firms, notably the Nishimura Sōzaemon House, which was established in the late seventeenth century. Nishimura, today better known as Chisō, hired the 30-year-old Keinen to create embroidered picture designs. An album of his bird-and-flower paintings was published by the firm in 1891.[26] By the 1880s, Keinen was also working for the Iida Shinshichi House (also known as Takashimaya, see cat. 141) and his work for that firm was exhibited internationally, including at the Chicago World Fair in 1893.

Keinen painted this silk panel when he was 76 years old, only three years before his death, but it is remarkable for the delicacy and precision of the brushwork.[27] CDEG

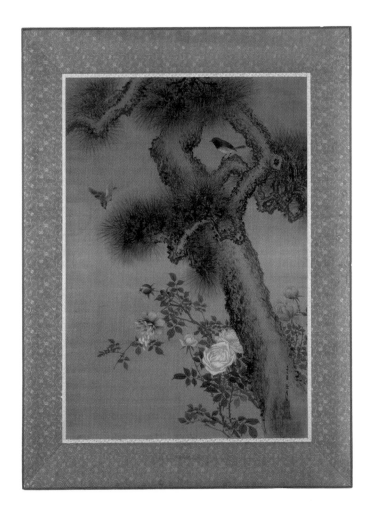

140

MITSUI TAKAMINE (1857–1948)
HANGING SCROLL PAINTING
(KAKEMONO), 1922

Ink and colour on paper, silk brocade, bone, wood

276.5 × 86.7 cm

Signed, dated and sealed: 三井高棟 ('Mitsui Takamine');
大正十一年四月 ('The fourth month in the eleventh year
of the Taishō period' [April 1922]). Mounter's stamp
of Ōedō, Kyoto

RCIN 69750.a

PROVENANCE: Presented to King Edward VIII when
Prince of Wales by Mitsui Takamine in Japan, 1922

Kakemono are hanging scrolls displayed in the dedicated alcove (*tokonoma*) of a reception room. Unlike painted sliding and folding screens, this form did not become popular in Japan until the late Kamakura period (1185–1333), with the exception of memorial paintings in Buddhist temples and Shintō shrines. The import of hanging scrolls from China in the early fourteenth century prompted the reconfiguration of indoor spaces to accommodate their display. *Kakemono* soon became an essential component of a wealthy samurai residence. In the Edo period, prints in this format (*kakemono-e*) provided a more modest alternative for artisans who could not afford painted examples.[28]

Seasonal landscapes were a popular subject for *kakemono*. Here, the pine-clad mountain, Arashiyama, near Kyoto, emerges from the mist. Diagonal lines of trees draw the viewer's eye down the length of the scroll to men punting rafts of timber down the Katsura River by the Togetsukyō Bridge. Cherry blossom indicates that it is springtime, and the season's freshness is reinforced by the bright mounting of gold and green brocade.

The painting is the work of Mitsui Takamine, an amateur artist and the tenth head of the Mitsui Sōryō family, who managed a conglomerate of trading, banking and mining companies. A devoted aesthete, Mitsui was a practitioner of the tea ceremony and of *Nō* drama. For the visit to Japan of Edward, Prince of Wales in 1922, he erected a theatre in the courtyard of his mansion at a reported cost of £30,000.[29] After the visit, he presented the prince with this *kakemono*. The composition is redolent of a scene by the Edo-period woodblock print artist, Utagawa Hiroshige I (Fig. 10.2). RP

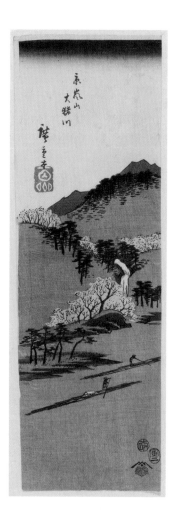

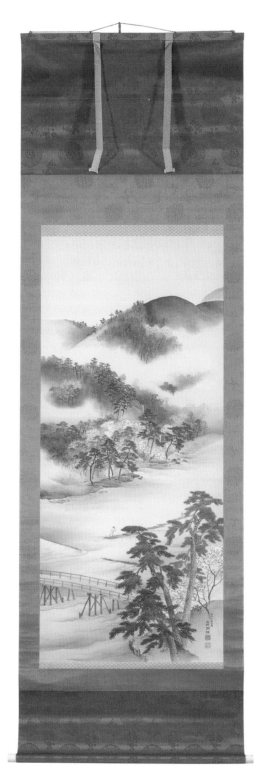

10.2 Utagawa Hiroshige I
(1797–1858), *Arashiyama and the
Ōi River, Kyoto*, 1854. Woodblock
print, 34.1 × 11.5 cm, Museum of
Fine Arts, Boston, 21.7087

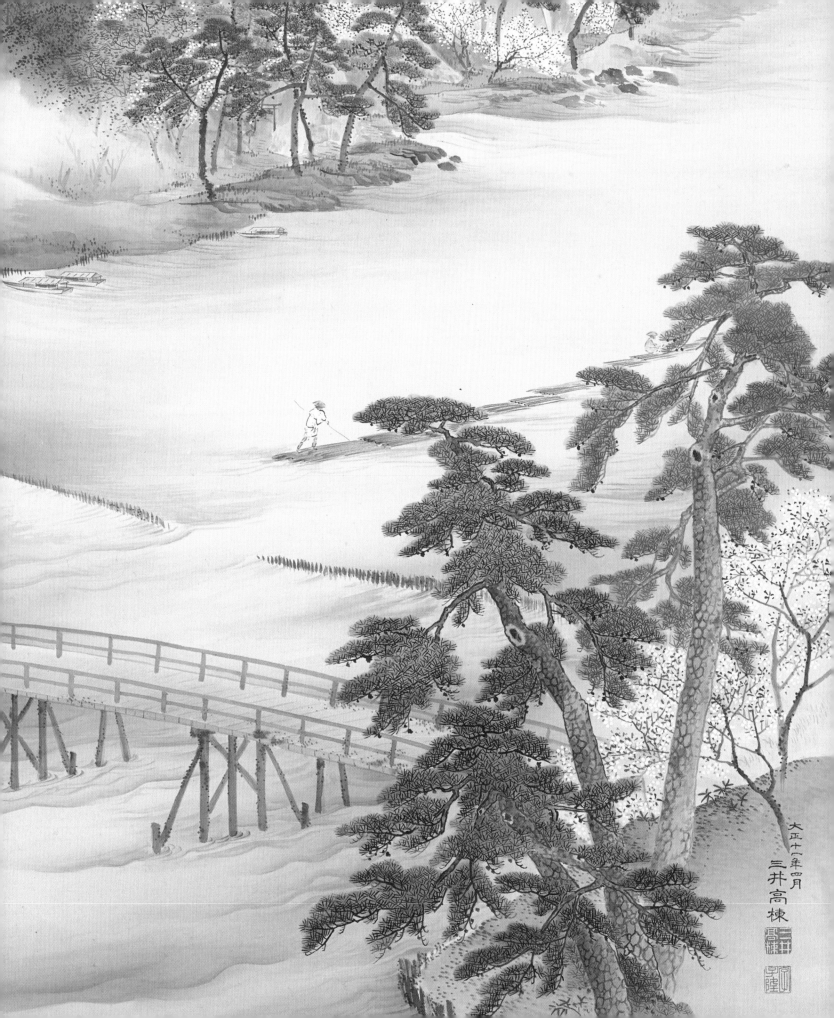

大正十一年四月
三井高棟

141

TAKASHIMAYA (EST. 1831)

EMBROIDERED PANEL,
c.1935

Silk, silk thread, coromandel wood frame

106.0 × 142.0 × 9.0 cm

RCIN 69597

PROVENANCE: Presented to King George V, probably for his Silver Jubilee, 1935

This design of a peacock and peahen with a tree peony is based on a painting on silk by Maruyama Ōkyo (1733–95) dated 1771. The peacock, a perennially popular subject with embroiderers, is representative of spring, particularly in combination with the peahen and tree peony. A variety of stitches have been used for the embroidery, including long sections of couched twisted thread. The panel was made by the firm Takashimaya, which was established in Kyoto in 1831 by Iida Shinshichi I (1803–74) as a shop dealing in second-hand clothes. The company began to produce decorative silk goods and *fukusa* (traditional embroidered wrapping cloths for lacquer boxes) from the 1870s. They achieved success at national exhibitions held in Kyoto and Tokyo, eventually becoming suppliers to the Imperial Household Agency. A positive reception at the 1889 Paris *Exposition Universelle* and the Chicago World Fair in 1893 contributed to the success of the firm and the rise of an overseas market.

The panel was presented in its dark wood frame as a gift to King George V in 1935, presumably for the Silver Jubilee on 6 May. The following year, after his death, it was lent by King Edward VIII for an exhibition of Silver Jubilee and other gifts held at Stafford Public Library, Art Gallery and Museum.[30] CDEG

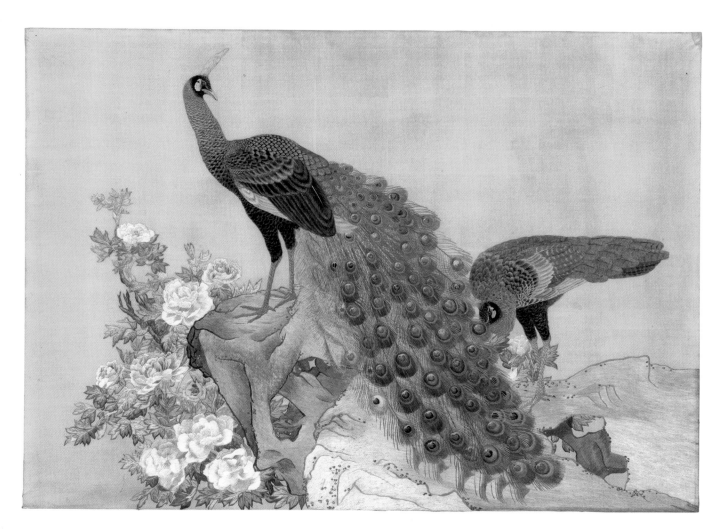

142

JAPAN

WRITING BOX AND COVER (SUZURIBAKO),
1775–1825

Wood, black, gold and silver lacquer, coral, horn, gilt bronze

3.8 × 19.4 × 18.0 cm

RCIN 33949.a–j

PROVENANCE: Almost certainly presented to Prince Alfred,
Duke of Edinburgh by the Emperor Meiji, 1869

Writing boxes are among the most accomplished of all Japanese lacquerware forms, and their careful craftsmanship reflects the exalted status of calligraphy in Japanese culture. Dedicated boxes for implements were a particularly Japanese tradition, for in China writing equipment was usually arranged directly on the desk itself. By the Edo period (1615–1868), these boxes had become choice vehicles for the lacquerer's art.

A dragon emerging from a stormy sky was a popular subject among Japanese ink-painters. The motif has its roots in ancient Chinese philosophy, where dragons were associated with water and believed to control rain. This writing box reproduces many features of the genre,
including the stylised, scrolling clouds which fill almost half the scene. Large flecks of gold scattered across the black ground suggest a dark night. Gold and silver *takamakie* of different heights and the upward curling tail of the dragon add dynamism to the composition. The coral jewel in the dragon's grasp has variously been interpreted as a representation of thunder, the moon or a tide-controlling gem. In this case, the dragon is depicted with three claws, as opposed to the four or five more commonly seen in Chinese depictions from the Song dynasty (960–1279) onwards, which were reserved for use on objects owned by individuals of high rank.[31]

The chronological account of the Emperor Meiji's reign, *Meiji tennō ki*, records that he gave Prince Alfred four writing boxes and four incense boxes during his 1869 visit to Japan, of which this is almost certainly one.[32] On the prince's return to England, the box was exhibited at the South Kensington Museum before being installed in his London residence, Clarence House (see Fig. 5.9 on p. 112). It was temporarily displayed at the Bethnal Green Museum after his death in 1900, and later entered the collections of Queen Mary. RP

INVENTORIES: Clarence House 1875, p. 21; V&A, AO.98 1918, no. 617, p. 16; QMPP, III, no. 175

LITERATURE: South Kensington Museum 1872, no. 560, p. 44; Huish 1888 (exh. cat.), no. 21, p. 76; Ayers 2016, III, no. 2209, p. 1004

143

JAPAN

BOX AND COVER, 1860–69

Wood, gold lacquer, pewter, glass, stone

5.0 × 25.9 × 23.0 cm

RCIN 29453.a–b

PROVENANCE: Almost certainly presented to Prince Alfred, Duke of Edinburgh by the Emperor Meiji, 1869

The cover of this box depicts two pheasants and a flowering peach tree – a combination derived from the print and painting genre, *kachō-e* ('bird-and-flower pictures'). Paintings of this kind emerged in China during the Song dynasty (960–1279), when they were classified as a type distinct from portraits and landscapes. The subject was taken up in Japan during the Muromachi period (1392–1573) and soon appeared in a myriad of styles and media, including screens and woodblock prints. Bird-and-flower arrangements were also translated onto lacquerware, often in stylised form. Far more than mere nature studies, such scenes had specific seasonal and poetic connotations. In this instance, the pheasants and peach blossoms represent spring.

Prince Alfred kept this box at his London residence, Clarence House, following its exhibition at the South Kensington Museum in 1872. It can be seen mounted on the wall in the 'Indian Room' there, in a photograph dated *c.*1870–80 (see Fig. 5.9 on p. 112). The display had been installed by May 1875, when Queen Victoria went to visit the enlarged and redecorated property and saw '2 old Drawing rooms … newly done up & full of the armour, china, & curios brought back by Affie [Prince Alfred] from abroad'.[33] RP

INVENTORIES: V&A, AO.98 1918, no. 614, p. 16; QMPP, III, no. 174

LITERATURE: South Kensington Museum 1872, no. 98, p. 15; Ayers 2016, III, no. 2217, p. 1010

144

JAPAN

WRITING BOX AND COVER (SUZURIBAKO), 1900–10

Wood, gold and silver lacquer

5.4 × 24.5 × 13.0 cm

RCIN 3294.a–o

PROVENANCE: Possibly presented to King Edward VII
on the occasion of his Coronation, 1902

A silver waterfall cascades from a craggy precipice, creating stylised spray in the rolling waves below. The force of the water is suggested by thin lines of gold within the flow, contrasting with the serenity of the evergreen pine. The scene may be taken from life, for it resembles the *Miyanotaki* ('Palace Falls'), near Yoshino in Nara, which appear in similar style on an Edo-period writing box.[34] At that spot, the Emperor Uda (866–931) is said to have composed the following *waka*:

> 'The Palace Waterfall'
> Yes, true to its name
> Can be heard
> The jewel-like resonance
> Of the falling white foam.[35]

The dynamic composition here evokes the thunderous sound of the crashing water. Within the box, a Buckingham Palace label reads, 'Given to / King Edward / the 7th.' The king never visited Japan, and so this writing set was possibly presented on the occasion of his Coronation on 9 August 1902, which was attended by Prince Komatsu. A hexagonal box of similar style in the Royal Collection is associated with Queen Alexandra, and the pair may have been presented together (Fig. 10.3). Inside are all the accoutrements for writing: an inkstone, water-dropper, brushes, awl and inkstick holder. RP

LITERATURE: Ayers 2016, III, no. 2214, p. 1007

10.3 Japan, *Hexagonal box with tray, small boxes and cover*, 1900–10. Wood, gold and silver lacquer, 5.6 × 13.5 cm, RCIN 29451.a–j

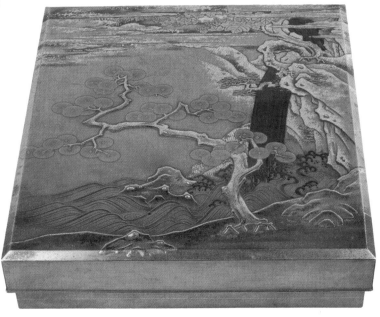

145
JAPAN

WRITING BOX (SUZURIBAKO) AND IMPLEMENTS, 1850–1900

Wood, black and gold lacquer

5.3 × 22.2 × 25.4 cm

Inscribed on inkstick, in gold: 天高気清
(*Tenkō kisei*; 'No clouds, clear sky, clean air')

RCIN 64476.a–o

PROVENANCE: Sent to King George V by
the Emperor Shōwa, June 1930

This box contains all the components necessary for calligraphy. In the centre is a flat, smooth inkstone (*suzuri*) on which the solid inkstick is ground with water to produce liquid ink for writing or painting. The consistency can be controlled by adding water from the silver water-dropper, which takes the form of two shells. Beside the box are matching brushes (*fude*), a paper knife (*kogatana*) and an inkstick holder (*sumi-basami*), as well as an awl (small spike) for puncturing paper. Inksticks were typically made from soot bound with animal glue, sometimes mixed with scented wood or cloves. This inkstick bears the inscription, 'No clouds, clear sky, clean air', an expression which evokes the late autumn season, when summer rains have passed.

On the lid, the variety of texture achieved through *nashiji* and *takamakie* decoration makes for sensitive presentation of an involving scene. The flowing lines of the water contrast with the stark silhouettes of rock, reeds and pine, which together evoke the coming winter. Swooping plovers (*chidori*) overhead symbolise long life, for their cry is a homonym for *chiyo* (千代) which means '1000 generations'. Court poets had explored this association as early as the tenth century, notably in the imperial *waka* anthology *Kokin Wakashū*.[36] The underside of the lid remains hidden to all but the user of the box, and so the delicate decoration here is intended for more exclusive enjoyment. Four cranes take flight above a large bamboo waterwheel, against a dramatic sky of bright *nashiji*.

The box was a gift to King George V from the Emperor Shōwa in 1930. It was almost certainly presented by the emperor's brother, Prince Takamatsu, who visited Britain to convey the emperor's thanks for the Order of the Garter bestowed the previous year. RP

LITERATURE: Ayers 2016, III, no. 2234, p. 1024

146
JAPAN
WRITING TABLE (BUNDAI),
1900–30

Wood, gold lacquer, silvered metal

12.2 × 60.5 × 36.1 cm

RCIN 7121.a

PROVENANCE: Probably sent to King George V
by the Emperor Shōwa, June 1930

Low rectangular tables for writing equipment have been used in Japan since the fourteenth century. One appears in the *Boki ekotoba*, an illustrated narrative of 1351 which includes a scene of a poetry meeting.[37] From the seventeenth century, these *bundai* were often produced as part of a matching set, alongside boxes for writing implements (*suzuribako*) and for paper (*ryōshibako*). They were customarily given as wedding gifts or as part of a bridal trousseau during the Edo period.

This desk matches the writing box sent to King George V by the Emperor Shōwa in 1930 (cat. 145). Both box and table show plovers (*chidori*) swooping through a speckled *nashiji* sky, and the birds are replicated in miniature on the matching silvered mounts. A Buckingham Palace label in the box suggests that the two were presented together.[38]

The river scene on this high-quality *bundai* combines *hiramakie*, *nashiji* and *fundame* decoration to gorgeous effect. A line of plovers parades on the outcrop of a riverbank, disrupting the undulating horizontal lines of the water. Above them, encrusted gold and silvered metal birds fly across swathes of mist. The design uses the full width of the surface, its meandering lines drawing the eye slowly up towards the distant horizon. Although unsigned, the lacquer decoration is of a calibre equal to that of artists such as Kawanobe Itchō and Funabashi Shūmin (1859–?), who were associated with the Imperial Household.[39] **RP**

LITERATURE: Ayers 2016, III, no. 2229, p. 1020

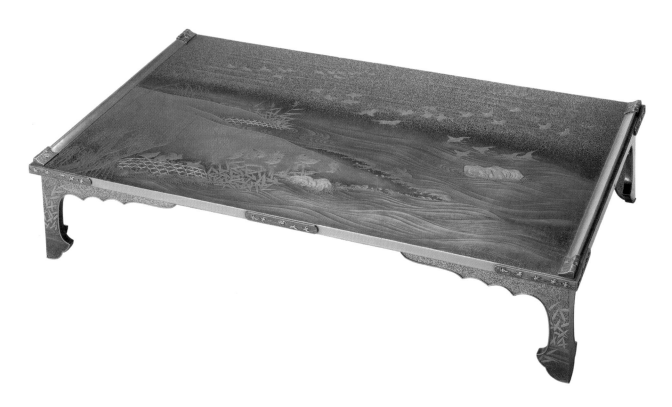

147

JAPAN

BOX FOR AN INCENSE GAME (KŌBAKO), 1700–1800

Wood, black, gold and silver lacquer, paper, bamboo, metal, feather, ivory

17.0 × 23.0 × 18.0 cm (large box); 3.4 × 15.9 × 7.0 cm (rectangular box and counters); 6.9 × 6.9 × 0.3 cm (paper pouches); 6.2 × 3.5 × 3.5 cm (bamboo pot)

RCINS 3484.a–c (large box), 4681.a–n (rectangular box and counters), 4682.b–i (paper pouches), 4679.a–g (bamboo pot and utensils)

PROVENANCE: Almost certainly presented to Prince Alfred, Duke of Edinburgh by the Emperor Meiji, 1869[40]

Incense was introduced to Japan from mainland Asia during the sixth century, and its appreciation quickly became a mark of refinement. During the Muromachi period (1391–1573) 'the way of incense' (*kōdō*) emerged as a fashionable aristocratic activity governed by strict rules of etiquette, alongside the tea ceremony (*chanoyu*) and flower arranging (*ikebana*). Rare incense woods were collected and burned on special occasions, or associated with particular poetic moods and scenes from classical literature like the *Tale of Genji*. By the mid-Edo period, elaborate incense games had become formalised and divided into separate schools. Sets of matching utensils in lavish lacquer boxes were included in the bridal trousseaux of women from *daimyō* families. These wares were also increasingly enjoyed by wealthy merchants and *chōnin* (townspeople).

This set contains some of the equipment required for an incense game called *jishū-ko* (literally 'ten types of incense'). Before the competition begins, three different kinds of incense wood are burned and named for the guests. Then follow ten rounds in which the master of ceremonies burns small pieces while the guests try to identify each, recording their answers on paper slips. The rounds include three of each of the original types of incense, as well as one piece of a fourth kind, the 'guest incense' (*kyaku-ko*).[41]

Within this lacquer box (*kōbako*) are counters, paper pouches for answer slips, a bamboo pot with assorted utensils for lighting the wood and a sectioned tray with silver chrysanthemum-shaped studs for placing small mica plates holding the heated incense. Larger sets might include a box for players to insert their answers, writing equipment for record-keeping and tools for cutting the incense wood. RP

INVENTORIES: Clarence House 1875, p. 22; V&A, AO.98 1918, no. 615, p. 16; QMPP, III, no. 169

LITERATURE: South Kensington Museum 1872, no. 559, p. 44; Huish 1888 (exh. cat.), no. 1, p. 75; Ayers 2016, III, nos 2193–4, pp. 992–3

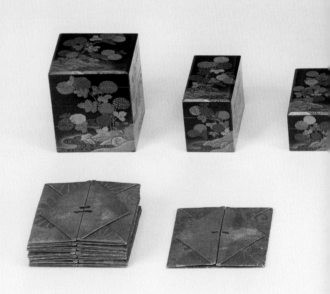

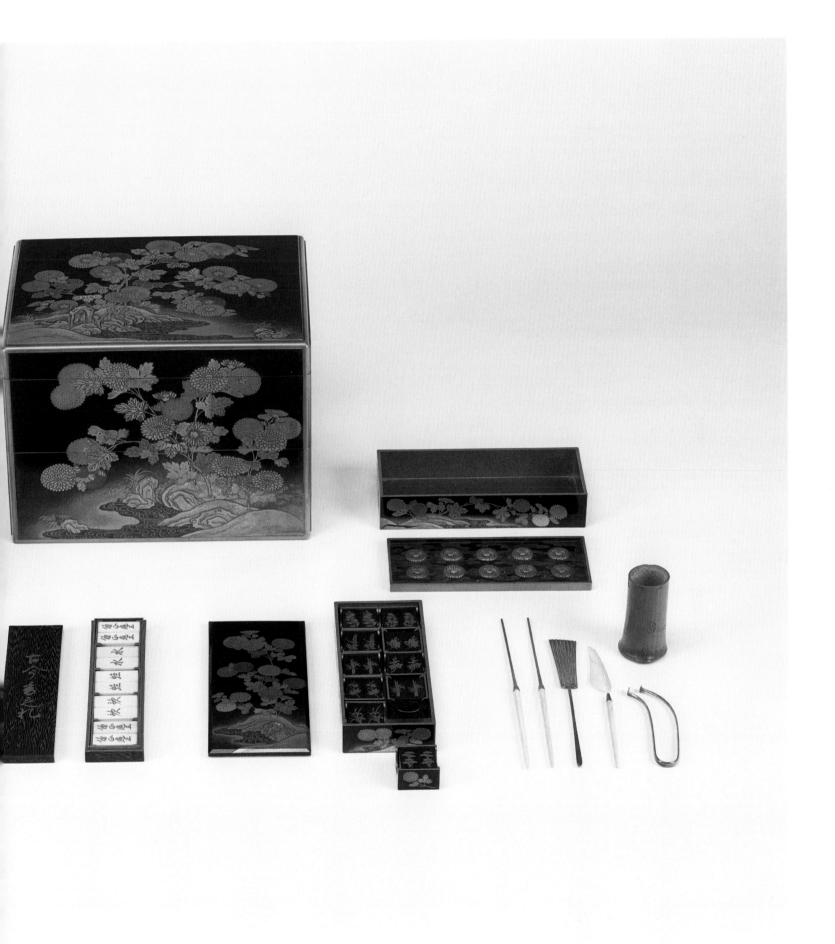

148

JAPAN

BOX AND COVER, 1850–1920

Wood, black, gold, silver, red and green lacquer, shell

5.8 × 12.6 × 9.8 cm

RCIN 29463.a–b

PROVENANCE: Presented to Queen Mary by Edward,
Prince of Wales, on her birthday, 26 May 1921

This small box is carefully decorated with instruments for *gagaku*
(literally 'elegant music'), the traditional court music of Japan.
The genre was codified during the Heian period (794–1185) and
encompasses styles introduced from Korea (*komagaku*), China
(*tōgaku*) and beyond.[42] At this time, courtiers and officials regularly
performed stylised dances as part of their official duties.

On the cover of the box in exceptional *takamakie* is a large
two-headed barrel drum known as a *kakko*, bearing the Shintō
tomoe (triple comma) motif and decorated with peony sprays in
green and red. The drum stand is a fine example of *mokume-gane*,
a woodgrain pattern achieved by layering contrasting metals and
then carving them to expose different hues. Around the sides are
a transverse flute (*komabue*), a mouth organ (*shō*), a plectrum for a
lute (*biwa*) and the removable bridges for a thirteen-stringed zither
(*koto*). Together, the instruments evoke the refined atmosphere of
the Imperial Court. On the underside of the lid (illustrated below),
a striped, coloured canopy suggests the more jovial setting of a
cherry-blossom festival, when revellers would gather outdoors
behind vibrant textile hangings. This diminutive and intricately
decorated box would surely have appealed to Queen Mary, whose
love of small, refined *objets d'art* is reflected in the many precious
gifts she received from family and friends. RP

INVENTORIES: QMPP, IV, no. 5

LITERATURE: Ayers 2016, III, no. 2219, p. 1011

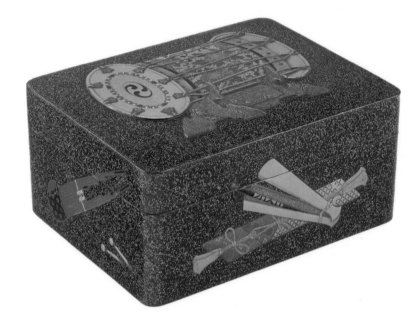

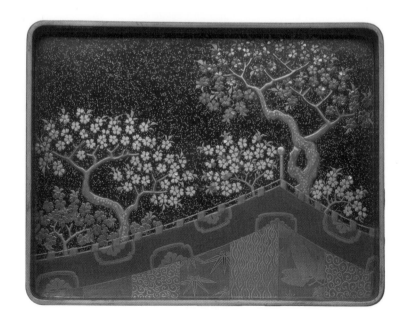

ŌMURA CHŌFU (ACTIVE 1902–22)

YAMATO-MAI PERFORMANCE, 4 MAY 1922

Oil on canvas

24.5 × 61.0 cm

Signed on the front in red: 長府 ('Chōfu') and 花押 ('kaō'); in black: '1922'. Inscribed on the reverse: 大正十一年五月四日 奉献 奈良市餅飯殿町十六番地 筆者 大邨長府 (Taishō jūichinen gogatsu yokka hōken Nara-shi mochiidono-chō jūroku-banchi hissha Ōmura Chōfu; 'Dedicated on the fourth day of the fifth month in the eleventh year of the Taishō period [4 May 1922], 16 Mochiidono Ward, Nara City, Painter: Ōmura Chōfu')

RCIN 403847

PROVENANCE: Presented to King Edward VIII when Prince of Wales in Japan, May 1922

At Kasuga Grand Shrine in Nara, a short piece of Shintō ritual music and dance called *yamato-mai* (倭舞) is performed. The ceremony, which first took place at the shrine on 11 February in AD 916, is a form of *gagaku*, the traditional performing arts preserved at the Imperial Court and certain shrines. Six men dressed in ancient costume are accompanied by musicians who sing and play a *kagurabue* (transverse flute with six holes), *hichiriki* (oboe) and *yamato-goto* (six-string zither). The ensemble leader maintains the beat using a *shakubyōshi* (clapper). The dancers bear symbolic offerings known as *tamagushi*, made from the branches of the sacred *sakaki* tree (*Cleyera ochnacea*) which grows nearby.

The artist, Ōmura Chōfu, has worked in the naturalistic style of the *Yōga* school (western-style painting), eschewing traditional paper and water-based pigments in favour of oil on canvas. Artists returning from study in Europe in the early Meiji period increasingly assimilated western materials and aesthetics into their work, founding the Meiji Art Society (*Meiji Bijutsu-kai*), Japan's first western painting association, in 1889. They nevertheless sought to appeal to a broad audience by depicting familiar festivals, myths and views, as here.[43] Ōmura referred to the *Jōganshiki*, a book of ceremony compiled in AD 869–71, for details of the *yamato-mai* performance.[44]

The Prince of Wales visited Kasuga Grand Shrine on 4 May 1922 and fed the sacred deer, which roam freely nearby.[45] After his return to England, the painting was sent to Buckingham Palace, and in 1935 it was transferred from there to Osborne House, where it was displayed in the Durbar Corridor.[46] RP

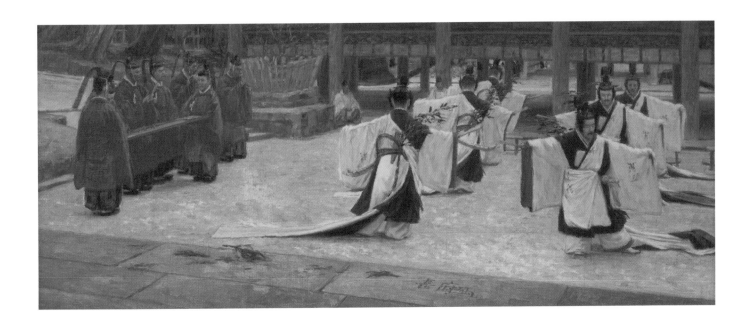

UTAGAWA KUNIHISA II (1832–91)

FOLDING FAN (ŌGI): FLYING A KITE
(RECTO) AND MOUNT FUJI (VERSO),
*c.*1870–90

Cream silk painted in watercolour and bodycolour over
black ink (fan leaf); ivory, mother-of-pearl, shell, cellulose-
based plastic, gold lacquer, bamboo, silver, red silk (guards
and sticks)

30.0 cm (guard length)

Signed (recto): 國久 画 (*Kunihisa ga*; 'Painted by Kunihisa');
seal: 國久 (*Kunihisa*)

RCIN 25232.a

PROVENANCE: Possibly acquired by Queen Mary

The earliest known surviving example of a Japanese fan dates from
the Nara period (710–94). It is a rigid fan with a single handle,
and it seems probable that such items were originally introduced
from China and used for ceremonial purposes.[47] The first folding
fans (*ōgi*) were documented in Japan towards the end of the Heian
period (794–1185), and may well have originated there.[48] Over the
centuries, their forms and uses ranged from the *gunsen* (war fan) for
signalling in battle and the *mita ōgi* (giant fan) used in processions,
to the *mai ōgi* (dancing fan) and the closed *ōgi* placed on the floor
during tea gatherings. During the Meiji period (1868–1912), as
Japan opened to international trade and interest in Japanese arts
grew in the West, fans such as the present example were produced
for export.

The fan leaf is signed and painted by the Japanese *ukiyo-e*
printmaker Kunihisa, a pupil and son-in-law of the celebrated
printmaker Kunisada (1786–1864). Kunihisa was a member of the
Yokohama school, specialising in landscapes, and on the recto has
rendered with a brush fine black ink figures in Japanese dress in
a wooded setting. The figure at far right flies a kite, while a boy to
his left carries an elaborately decorated kite in his hand. Colour
has been added through washes of watercolour, with bodycolour
providing the flesh tones on the figures. The leaf of the verso
is decorated with auspicious red-crowned cranes (*tanchōzuru*),
wading among reeds and in flight by Mount Fuji.

A small number of fans by Kunihisa are known, the leaves
always signed in black ink over a red seal. Most are mounted onto
bamboo or ivory sticks with the same cut decoration, and with
ivory guards decorated with gold lacquer in high relief (*takamakie*)
or applied decoration (*shibayama*), or both, as on this fan.[49] RW

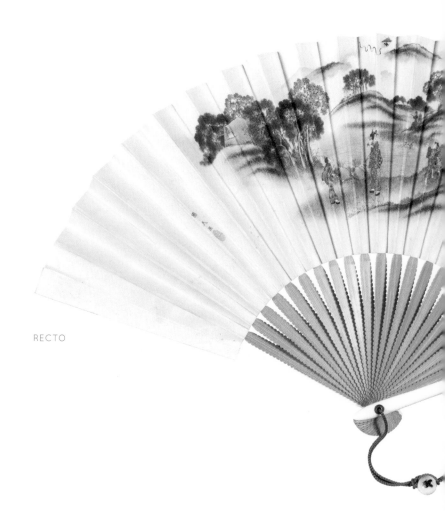

RECTO

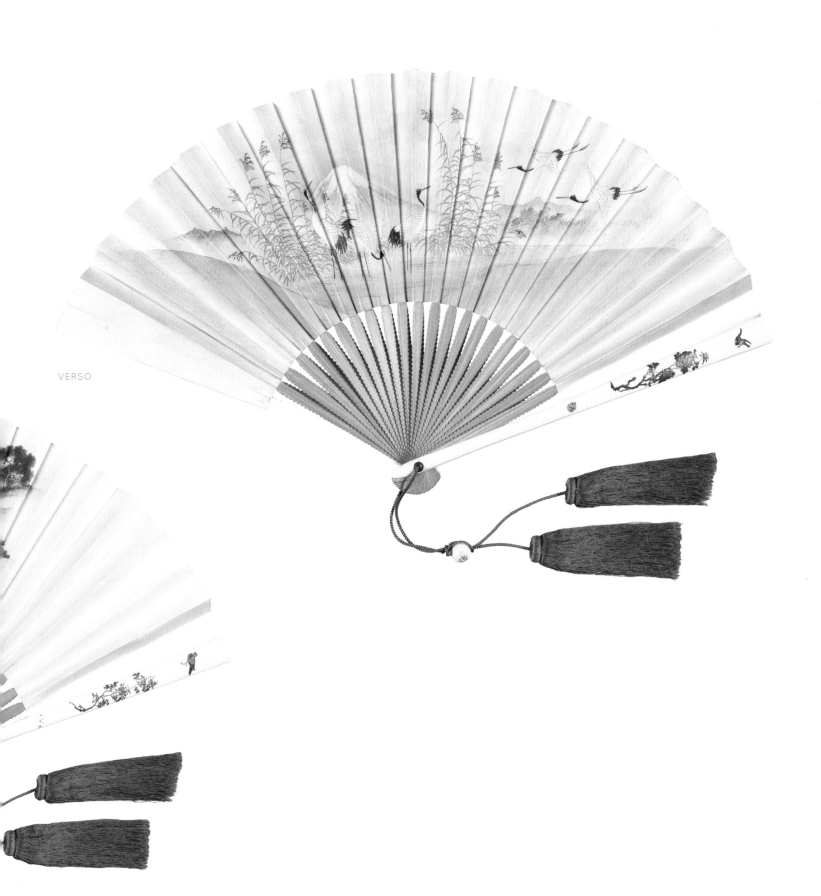

VERSO

JAPAN

FAN (ŌGI) AND PRESENTATION BOX, c.1880

25.7 cm (fan, guard length); 5.0 × 32.5 × 9.5 cm (box)

Ivory, gold lacquer, silver, silk (fan); wood, black and gold lacquer, silk (box)

RCIN 25182.a–b

PROVENANCE: Presented by Princess Chichibu to either Queen Mary or Queen Elizabeth, 1937

This ivory fan (*zōge ōgi*) is of brisé design – that is, with solid sticks of ivory joined together with a ribbon, rather than with a folded leaf attached to the sticks. Both the fan and its box are decorated in high-relief gold lacquer (*takamakie*) of different shades. The lacquer work on the fan is abundant, filling both guard sticks, and the design across the recto is repeated in reverse on the back. It is typical of the high-quality export wares created in Japan towards the end of the nineteenth century. Chrysanthemums, associated with the Japanese imperial family and depicted in their *mon*, appear on both the fan and its box. This was evidently a deliberate choice, as a note in the box indicates that they were a gift from Princess Chichibu (1909–95).

Princess Chichibu was born Setsuko Matsudaira, in the Surrey town of Walton-on-Thames. She was the daughter of Tsuneo Matsudaira, Japanese Ambassador to Washington and London, and in 1928 she married Prince Chichibu, the younger brother of the Emperor Shōwa. The prince and princess attended the Coronation of King George VI in 1937. During their visit, the couple visited both Queen Mary at Marlborough House (on 30 April) and the king and queen at Buckingham Palace (on 19 May), but it is not known to whom the fan was presented. RW

LITERATURE: J. Roberts *et al.* 2005 (exh. cat.), no. 57, p. 137

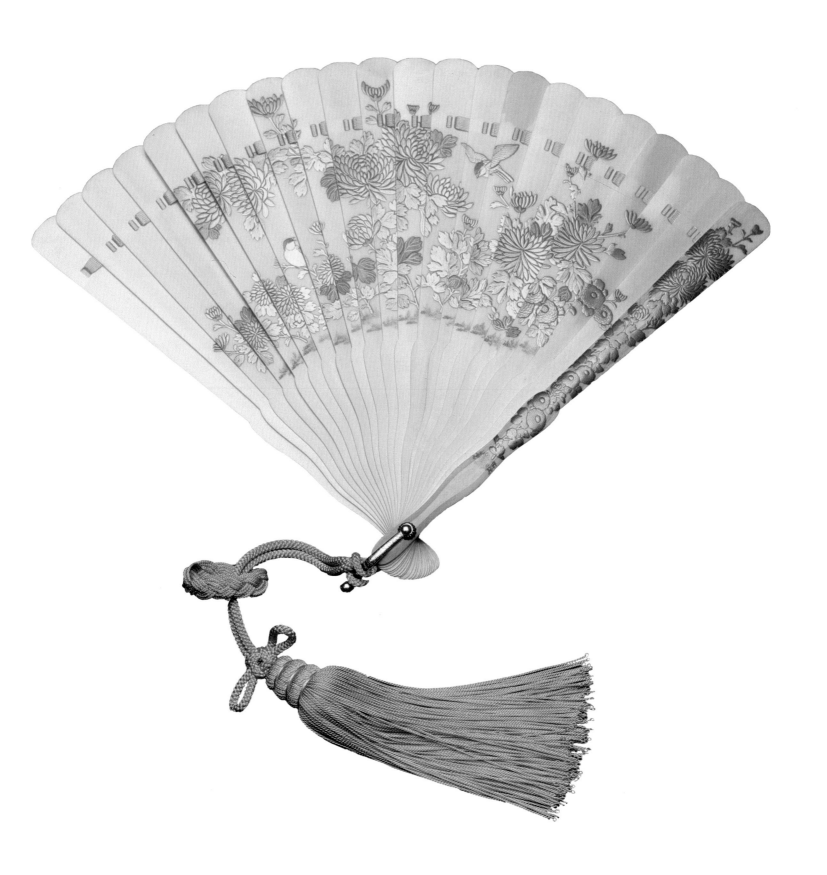

OSAKA MINT

INSIGNIA OF THE ORDER OF THE
CHRYSANTHEMUM: COLLAR, COLLAR BADGE
AND CASE, BADGE, STAR, SASH AND CASE,
c.1911–18

Gold, enamel, silk, lacquer, wood

82.0 × 4.5 cm (collar: chain length and width);
7.5 × 5.4 cm (collar badge), 33.6 × 33.6 × 4.0 cm (collar case);
12.5 × 7.6 cm (badge); 9.0 × 9.0 cm (star), 149.0 × 10.6 cm (sash),
26.0 × 13.8 × 6.5 cm (case)

Inscribed on the reverse: 大勲旌章 (*Daikunseishō*;
'Commendation of the Supreme Order'); 'M' mark of the
Osaka mint

RCINS 441562.a–b (collar and collar badge), 441659.c (collar case),
442247.a–b, d⁵⁰ (badge, star and case), 442537.b (sash)

PROVENANCE: Collar, badge and collar case presented to
King George V by Prince Higashi-Fushimi Yorihito, 1911;
sash, badge and star with case presented to King Edward VIII
when Prince of Wales by Prince Higashi-Fushimi Yorihito, 1918

Shortly after his restoration to power, the Emperor Meiji established
a series of honours and decorations as part of Japan's adoption and
adaptation of the courtly traditions of Europe. Much along the French,
Prussian and Russian models, these awards comprised different grades
and rules for appointment. The first to be instituted was the Order of
the Rising Sun in 1875. The Supreme Order of the Chrysanthemum –
Japan's highest decoration – followed in 1876. Originally, the insignia
of this Order comprised only the Grand Cordon (badge and star with
sash), but a collar and collar badge were added as an additional, higher
honour in 1888. In the same year, three other orders were instituted: the
Orders of the Paulownia Flowers, the Sacred Treasure and the Precious
Crown. The Order of the Golden Kite, a purely military award, was
instituted in 1890.

The insignia of the Order of the Chrysanthemum is presented in
a black lacquer box lined with gold silk brocade and decorated on
the outside with the imperial chrysanthemum *mon*. Speckled *nashiji*
gold lacquer adorns the underside of the lid, and the whole is tied
with magenta silk cords. The badge and star of the Grand Cordon
are formed of white enamel rays emanating from a red enamel sun
enclosed with chrysanthemum flowers and leaves. The same device
is used in a smaller form for the collar badge. The collar itself is
composed of chrysanthemum flowers and leaves between gold links
bearing the stylised *kanji* letters '*mei*' and '*ji*' for the imperial era of
its establishment.

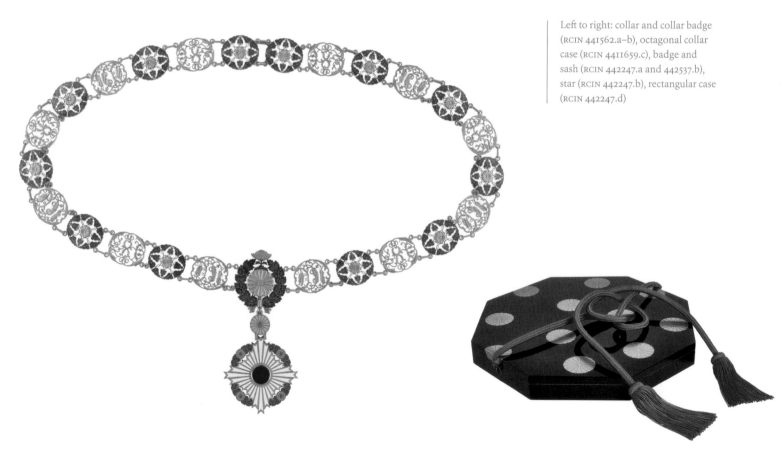

Left to right: collar and collar badge
(RCIN 441562.a–b), octagonal collar
case (RCIN 4411659.c), badge and
sash (RCIN 442247.a and 442537.b),
star (RCIN 442247.b), rectangular case
(RCIN 442247.d)

The Order effectively has two grades, with the collar normally reserved for members of the imperial family and reigning foreign monarchs. King Edward VII was appointed to the Grand Cordon when Prince of Wales on 20 September 1886, and the investiture by Prince Komatsu on behalf of the emperor took place at Marlborough House on 7 December that year.[51] He received the collar as king in 1902 and was therefore the first British recipient of either grade. On the same date, Queen Alexandra received the Order of the Precious Crown, both appointments being made on 13 April 1902. After 1886, the Grand Cordon was next bestowed on Prince Arthur, Duke of Connaught during his visit to Japan in May 1890 and to members of the British royal family on six subsequent occasions before 1937.[52]

Appointments to the Order of the Chrysanthemum coincided with royal visits to and from Japan. In particular, they were associated with the missions sent by King Edward VII and King George V to invest the Meiji, Taishō and Shōwa emperors with the Order of the Garter in 1906, 1912 and 1929 respectively. As the king's representative on two of these Garter missions, Prince Arthur of Connaught received the Grand Cordon in 1906 and then the collar in 1912. Prince Henry, Duke of Gloucester, who had received the Grand Cordon in 1921, received the collar in 1929 when leading the mission to invest the Emperor Shōwa.

Discussions about the exchange of orders had taken place even before the appointment of Albert Edward, Prince of Wales in 1886. When Prince Arisugawa Takehito was to visit Britain in 1880, the Emperor Meiji wished to present Queen Victoria with the Chrysanthemum. It was proposed that, if this took place, a reciprocal award could be made of the Order of the Bath[53] or the Order of the Star of India.[54] However, the former was deemed not suitably distinguished and the latter was seen as a reward for colonial rulers and therefore unsuitable for the emperor. The British appear to have been reluctant to bestow a Christian Order on a non-Christian ruler. This was despite the fact that two Ottoman sultans and the Shah of Persia had received the Garter in 1856, 1867 and 1873 respectively. In the end, it was felt that offering either the Order of the Bath or of the Star of India would result in a lower order than the Chrysanthemum being bestowed on the queen, causing embarrassment to Britain, and so the topic was dropped.[55] The question of reciprocal appointments was not resolved until King Edward VII appointed the Emperor Meiji to the Garter in 1906, following the Anglo-Japanese Alliance.

The investiture of Prince Arthur, Duke of Connaught with the Chrysanthemum in 1906 was of particular significance because he was the first-ever recipient to be invested personally by the emperor. A.B. Mitford recorded that the Emperor Meiji visited the prince at his accommodation following his own investiture with the Garter earlier that day: 'The Emperor expressed great admiration for the ceremonial … and repeated his sentiments of gratitude to King Edward. Then producing a lacquer box, he took from it the ribbon and star of the Order of the Chrysanthemum and with his own hands put the ribbon over the Prince's shoulder and pinned the star to his breast'.[56] The investiture passed without incident, whereas during the earlier Garter ceremony the prince had pricked his finger on the pin of the Garter as he buckled it below the emperor's knee. The mishap drew blood, which stained the decoration. Mitford recalled, 'The prince, who was only twenty-three, was obviously nervous, but the emperor seemed quite unperturbed.'[57] SJP

LITERATURE: Patterson 1996, no. 133, pp. 180–81

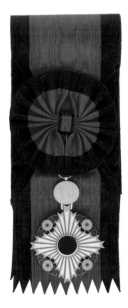

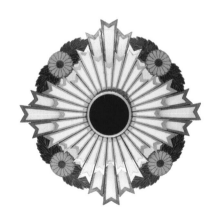

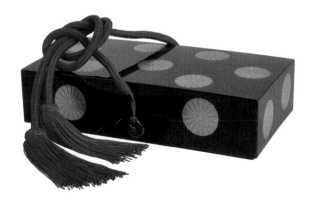

153

?OSAKA MINT

GRAND CORDON OF THE ORDER OF
THE PRECIOUS CROWN: BADGE, STAR
AND SASH, c.1905

Gold, enamel, pearls, silk
8.5 × 5.0 cm (badge); 135.0 × 8.0 cm (sash); 6.6 × 6.6 cm (star)
RCINS 441068.a–b (badge and sash), 441069 (star)
PROVENANCE: Presented to Queen Mary when
Princess of Wales, 1905

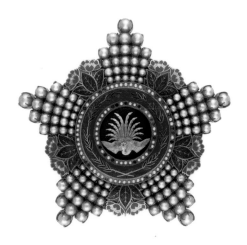

The Order of the Precious Crown, instituted by the Emperor Meiji
in 1888 as a decoration for women, was first received by a member
of the British royal family when it was presented to the Duchess
of Connaught in 1890. The Duke of Connaught recorded in their
joint diary,

> the Prince [Komatsu] handed her the Order of the Imperial Crown
> [sic] (the Chief Ladies order of Japan) … The presentation of this
> order was quite unexpected & gave us great pleasure. Except the
> Empress of Russia no other foreign princess has this order. It was
> very appropriate as L.Sn. [Louise] was the first Princess of any
> Royal House that has visited Japan.[58]

After the honour was bestowed on Queen Alexandra in 1902, the
Princess of Wales (later Queen Mary) was appointed to the Order
on 28 March 1905. The insignia was probably presented in June that
year during the visit of Prince and Princess Arisugawa. Subsequent
appointments to the Order before 1940 included Princess Arthur of
Connaught (1891–1959) in 1918, Princess Mary (1897–1965) in 1921
and Queen Elizabeth (later the Queen Mother) in 1937.

The centre of the badge bears a representation of a filigree crown
topped with a bird of paradise, as worn by ancient empresses,
encircled by pearls, designs of bamboo shoots, and cherry blossoms
and leaves suspended from the ribbon by a wreath of paulownia
flowers. Decorated with rays set with pearls, the star bears, at its
centre, a bird of paradise. SJP

LITERATURE: Patterson 1996, no. 134, p. 182

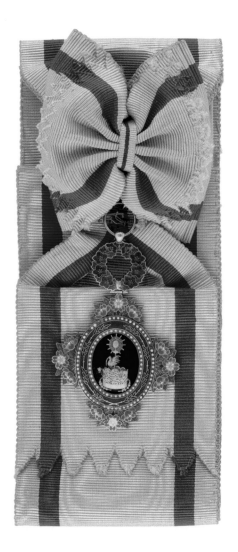

154
?OSAKA MINT
FIELD MARSHAL'S BADGE, c.1918

Silver, gold and enamel

6.4 × 4.2 cm

Inscribed on the reverse: 贈進大不列顛國皇帝ジョージ
第五世陛下嘉仁 (*zōshin Daiburitenkoku kōtei Jōji dai gosei
heika, Yoshihito*; 'Presented to the Emperor of Great Britain,
His Majesty [King] George V, Yoshihito')

RCIN 441124

PROVENANCE: Presented to King George V by Prince
Higashi-Fushimi Yorihito on behalf of the Emperor Taishō,
29 October 1918

King George V's appointment to the rank of Field Marshal of
the Imperial Japanese Army (*gensui rikugun-taishō*) followed the
appointment of the Emperor Taishō as a Field Marshal in the
British Army on 1 January 1918.[59] The badge and sword (cat. 96)
were presented to the king by Prince Higashi-Fushimi Yorihito, who
travelled especially to Britain to make the presentation on behalf
of the emperor. The prince's arrival on 28 October was marked with
appropriate ceremony, and the king and the Duke of Connaught
met him at Paddington Station.[60] The king described the investiture
the following day in his diary: 'At 10.0 Prince Yorihito presented me
with the sword & badge of a Japanese Field Marshal in the throne
room, a nice little ceremony, very well carried out.'[61] Following the
presentation, the prince was decorated with the Royal Victorian
Chain, one of only three Japanese recipients.[62]

The oval badge depicts two crossed ensigns of the Imperial
Japanese army and navy, the proper left edged in purple,
beneath a spray of paulownia flowers topped with the imperial
chrysanthemum *mon*. Following the rank's institution in 1872, it
was awarded to only 18 individuals; of these, King George V was
the only foreign recipient. SJP

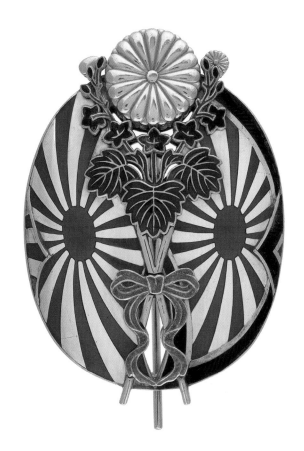

155

KAWASHIMA, KYOTO

FOUR-FOLD EMBROIDERED SCREEN,
c.1970–71

Silk, silk thread, figured silk, wood

167.0 × 69.5 × 2.9 cm (each leaf)

RCIN 29941

PROVENANCE: Presented to Queen Elizabeth II by
the Emperor Shōwa during his State Visit to the
United Kingdom, 1971

The scene portrayed across the four panels, worked in silk thread on
a gold ground, is from Murasaki Shikibu's eleventh-century novel,
the *Tale of Genji* (*Genji Monogatari*). The tale recounts the amorous
escapades of the 'Shining Prince', Genji, and introduces some of the
most important characters in the history of Japanese literature. It is
often referred to as the earliest novel.

All of the episodes in the novel are set in and around the former
capital of Japan, called *Heian-kyō* or *Miyako*, and now known as
Kyoto. In the episode embroidered on this screen, which occurs in
chapter 34, a group of courtiers play *kemari* (kickball) beneath swirling
cherry blossoms while Prince Genji's wife, the Third Princess, watches
from behind a screen. During the game, a cat pushes aside the blind
concealing her, momentarily revealing the princess to one of the
players, Kashiwagi, who immediately falls in love. The *Tale of Genji* had
a profound impact on decorative arts from the Heian period (794–1185)
onwards, and episodes from the narrative were frequently reproduced
in exquisite detail on screen paintings and other objects. Unlike many
six-leaf folding screens which depict the princess in her rooms in the
background, this four-leaf screen shows only the *kemari* players.

The borders around the panels are covered with figured silk while the
reverse of the screen is applied with gilt squares on a green background.

Since the late nineteenth century, art textiles have remained among
the Imperial Household's choicest gifts, including well into the twentieth
century when this screen entered the Royal Collection. RP & CDEG

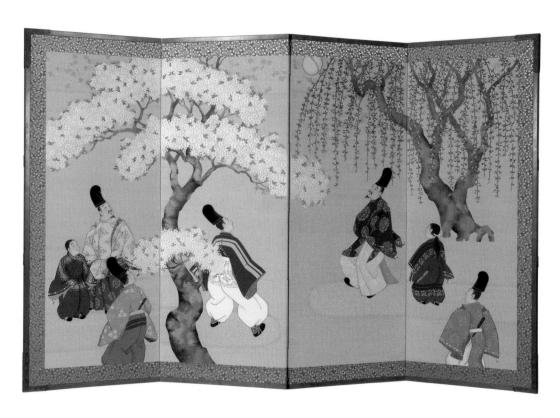

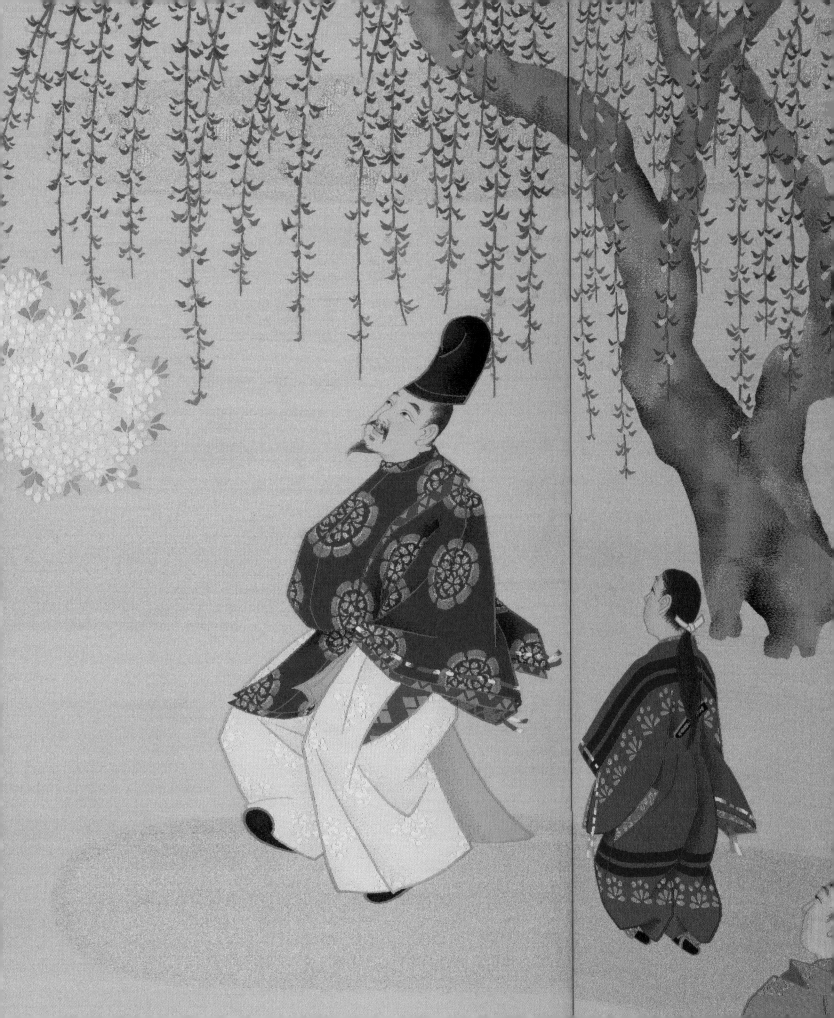

日本の芸術

11

CODA

RACHEL PEAT

I N October 2019, HRH The Prince of Wales (b. 1948) attended the Ceremony of Enthronement (*Sokuirei-Seiden-no-gi*) for the Emperor Naruhito (b. 1960) at the Imperial Palace in Tokyo. Standing on the dais of the elaborate canopied throne (*takamikura*) and holding a wooden sceptre (*shaku*) symbolising dignity, the new emperor pledged to fulfil his role 'as the symbol of the State and of the unity of the people of Japan, while always wishing for the happiness of the people and the peace of the world'. His accession was precipitated by the abdication of his father, the Emperor Heisei (1933–) in April that year. During the visit, The Prince of Wales attended a Court Banquet and viewed the model of the Taitokuin Mausoleum at Zōjō-ji visited by his great-grandfather, King George V, more than a century earlier. He later commended the 'close and special bond' between the 'two Island nations' during a reception at the British Ambassador's residence in Tokyo. The exchange was testament to the vibrant and friendly relations which persist between the royal and imperial families and peoples of Japan and Britain today.

Since Her Majesty The Queen's accession in 1952, a new era of Japanese-British co-operation has been forged (see cat. 156). The Second World War (1939–45) had severely damaged the international bonds of the early twentieth century, and the profound effects on both nations should not be underestimated. However, in 1971, the Emperor Shōwa made a State Visit to the United Kingdom, the first reigning emperor to do so (Fig. 11.1). The Queen reciprocated in 1975, becoming the first reigning monarch of the United Kingdom to visit Japan (Fig. 11.2). The Emperor Heisei likewise came to the United Kingdom in 1998. On each occasion, gifts were exchanged and the royal visitors sought to learn more of the culture and society of the host nation.

Today, Japanese works of art adorn the walls of more than a dozen current and former royal residences in the

11.1 Central Office of Information, London, *The Emperor Shōwa arrives at Buckingham Palace* (detail), 5 October 1971. Gelatin silver print, 15.2 × 20.6 cm, RCIN 2004218

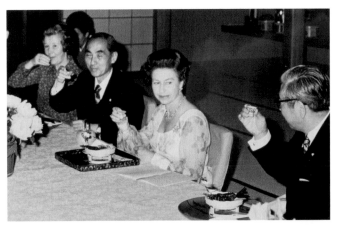

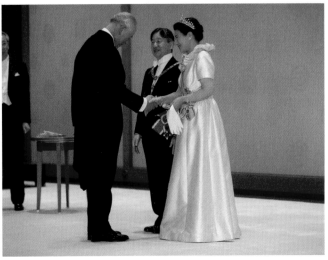

11.2 Fox Photos, *Her Majesty The Queen drinks saké in Kyoto during the State Visit to Japan* (detail), 10 May 1975. Gelatin silver print, 16.5 × 21.6 cm, RCIN 2002920

11.3 PA Images, *The Emperor Naruhito and Empress Masako welcome HRH The Prince of Wales to a Court Banquet at the Imperial Palace, Tokyo,* October 2019

United Kingdom, as they have done for centuries. The Queen remarked at the State Banquet for the Emperor Shōwa in 1971: 'People can be fascinated by things which are remote and mysterious, but they can only like and admire things which they know and understand. That is why I believe every contact between our two peoples is to be fostered and encouraged.'[1]

SHIRAYAMA SHŌSAI (1853–1923)
COSMETIC BOX AND COVER (TEBAKO),
c.1890–1905

Wood, black, gold and silver lacquer

23.2 × 27.5 × 33.5 cm

Inscribed on the underside of the lid with the signature and *kaō*
of Shirayama Shōsai

RCIN 39503.a–b

PROVENANCE: Sent to Queen Elizabeth II by the Emperor
Shōwa on the occasion of her Coronation, 2 June 1953

The Emperor Shōwa sent this rare and refined piece to Her Majesty
The Queen as a Coronation gift in 1953 – just one year after Japanese-
British relations had been normalised by the Treaty of San Francisco,
signed in 1951 and brought into force in 1952. The presentation of this
first post-war diplomatic gift was therefore of great significance, and the
Imperial Household evidently sought a piece of the highest calibre.

This exceptional box is the work of Shirayama Shōsai, one of the
most prestigious lacquerers of the Meiji and Taishō eras. Today, fewer
than 70 examples of his work are known in Japan, Europe and the
United States.[2] Here, Shōsai presents one of his favourite subjects –
a heron – with a combination of exceptional boldness and delicacy.
Soft white feathers are carefully rendered in silver lacquer, accented
with minuscule gold lacquer streaks and contrasting dramatically with
Shōsai's trademark ground of lustrous black. The latter has been highly
polished to achieve a deep, mirror-like finish. On the underside of the
lid, six black crows surround a bare plum tree. Shōsai combined herons
and crows on several occasions,[3] and together they evoke the hard
winter season. The heron's posture, nestled in its feathers, reinforces the
chilly atmosphere.

In 1890, Shōsai exhibited a cosmetic box bearing a white heron at
the Third National Industrial Exposition in Tokyo. The design was
taken from a painting by Kanō Tsunenobu (1636–1713) and praised
by the jury as a 'first rank' piece.[4] This may be the same box, or a very
similar design. The signature which appears here is not inconsistent with
the way Shōsai signed his work at that time, which could make this one
of the few known works from his early independent output.[5]

Shōsai had been instrumental in the re-establishment of lacquer
(*urushi*) as a revered art form during the Meiji period. In 1880,
he began working for the semi-governmental export company,
Kiritsukōshōgaisha, and it was there that he took his art name,
Shōsai. In 1890 he became a founder-member of the Japan Lacquer
Society (*Nihon shikkōkai*), and he subsequently did much to promote
recognition of lacquerers as individual artists – a status enjoyed in
the Edo period but largely lost during the export-focused years of the
Meiji restoration. In 1906, he was made an Imperial Household Artist
(*Teishitsu Gigei'in*).[6] RP

LITERATURE: Dees 2007, p. 30; Ayers 2016, III, no. 2236, p. 1026;
Goodsir 2017, p. 62

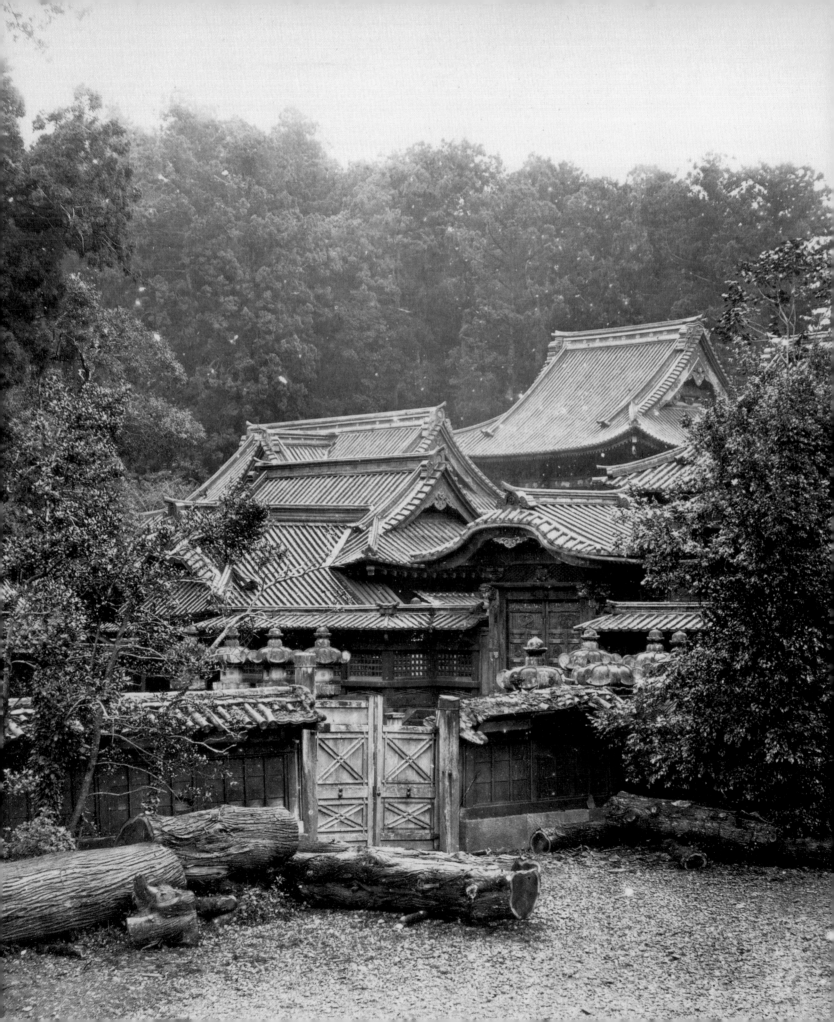

日本の芸術

12

THE MODEL OF THE TAITOKUIN MAUSOLEUM

WILLIAM H. COALDRAKE

I N the autumn of 1881, 16-year-old Prince George, later King George V, together with his elder brother Prince Albert Victor, were on a world tour as midshipmen aboard HMS *Bacchante* when their ship docked in Yokohama. On the morning of 25 October, the second day of their shore leave in Tokyo, they visited Zōjō-ji.[1] This was the family temple of the former ruling shogunal family, the Tokugawa, where no fewer than seven shōgun, their wives and families were interred during the Edo period (1615–1868). The buildings there included the mausoleum of the second shōgun, Hidetada (1579–1632), known as Taitokuin after his death (Fig. 12.1). Jōdo Buddhism, to which the temple and its shogunal mausolea were dedicated, offers the promise of salvation after death in the paradise of Amida Buddha, with its cooling waters, flowering lotuses and myriads of birds and flowers.

The temple was but a short carriage ride from the princes' accommodation in central Tokyo. Albumen prints of Zōjō-ji and of the Tokugawa mausolea are included in the photograph album compiled after their visit (see cat. 67). One of these photographs shows a tight cluster of buildings with a densely wooded hill behind (Fig. 12.2). The two roofs visible at the rear belong to the Taitokuin Mausoleum. The upper roof of the Main Hall (*Honden*) rises above the clutter of the others; to its left can be seen the roof of the Worship Hall (*Haiden*). These were covered with the copper sheet tiles preferred by the Tokugawa for their mausolea, being lighter and more durable than the terracotta tiles normally used on temple roofs.[2] The mausoleum had been constructed immediately after Hidetada's death in 1632 but was almost entirely destroyed by wartime bombing in May 1945. The photograph is therefore particularly valuable for offering a glimpse of this lost structure.

The Taitokuin Mausoleum was the finest of all the Tokugawa mausolea built at Zōjō-ji under the patronage of Hidetada's son and shogunal successor, Iemitsu (1604–51). It was a place where profound religious belief and pervasive political authority came together in emphatic architectural and artistic expression. Construction tapped the vast resources of the shogunate and

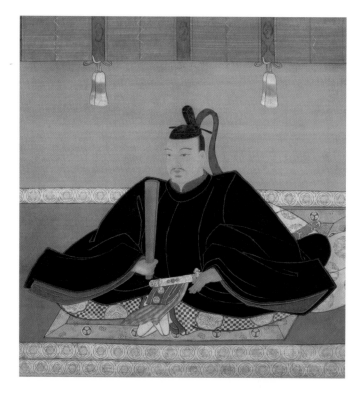

12.1 Unknown artist, *Portrait of Tokugawa Hidetada* (detail), Edo period (1615–1868). Pigment on silk, 94.5 × 100.0 cm (painting), 132.0 × 117.3 cm (hanging scroll), Zōjō-ji Collection

employed the genius of the leading architects, carpenters, sculptors and artists of the day. These included Kōra Munehiro (1574–1645), a sculptor of extraordinary three-dimensional creatures and an exponent of curvilinear architecture in the Song-dynasty inspired idiom known as *Zenshūyō*. The decorative programme was directed by the official Tokugawa artist Kanō Tan'yū (1602–74).

A more complete idea of the appearance of the Taitokuin Mausoleum can be gained from the *Edozu byōbu*, which depicts the city of Edo during the reign of Iemitsu (Fig. 12.3). The main buildings are bedecked in a riot of polychrome sculpture. At the rear, the Main Hall, incorrectly shown with the roof sideways, is connected to the Worship Hall by a roofed gallery, the *Ainoma*, the roof ridge just visible in this foreshortened view. This was the standard three-building configuration of

12.2 Baron Raimund von Stillfried (1839–1911), *Shiba: Panoramic View of the Tokugawa Mausolea on the Southern Side of Zōjō-ji*, 1871–81. Albumen print, 21.7 × 27.7 cm, RCIN 2581131. This photograph shows Zōjō-ji at the time of the visit by Prince Albert Victor and Prince George

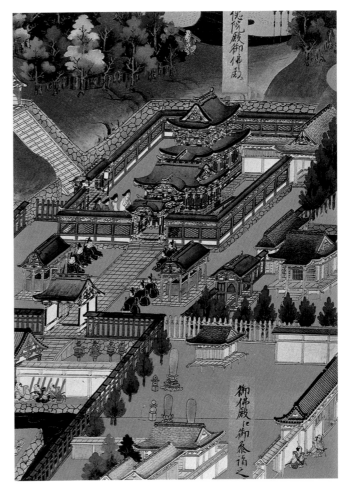

12.3 Unknown artist (Japan), *Edozu byōbu* (detail from one of a pair of six-fold screens: left screen, sixth panel from right), *c.*1632–40. Each screen 162.5 × 366.0 cm, National Museum of Japanese History, Sakura. This shows the Taitokuin Mausoleum at the time of the third shōgun, Tokugawa Iemitsu

mausoleum architecture. The timber framing of the Main Hall is lacquered a brilliant red and that of the Worship Hall a striking black. These buildings are surrounded by a roofed fence, decorated with transom sculpture. The compound is entered through a gateway (*Chūmon*) approached along an axis path with further gateways. A survey of the Taitokuin Mausoleum in 1933–4 records that the main mausoleum buildings were 32.05 m long, the Main Hall 13.82 m wide and the Worship Hall 12.44 m wide.[3]

When the two princes visited Zōjō-ji in 1881, they inspected the mausolea of the seventh, ninth and fourteenth shōguns. They remarked that

> often as we have seen photographs of these temples with their heavy overhanging dark-tiled roofs and carvings, we have never realised anything of the real beauty produced by their vermillion painted beams, and the mass of gold and lacquer, black and scarlet, and of bronze and wood carvings of birds and flowers, gold pheasants, cocks,

> chrysanthemums, peonies, and monsters, amid rolls of arabesque work, coloured with every tint of brightness and enamel.[4]

The princes were then escorted past the Taitokuin Mausoleum, 'the exterior of which apparently is just as gorgeous as that of those into which we have been, and as far as we can see, through their open doors, the interior also'.[5] A pre-war

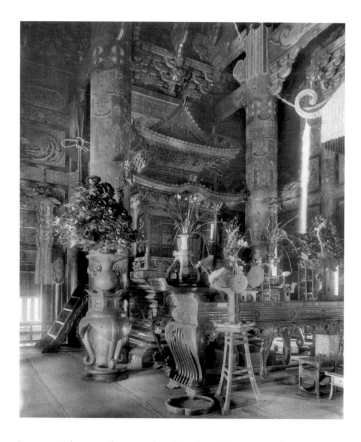

12.4 Unknown photographer, *Interior of the Main Hall (Honden) of the Taitokuin Mausoleum*, 1930. Paper print from glass negative, Nara National Research Institute for Cultural Properties, photograph no. 131025

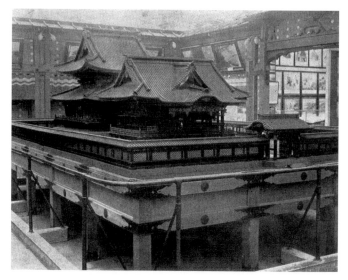

12.5 Unknown photographer, *Taitokuin Mausoleum Model on display at the Japan-British Exhibition*, Shepherd's Bush, 1910. Photolithograph, *Illustrated London News*, 13 August 1910, p. 8

photograph shows the interior, with a shrine flanked by monumental pillars marking the way to the Amida Paradise (Fig. 12.4). These pillars were known as the *Raikō-bashira* (called *raigō-bashira* in other Buddhist denominations), the 'pillars of the coming of paradise'.

KING GEORGE V AND THE TAITOKUIN MAUSOLEUM MODEL, 1910

Through a remarkable conjunction of circumstances, an accurate one-tenth scale replica of the main precinct of the Taitokuin Mausoleum is now part of the Royal Collection.

On Saturday 6 August 1910, King George V – once the young Prince George of the 1881 Zōjō-ji visit – made an official tour of the Japan-British Exhibition, where a model of the mausoleum was on display.[6] The exhibition took place at White City, Shepherd's Bush, to the west of London, from May to October 1910. It built on the Anglo-Japanese Alliance of 1902 by promoting trade and international recognition of Japanese art and industry. Over 8,350,000 people visited during the six months it was open.[7]

The *Illustrated London News* later published a photograph of the model at the exhibition, sitting on a one-metre high stand (Fig. 12.5). This height allowed visitors a clear view of the decoration under the eaves, and of the interior through the open shutters. The caption states that 'during his visit to the Anglo-Japanese Exhibition, King George graciously accepted from the Japanese Commission this model of the shrine of Shogun [*sic*], at Tokyo, which is especially remarkable for its lacquer-work'.

The model had been specially commissioned for the Japan-British Exhibition by the City of Tokyo. It was made

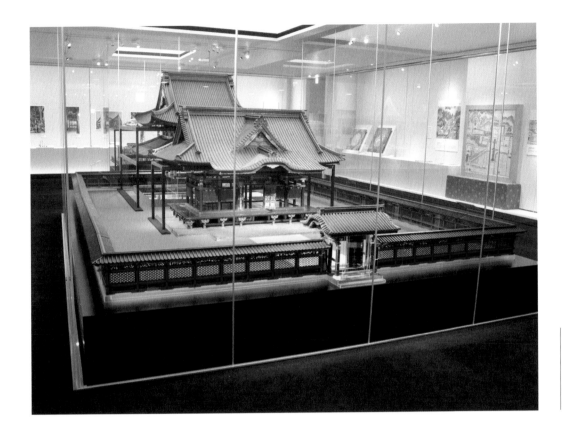

12.6 Saitō Yukinari,
*Taitokuin Mausoleum
Model, front oblique
view*, 2015. On display at
Zōjō-ji following partial
restoration in 2014–15

while the mausoleum at Zōjō-ji still stood, based on precise measurements and a careful study of its architecture and decoration, the first since the end of the Tokugawa shogunate 40 years earlier. The Tokyo School of Fine Arts (now Tokyo University of the Arts) prepared the model under the direction of Takamura Kōun (1852–1934) and the architect Kouda Minoru.[8] Takamura, the famed wood sculptor, was the first person to be designated a Living National Treasure (*Ningen Kokuhō*) for his technical and artistic skill in making Buddhist images. An average of 150 people were employed each month to make the model from mid-August 1909 until the end of December 1909, according to R. Yamasaki, the Commissioner of the City of Tokyo to the Japan-British Exhibition.[9]

Judging from the model, it is easy to see why the young princes were so impressed with the original buildings (Fig. 12.6). The model is a *tour de force* of Japanese architectural and decorative arts and, at 3.6 m wide, 5.4 m long and 1.8 m high, it is substantial

in size and commanding in presence. At a scale of one-tenth of the original, it was possible to make it with the same materials and techniques as the mausoleum. It is constructed from Japanese cypress wood (*hinoki*) from the province of Owari (now Aichi Prefecture), re-used from a shrine dating to the time of Shōgun Tokugawa Iemitsu.[10] It has timber framing assembled with mortise-and-tenon joinery, and precisely crafted bracket-sets and other structural features found in the full-scale building that it represents. It is decorated with gold and silver lacquerwork (*makie*), metalwork bearing the Tokugawa family crest (*mon*), polychrome sculpture and gold leaf, and even miniature bamboo blinds.

Unlike most models, the interior is fully realised, in its own way a Japanese version of Queen Mary's magnificent one-twelfth scale Dolls' House at Windsor Castle (constructed 1921–4). It has miniature *tatami* mats, transom sculptures, Buddhist ritual utensils and paintings of the Amida Paradise

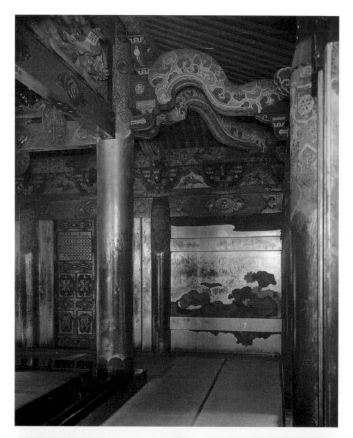

12.7 and 12.8 Nara National Research Institute for Cultural Properties (above), author (below), *Wall paintings depicting the Amida Paradise, Outer Sanctuary of the Main Hall*, seen inside the mausoleum in 1930 (above) and inside the model in 2015 (below)

in gold and mineral pigments of malachite and azurite – just like the originals, but on a smaller scale (Figs 12.7 and 12.8). Fantastical creatures like those noted by the princes sit under the eaves, and comparison with pre-war photographs shows how accurately they were made. The official report of the exhibition noted that the model was 'very highly admired as a work of art, with its tiny bronze tiles covering artistically shaped roofs and with the exquisite work in which the whole structure was decorated'.[11] These painstakingly crafted tiles may be seen on the model today, the wooden formwork beneath now exposed where pieces have been lost.

THE MODEL AT THE ROYAL BOTANIC GARDENS, KEW, 1910–58

After the conclusion of the Japan-British Exhibition, the model was displayed in Timber Museum No. III at the Royal Botanic Gardens, Kew. This was the Orangery designed by William Chambers (1723–96) and completed in 1761, shortly before he built his Great Pagoda nearby. King George V evidently took a personal interest in the model's display, perhaps remembering with nostalgia the visit with his late brother to Zōjō-ji almost 30 years earlier. The king approved the proposal to place the model at Kew, though 'on the understanding that the model is housed in a suitable place, where it will not be damaged by an unfavourable temperature'.[12] After the model had been moved, Sir Frederick Ponsonby, the king's Assistant Private Secretary, wrote to the Director of Kew, Lt Colonel Prain, that 'His Majesty hopes to have an opportunity later on of seeing the model in its new situation.'[13]

That visit did not eventuate. No photographs survive showing the model in Timber Museum No. III, probably due to the strict ban on interior photography in the Kew museum buildings.[14] By 1936, the model's condition was cause for concern among the Kew authorities, and H. Clifford Smith of the Victoria and Albert Museum was commissioned to conduct a condition survey.[15] The Director of Kew, Sir Arthur Hill, wrote to King Edward VIII's Private Secretary that:

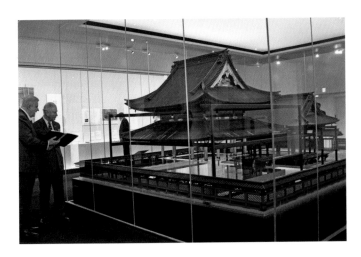

12.9 HRH The Prince of Wales visits the Taitokuin Mausoleum model at Zōjō-ji, 23 October 2019, guided by the author

I have had the model very carefully examined, and we find that after twenty-six years – exposed as it has been to the dust and dirt of the atmosphere – it has suffered considerably from the accumulation of dust and from the continuous cleaning which is necessary to keep it in order. As the model is of delicate construction, we find that some pieces are becoming detached owing to the great difficulty of cleaning so elaborate a piece of work.[16]

Attempts were made to find the model a more suitable home, but it remained at Kew until 1958. At this date, after further unsuccessful attempts to rehouse it, it was dismantled and put into storage because of plans to convert Timber Museum III back to use as an orangery.[17]

THE TAITOKUIN MAUSOLEUM MODEL TODAY

For more than 30 years, the model disappeared from view until it was rediscovered at the storage facility of the Historic Buildings and Monuments Commission (later English Heritage) in the early 1990s. The model was fully unpacked for the first time in nearly 50 years during a full-scale condition

survey in 2000. Identification of the gilded and polychrome model of one of the Pillars of Paradise, a defining feature of the original mausoleum (as seen in Fig. 12.4), confirmed that it was indeed the replica of the Taitokuin Mausoleum. This pillar was presented to Zōjō-ji in 2008 by HRH The Prince of Wales, as a symbol of the links between the United Kingdom and Japan.

In April 2014, each component was moved to Tokyo and partially restored over the following 12 months, in preparation for display in a specially designed Treasures Gallery at Zōjō-ji. Today, the model is on long-term loan from Her Majesty The Queen at the same site where the princes marvelled at the temple architecture during their 1881 visit (Fig. 12.9). The model resides just metres from the tomb of Hidetada, which was relocated after the war. In this sense, it has become the surrogate for Hidetada's lost mausoleum, itself reborn, albeit on a smaller scale than its original manifestation.

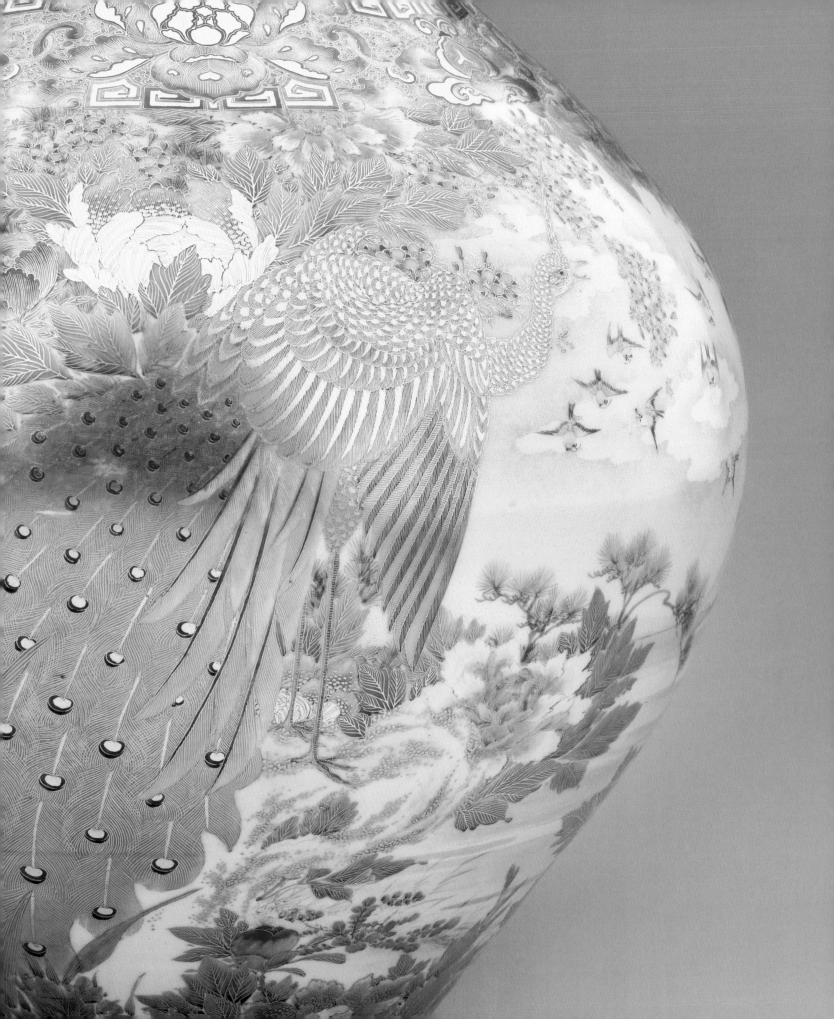

abumi	stirrup
aiguchi	sword or dagger mounting without a *tsuba*
aogai	pieces of shell inlaid on lacquer
aoi	wild ginger plant, often erroneously referred to as hollyhock
bakufu	military government
bundai	low table for writing implements
bushidō	'the way of the warrior'
byōbu	folding screen
chanoyu	a tea gathering (tea ceremony)
chidori	plovers: small birds found by the seashore; associated with winter in poetry and art
chōnin	townspeople
daimyō	regional feudal lord
daishō	a matching pair of long and short swords, the *katana* and *wakizashi*
dō	cuirass
dōmaru	body-wrapped cuirass which is hinged around the body and fastens on the right
ebira	quiver with an open frame
emakimono	horizontal painting illustrating a narrative, mounted as a handscroll
fubako	box for letters
fude	brush for calligraphy
fundame	a form of lacquer decoration in which fine metal powders are applied smoothly and consistently to create a matt surface
gagaku	traditional performing arts of the Imperial Court
geisha	professional female entertainer
haiku	a poem with 17 syllables
hamon	the crystalline pattern on the hardened edge of a sword blade
hanabishi	geometric pattern of flowers within rhombus-shaped frames
hiramakie	'flat sprinkled picture'; a form of lacquer decoration in which metal powders are sprinkled onto wet lacquer
hirame	'flat eye'; a form of lacquer decoration in which large irregular flakes of gold are sprinkled onto a flat ground
horimono	decorative engraving or carving on a sword blade
ikebana	flower arrangement
Imari-style	porcelain associated with the export port of Imari, characterised by dense overglaze enamel decoration in yellow, red, green, aubergine and blue, with highlights in black and gold
inrō	small tiered container, originally used to hold medicine, worn hanging from the waist sash
jūnishi	East Asian Zodiac calendar
kabuki	popular theatre that developed in the Edo period
kachō-e	pictures of birds and flowers
kakemono	hanging scroll painting
kaki	Japanese persimmon, also used to denote the colour of the fruit
Kakiemon-style	porcelain produced in Arita, Hizen province, in the later seventeenth century, characterised by a fine, white body and sparse, asymmetric designs in coloured overglaze enamel
kakko	two-headed barrel drum, played with sticks
kame	tortoise
kanji	Japanese writing system using ideograms adapted from Chinese characters
kankodori	motif of a cock on a drum, symbolising peace and good govenance
kaō	seal or monogram used as part of an artist's signature
katana	the longer of the two swords in *daishō* mounts, worn in a waist sash with the cutting edge uppermost
kazaridana	open cabinet with an assortment of asymmetrical cupboards and shelves
kikumon	the 16-petalled chrysanthemum crest, emblem of the Imperial Household
kōdō	'the way of incense'
kōgai	bodkin kept in the scabbard of a sword
kogatana	small knife kept in the scabbard of a sword
komabue	transverse flute with six finger holes
kote	armoured sleeve
kura	saddle tree
kurodana	open shelf for display, particularly of cosmetic boxes
kushide	repeating 'comb teeth' pattern characteristic of Nabeshima porcelain

kyōgen	comic interlude within or between *Nō* performances	*saikan sanyū*	see *shō-chiku-bai*
makie	'sprinkled picture', a form of lacquer decoration; see *hiramakie*, *takamakie* and *togidashi makie*	*saké*	alcoholic drink made from fermented rice
menpō	a half-mask covering the face below the eyes	*sakoku*	Japanese system of limited contact with the world during the Edo period
menuki	small metal ornaments fitted on a sword-hilt	samurai	member of the hereditary warrior class
Mingei	Japanese Folk Craft movement	*santana*	set of three open shelves for writing equipment, cosmetics and toiletries, traditionally part of a wealthy bride's trousseau
minogame	mythical, auspicious tortoise, characterised by its long, hairy tail, which is considered to show its great age; a symbol of longevity and wisdom	*sankin kōtai*	'alternate attendance'; Tokugawa system in which the *daimyō* were required to reside for part of each year in Edo, and to leave their families there in their absence, as a means of ensuring their loyalty to the *shōgun*
mon	family crest or heraldic badge		
musen	enamel technique in which the wires are removed before firing		
naginata	long staff with a curved blade	*Sengoku Jidai*	Period of the Warring Provinces, 1467–1568
nakago	the tang of a blade	*seppuku*	honourable ritual suicide by samurai
nanako	a pattern of small dots on metalwork, resembling fish roe	*shakudō*	alloy of copper and small amounts of gold, patinated to a purple-black colour
nanban	'southern barbarian'; the term used in Japan in the sixteenth and seventeenth centuries to describe Europeans or products reflecting their taste	*shibayama*	intricate style of inlaying materials such as mother-of-pearl, ivory, tortoiseshell and coral on a range of surfaces, particularly lacquer
nashiji	'pear-skin ground'; irregularly shaped flakes of gold suspended in lacquer	*shibui*	an aesthetic of simple, subtle and unobtrusive beauty
netsuke	decorative toggle used to keep the cord of a suspended *inrō* tucked in place beneath the *obi*	*shibuichi*	alloy of roughly three parts copper and one part silver, patinated to achieve a range of greys and other colours
nigoshide	opaque white porcelain glaze with a milky ground	*shin-hanga*	early twentieth-century woodblock print style using the traditional four-part system of publisher, artist, woodblock carver and printer but reflecting western influences
Nihonga	Japanese-style painting, usually defined in contrast to *Yōga* (western-style painting)		
Ningen Kokuhō	a master practitioner of traditional Japanese art, designated by the imperial government as a 'Holder of Important Intangible Cultural Properties' (commonly known as a 'Living National Treasure')	Shintō	the indigenous belief system of Japan, based on the veneration of natural phenomena
		shishi	mythical lion–dog associated with Chinese temples
Nō	classical dance–drama characterised by slow movements and chanting	*shō*	mouth organ
noborigama	ceramic kiln built into the hillside and comprising multiple, interconnected chambers	*shō-chiku-bai*	'The Three Friends of Winter': pine, bamboo and plum blossom, found commonly together as a decorative motif; also known as *saikan sanyū*
obi	waist sash worn with a kimono	*shodana*	open shelf for display, particularly of writing equipment
ōgi	fan		
ojime	sliding bead which acts as a fastener	*shōgun*	military ruler of Japan, exercising power on behalf of the emperor
rōnin	masterless samurai		

shōsen	enamel technique in which barely visible wires are used to accentuate details of the design
shōtai-shippō	enamel technique in which the temporary supporting framework is removed, producing a translucent effect similar to stained glass
sode	shoulder guards
sōmen	full face mask
sōsaku-hanga	early twentieth-century woodblock print style along western lines, in which the artist undertakes all aspects of production
suneate	shin guards
suzuri	flat, smooth stone on which an inkstick is ground with water, for use in calligraphy and painting
suzuribako	'inkstone box'; a box to hold writing implements
tachi	long sword, worn with the cutting edge down
takamakie	'high sprinkled picture'; a form of lacquer decoration which is built up in relief with powdered clay or charcoal
tantō	dagger or knife less than 30 cm long
tebako	cosmetic box
Teishitsu Gigei'in	Imperial Household Artist
togidashi makie	'polished-out picture', a form of lacquer decoration in which an initial low-relief design is covered in black or transparent lacquer that is then polished until the design reappears, flush with the new ground
tokonoma	alcove in a reception room for the formal display of hanging scroll paintings, flowers and other items
tomoe	spherical comma motif used at Buddhist and Shintō sites since the Heian period
tsuba	sword guard
ukiyo	'the floating world' of transient urban pleasure, Edo period
ukiyo-e	paintings and prints of the 'floating world'
urushi	lacquer
wabi sabi	an aesthetic of rustic simplicity and restrained good taste (*wabi*) incorporating the natural patina of ageing materials (*sabi*), a central aesthetic of the tea gathering (*chanoyu*)
waka	a poem with 31 syllables
wakizashi	the shorter of two swords in *daishō* mounts, usually around 60 cm long
yamato-mai	a piece of Shintō ritual performance in the *gagaku* genre, involving four or six dancers accompanied by musicians
yari	spear
Yōga	western-style painting, usually defined in contrast to Japanese-style (*Nihonga*)
yumi	bow
zōgan	inlay technique; literally to inlay (*gan*) a shape or figure (*zō*)
zushi	portable shrine
zushidana	open shelf for displaying incense equipment and small boxes

INTRODUCTION

1 Dalton 1886, II, p. 26.
2 Jitoku was appointed a member of the Imperial Fine Arts Academy (*Teikoku Bijutsuin*) in 1930, an honour comparable to the title of Imperial Craftsman (*Teishitsu Gigei'in*). See Dees 2007, p. 46.
3 Royle 1857, p. 174.
4 Science and Art Department 1868, pp. 1–66.
5 Ayers 2016.
6 Dalton 1886, II, p. 91.

1. FIRST ENCOUNTERS

1 In Satow 1900, p. lxxviii. The English original of this letter does not survive. Note that the translation of the Japanese text provided by A. Farrington differs markedly in wording though not in essence (see Farrington 1991, I, p. 92).
2 Quoted in Massarella 2008, p. 13.
3 Raimondo de Soncino, the Milanese ambassador in London, Dec. 1497, quoted in Massarella 2008, p. 49.
4 Starkey and Ward 1998, p. 5.
5 Das 2016, p. 1357.
6 Hakluyt 1600, p. 817.
7 Hume 1899, no. 481, pp. 474–92.
8 Hakluyt 1589, sig. 3r.
9 William Adams, letter, 22 Oct. 1611, in Cooper 1965, p. 6.
10 EIC Commission for Captain John Saris, 4 Apr. 1611, in Satow 1900, pp. xii–xvi.
11 James I of England to the 'Emperor' of Japan, 10 Jan. 1612, in Farrington 1991, I, p. 75.
12 Journal of Captain John Saris (hereafter 'Saris Journal'), 3 Aug. 1613, in Satow 1900, p. 113.
13 Saris Journal, 14 Sep. 1613, in Satow 1900, p. 133.
14 Ibid., p. 134. One armour is now in the Royal Armouries collection (XXVIA.1); the other remains in the Royal Collection (cat. 1). The gifts to Saris have never been traced.
15 Ibid., p. 141.
16 Privileges granted to the EIC by Tokugawa Ieyasu, 2 Oct. 1613, in Farrington 1991, I, p. 88.
17 John Saris to the EIC in London, 17 Oct. 1614, in Farrington 1991, I, pp. 209–10.
18 EIC Court Minutes, 6 and 16 Dec. 1614, in Farrington 1991, I, pp. 238–9.
19 EIC Court Minutes, 20 Dec. 1614, in Farrington 1991, I, p. 239.
20 O. Millar 1970–72, no. 67, p. 89.

21 Ibid., no. 49, p. 154.
22 TNA, SP 14/96, fol. 159.
23 TNA, SP 14/111, fol. 201.
24 Sansom 1978, p. 290.
25 Bottomley 2004, p. 5.
26 Saris Journal, 19 Sep. 1613, in Satow 1900, p. 134. The second armour is now in the Royal Armouries collection (XXVIA.1).
27 EIC Court Minutes suggest that the presentation may have been scheduled for late October, for it was noted that 'His Ma'tie expecteth p'formaunce of a present from the Emperor of Japan, the time beeinge well neare expired w'ch Mr Gov'nor did signifie unto His M'tie' (18 Oct. 1614, in Farrington 1991, I, p. 205).
28 Survey of the Tower Armoury 1660, p. 350.
29 O. Millar 1970–72, no. 49, p. 154.
30 Quoted in Ffoulkes 1916, I, p. 44.
31 Ibid., no. 128, p. 141. Ffoulkes described and illustrated XXVIA.2, which had been bought by the Royal Armouries in the 1840s, as one of the gifts to James I in 1613.
32 RCIN 2100853.

2. TRADE

1 See Rouse 1905, p. 101.
2 O. Millar 1970–72, p. 111.
3 Purchas 1614, p. 451. Cf. Parissien 2004, p. 350.
4 O. Millar 1970–72, pp. 121, 129.
5 Cooper 1965, pp. 21–3.
6 Pepys 1893–6, II: 20 Apr. 1661.
7 Evelyn 1983, period 16 Jan.–15 Aug. 1662, p. 195.
8 Delboe *et al.* 1673, pp. 351–2. Like many texts in this period, this document mistakenly refers to the shōgun as the 'emperor'.
9 Parker and Stalker 1688, Preface.
10 TNA, LC 9/275, fol. 158.
11 TNA, LC 9/278, fol. 81.
12 TNA, LC 9/276, fol. 54.
13 Parker and Stalker 1688, Preface.
14 Impey 1990a (exh. cat.), pp. 18, 22.
15 Volker 1954, p. 136.
16 Shaw 1916, VII, 26 Aug. 1684. Shulsky erroneously says these were a gift to James, Duke of York (Shulsky 1998, p. 34).
17 Lockyer 1711, p. 126.
18 The arrangement of Mary's porcelain collection has been painstakingly reconstructed from three surviving inventories, taken in 1693, 1697 and 1699, by Linda R. Shulsky (Shulsky 1998, pp. 27–49).
19 Fiennes 1888, p. 47.
20 Shulsky 1998, p. 27.

21 Defoe 1928, p. 166.
22 Impey 1990a (exh. cat.), p. 21.
23 Impey 1989 (exh. cat.), pp. 127–8.
24 TNA, LC 9/282, fol. 79. See Wheeler 2019.
25 Bickham 1755, p. 81.
26 Bickham 1742, p. 52.
27 TNA, LC 9/289, LC 9/307, LC 11/7, *passim*.
28 Pyne 1819, I, 'Frogmore', pp. 21, 18. The panels painted by Princess Elizabeth are now in the Schloss at Bad Homburg, Hesse, her married home.
29 Christie's 1819, pp. 2, 23.
30 Frampton 1885, p. 264.
31 RA GEO/MAIN/26438, 'From George IV's Privy Purse bills for purchases'.
32 Kopplin 2001 (exh. cat.), p. 43.
33 Ackermann 1808, I, p. 112.
34 CH AA: *A Catalogue of Arms … at Carlton House*, II, no. 1189; III, no. 2345; IV, no. 2911. The samurai did not carry shields, because they needed both hands free for the bow; these examples were certainly made for export.
35 CH AA: ibid., IV, no. 2808. The armour was bought from Dr Buchan with a 'Mandarin's Dress Coat' for £26 5s. od. on 4 March 1818 (RCIN 1113365, p. 40). The cuirass and thigh guards were displayed on the wall of the Grand Vestibule c.1905–10 and sent to the Royal Armouries in 1954.
36 CH AA: ibid., IV, nos 2717 and 2720.
37 Raffles 1929, pp. 121 and 201; Screech 2016, pp. 25–8.
38 Ibid., p. 209; CH AA: *A Catalogue of Arms … at Carlton House*, IV, no. 2746.
39 RA VIC/MAIN/QVJ (w), 2 Nov. 1848.
40 Blome 1670, title page.
41 Ibid., p. 95.
42 Pennington 1982, nos 693 and 693A.
43 For a discussion of portraiture in Japan in the Edo period, see Screech 2012, pp. 165–203.
44 Similar dress and jewellery are also found in an earlier French print of the Emperor of Japan after Claude Vignon in the British Museum (BM 1952,0405.179).
45 See Fuhring *et al.* 2015 (exh. cat.), pp. 178–81.
46 See the series at the BM, BM 1874,0711.799.
47 Clulow 2016, p. 106. In 1790, the frequency of the Court journey was reduced to once every four years.
48 Kazui and Videen 1982, pp. 283–4.
49 Mason and Caiger 1997, p. 205.

3. PORCELAIN

1 Kidder 2003.
2 Ayers 2016, I, p. 1.

3 Impey 1990b (exh. cat.), pp. 25–6.
4 Smith *et al.* 1990, p. 163.
5 Rousmaniere 2002, p. 161.
6 Nishida 2003.
7 Impey 1990b (exh. cat.), p. 29.
8 Ibid., p. 31.
9 Impey 1990a (exh. cat.), p. 18.
10 Ibid., p. 22.
11 Ibid., p. 21.
12 Irvine 2016, p. 163.
13 Ayers 2016, I, pp. 164–5.
14 Impey 1990b (exh. cat.), p. 27.
15 Shirane 2012, p. 150.
16 Dillon 1910, p. 24, cat. 64 (I, II).
17 Ayers 2016, I, p. 109.
18 Ibid., pp. 116–17.
19 T.H. Lunsingh Scheurleer 1962, p. 35.
20 TNA, C 104/58(II), Ledger no. 32, p. 77.
21 Ibid., Ledger no. 34, p. 212.
22 Ayers 2016, II, pp. 640–41.
23 They are incorrectly described as Japanese in Ayers *et al.* 1990 (exh. cat.), no. 153, pp. 172–3, and correctly as Chelsea in Ayers 2016, II, p. 641.
24 Brighton Pavilion Inventory 1829B, pp. 6–7.
25 Ayers 2016, I, p. 22.
26 Ford and Impey 1989 (exh. cat.), pp. 61 and 66.
27 Ayers 2016, I, p. 159.
28 Ibid., p. 161.
29 Ayers *et al.* 1990 (exh. cat.), p. 181.
30 Ibid., p. 175.
31 See, for example, RCIN 26084.a–d.
32 Brighton Pavilion Inventory 1829B, p. 115.
33 Shirane 2012, p. 34.
34 Ibid., p. 35.
35 RA GEO/MAIN/26440, 'From George IV's Privy Purse bills for purchases'.
36 Impey 1990b (exh. cat.), p. 33.
37 Dusenbury and Bier 2004, p. 215.
38 V&A no. 3193-1901.
39 RA GEO/MAIN/26349, 'From George IV's Privy Purse bills for purchases'.
40 Ayers 2016, I, pp. 104–5.
41 Impey 1990b (exh. cat.), p. 33.
42 Ibid., p. 33.
43 Ayers *et al.* 1990 (exh. cat.), p. 33.
44 Frédéric 2002, p. 186.
45 Sargent 1991, p. 34.
46 Ibid.
47 Brighton Pavilion Inventory 1829B, p. 86; 1829A, p. 31.
48 Frédéric 2002, p. 460; Ayers *et al.* 1990 (exh. cat.), p. 177.
49 Volker 1954, p. 152.
50 Brighton Pavilion Inventory 1829B, p. 109.
51 Ibid.
52 Smith *et al.* 1990, p. 72.
53 Ayers 2016, II, p. 652.
54 Ibid., III, p. 1103.
55 Brighton Pavilion Inventory 1829A, p. 20.
56 A hare incense burner of identical form, but

without the colourful overglaze decoration, is in the MacDonald Collection at the Gardiner Museum, Toronto. See Impey *et al.* 2009, p. 103, fig. 53.
57 TNA, LC 11/25; Brighton Pavilion Inventory 1829A, p. 20.
58 QEQM CH 2000, p. 165.
59 Shirane 2012, p. 142.
60 Ayers 2016, I, p. 40, and II, pp. 655–6.
61 Bundesmobilienverwaltung-Silberkammer Hofburg, Vienna, Inv. MD 038354 and 038356.
62 Brighton Pavilion Inventory 1829B, p. 60.
63 Brighton Pavilion Inventory of Clocks and China 1828, p. 55.
64 Ayers 2016, II, p. 650.
65 Murase 2000 (exh. cat.), p. 305.
66 Ibid., p. 306.
67 Ayers 2016, II, p. 707.
68 Freer Sackler Collection, no. F1907.638.
69 Brighton Pavilion Inventory 1829B, p. 72.
70 Jutsham Dels & Recs, I, 224.
71 Ayers *et al.* 1990 (exh. cat.), p. 44.
72 Science and Art Department 1868, nos 308–11.
73 TNA, FO 46/3; TNA, FO 46/8.
74 Science and Art Department 1868, nos 291–1865 to 299–1865.
75 Paris 1889 (exh. cat.), p. 33.
76 Fraser 1982, p. 397.
77 Shugio 1910, p. 292; Louisiana 1904, p. lxix.
78 Irvine 2016, p. 163.
79 Dusenbury and Bier 2004, p. 227.
80 RA EDVIIIPWH/PS/VISOV/1921–2/INDJAP, Box 2: 'List of letters of thanks sent to donors in Japan, 1922'.
81 RCIN 1111789.b.
82 Birks and Digby 1990, p. 6.
83 Leach 1976, p. 130.
84 *The Times*, 7 May 1975, 'Lessons for the world in tea rooms', p. 8.

4. LACQUER

1 De Hond and Fitski 2016, p. 109; Llorens Planella 2015, pp. 348–9.
2 Impey and Jörg 2005, p. 145.
3 Ibid., p. 144.
4 Dower 1985, pp. 13, 25, 27, 52–3, 68–9, 82, 84.
5 Ibid., pp. 8, 12–14.
6 Kisluk-Grosheide 2000, p. 27; Llorens Planella 2015, p. 367; Impey and Jörg 2005, p. 28.
7 Llorens Planella 2015, p. 355.
8 Baird 2001, pp. 97–8, 111–12.
9 Bickham 1755, p. 81.
10 Borman *et al.* 2018, pp. 56–60.
11 TNA, LC 9/282, no. 70, fol. 79.
12 Sotheby's, London, 10 July 1998 (lot 116); Bowett 2002, p. 149.
13 See Wheeler 2019. The original interior of this cabinet may be identifiable as part of a chest of drawers, RCIN 21021.

14 Impey and Kisluk-Grosheide 1994, p. 50.
15 Colvin 1963–76, V, pp. 237–9.
16 Impey and Kisluk-Grosheide 1994, p. 52; Impey and Jörg 2005, p. 120.
17 Baird 2001, pp. 98, 145–6.
18 H. Roberts 2001, pp. 235–8.
19 Ibid., pp. 240–41, no. 711.
20 Kleutghen 2017, p. 178; Impey and Jörg 2005, p. 35.
21 See National Museum of Denmark, inv. no. EAC 105–10.
22 Impey and Jörg 2005, pp. 46, 157.
23 Wheeler 2019; Pyne 1819, I, pl. facing p. 106.
24 Hudson 1997, pp. 117–23.
25 Kisluk-Grosheide 2000, pp. 23, 39; Wolvesperges 2000, p. 165.
26 Brugier 2000, p. 47.
27 Vinhais and Welsch 2008, pp. 320–23, no. 44.
28 The author is grateful to Stefanie Rinza, Managing Director at Carlton Hobbs LLC, who pointed her towards this sale; Sotheby's, Paris, 21 June 2001 (lot 79).
29 Bureaux of this shape and size with similar mounts were made by cabinetmakers such as Claude Charles Saunier (*maître* 1752) and J.-B. Vassou (*maître* 1767). See Watson 1960, pp. 116–17, no. 67; L'estampille 1987, p. 85.
30 RA GEO/MAIN/25270, 'From George IV's Privy Purse bills for purchases', no. 473.
31 Impey and Jörg 2005, pp. 129–39. The cabinets are possibly RCINS 35485.1–2 and 35273.
32 See E. Impey 2003, pp. 86–7.
33 Christie's 1819, p. 23.
34 Irvine 2016, pp. 35, 40.
35 Brighton Pavilion Inventory 1829A, p. 52.
36 RA GEO/MAIN/27911; RA GEO/MAIN/25158, 'From George IV's Privy Purse bills for purchases'.
37 '*1 Grand plat Rond … avec Les Armes d'Angleterre* 250-0 [francs]', RA GEO/MAIN/26438.
38 Brighton Pavilion Inventory 1829A, p. 52.
39 Jackson and Jaffer 2004, p. 261.
40 RA GEO/MAIN/25157, 'From George IV's Privy Purse bills for purchases': Account of goods delivered at Carlton House.
41 Brighton Pavilion Inventory 1829A, p. 54.
42 Clifford Smith 1931, pl. 319.
43 Hutt 2008, p. 5.
44 Ibid., pp. 16–17.
45 Dusenbury and Bier 2004, p. 215.
46 RA GEO/MAIN/26423, 'From George IV's Privy Purse bills for purchases'.
47 Shirane 2012, p. 152.
48 JAANUS 2001, 'Tomoemon', accessed 18 Feb. 2019.
49 RCIN 708000.au and Brighton Pavilion Inventory 1829B, p. 61.
50 Rousmaniere 2002, p. 273.
51 Chiba 1998, pp. 4–6.
52 Bandini 2016, pp. 761–72.
53 QMB, II, nos 197–200.
54 RCIN 1117607.b.
55 See, for example, BM 1907,0531,0.543.

56 RA PPTO/PP/QV/MAIN/1866/20768, 'Privy Purse correspondence covering the years 1843–1901': Austin Layard to Sir Charles B. Phipps, 9 Jan. 1866.
57 Ibid.
58 Ibid.
59 Murase 2000 (exh. cat.), p. 231.
60 TNA, FO 46/3.
61 See, for example, V&A 289-1865. Two were later transferred to the National Museum of Scotland: NMS A.1866.19.7 and A.1866.19.8.
62 RCINS 41565.a–c, 70645.a–b and 70646.1–2.a–b respectively.
63 Shirane 2012, pp. 137–8.
64 Murase 2000 (exh. cat.), p. 231.
65 'The Queen's Jubilee Gifts', *Morning Post*, 18 October 1897.

5. TRAVEL

1 RA VIC/ADDA20/1296: letter from Prince Alfred, Duke of Edinburgh to Queen Victoria, Peiko [Hai He] River, China, 3 Oct. 1869.
2 'Sketches in Japan', *ILN*, 27 January 1855, p. 77; Hansard, HC Deb 16 February 1855, vol. 136, cc1472–1502 <https://api.parliament.uk/historic-hansard/commons/1855/feb/16/supply-navy-estimates> (accessed 26 Feb. 2020).
3 'Yacht for the Emperor of Japan', *ILN*, 13 Dec. 1856, p. 592.
4 Harrison and Sons 1860. The treaty allowed for establishment of a British legation overseen by a consul-general, later referred to as the Envoy Extraordinary and Minister Plenipotentiary or 'minister'.
5 The armour is now in the Victoria and Albert Museum (V&A 362-1865).
6 Royle 1857, p. 174.
7 Alcock 1862.
8 Diary of Fuchibe Tokuzō, quoted in Keene 1998, p. 61.
9 Jackson and Faulkner 1995, p. 166.
10 Ibid., p. 158; Science and Art Department 1868, nos 248–365.
11 Two lists of gifts to be presented were supplied by Alcock: TNA, FO 46/3 (14 July 1859) and TNA, FO 46/8 (Dec. 1860). They differ because some presents on the first list were destroyed by a fire at Edo Castle.
12 RA VIC/MAIN/QVJ (W), 4 Dec. 1867; WC North Corridor, nos 875–878.
13 Yokoyama 1987, p. 2; Daniels and Tsuzuki 2002, p. 3; Jackson 1992, pp. 245–56.
14 RA VIC/MAIN/Q/15, 'Papers placed before Queen Victoria relating to Japan, 1857–59', no. 77, enclosure no. 8: Translation of the Emperor Kōmei's letter to Shōgun Tokugawa Iemochi, Dec. 1862.

15 Sir Charles B. Phipps to Earl Russell, Dec. 1862, in Buckle 1926, I, p. 51.
16 Keene 2002, p. 77.
17 RA VIC/MAIN/QVJ (W), 5 Dec. 1872.
18 Mitford 1915, II, p. 460.
19 Ibid.
20 Keene 2002, p. 135.
21 See, for example, 'Civil War in Japan', *ILN*, 11 Sep. 1869, pp. 248 and 257, which includes a woodcut of the naval battle at Hakodate on 8 June 1869.
22 Edo was renamed Tokyo on 3 Sep. 1868, but often still referred to by its previous name at the time of the prince's visit. It is referred to here as Tokyo throughout.
23 RA VIC/ADDA20/1294: letter from Prince Alfred, Duke of Edinburgh to Queen Victoria, Edo [Tokyo], Japan, 3 Sep. 1869.
24 Keppel 1899, III, pp. 288, 295.
25 Mitford 1915, II, p. 496. Mitford was describing the duke's earlier journey from Yokohama to Tokyo, but he received the same honour en route to the imperial audience on 4 Sep. See South Kensington Museum 1872, p. 46.
26 Mitford 1915, II, p. 499.
27 Quoted in translation in Keene 2002, p. 186; South Kensington Museum 1872, no. 90.
28 RA VIC/ADDA20/1296: letter from Prince Alfred, Duke of Edinburgh to Queen Victoria, Peiko [Hai He] River, China, 3 Oct. 1869.
29 South Kensington Museum 1872, nos 463 and 620.
30 Ibid., nos 877, 883–884 and 881. Only 13 of Chevalier's views from the 1872 South Kensington exhibition remain in the Royal Collection, and none from the Japanese leg of the tour. See D. Millar 1995, I, pp. 189–90.
31 'The Duke of Edinburgh's Museum', *The Graphic*, 9 Mar. 1872.
32 'The Duke of Edinburgh's Collection at South Kensington (Second Notice)', *The Architect*, 10 Feb. 1872, p. 67.
33 After he became Duke of Saxe-Coburg and Gotha in 1893, Prince Alfred transferred 44 Japanese pieces from his collection to Schloss Friedenstein in Gotha, which already had a sizeable East Asian collection. Of these, only 14 survived the Second World War: Schäfer *et al.* 2008 (exh. cat.), p. 139.
34 Audsley and Bowes 1881, dedicatory page.
35 Dalton 1886, II, p. 17.
36 RA VIC/MAIN/Z/474/9: letter from John Dalton to Albert Edward, Prince of Wales, 31 Oct. 1881.
37 Ibid.
38 Dalton 1886, II, p. 39. The service was just one example of the silverware, ceramics and furniture explicitly modelled on British royal precedent. One table commissioned by the emperor was to be 'made using Brazilian mahogany, like [that] at Buckingham Palace': Redfern 2016, pp. 543–8.
39 Dalton 1886, II, p. 41.

40 RA VIC/MAIN/Z/474/10: letter from John Dalton to Albert Edward, Prince of Wales, 28 Oct. 1881; RA GV/PRIV/GVD/1881: diary of King George V (as Prince of Wales), 20 Oct.–12 Nov. 1881: 12 Nov.
41 RA GV/PRIV/GVD/1881: diary of King George V: 26 Oct.
42 RA VIC/MAIN/QVJ (W), 12 Aug. 1882.
43 Cole 1877, pp. 39, 118, 119.
44 Cortazzi 2009, pp. 9–16. The village attracted some 250,000 visitors between its opening in Jan. 1885 and its accidental destruction by fire in May that year.
45 RA VIC/MAIN/QVJ (W), 4 Sep. 1891.
46 Fraser 1982, p. 389.
47 Ibid., p. 397.
48 RA VIC/MAIN/QVJ (W), 28 May 1890.
49 Fraser 1982, p. 397.
50 RA VIC/ADDA15/8445: journal of the Duke and Duchess of Connaught: 7 May 1890.
51 Prince Komatsu belonged to the *Fushimi-no-miya* lineage, one of four hereditary cadet branches (*seshū shinnōke*) of the imperial family that could provide a successor to the throne if the emperor failed to produce an heir. When he first visited England as a student in 1871–2, he was known as Prince Higashi-Fushimi Yoshiaki.
52 House of Commons 2008. The 1894 treaty came into effect in 1899.
53 Keene 2002, pp. 506–10.
54 RA VIC/MAIN/QVJ (W), 20 June 1887.
55 Ibid., 24 June 1897.
56 'The Duke of Edinburgh's Collection at South Kensington', *The Architect*, 10 Feb. 1872, p. 67.
57 Edwards 2006, p. 71.
58 McCauley 1985, pp. 45–6.
59 Ibid.
60 Hacking 2010, p. 871.
61 The author is grateful to Mr Tani Akiyoshi, University of Tokyo, for identifying the sitters and providing their life dates.
62 Cortazzi 2007b, p. 16.
63 RA VIC/ADDA20/1295: letter from Prince Alfred, Duke of Edinburgh to Queen Victoria, Hyōgo [Kōbe], Japan, 19 Sep. 1869.
64 RA VIC/ADDA20/1299: letter from Prince Alfred to Queen Victoria, 1 Dec. 1869.
65 Kornicki *et al.* 2019, p. 26.
66 Cortazzi 1985, p. 34.
67 Kornicki 2008.
68 Stalker 2018, pp. 157–9.
69 Gordon and Lawton 1999, p. 170.
70 Hight 2011, p. 103.
71 Lacoste 2010 (exh. cat.), p. 18.
72 A great number of the documented artefacts from Nara's temples and shrines are currently in the collection of the Tokyo National Museum. The author is grateful to Shikibu Horiuchi, Co-ordinator of International Affairs, Dr Sakae Naito,

Chief Curator, and Motoko Miyasaki, Curator, at Nara National Museum for this information.

73 See RCIN 2580234.

74 Each volume of the *Bacchante* series is marked on the first page with the stamp of Franck Vaughan, Head Bookbinder at the Royal Library from *c.*1914 to 1936. The material and style of the albums' guarding and binding suggest that the volumes were bound in the later part of his career.

75 Bate 1993, p. 86.

76 Fanon 1965, p. 35.

77 See, for example, the studio portraits taken by John Thompson (1837–1921) for the Devonshire House Ball of 1897 in Ovenden 1997, pp. 118–20.

78 Gordon 2014, p. 121.

79 Ibid., pp. 121–2.

80 Slade 2009, pp. 54–5.

81 Kramer 2013, p. 10.

82 Ibid., pp. 10–11.

83 Weiss 2006, p. 84.

84 RA VIC/MAIN/QVJ (W), 4 Dec. 1848.

85 Stevenson 1978, p. 48.

86 RA F&V/PRFF/MAIN/1891.0108-10.

87 RA VIC/MAIN/QVJ (W), 9 Jan. 1891.

88 For further information on Cornelius Jabez Hughes and Hughes & Mullins, the company he founded with Gustav William Henry Mullins (1854–1921) in 1883, see Turley 2001, pp. 33 and 58–70.

6. SAMURAI, ARMS AND ARMOUR

1 Clarke 1910, nos 698 and 719, pp. 50 and 51.

2 Dufty 1965 (exh. cat.), no. 37, p. 8.

3 Ibid., no. 42, p. 9, and Bottomley 2013, p. 11.

4 Baird 2001, p. 164.

5 TNA, FO 46/42, quoted in Cortazzi 2007b, p. 19. See RCIN 38463.1-2.a.-c.

6 Prince of Wales 1922, unpaginated.

7 RA EDVIIIPWH/PS/VISOV/1921-2/INDJAP: The Prince of Wales's Office papers, concerning his visit to India and Japan, 1921–22, 'Kagoshima. From Prince Shimadzu [*sic*]'.

8 TNA, FO 46/8.

9 They are described as '50 *Nagazi Tuli* (spears)' (TNA, FO 46/3).

10 V&A 248-1865 to 257-1865.

11 RCIN 2100853.

12 South Kensington Museum 1872, no. 91, p. 14.

13 Ibid.; 'Court Circular', *The Times*, 16 June 1871, p. 9.

14 RA RC/WOA/WINV/MEMO/73: 'Windsor Inventory Clerk's memoranda, lists and papers re movements of works of art, 1892–1959', no. 32.

15 CH AA: *A Catalogue of Arms … at Carlton House*, III, no. 2345.

16 Thomas 1995, p. 69.

17 The 1905 Japan Society catalogue entry

erroneously describes the mounts for this *daishō* with the blades of cat. 95.

18 Prince of Wales 1922, unpaginated.

19 WC North Corridor, no. 2440.

20 Irvine 2000, p. 96.

21 V&A 266-1865.

22 V&A 263-1865. A similar *itō-maki no tachi* signed by Korekazu is in the British Museum (BM 1958,0730.174).

23 Cat. 10 in Japan Society 1905 erroneously combines the description of the present blades with the *daishō* RCIN 72786.a-b and 62627.a-d.

24 Sinclaire 2008, pp. 1–16.

25 Siong 1998, p. 14.

7. METALWORK

1 Jenyns 1965, p. 57.

2 The author is grateful to the staff of Kagoshima Prefectural Museum for this information.

3 Champney and Champney 1917, pp. 29, 42–5.

4 Ibid., pp. 46–7.

5 RA VIC/MAIN/QVJ (W), 25 Nov. 1882.

6 'The Court', *ILN*, 2 Dec. 1882, p. 566.

7 Shirane 2012, p. 41.

8 Dalton 1886, II, pp. 46–7.

9 Ibid., p. 91.

10 Ibid., p. 101.

8. TREATY

1 RA EDVIIIPWH/PS/VISOV/1921-2/IND JAP: Box 4, 'Japan 1922 Speeches & Addresses'.

2 Best 2007, pp. 63–5.

3 RA VIC/MAIN/Q/16/32: papers placed before Queen Victoria relating to Japan, 1881–1900; letter from Marquess of Salisbury to Mr Whitehead, 6 July 1900.

4 Keene 2002, p. 575.

5 RA VIC/MAIN/W/42/29: correspondence about Foreign Affairs, 1901–10: letter from Mr S. McDonnell to Captain F. Ponsonby, 26 Aug. 1901.

6 'The naval review: the Anglo-Japanese Alliance as symbolised on board the Japanese flag-ship "Asama"', *ILN*, 23 Aug. 1902, frontispiece.

7 'Court Circular', *The Times*, 13 June 1902, p. 10.

8 TNA, PRO 30/29/37. See also Best 2007, p. 65.

9 Mitford 1906, p. 6. *Banzai* can be translated as '[May you live] ten thousand years!' and in this context is the equivalent of 'hurrah!'.

10 Ibid., p. 8.

11 Mitford 1906, pp. 19–20.

12 Ibid., pp. 22–3.

13 RA VIC/MAIN/X/24: 'Correspondence about the

visit of Prince Fushimi of Japan to Britain in 1907', Memorandum from Lord Chamberlain's Office, 26 Mar. 1907.

14 RA VIC/MAIN/X/24: ibid., letter from Arthur Ellis to Colonel Sir Arthur Davidson, 2 Apr. 1907.

15 Reese 1976, p. 299.

16 Laking 1905, p. 20.

17 The catalogue contains several provenance errors which were repeated in subsequent exhibitions and literature. The 1860 Iemochi gift armour was, for example, said to have been an 1887 Golden Jubilee gift to Queen Victoria (Case P, No. I).

18 Huish and Holme 1905 (exh. cat.), pp. 10–11.

19 'Japanese imperial visitors', *Evening Standard*, 30 June 1905, p. 6.

20 Official Guide to the Japan-British Exhibition 1910, p. 3.

21 'The Japan-British Exhibition', *The Times*, 29 Oct. 1910, p. 5.

22 'The King and Queen', *The Times*, 8 Aug. 1910, p. 8.

23 Joly and Tomita 1915, p. 6.

24 The emperor was the first non-European to be accorded this rank.

25 RCIN 1111789.a-c.

26 QMPP, III, no. 153.

27 Clifford Smith 1931.

28 BP 1911, IX, pp. 74 and 267.

29 Clarke 1910, nos 698 and 719. Each armour was described as a 'Suit of Plate-Armour (*Roku-gusoku*)' but not illustrated. They cannot conclusively be identified, but may be cats 72–73.

30 'A courier of friendship: first of his line to leave Japan', *ILN*, 14 May 1921, p. 640.

31 'The Crown Prince', *The Times*, 11 May 1921, p. 10.

32 These dense displays were the work of Sir Guy Laking (1875–1919), Keeper of the King's Armoury.

33 RA EDVIIIPWH/PS/VISOV/1921-2/IND JAP: 'The Prince of Wales's Office papers concerning his visit to India and Japan, 1921-22, Box 4: Memorandum from Sir Godfrey Thomas to Admiral Halsey, 14 July 1921.

34 Ibid., Box 1: 'Diary'.

35 Ibid., Box 4: reply at prime minister's banquet, 16 Apr. 1922.

36 Ibid., Box 4: letter from Crown Prince Hirohito to Edward, Prince of Wales, 3 May 1922 (typed copy).

37 Ibid., Box 4: address by the Crown Prince to Edward, Prince of Wales, Imperial Palace, Tokyo, 12 Apr. 1922.

38 Ibid., Box 4: address by the Governor of Kanagawa to Edward, Prince of Wales, Kanagawa, undated.

39 Ibid., Box 4: address by the Prime Minister of Japan to Edward, Prince of Wales, Tokyo, 16 Apr. 1922.

40 Ibid., Box 3: Correspondence re Presents & Decorations.

41 'The Prince of Wales [*sic*] farewell to Japan', *Daily Telegraph* (Launceston, Tasmania), 10 May 1922, p. 5.

42 Christie's 2006, lots 585–779. See, for example, BM 2008,3007.8.

43 RA LC/LCO/SPECIAL/1930/Japanese visit, 9: letter from the Lord Chamberlain, Rowland Baring, 2nd Earl of Cromer, to Sir Derek Keppel, 13 June 1930.

44 King George V received the collar of the Order of the Chrysanthemum and Queen Mary the Order of the Precious Crown (RA PS/PSO/GVI/PS/COR/01000/103: Private Secretary's Office files relating to the Coronation of King George VI, 1936–7).

45 Best 2007, p. 70.

46 'The king and his visitor', *The Times*, 10 May 1921, p. 12.

47 'The nation's guest', *The Times*, 10 May 1921, p. 10.

48 Nish 2001, II, p. 244.

49 'Court Circular', *The Times*, 12 May 1921, p. 13.

50 Speaight 1926, p. 223.

51 Ibid., p. 222.

52 Ibid.

53 See 'Our busy prince: his Japanese guest; and many visits', *ILN*, 21 May 1921, p. 671.

54 Bix 2009, p. 110.

55 Ziegler 1990, p. 145.

56 Windsor 1951, p. 181.

57 Wilson 2011, p. 298.

58 RA F&V/SVIN/1930/JAPAN: 'Visit of Prince and Princess Takamatsu'.

59 RA MRH/MRH/GV/FUNC/212: 'The Master of the Household's correspondence relating to functions and events, 1918–36'.

60 'Vandyk Ltd. Buckingham Palace Road, S.W.', in *Professional Photographer* 1916.

61 RA MRH/MRH/GV/FUNC/212: 'The Master of the Household's correspondence relating to functions and events, 1918–36'.

62 These two negatives (NPG x200709 and NPG x200710) were acquired as part of the collection of Vandyk's glass plates by the National Portrait Gallery, London, in 1974.

63 NPG x44631.

64 Dees 2007, p. 47.

65 Ibid., p. 48.

66 Dees 1997a, pp. 4–8.

67 Ibid., p. 3.

68 Freer Gallery of Art and Arthur M. Sackler Gallery, F1997.17a–e.

69 'Court Circular', *The Times*, 19 Oct. 1915, p. 11, and 'Court Circular', *The Times*, 15 Nov. 1915, p. 11.

70 Hutt 1995, p. 50.

71 RA VIC/MAIN/X/26: 'Correspondence about the visit of Prince Fushimi of Japan to Britain in 1907', letter from the Hon. Arthur Walsh to Sir Arthur Davidson, 28 May 1907.

72 Shirane 2012, p. 139.

73 Ibid., p. 155.

74 Prince of Wales 1922, unpaginated.

75 Pekarik 1980 (exh. cat.), p. 28.

9. ARTISTIC EXCHANGE

1 Naramoto T., *Kindai tōjiki-gyō no seiritsu* ('The formation of the modern ceramic industry'), Tokyo 1943, p. 30, cited in Pollard 2002, p. 24, n. 43, and Bibliography, p. 159.

2 See Ayers 2016, III, pp. 713–15.

3 'King and Queen at the Japanese Exhibition', *The Times*, 8 Aug. 1910, p. 8.

4 *Nichiei Shinshi* [London newspaper], 1915, p. 6, cited in Itoh 2001, p. 110.

5 Fukuzawa 1862.

6 RA VIC/MAIN/QVJ (w), 21 June 1887.

7 'Japanese Artist's Work', *Western Daily Press*, Bristol, 2 May 1928, p. 8.

8 Loftie 1907, p. xxxvij.

9 Chapman and Horner 2017, p. 7.

10 See ibid., p. 23, for illustrations of the printing of this work.

11 Ibid., pp. 27, 196.

12 'Court Circular', *The Times*, 26 June 1928.

13 These prints correspond to four of the prints in the list of works in Deighton & Sons 1928, the Abbey Gallery exhibition catalogue; each print still has its original frame. The print *Lilies* (RCIN 502222, not included here), has a note on the back in Queen Mary's hand: 'Set of 4 coloured / woodcuts by a / Japanese artist Urushibara / bought by Queen Mary / 1928'.

14 See Chapman and Horner 2017, p. 13.

15 RA QEQMH/TREAS/TREAS/CSP/PURCHASES: 'Queen Elizabeth's Treasurer's correspondence', Schedule of Purchases from 1 Jan. 1937: List of Purchases, Year ended 31 Dec. 1937, no. 342.

16 Miles 1991 (exh. cat.), p. 13.

17 Owens 2005 (exh. cat.), pp. 156–8.

18 The author is grateful to Manfred Heiting and Torin Boyd for their help in attributing these photographs.

19 For a more extensive account of Okamoto's biography, see Nakagawa 2012, pp. 73–102.

20 Kaneko 2001 (exh. cat.), pp. 104–5.

21 For example, Fukuhara Shinzo (1883–1949), who became one of the founding members of the *Photographic Art Society* (*Shasin Geijutsusha*) in 1921 (Fuku 2000, p. 9).

22 Kaneko 2003, pp. 110–11.

23 For example Okamoto's images appear in *The Japan Photographic Annual*'s editions of 1925–6, 1926–7, 1927–8 and *Asahi Camera*, June and December 1926 issues.

24 Nakagawa 2012, p. 194.

10. COURTLY RITUAL

1 Hofer 1973 (exh. cat.), p. 26.

2 Mitford 1915, II, p. 498.

3 Prince of Wales 1922, unpaginated.

4 Irvine 2016, p. 71.

5 Harris 1994 (exh. cat.), p. 17.

6 Imamura 2015, pp. 207–25; Kornicki *et al.* 2019, p. 19.

7 Kramer 2013, p. 3.

8 Lillehoj 2011, pp. 161–3.

9 Ibid., pp. 164–5.

10 The editor and author thank Dr Rosina Buckland, Curator of Japanese Art & Culture, Royal Ontario Museum, for her comparisons between the screens and the attribution to Itaya Hiroharu.

11 Jansen 2002, p. 274. The advice was politely declined.

12 One screen from the 1845 gift is in the Dutch Royal Collection, The Hague, MU8116; 18 items from the 1856 gift are in Museum Volkenkunde, Leiden, RV-4-27 to 40 and RV-360-7742 to 7745.

13 TNA, FO 46/3 and 46/8; Sakakibara 2002, pp. 281–2.

14 Sakakibara 2002, pp. 290–91.

15 RA VIC/MAIN/QVJ (w), 24 June 1897.

16 'The Queen's jubilee presents', *ILN*, 23 Oct. 1897, p. 577.

17 The editor and author are grateful to the staff of the Imperial Household Agency, Tokyo, for this information.

18 McDermott and Pollard 2012 (exh. cat.), p. 123.

19 Shirane 2012, *passim*.

20 McDermott 2010, p. 70.

21 The editor and author are grateful to the staff of the Imperial Household Agency, Tokyo, for this information.

22 Sibbick 1989 [see Inventories], p. 250.

23 Ayers 2016, I, p. 19. It is now known as the 'Small Chinese Room'.

24 RA QM/PRIV/CC62: Queen Mary's papers concerning royal residences, c.1889–1952.

25 RA EDVIIIPWH/PS/VISOV/1921-2/INDJAP: 'The Prince of Wales's Office papers concerning his visit to India and Japan, 1921–22', List of gifts presented to The Prince of Wales.

26 McDermott and Pollard 2012 (exh. cat.), p. 42.

27 The author thanks Dr Rosina Buckland for her attribution to Imao Keinen and translation of his inscription. Age in Japan was calculated starting at '1' in the year of birth, so when Keinen was in his 77th year he would have been 76 by western methods of counting.

28 Rousmaniere 2002, pp. 72, 87.

29 Prince of Wales 1922, unpaginated.

30 Stafford 1936 (exh. cat.), no. 33.

31 Dusenbury and Bier 2004, p. 176.

32 The author is grateful to the staff of the Imperial Household Agency, Tokyo, for this information.

33 RA VIC/MAIN/QVJ (w), 7 May 1875.

34 The Metropolitan Museum of Art, 81.1.173.

35 Borgen 1986, p. 263.

36 JAANUS 2001, 'chidori'.

37 Watt and Ford 1991 (exh. cat.), p. 213.

38 The label reads, 'From H.I.M. the Emperor / of Japan / to H.M. The King / June 1930 / Writing stand & box'.
39 The author is grateful to Dr Jan Dees for his thoughts on this piece.
40 *Meiji tennō ki* for 1869 records that the Emperor Meiji presented Prince Alfred with four lacquer incense boxes during his visit, of which this is almost certainly one. The author is grateful to the staff of the Imperial Household Agency in Tokyo for this information.
41 Sakomura 2004, pp. 255–7.
42 Randel 1986, p. 331.
43 Tsuji 2018, p. 385.
44 This is noted in the Japanese inscription on the backboard.
45 Prince of Wales 1922, unpaginated.
46 Sibbick 1989 [see Inventories], no. 82.
47 Iröns 1982, p. 38; Hutt 1992, p. 13.
48 Hutt 1992, pp. 13–14.
49 For example, ibid., no. 38; Iröns 1992, nos 21 and 30; Kammerl 1989, no. 153; Preston 2001 (exh. cat.), no. 23.
50 The insignia illustrated here is RCIN 442638.a–b.
51 'Prince Komatsu of Japan', *ILN*, 1 Jan. 1887, p. 3.
52 Information provided to the author by the Decorations Bureau, Tokyo, Nov. 2018.
53 RA VIC/MAIN/B/32/19: letter from Lord Granville to Queen Victoria, 14 Dec. 1880.
54 RA VIC/MAIN/B32/30: letter from Lord Granville to Sir Henry Ponsonby, 3 Jan. 1881, with a note from Ponsonby dated 5 Jan. 1881.
55 RA VIC/MAIN/T8/45: letter from Lord Granville to the Prince of Wales, 15 May 1881.
56 Mitford 1906, p. 22.
57 Ibid., p. 634.
58 RA VIC/ADDA15/8445: journal of the Duke and Duchess of Connaught.
59 *Edinburgh Gazette*, 25 Jan. 1918, p. 416.
60 'The arrival in England of Admiral Prince Yorihito', *ILN*, 2 Nov. 1918, p. 526.
61 RA GV/PRIV/GV/1918: diary of King George V, 29 Oct.
62 Martin 1996, p. 101.

11. CODA

1 PSO 1971: 5 Oct.
2 Dees 2007, p. 34.
3 See, for example, ibid., p. 182.
4 Ibid., p. 30.
5 Ibid., pp. 37–8, 190. The author is grateful to Dr Jan Dees for his thoughts on this piece.
6 The biographical details for Shōsai presented here are largely drawn from Dees 2007, pp. 29–39.

12. THE MODEL OF THE TAITOKUIN MAUSOLEUM

1 Dalton 1886, II, p. 25.
2 Tōkyō-fu 1934, p. 16.
3 Ibid., fig. 5.
4 Dalton 1886, II, p. 26.
5 Ibid., p. 28.
6 'The King and Queen', *The Times*, 8 Aug. 1910, p. 8.
7 Mutsu 2002, p. 178.
8 Kenchiku Zasshi 1910, pp. 60–62.
9 RBGK 1/MUS/24 Taitokuin Shrine, 8, 9.
10 Kenchiku Zasshi 1910, pp. 60–61.
11 Official Report of the Japan-British Exhibition 1911, p. 275.
12 RBGK, 1/MUS/24 Taitokuin Shrine, 6: Memorandum from Sir Arthur Bigge to Sir Schomberg McDonnell, 13 Nov. 1910.
13 RBGK, 1/MUS/24 Taitokuin Shrine, 18.
14 Mark Nesbitt, email correspondence with author, 1 Feb. 2019.
15 RBGK, 1/MUS/24 Taitokuin Shrine, 35.
16 RBGK, 1/MUS/24 Taitokuin Shrine, 20: 12 Oct. 1936.
17 RBGK QE 228/53, 57, 58/1–2, 60, 69, 73.

BIBLIOGRAPHY

ABBREVIATIONS

BM
British Museum

HC Deb
House of Commons Debate

ILN
Illustrated London News

NPG
National Portrait Gallery, London

ODNB
Oxford Dictionary of National Biography

QG
The Queen's Gallery, Buckingham Palace

RA
Royal Archives, Windsor Castle

RBGK
Royal Botanic Gardens, Kew

RCIN
Royal Collection Inventory Number

V&A
Victoria and Albert Museum, London

INVENTORIES AND OTHER PRIMARY SOURCES

BP 1911
Buckingham Palace: An Inventory Prepared for the Lord Chamberlain's Department by Messrs Trollope of London, 11 vols, RCINS 1112919–72 and 1113364

Brighton Pavilion Inventory (1829A and 1829B)
Inventory of the Royal Pavilion, Brighton, of 1829 and later, with comments and annotations up to the early twentieth century. A typescript in two volumes of the inventories that are held in the Brighton Public Library, rearranged by subject with additional information.

Brighton Pavilion Inventory of Clocks and China 1828
Four different inventories relating to clocks and china at Brighton, by room and location within room. Annotated with object locations and movements, 1914: Windsor Castle and Buckingham Palace.

Brighton Pavilion 1847
Inventory of Brighton Pavilion, 1847, received from the Lord Chamberlain's Office 1886. RCIN 1114931

Brighton Pavilion 1847–8
List of furniture moved from the Royal Pavilion, Brighton to Kensington Palace. RCIN 1114930

CH AA
B. Jutsham, *A Catalogue of Arms The property of His Royal Highness The Prince of Wales at Carlton House*, 5 vols, c.1803–1827. RCINS 1113358–60, 1113362–3

Clarence House 1875
W. Clowes & Sons, *Catalogue of the Collection of Specimens of Oriental Art formed by H.R.H the Duke of Edinburgh K.G. During His Cruise in H.M.S. 'Galatea' … at Clarence House, St James's*, London

Cumberland Lodge 1873
Cumberland Lodge: An inventory of 1873. RCIN 1006857

Cumberland Lodge 1907
An inventory of the property of the Crown at Cumberland Lodge, Windsor Great Park, the residence of Their Royal Highnesses Prince and Princess Christian of Schlesswig-Holstein, April 1907. RCIN 1172072.a

Holyrood 1978
Unpublished list of the contents of the Palace of Holyroodhouse, 2 vols. RCINS 1116559–1116560.a–b

Jubilee 1897
List of Diamond Jubilee Presents Handed over to the Inspector, Lord Chamberlain's Department, Windsor Castle. RCIN 1006942

Jutsham Dels & Recs I
An Account of Furniture &c … Deliver'd by Benjamin Jutsham at Carlton House, 1806–20. RCIN 1112484

Jutsham Dels III
An Account of Furniture &c … Deliveries, 1820–30. RCIN 1112485

Osborne 1876
Catalogue of the Paintings, Sculpture and other Works of Art at Osborne, compiled by Harrison & Sons, London. RCIN 1114717

Osborne 1901
Inventory of the Works of Art at Osborne up to 1900, compiled by J. Curry, 2 vols. RCINS 1114803.a–1114804

Osborne 1904
Inventory of Works of Art and Furniture at Osborne. RCIN 1114499.a

PSO 1971
Private Secretary's Office, *Her Majesty The Queen's Speech at the State Banquet, 5 October 1971*, State Visit of the Emperor of Japan, 12120.26 (2194)

QC Library Catalogue
Catalogue of the library of Queen Caroline at St James's Palace. RCIN 1028932.a

QEQM CH 2000
Collection of Queen Elizabeth The Queen Mother at Clarence House, Vol. 5: European Porcelain, Chinese Ceramics & Enamels, compiled by Christie's, London. RCIN 1049431

QMB
Catalogue of Bibelots, Miniatures and Other Valuables, the Property of Queen Mary, 4 vols (I, 1893–1920; II, 1921–31; III, 1932–7; IV, 1938–45). RCINS 1114504–09

QMPP
Catalogue of Miniatures, Jewels and Other Valuables, the Property of Queen Mary, 11 vols, 1912–48, illustrated typescript (I, 1912; II, 1913; III, 1922; IV, 1925; V, 1929; VI, 1931; VII, 1933; VIII, 1936; IX, 1936–8; X, 1938–45; XI, 1946–8). RCINS 1114193–9 and 1114500–03

Sibbick 1989
E. Sibbick, *Notes on the Exhibits in the Indian Corridor at Osborne*, 2 vols, RCINS 1114729–1114730.a

Staatliche Kunstsammlungen Dresden 1779
Inventarium vom Chur. Fürstl. Sächsischen Japanischen Palais zu Neustadt bey Dresden und zwar Über das indianische ingleichen schwarz-sächsische Porcellain, Bd 5, c) 'An Tisch-Service und dergleichen', S. 129v

V&A, AO.98, 1918
List of objects on loan (including the Curzon Collection), Bethnal Green Museum, 1918, pp. 3–16

WC '1866'
An inventory of the decorative china at Windsor Castle, started in 1866 and annotated until 2000. RCINS 1170923–5

WC Bronzes
Windsor Castle Catalogue of Bronzes, begun in 1866 and annotated until 2000. RCIN 1170015.a

WC North Corridor
'Windsor Castle Inventory of Arms &c.', c.1850–1866 (continuously updated until 1994), 3 vols, RCINS 1122400–02

WC Oriental China 1927
Descriptive inventory of the oriental china collection at Windsor Castle, compiled by Bernard Rackham, W.B. Honey and E.C. Goode by desire of Her Majesty The Queen. RCIN 1170302.a

WL Catalogue 1780
Inventory of the Windsor Library of George III. Compiled by F.A. Barnard c.1780 with additions made until c.1812. RCIN 1028949

Royal Archives, Windsor Castle

RA EDVIIIPWH/PS/VISOV/1921–2/INDJAP
The Prince of Wales's Office papers, concerning his visit to India and Japan, 1921–22

Box 1: 'Diary. No. 2'

Box 2: 'India and Japan, 1921–22', 'Correspondence re presents & decorations', 'List of presents received on the Indian Tour, 1921–22' (including 'List of letters of thanks sent to donors in Japan, 1922')

Box 4: Folders 'Japan, 1922', 'Visit to Japan, 1922' and 'Japan, 1922: Speeches & Addresses'

RA F&V/PRFF/MAIN/1891.0108–10
Programme of *tableaux vivants* performed at Osborne House, 8 and 10 January 1891

RA F&V/SVIN/1930/JAPAN
'Visit of Prince and Princess Takamatsu'

RA GEO/ADD/19/18 fol. 11r
'Inventory of pictures, paintings, etc., at Kensington Palace, Hampton Court and Windsor Castle, 1732–1750'

RA GEO/MAIN/25157, 25158, 25270, 26349, 26423, 26438, 26440, 27911
From George IV's Privy Purse bills for purchases

RA GV/PRIV/GVD
Diary of King George V

RA LC/LCO/SPECIAL/1930/Japanese visit
1930 Visit of Prince and Princess Takamatsu of Japan

RA MRH/MRH/GV/FUNC/001–394
The Master of the Household's correspondence relating to functions and events, 1918–36

RA MRH/MRHSOV/MIXED/120
Papers relating to the visit to Britain of Crown Prince Hirohito, 1921

RA MRH/GV/MAIN/340
'File concerning the loan of items from the Royal Collection to the Bethnal Green Museum, 11 October 1924–26 April 1929'

RA MRH/SUPTBP/MAIN
The papers of the Buckingham Palace Superintendent

'Loan to "Rapallo House" Museum, Llandudno', 13 Nov. 1930

'Loan to Doncaster Museum, 1931 and 1936'

'Coronation Addresses and Presents, 1953'

RA PPTO/PP/QV/MAIN/1866/20768
'Privy Purse correspondence covering the years 1843–1901', Letter from Austin Layard at the Foreign Office to Sir Charles B. Phipps, Sep. 1866

RA PS/PSO/GVI/PS/COR/01000/103
'Private Secretary's Office files relating to the Coronation of King George VI, 1936–7'

RA QEQMH/TREAS/TREAS/CSP/PURCHASES
'Queen Elizabeth The Queen Mother's Treasurer's correspondence'

RA QM/PRIV/CC62
'Queen Mary's papers concerning royal residences, c.1889–1952'

RA RC/WOA/WINV/MEMO/73
'Windsor Inventory Clerk's memoranda, lists and papers re movements of works of art, 1892–1959'

RA VIC/ADDA15/8445
The joint journal of the Duke and Duchess of Connaught: Arthur, Duke of Connaught (1850–1942) and Louise Margaret, Duchess of Connaught (1860–1917). The citations here are from vol. IX, 1 Apr.–21 June 1890 [cat. 69]

RA VIC/ADDA20
The papers of Alfred, Duke of Edinburgh

/1294: Letter from Prince Alfred, Duke of Edinburgh to Queen Victoria, Edo [Tokyo], Japan, 3 Sep. 1869 [cat. 61]

/1295: Letter from Prince Alfred, Duke of Edinburgh to Queen Victoria, Hyōgo [Kōbe], Japan, 19 Sep. 1869

/1296: Letter from Prince Alfred, Duke of Edinburgh to Queen Victoria, Peiko [Hai He] River, China, 3 Oct. 1869 [cat. 62]

/1299: Letter from Prince Alfred to Queen Victoria, 1 Dec. 1869

RA VIC/MAIN/B/32
Ministers' letters, 1880–81

/19: Letter from Lord Granville to Queen Victoria, 14 Dec. 1880

/30: Letter from Lord Granville to Sir Henry Ponsonby, 3 Jan. 1881, with a note from Ponsonby dated 5 Jan. 1881

RA VIC/MAIN/Q/15
Papers placed before Queen Victoria relating to Japan, 1857–9

RA VIC/MAIN/Q/16
Papers placed before Queen Victoria relating to Japan, 1881–1900

RA VIC/MAIN/QVJ (W)
Queen Victoria's Journal

Unless otherwise stated, the citations here are from the edited copy in the hand of Princess Beatrice, who destroyed the originals after her mother's death and on her mother's instructions.

RA VIC/MAIN/T/8/45
Letter from Lord Granville to the Prince of Wales, 15 May 1881

RA VIC/MAIN/W/42–55
Correspondence about Foreign Affairs, 1901–10

RA VIC/MAIN/X/24–26
Correspondence about the visit of Prince Fushimi of Japan to Britain in 1907

RA VIC/MAIN/Z/474
Correspondence of the Prince of Wales regarding Prince Albert Victor and Prince George, 1878–85

The Royal Collection

RCIN 708000.ao
After Augustus Charles Pugin (1762–1832), *Banqueting Room Gallery, Brighton Pavilion*, in Brayley 1838. Etching with aquatint; hand colouring

RCIN 708000.au
Henry Winkles (active 1819–32) after Augustus Charles Pugin, *The Library, Brighton Pavilion*, in Brayley 1838. Etching with aquatint; hand colouring

RCIN 1111789.a–c
Christie, Manson & Woods, *The Important Collection of Japanese Objects of Art Formed by the late C.H.T. Hawkins, Esq. [Second Portion]*, with annotations by Queen Mary and two letters from Lance Hamilton regarding purchases made at the auction in London, 7–8 Mar. 1927

RCIN 1113365
Benjamin Jutsham, *Bills on Account of Privy Purse for expenses of Armoury &c* (1812–30)

RCIN 1117607.b
List of wedding presents to Lady Elizabeth Bowes-Lyon, 1923

RCIN 2100853
Russell & Son: 17 Baker Street, Portman Square, London, *The Grand Vestibule, Windsor Castle*, c.1905–1910

RCIN 2102382
Country Life, *The Saloon at Sandringham*, 1934, gelatin silver print, 20.7 × 15.6 cm

Archives of the Royal Botanic Gardens, Kew

RBGK/I.MUS/24
Taitokuin Shrine (1910–36)

RBGK QE 228
Restoration of Museum No. 3 for use as Orangery (1957–61)

The National Archives, Kew

TNA, C 104
Records created, acquired, and inherited by Chancery, and also of the Wardrobe, Royal Household, Exchequer and various commissions

TNA, FO 46/2
General Correspondence before 1906, Japan. To Colonel Neale and Sir R. Alcock

TNA, FO 46/3
General Correspondence before 1906, Japan 1859, Jan.–Sep. 7

Translation of the list of presents presented by His Majesty the Tycoon to Her Majesty the Queen, 14 July 1859

TNA, FO 46/8
General Correspondence before 1906, Japan, 1860 July–Dec.

List of the presents from the Tycoon to Her Majesty the Queen, Dec. 1860

TNA, LC 9
Lord Chamberlain's Department: Accounts and Miscellanea. GREAT WARDROBE. Bill Books: Series I–II, Tradesmen's Bills, etc.

275: 1675–9
276: 1679–83
278: 1685–7
282: 1703–8
289: 1733–40
307: 10 Oct. 1761–10 Oct. 1762

TNA, LC 11
Lord Chamberlain's Department: Bill Books, Series IV, Tradesmen's bills for work done and goods delivered

7: 10 Oct. 1797–5 Jan. 1801
23: 5 Jan. 1817–5 July 1817
25: 5 Jan. 1818–5 July 1818

TNA, PRO 30/29/37
Letter from Henry Ponsonby to Earl Granville, 24 Dec. 1880

TNA, SP 14/96, fol. 159
State Papers, Domestic, James I

Letter from Sir Thomas Wilson to James I concerning correspondence sent by Richard Cocks from Japan, Mar. 1617

TNA, SP 14/111, fol. 201
State Papers, Domestic, James I

Letter from Sir Thomas Wilson to James I concerning correspondence sent by Richard Cocks from Japan, 1619

PERIODICALS

The Architect
Daily Telegraph (Launceston, Tasmania)
Edinburgh Gazette
Evening Standard
The Graphic
Illustrated London News
London Gazette
Morning Post
The Times

EXHIBITION CATALOGUES

Arizzoli-Clémentel and Salmon 2008
P. Arizzoli-Clémentel and X. Salmon, *Marie-Antoinette*, Galeries nationales du Grand Palais, Paris

Ayers et al. 1990
J. Ayers, O. Impey and J.V.G. Mallet, *Porcelain for Palaces: The Fashion for Japan in Europe*, BM, London

Beaux-Arts Gallery 1937
Beaux-Arts Gallery, *Exhibition of Colour Prints of the Far East by Elizabeth Keith*, London

Croissant et al. 1993
D. Croissant, L. Ledderose, H. Budde and G. Sievernich (eds), *Japan und Europa, 1543–1929*, Martin-Gropius-Bau, Berlin

Deighton & Sons 1928
W.R. Deighton & Sons Ltd, *An Exhibition of Colour Woodcuts by Y. Urushibara*, The Abbey Gallery, London

Dimond 1995
F. Dimond (ed.), *Presenting an Image: Photographs from the Royal Photographic Collection, Windsor Castle*, Drawings Gallery, Windsor Castle, Windsor

Dobson and Isherwood 1998
S. Dobson and M. Isherwood, *The Theme and Spirit of Anglo-Japanese Relations: An Exhibition of Photographs*, The Grosvenor House Hotel, London

Dufty 1965
A.R. Dufty, *Catalogue of an Exhibition of Japanese Armour*, H.M. Tower of London

Ford and Impey 1989
B.B. Ford and O. Impey, *Japanese Art from the Gerry Collection in the Metropolitan Museum of Art*, New York

Fuhring et al. 2015
P. Fuhring, L. Marchesano, R. Mathis and V. Selbach (eds), *A Kingdom of Images: French Prints in the Age of Louis XIV, 1660–1715*, Getty Research Institute, Los Angeles

Harris 1994
V. Harris, *Japanese Imperial Craftsmen: Meiji Art from the Khalili Collection*, BM, London

Hofer 1973
P. Hofer, *The Courtly Tradition in Japanese Art and Literature: Selections from the Hofer and Hyde Collections*, Fogg Art Museum, Harvard University, Cambridge, Massachusetts

Huish 1888
M.B. Huish, *Catalogue of, and Notes Upon, the Loan Exhibition of Japanese Art*, Fine Art Society, London

Huish and Holme 1905
M.B. Huish and C. Holme (eds), *Arms and Armour of Old Japan, Catalogue of an exhibition held by the Japan Society, London, in June 1905*, Japan Society, London

Impey 1989
O. Impey, 'Appendix A: The early appreciation of Japanese art in Europe', in Ford and Impey 1989, pp. 125–30

Impey 1990a
O. Impey, 'The trade in Japanese porcelain', in Ayers et al. 1990, pp. 15–24

Impey 1990b
O. Impey, 'Japanese export porcelain', in Ayers et al. 1990, pp. 25–34

Japan-British Exhibition 1910
Japan-British Exhibition, *Official Guide*, White City, London

Japan Society 1905
Japan Society of London, *Catalogue of an Exhibition of Arms and Armour of Old Japan*, Royal Society of Painters in Water Colours, London

Johnson and Norman 1962–3
G. Johnson and A.V.B. Norman (eds), *Treasures from the Royal Collection*, QG, London

Kaneko 2001
R. Kaneko, *Modern Photography in Japan: 1915–1940*, The Friends of Photography at the Ansel Adams Center, San Francisco

Kopplin 2001
M. Kopplin (ed.), *Les Laques du Japon: Collections de Marie-Antoinette*, Musée nationales des châteaux de Versailles et de Trianon and Museum für Lackkunst, Münster

Lacoste 2010
A. Lacoste, *Felice Beato: A Photographer on the Eastern Road*, The J. Paul Getty Museum, Los Angeles

Lyden et al. 2014
A.M. Lyden, S. Gordon and J. Green-Lewis, *A Royal Passion: Queen Victoria and Photography*, J. Paul Getty Museum, Los Angeles

McDermott and Pollard 2012
H. McDermott and M.C. Pollard (eds), *Threads of Silk and Gold: Ornamental Textiles from Meiji Japan*, Ashmolean Museum

Miles 1991
R. Miles, *Elizabeth Keith: The Printed Works*, Pacific Asia Museum, Pasadena, California

Murase 2000
M. Murase, *Bridge of Dreams: The Mary Griggs Burke Collection of Japanese Art*, The Metropolitan Museum of Art, New York

Owens 2005
S. Owens, *Watercolours and Drawings from the Collection of Queen Elizabeth The Queen Mother*, QG, London

Paris 1889
Exposition Universelle Internationale de 1889 à Paris, *Catalogue Général Officiel, Tome Trosième, Groupe III*, Lille

Pauli 2006
L. Pauli (ed.), *Acting the Part: Photography as Theatre*, National Gallery of Canada, Ottawa

Pekarik 1980
A. Pekarik, *Japanese Lacquer, 1600–1900: Selections from the Charles A. Greenfield Collection*, The Metropolitan Museum of Art, New York

Preston 2001
H. Preston (ed.), *From the Land of the Fan*, The Fan Museum, London

J. Roberts 2002–3
J. Roberts (ed.), *Royal Treasures: A Golden Jubilee Celebration*, QG, London

J. Roberts 2004
J. Roberts (ed.), *George III and Queen Charlotte*, QG, London

J. Roberts et al. 2005
J. Roberts, P. Sutcliffe and S. Mayor, *Fans in the Royal Collection: Unfolding Pictures*, QG, London

Schäfer et al. 2008
B. Schäfer, U. Wallenstein and F. Reitz, *Ein Prinz entdeckt die Welt: Die Reisen und Sammlungen Herzog Alfreds von Sachsen-Coburg und Gotha (1844–1910)*, Schlossmuseum, Gotha

Shawe-Taylor 2014
D. Shawe-Taylor (ed.), *The First Georgians: Art and Monarchy in Early Georgian Britain, 1714–1760*, QG, London

Society of Graver-Printers 1925
The Society of Graver-Printers in Colour, Tenth Annual Exhibition of Works by Members, London

Stafford 1936
Silver Jubilee and Other Gifts to His Majesty King George V, Stafford Public Library, Art Gallery and Museum

Tucker et al. 2003
A.W. Tucker, D. Friis-Hansen, R. Kaneko and T. Joe, *The History of Japanese Photography*, The Museum of Fine Art, Houston and The Cleveland Museum of Art, Cleveland

Waterfield 1991
G. Waterfield, *Palaces of Art: Art Galleries in Britain 1790–1900*, Dulwich Picture Gallery, London

Watt and Ford 1991
J. Watt and B. Ford, *East Asian Lacquer from the Florence and Herbert Irving Collection*, The Metropolitan Museum, New York

OTHER PUBLISHED SOURCES

Ackermann 1808
R. Ackermann, *Microcosm of London*, 2 vols, London

Alcock 1862
R. Alcock, *International Exhibition, 1862: Catalogue of Works of Industry and Art Sent from Japan*, London

Audsley and Bowes 1881
G.A. Audsley and J.L. Bowes, *Keramic Art of Japan*, London

Ayers 2016
J. Ayers (ed.), *Chinese and Japanese Works of Art in the Collection of Her Majesty The Queen*, 3 vols, London

Baird 2001
M.C. Baird, *Symbols of Japan: Thematic Motifs in Art and Design*, New York

Baker 1989
D. Baker, *The Royal Gunroom at Sandringham*, Oxford

Bandini 2016
R. Bandini, 'Netsuke and inrō collectors in the nineteenth and twentieth centuries', in Cortazzi 2016, pp. 761–72

Bate 1993
D. Bate, 'Photography and the colonial vision', *Third Text*, 22, pp. 81–91

Best 2007
A. Best, 'A royal alliance: court diplomacy and Anglo-Japanese relations, 1900–41', in Cortazzi 2007a, pp. 63–70

Bickham 1742
G. Bickham, *Deliciae Britannicae, or, The Curiosities of Hampton-Court and Windsor-Castle, Delineated*, London

Bickham 1755
G. Bickham, *Deliciae Britannicae, or the Curiosities of Kensington, Hampton Court and Windsor Castle, Delineated*, London

Birks and Digby 1990
T. Birks and C.W. Digby, *Bernard Leach, Hamada and their Circle: from the Wingfield Digby Collection*, London

Bix 2009
H.P. Bix, *Hirohito and the Making of Modern Japan*, New York

Blome 1670
R. Blome, *A Geographical Description of the Four Parts of the World*, London

Borgen 1986
R. Borgen, *Sugawara No Michizane and the Early Heian Court*, Cambridge, Massachusetts

Borman et al. 2018
T. Borman, O. Fryman and D. Starkey (eds), *Kensington Palace: Art, Architecture and Society*, London

Bottomley 2004
I. Bottomley, 'Diplomatic gifts of arms and armour between Japan and Europe during the 16th and 17th centuries', *Arms & Armour*, 1, pp. 5–23

Bottomley 2013
I. Bottomley, 'Japanese diplomatic gifts of armour to Europe of the sixteenth and seventeenth centuries' in Richardson 2014, pp. 1–39

Bottomley 2017
I. Bottomley, *Japanese Arms and Armour*, Royal Armouries Arms and Armour Series, Leeds

Bowett 2002
A. Bowett, *English Furniture, 1660–1714: From Charles II to Queen Anne*, Woodbridge, Suffolk

Brayley 1838
E.W. Brayley, *Illustrations of Her Majesty's Palace at Brighton*, London

Brugier 2000
N.J. Brugier, 'From Asia to Europe: Asian lacquerware applied to French furniture', in Kühlenthal 2000, pp. 47–51

Buckle 1926
G.E. Buckle (ed.), *The Letters of Queen Victoria (Second Series)*, 2 vols, London

Campbell Fine Art 2003
Campbell Fine Art, *British & European Prints 18th–20th Centuries*, Catalogue 10, Tunbridge Wells

Champney and Champney 1917
E.W. Champney and F. Champney, *Romance of Old Japan*, London and New York

Chapman and Horner 2017
H. Chapman and L. Horner, *Yoshijiro Urushibara, A Japanese Printmaker in London: A Catalogue Raisonné*, Leiden

Chiba 1998
Y. Chiba, 'Japonisme: East–West renaissance in the late 19th century', *Mosaic: An Interdisciplinary Critical Journal*, 31 (2), pp. 1–20

Christie's 1819
Christie's, *A Catalogue of the First Part of A Magnificent Collection of Oriental Curiosities and Porcelain, &c. &c. &c.... sold by auction by Mr. Christie... Friday May 7 1819 and the Three Following Days*, London

Christie's 2006
Christie's, *Japanese Art and Design Including Netsuke from the Estate of His Royal Highness The Prince Henry, Duke of Gloucester, KG., KT., KP., Wednesday 12 and Thursday 13 July*, London

Clarke 1910
C.P. Clarke, *Arms and Armour at Sandringham: the Indian Collection presented... to... Edward VII, when Prince of Wales, on the Occasion of his Visit to India in 1875–1876. Also Weapons and War-Relics from Other Countries*, London

Clifford Smith 1931
H. Clifford Smith, *Buckingham Palace: Its Furniture, Decoration and History*, London and New York

Clulow 2016
A. Clulow, *The Company and the Shogun: The Dutch Encounter with Tokugawa Japan*, New York

Cole 1877
A. Cole, *A Catalogue of the Works of Art at Marlborough House, London and at Sandringham, Norfolk, Belonging to their Royal Highnesses the Prince & Princess of Wales*, London

Colvin 1963–76
H.M. Colvin (ed.), *The History of the King's Works*, 6 vols, London

Cooper 1965
M. Cooper (ed.), *They Came to Japan: An Anthology of European Reports on Japan, 1543–1640*, London

Cortazzi 1985
H. Cortazzi (ed.), *Mitford's Japan: The Memoirs and Recollections, 1866–1906, of Algernon Bertram Mitford, the First Lord Redesdale*, London

Cortazzi 2007a
H. Cortazzi (ed.), *Britain and Japan: Biographical Portraits*, VI, Folkestone

Cortazzi 2007b
H. Cortazzi, 'Japanese envoys in Britain, 1862–72', in Nish 2007, pp. 8–20

Cortazzi 2009
H. Cortazzi, *Japan in Late Victorian London: The Japanese Native Village in Knightsbridge and the Mikado, 1885*, Norwich

Cortazzi 2015
H. Cortazzi (ed.), *Britain and Japan: Biographical Portraits*, IX, Folkestone

Cortazzi 2016
H. Cortazzi (ed.), *Britain and Japan: Biographical Portraits*, X, Folkestone

Dalton 1886
J.N. Dalton (ed.), *The Cruise of Her Majesty's Ship "Bacchante", 1879–1882, Compiled from the Private Journals, Letters and Note-Books of Prince Albert Victor and Prince George of Wales with Additions by John N. Dalton*, 2 vols, London

Daniels and Tsuzuki 2002
G. Daniels and C. Tsuzuki (eds), *The History of Anglo-Japanese Relations, 1600–2000*, London

Das 2016
N. Das, 'Encounter as process: England and Japan in the late sixteenth century', *Renaissance Quarterly*, 69, pp. 1343–68

De Bellaigue 1975
G. de Bellaigue, 'Chinoiserie at Buckingham Palace', *Apollo*, CI, May, pp. 380–93

De Bellaigue 1997
G. de Bellaigue, 'Samuel Parker and the Vulliamys, purveyors of gilt bronze', *Burlington Magazine*, CXXXIX, Jan., pp. 26–37

Dees 1988
J. Dees, 'Imperial lacquer boxes by Akatsuka Jitoku', *Andon*, 30, pp. 103–10

Dees 1997a
J. Dees, 'Akatsuka Jitoku in Buckingham Palace', *Andon*, 57, pp. 3–12

Dees 1997b
J. Dees, 'Japanese Imperial presentation boxes, 1900–30', *Oriental Art*, 43 (1), pp. 2–9

Dees 2007
J. Dees, *Facing Modern Times: The Revival of Japanese Lacquer Art, 1890–1950*, Rotterdam

Defoe 1928
D. Defoe, *A Tour Through England and Wales*, G.D.H. Cole (ed.), 2 vols, London and New York

De Hond and Fitski 2016
J. de Hond and M. Fitski, *A Narrow Bridge: Japan and the Netherlands from 1600*, Amsterdam

Delboe et al. 1673
S. Delboe, H. Gibben and W. Ramsden, 'A copy of the Japan Diary receiv'd per a Danish ship July 18 1674 and given to Sir Robert Southwell by Sir Nathaniel Hearne. Sunday June 29. Anno Dom. 1673. Aboard the ship Return', in Kaempfer 1906, pp. 341–60

Dillon 1910
E. Dillon, *Catalogue of the Chinese and Japanese Porcelain and of the Delft Fayence at the Palaces of Hampton Court and St James's*, London

Dimond 2004
F. Dimond, *Developing the Picture: Queen Alexandra and the Art of Photography*, London

Dower 1985
J.W. Dower, *The Elements of Japanese Design: A Handbook of Family Crests, Heraldry & Symbolism*, New York

Dusenbury and Bier 2004
M.M. Dusenbury with C. Bier, *Flowers, Dragons & Pine Trees: Asian Textiles in the Spencer Museum of Art*, New York and Manchester

Earle et al. 1986
J. Earle, R. Faulkner, V. Wilson, R. Kerr and C. Clunas, *Japanese Art and Design: Victoria and Albert Museum*, London

Earle 2002
J. Earle, *Splendors of Imperial Japan: Arts of the Meiji period from the Khalili Collection*, London

Edwards 2006
S. Edwards, *The Making of English Photography: Allegories*, University Park, Pennsylvania

ESTC
English Short Title Catalogue
Hosted by the British Library, http://estc.bl.uk (accessed 27 February 2020)

Evelyn 1983
J. Evelyn, *The Diary of John Evelyn*, J. Bowle (ed.), Oxford and New York

Fanon 1965
F. Fanon, *A Dying Colonialism*, New York

Farrington 1991
A. Farrington, *The English Factory in Japan, 1613–1623*, 2 vols, London

Ffoulkes 1916
C. Ffoulkes, *Inventory and Survey of the Armouries of the Tower of London*, 2 vols, London

Fiennes 1888
C. Fiennes, *Through England on a Side Saddle in the Time of William and Mary: Being the Diary of Celia Fiennes*, E. Griffiths (ed.), London

Frampton 1885
M. Frampton, *The Journal of Mary Frampton from the Year 1779, until the Year 1846*, H.G. Mundy (ed.), London

Fraser 1982
M. Fraser, *A Diplomatist's Wife in Japan: Sketches at the Turn of the Century*, H. Cortazzi (ed.), New York

Frédéric 2002
L. Frédéric, *Japan Encyclopedia*, Cambridge, Massachusetts and London

Fuku 2000
N. Fuku, *Shinzo and Roso Fukuhara: Photographs by Ginza Modern Boys, 1913–1941*, Tokyo

Fukuzawa 1862
Fukuzawa Y., *Seiyō jijō* ['Conditions in the West'], Edo [Tokyo]

Galloway 1996
P. Galloway (ed.), *Royal Service*, 3 vols, London

Goodsir 2017
S. Goodsir, *Royal Gifts: Arts and Crafts From Around the World*, London

Gordon 2014
S. Gordon, 'Queen Victoria's private photographs' in Lyden et al. 2014 (exh. cat.), pp. 107–27

Gordon and Lawton 1999
P. Gordon and D. Lawton, *Royal Education: Past, Present & Future*, London and Portland, Oregon

Hacking 2010
J. Hacking, 'Camille Silvy's repertory: the *Carte-de-Visite* and the London theatre', *Art History*, 33 (5), pp. 856–85

Hakluyt 1589
R. Hakluyt, *Principall Nauigations, Voyages and Discoveries of the English Nation*, London

Hakluyt 1600
R. Hakluyt, *The Principal Navigations, Voyages, Traffiques, and Discoveries of the English Nation*, III, London

Harris et al. 1968
J. Harris, G. de Bellaigue and O. Millar, *Buckingham Palace*, London

Harrison and Sons 1860
'Treaty of Peace, Friendship and Commerce, between Her Majesty and the Tycoon of Japan, signed in the English, Japanese and Dutch languages at Yedo, August 26, 1858', London

Harvey-Lee 1994
E. Harvey-Lee, *North–South; East–West: Dialogue & Divergence*, Catalogue 15, North Aston, Oxfordshire

Harvey-Lee 2001
E. Harvey-Lee, *Paper Touched With Magic*, Catalogue 30, North Aston, Oxfordshire

Harvey-Lee 2007
E. Harvey-Lee, *Some Winter Colour*, Catalogue 42, North Aston, Oxfordshire

Hight 2011
E.M. Hight, *Capturing Japan in Nineteenth-Century New England Photography Collections*, Farnham, Surrey

Hinton and Impey 1998
M. Hinton and O. Impey (eds), *Kensington Palace and the Porcelain of Queen Mary II: Essays in Association with the Exhibition China Mania: A Re-creation of Queen Mary II's Display of Oriental Porcelain at Kensington Palace in the 1690s*, London

House of Commons 2008
Parliament, House of Commons, *Treaty of Commerce and Navigation Between Great Britain and Japan. Signed at London, July 16, 1894*, Treaty Series, No. 23, London

Hudson 1997
H.L. Hudson, *Cumberland Lodge: A House through History*, London

Hume 1899
M. Hume (ed.), *Calendar of State Papers, Vol. 4, 1587–1603, Spain (Simancas)*, London

Hutt 1992
J. Hutt and H. Alexander, *Ōgi: A History of the Japanese Fan*, London

Hutt 1995
J. Hutt, 'Japanese lacquerware of the Edo and Meiji periods', in Impey *et al.* 1995, IV (Part I), pp. 22–55

Hutt 2008
J. Hutt, 'From the eight views of the Xiaoxiang to the Ōmi Hakkei: a new interpretation of the iconography of the Mazarin chest', *Transactions of the Oriental Ceramic Society*, 71, 2006–7, pp. 3–18

Imamura 2015
A. Imamura, 'John William Fenton (1831–1890) and The Japanese National Anthem Kimigayo' in Cortazzi 2015, pp. 207–25

Imperial Institute 1897
Imperial Institute, *Catalogue of Selected Gifts and Addresses Presented to Her Majesty the Queen on the Occasion of her Diamond Jubilee. Exhibited in the North Gallery*, London

E. Impey 2003
E. Impey, *Kensington Palace, The Official Illustrated History*, London and New York

Impey *et al.* 1995
O. Impey, M. Fairley and J. Earle (eds), *Meiji No Takara: Treasures of Imperial Japan / The Nasser D. Khalili Collection of Japanese Art*, 5 vols, London

Impey and Jörg 2005
O. Impey and C. Jörg, *Japanese Export Lacquer, 1580–1850*, Amsterdam

Impey *et al.* 2009
O. Impey, C. Jörg and C. Mason, *Dragons, Tigers and Bamboo: Japanese Porcelain and its Impact in Europe*, Toronto

Impey and Kisluk-Grosheide 1994
O. Impey and D. Kisluk-Grosheide, 'The Japanese connection: French eighteenth-century furniture and export lacquer', *Apollo*, CXXXIX, 383, Jan., pp. 48–61

Iröns 1982
N.J. Iröns, *Fans of Imperial Japan*, Hong Kong

Irvine 2000
G. Irvine, *The Japanese Sword: The Soul of the Samurai*, London

Irvine 2016
G. Irvine (ed.), *Japanese Art and Design*, Victoria and Albert Museum, London

Itoh 2001
K. Itoh, *The Japanese Community in Pre-War Britain, From Integration to Disintegration*, Richmond, Surrey

JAANUS 2001
Japanese Architecture and Art Net Users System, M. Parent (ed.), http://www.aisf.or.jp/~jaanus/ (accessed 18 Feb. 2019)

Jackson 1992
A. Jackson, 'Imagining Japan: The Victorian perception and acquisition of Japanese culture', *Journal of Design History*, 5, pp. 245–56

Jackson 2015
A. Jackson (ed.), *Kimono: The Art and Evolution of Japanese Fashion*, London

Jackson and Faulkner 1995
A. Jackson with F. Faulkner, 'The Meiji period in South Kensington: The representation of Japan at the Victoria and Albert Museum 1852–1912', in Impey *et al.* 1995, I, pp. 152–95

Jackson and Jaffer 2004
A. Jackson and A. Jaffer (eds), *Encounters: The Meeting of Asia and Europe, 1500–1800*, London and New York

Jackson-Stops 1993
G. Jackson-Stops, '"A Noble Simplicity": Pyne's views of Buckingham House', *Apollo*, CXXXVIII, Aug., pp. 44–56

Jansen 2002
M. Jansen, *The Making of Modern Japan*, Cambridge, Massachusetts and London

Jenyns 1965
S. Jenyns, *Japanese Porcelain*, London

Joly and Tomita 1915
H.L. Joly and K. Tomita, *Japanese Art & Handicraft: An Illustrated Record of the Loan Exhibition Held in Aid of the British Red Cross in October–November 1915*, London

Jones 2017
K. Jones, *European Silver in the Collection of Her Majesty The Queen*, London

Kaempfer 1906
E. Kaempfer, *The History of Japan: Together with a Description of the Kingdom of Siam*, 2 vols, trans. J.G. Scheuchzer, New York

Kammerl 1989
C. Kammerl, *Der Fächer Kunstobjekt und Billetdoux*, Munich

Kaneko 2003
R. Kaneko, 'The origins and developments of Japanese art photography' in Tucker *et al.* 2003 (exh. cat.), pp. 102–13

Kazui and Videen 1982
T. Kazui and S.D. Videen, 'Foreign relations during the Edo period: Sakoku reexamined', *Journal of Japanese Studies*, 8 (2), summer 1982, pp. 283–306

Keene 1998
D. Keene, *Modern Japanese Diaries: The Japanese at Home and Abroad as Revealed through their Diaries*, New York

Keene 2002
D. Keene, *Emperor of Japan: Meiji and His World, 1852–1912*, New York

Kenchiku Zasshi 1910
'Nichiei hakurankai ni okeru tatemono mokei', 'zakki' ['Models of buildings at the Japan-British Exhibition', 'Miscellaneous notes'], *Kenchiku Zasshi*, no. 277, pp. 60–62

Keppel 1899
H. Keppel, *A Sailor's Life under Four Sovereigns*, 3 vols, London

Kidder 2003
J.E. Kidder, 'Low-fired wares' in *Grove Art Online*, 'Japan', IX, https://doi-org.ezproxy2.londonlibrary.co.uk/10.1093/gao/9781884446054.article.T043440 (accessed 7 Feb. 2019)

Kisluk-Grosheide 2000
D. Kisluk-Grosheide, 'The (ab)use of export lacquer in Europe', in Kühlenthal 2000, pp. 27–43

Kleutghen 2017
K. Kleutghen, 'Imports and imitations: the taste for Japanese lacquer in eighteenth-century China and France', *Journal for Early Modern Cultural Studies*, 17 (2), pp. 175–206

Kornicki 2008
P. Kornicki, 'Dickins, Frederick Victor (1838–1915), Japanologist', in *ODNB*, https://www.oxforddnb.com/view/10.1093/ref:odnb/9780198614128.001.0001/odnb-9780198614128-e-47196 (accessed 29 May 2019)

Kornicki *et al.* 2019
P. Kornicki, A. Best and H. Cortazzi, *British Royal and Japanese Imperial Relations, 1868–2018: 150 Years of Association, Engagement and Celebration*, Folkestone

Kramer 2013
E. Kramer, '"Not so Japan-easy": The British reception of Japanese dress in the late nineteenth century', *Textile History*, 44 (1), pp. 3–24

Kühlenthal 2000
M. Kühlenthal (ed.), *East Asian and European Lacquer Techniques*, Munich

Laking 1905
G.F. Laking, *The Furniture of Windsor Castle*, London

Laking 1933
G. Laking, *An Illustrated Guide to Osborne … with a catalogue of the Pictures, Porcelain and Furniture in the State Apartments*, London

Lane 1949–50
A. Lane, 'Queen Mary II's porcelain collection at Hampton Court', *Transactions of the Oriental Ceramic Society*, 25, pp. 21–31

Leach 1976
B. Leach, *Hamada: Potter*, London

L'estampille 1987
'Petit bureau de dame à cylindre, estampillé J.-B. Vassou', *L'estampille*, 203, May, p. 85

Lillehoj 2011
E. Lillehoj, *Art and Palace Politics in Early Modern Japan, 1580s–1680s*, Leiden and Boston

Llorens Planella 2015
M. Llorens Planella, 'Silk, porcelain and lacquer: China and Japan and their trade with Western Europe and the New World, 1500–1644. A survey of documentary and material evidence', PhD dissertation, Leiden University

Lockyer 1711
C. Lockyer, *An Account of the Trade in India*, London

Loftie 1907
W.J. Loftie, *The Colour of London*, London

Louisiana 1904
Louisiana Purchase Exhibition, *Illustrations of Selected Works in the Various National Sections of the Department of Art, with Complete List of Awards by the International Jury, Universal Exposition, St. Louis, 1904*, St. Louis, Louisiana

D.F. Lunsingh Scheurleer 1980
D.F. Lunsingh Scheurleer, *Chinesisches und japanisches Porzellan in europäischen Fassungen*, Brunswick

T.H. Lunsingh Scheurleer 1962
T.H. Lunsingh Scheurleer, 'Documents on the furnishing of Kensington House', *Volume of the Walpole Society*, 38 (1960–62), pp. 15–58

Mackenzie and Finkel 2004
C. Mackenzie and I. Finkel (eds), *Asian Games: The Art of Contest*, New York

Martin 1996
S. Martin, 'The Royal Victorian Chain' in Galloway 1996, I, pp. 89–106

Mason and Caiger 1997
R.H.P. Mason and J.G. Caiger, *A History of Japan*, revised edn, Tokyo

Massarella 2008
D. Massarella, *A World Elsewhere: Europe's Encounters with Japan in the Sixteenth and Seventeenth Centuries*, New Haven

McCauley 1985
E.A. McCauley, *A.A.E Disdéri and the Carte de Visite Portrait Photograph*, New Haven and London

McDermott 2010
H. McDermott, 'Meiji Kyoto textile art and Takashimaya', *Monumenta Nipponica*, 65 (1), pp. 37–88

D. Millar 1995
D. Millar, *The Victorian Watercolours and Drawings in the Collection of Her Majesty The Queen*, 2 vols, London

O. Millar 1970–72
O. Millar, 'The inventories and valuations of the king's goods, 1649–1651', *Volume of the Walpole Society*, 43, pp. iii–v, vii, ix, xi–xxviii, 1–458

O. Millar 1992
O. Millar, *The Victorian Pictures in the Collection of Her Majesty The Queen*, 2 vols, Cambridge

Mitford 1906
A.B. Mitford, *The Garter Mission to Japan*, London and New York

Mitford 1915
A.B. Mitford, *Memories*, 2 vols, London

Morley 1984
J. Morley, *The Making of the Royal Pavilion, Brighton*, London

Murase 1975
M. Murase, *Japanese Art: Selections from the Mary and Jackson Burke Collection*, New York

Mutsu 2002
H. Mutsu (ed.), *The British Press and the Japan-British Exhibition of 1910*, London and New York

Nakagawa 2012
K. Nakagawa, *Animals/Plants Photographs and Modern Paintings in Japan*, Kyoto

Nish 2001
I. Nish, *Collected Writings of Ian Nish*, 2 vols, Richmond, Surrey

Nish 2007
I. Nish (ed.), *Japanese Envoys in Britain, 1862–1964, A Century of Diplomatic Exchange*, Folkestone

Nishida 2003
H. Nishida, 'Porcelain and overglaze enamels', in *Grove Art Online*, 'Japan', IX, https://doi-org.ezproxy2.londonlibrary.co.uk/10.1093/gao/9781884446054.article.T043440 (accessed 7 Feb. 2019)

Official Report of the Japan British Exhibition 1911
Official Report of the Japan British Exhibition 1910 at the Great White City, Shepherd's Bush, London, London

Ovenden 1997
R. Ovenden, *John Thompson (1837–1921)*, Edinburgh

Parissien 2004
S. Parissien, 'European fantasies of Asia' in Jackson and Jaffer 2004, pp. 348–59

Parker and Stalker 1688
G. Parker and J. Stalker, *A Treatise of Japaning [sic] and Varnishing…*, London

Patterson 1996
S. Patterson, *Royal Insignia: British and Foreign Orders of Chivalry from the Royal Collection*, London

Peck 1857
J. Peck, *Catalogue of the Art Treasures of the United Kingdom Collected at Manchester in 1857*, London

Pennington 1982
R. Pennington, *A Descriptive Catalogue of the Etched Work of Wenceslaus Hollar 1607–1677*, Cambridge and London

Pepys 1893–6
The Diary of Samuel Pepys M.A. F.R.S., H.B. Wheatley (ed.), 8 vols, London

Pollard 2002
C. Pollard, *Master Potter of Meiji Japan: Makuzu Kōzan (1842–1916) and his Workshop*, Oxford

Prince of Wales 1922
The Prince of Wales' Eastern Book: A Pictorial Record of the Voyages of H.M.S. "Renown", 1921–1922, London, New York and Toronto

Professional Photographer 1916
'Vandyk Ltd. Buckingham Palace Road, S.W.', *The Professional Photographer*, 1 Oct. 1916, pp. 291–6

Purchas 1614
S. Purchas, *Purchas His Pilgrimage: or Relations of the World and the Religions Observed in All Ages and Places Discovered…*, London

Pyne 1819
W.H. Pyne, *The History of the Royal Residences of Windsor Castle, St James's Palace, Carlton House, Kensington Palace, Hampton Court, Buckingham House and Frogmore*, 3 vols, London

Raffles 1929
S. Raffles, *Report on Japan to The Secret Committee of the English East India Company by Sir Stamford Raffles, 1812–1816, with Preface by M. Paske-Smith*, Kōbe

Randel 1986
D.M. Randel, *The New Harvard Dictionary of Music*, 2nd edn, Cambridge, Massachusetts and London

Redfern 2016
M. Redfern, 'Minton for the Meiji Emperor', in Cortazzi 2016, pp. 542–53

Reese 1976
M. Reese, *The Royal Office of Master of the Horse*, London

Richardson 2014
T. Richardson (ed.), *East Meets West: Diplomatic Gifts of Arms and Armour between Europe and Asia*, Leeds

H. Roberts 2001
H. Roberts, *For the King's Pleasure: The Furnishing and Decoration of George IV's Apartments at Windsor Castle*, London

Rodner 2012
W.S. Rodner, *Edwardian London through Japanese Eyes: The Art and Writings of Yoshio Markino, 1897–1915*, Leiden and Boston

Rouse 1905
W. Rouse (ed.), *Early Voyages to Japan: John Saris and William Adams*, London

Rousmaniere 2002
N.C. Rousmaniere (ed.), *Kazari: Decoration and Display in Japan, 15th–19th Centuries*, London

Royle 1857
J.F. Royle, 'Museum of Ornamental Art' in Peck 1857, pp. 137–76

Sakakibara 2002
S. Sakakibara, *Bi no kakehashi: ikoku ni tsukawasareta byōbu tachi*, Tokyo

Sakomura 2004
T. Sakomura, 'Japanese games of memory, matching and identification', in Mackenzie and Finkel 2004, pp. 253–71

Sansom 1978
G. Sansom, *A History of Japan, 1334–1615*, revised edn, Folkestone

Sargent 1991
W. Sargeant, *The Copeland Collection: Chinese and Japanese Ceramics Figures*, Salem, Massachusetts

Satow 1900
E. Satow (ed.), *The Voyage of Captain John Saris to Japan, 1613*, London

Science and Art Department 1868
Science and Art Department of the Committee of Council on Education, 'Inventory of art objects acquired in the year 1865', in *Inventory of the Objects in the Art Vision of the Museum at South Kensington, Arranged According to the Dates of Their Acquisition, I: For the Years 1852 to the End of 1867*, London

Screech 2012
T. Screech, *Obtaining Images: Art, Production and Display in Edo Japan*, London

Screech 2016
T. Screech, 'Thomas (Sir Stamford) Raffles (1781–1826) and Dr Donald Ainslie', in Cortazzi 2016, pp. 20–36

Shaw 1916
W.A. Shaw (ed.), *Calendar of Treasury Books. Vol. VII, 1681–1685*, 32 vols, London

Shirane 2012
H. Shirane, *Japan and the Culture of the Four Seasons: Nature, Literature and the Arts*, New York

Shugio 1910
H. Shugio, 'Japanese art and artists of to-day: II – ceramic artists', *International Studio*, XLI, 164, pp. 286–93

Shulsky 1998
L.R. Shulsky, 'Queen Mary's collection of porcelain and its display at Kensington Palace', in Hinton and Impey 1998, pp. 27–49

Sinclaire 2008
C. Sinclaire, 'Gifts, presentations and special orders', *To-ken Society* [journal], copy provided in email correspondence from Greg Irvine, 2018, pp. 1–16

Siong 1998
H.B. Siong, 'Probably the one and only gensuitō outside Japan and other interesting Japanese swords at Windsor Castle', *Japanese Sword Society of the United States*, 30 1-A, Special Issue, pp. 1–35

Slade 2009
T. Slade, *Japanese Fashion: A Cultural History*, Oxford

Smith 1988
L. Smith, *Ukiyoe: Images of Unknown Japan*, London

Smith et al. 1990
L. Smith, V. Harris and T. Clark, *Japanese Art: Masterpieces in the British Museum*, London

Sotheby's, London, sale cat., 10 July 1998 (lot 116)

Sotheby's, Paris, sale cat., 21 June 2001 (lot 79)

South Kensington Museum 1872
South Kensington Museum, *A Guide to the Works of Art and Science Collected by Captain His Royal Highness the Duke of Edinburgh, K.G. During his Five-Years' Cruise Round the World in H.M.S. 'Galatea' (1867–1871) and Lent for Exhibition in the South Kensington Museum*, 3rd edn, London

Speaight 1926
R.N. Speaight, *Memoirs of a Court Photographer*, London

Stalker 2018
N.K. Stalker, *Japan: History and Culture from Classical to Cool*, Oakland, California

Starkey and Ward 1998
D. Starkey and P. Ward (eds), *The Inventory of King Henry VIII. Vol. I: The Transcript*, London

Stevenson 1978
S. Stevenson and H. Bennett, *Van Dyck in Check Trousers*, Edinburgh

Strange 1927a
E. Strange (ed.), 'The Royal Collections: Furniture at Windsor Castle, II', *Old Furniture*, I (2), July 1927, pp. 83–99

Strange 1927b
E. Strange (ed.), 'The Royal Collections: Furniture at Windsor Castle, III', *Old Furniture*, I (3), Aug. 1927, pp. 157–71

Suchomel and Suchomelová 2002
F. Suchomel and M. Suchomelová, *A Surface Created for Decoration: Japanese Lacquer Art from the 16th to the 19th Centuries*, Prague

Survey of the Tower Armoury 1660
A. Way (ed.), *Archaeological Journal*, 4, 1847, pp. 341–54

Tadao 1987
O. Tadao, *The Complete Woodblock Prints of Yoshida Hiroshi*, Tokyo

Tennants Auctioneers 2018
Tennants Auctioneers, *The Arthur Blackborne Collection of Fine Antique Fans – Part I*, 23 May 2018

Thomas 1995
I. Thomas, 'Far Eastern photography in the Victoria and Albert Museum', *Orientations*, 26 (10), Nov. 1995, pp. 69–71

Tōkyō-fu 1934
Shiba-Ueno Tokugawa reibyô, Tôkyôfu shiseki hozonbutsu chôsa hôkokusho, 11, Tôkyô-fu ('Report on Survey of Historical Sites, Tokyo, no. 11: The Tokugawa Mausolea at Shiba and Ueno')

Tsuji 2018
N. Tsuji, *History of Art in Japan*, trans. N.C. Rousmaniere, Tokyo

Turley 2001
R.V. Turley, *Isle of Wight Photographers (1840–1940)*, Southampton

Turner 2011
S. Turner, *The New Hollstein German Engravings, Etchings and Woodcuts, 1400–1700: Wenceslaus Hollar*, Part VII of parts I–IX, Ouderkerk aan den Ijssel, Netherlands, 2009–12

Vinhais and Welsch 2008
L. Vinhais and G. Welsch (eds), *After the Barbarians: Namban Works of Art for the Japanese, Portuguese and Dutch Markets*, London

Volker 1954
T. Volker, *Porcelain and the Dutch East India Company, 1662–1682*, Leiden

Watkin 1984
D. Watkin, *The Royal Interiors of Regency England*, London and Melbourne

Watson 1960
F.J.B. Watson, *Louis XVI Furniture*, New York

Weigert et al. 1973
R. Weigert, P. Lemoisne, M. Préaud and Bibliothèque Nationale Départment des Estampes, *Inventaire du fonds français: graveurs du XVIIᵉ siècle*, 14 vols, Paris, 1939–2008, *Tome 6: Labbé–La Ruelle*, 1973

Weiss 2006
M. Weiss, 'Staged photography in the Victorian album', in Pauli 2006 (exh. cat.), pp. 81–99

Wheeler 2019
D. Wheeler, 'New light on a suite of lacquer and giltwood furniture made for Queen Anne *c.*1705 and other lacquer and giltwood furniture illustrated in Pyne's Royal Residences', *Furniture History*, LV, 2019, pp. 71–86

Wilson 2011
S. Wilson, 'Enthroning Hirohito: Culture and nation in 1920s Japan', *The Journal of Japanese Studies*, 37 (2), pp. 289–323

Windsor 1951
The Duke of Windsor, *A King's Story: The Memoirs of the Duke of Windsor, KG*, London

Wolvesperges 2000
T. Wolvesperges, *Le Meuble français en laque au XVIIIe siècle*, Brussels

Yokoyama 1987
T. Yokoyama, *Japan in the Victorian Mind: A Study of Stereotyped Images of a Nation, 1850–1880*, London

Yoshida 1939
H. Yoshida, *Japanese Woodblock Printing*, Tokyo and Osaka

Ziegler 1990
P. Ziegler, *King Edward VIII: The Official Biography*, London

NOTES ON CONTRIBUTORS

AB **Andrew Brown** is Collection Acquisitions and Descriptions Officer, Royal Library, Royal Collection Trust

AK **Aris Kourkoumelis** is Assistant Curator of Photographs, Royal Collection Trust

CDEG **Caroline de Guitaut** is Deputy Surveyor of The Queen's Works of Art, Royal Collection Trust

GI **Gregory Irvine** is Senior Curator, Victoria and Albert Museum

ICVB **Ine Castelijns van Beek** was Curatorial Intern, Decorative Arts, Royal Collection Trust

KJ **Kathryn Jones** is Senior Curator of Decorative Arts, Royal Collection Trust

MW **Melanie Wilson** is Catalogue Raisonné Assistant, Royal Collection Trust

RP **Rachel Peat** is Assistant Curator of Non-European Works of Art, Royal Collection Trust. She is curator of the *Japan: Courts and Culture* exhibition at The Queen's Gallery, Buckingham Palace

RW **Rhian Wong** is Assistant to the Curators of the Print Room, Royal Collection Trust

SG **Sally Goodsir** is Curator of Decorative Arts, Royal Collection Trust

SJP **Stephen Patterson** is Head of Collections Information Management, Royal Collection Trust

WC **William H. Coaldrake** was Taitokuin Mausoleum Model Restoration Project Co-ordinator, 2013–16; Department of Architecture, University of Tokyo

ACKNOWLEDGEMENTS

This book owes a considerable debt to John Ayers's three-volume catalogue raisonné, *Chinese and Japanese Works of Art in the Collection of Her Majesty The Queen* (2016), and to all involved in its production.

Numerous experts in the field of Japanese history and art have been unremittingly generous with their knowledge and time. Our sincere thanks go to Professor Nicole Coolidge Rousmaniere, Research Director at the Sainsbury Institute for the Study of Japanese Arts and Cultures, University of East Anglia, for her exceptional advice, enthusiasm and support throughout the project. Hanaoko Kiyoko of the Ashmolean Museum supplied many of the translations. We are grateful for the assistance of Uchida Hiromi, Uchiyama Atsuko, Ambassador Tsuruoka, Alex Bradshaw, Hayashida Hideki, the Daiwa Anglo-Japanese Foundation and the Great Britain Sasakawa Foundation in facilitating research in Japan in 2019. The staff of the Imperial Household Agency, Tokyo National Museum and Nikkō Tōshōgū Shrine were exceptionally generous with their time and expertise. In London, Heidi Potter was most kind in facilitating access to the Japan Society archives.

The editor and authors have benefited from the insights and research of John Anderson, David Beevers, Natasha Bennett, Dr Antony Best, Dr Rosina Buckland, Timothy Clark, Dr Jan Dees, Mike Dobby, Sebastian Dobson, Menno Fitski, Clare Freestone, Dr Luke Gartlan, Mark Hinton, Julia Hutt, Anna Jackson, Professor Peter Kornicki, Kyoko Kusunoki, Susan Meehan, Professor Miki Yoshi, Murose Kazumi, Dr Cóilín Ó Dubhghaill, Kathy Peat, Michael Peat, Brian Pilkington, Dr Mary Redfern, Dennis Reed, Professor Timon Screech and Simon Wright.

Within the Royal Household, we are grateful to Danielle Boldero, Leslie Chappell, Tricia Earl, Kate Gillham, Katherine Flaherty and Paul Southwell. Expert assistance at the Royal Archives was provided by Julie Crocker, Allison Derrett, Kathryn Johnson and Bill Stockting.

Colleagues past and present across the Royal Collection Trust have been instrumental in the publication of this catalogue. Rufus Bird and Fiona Norbury provided invaluable support and guidance throughout the project. We are particularly grateful for the enthusiasm and expertise of Alison Guppy, Francesca Levey, Simon Metcalf and Sophy Wills in preparing the arms, armour and metalwork for exhibition. Our thanks also go to conservators Irene Campden, Emma Clare, Megan Gent, Cathryn Harvey, Michelle Kirk, Clara de la Peña Mc Tigue, Deborah Phipps, Puneeta Sharma, Kate Stone, Emma Turner, Jane Wallis, David Wheeler and Natalia Zagorska-Thomas. All have worked tirelessly to prepare the objects for photography and display.

This catalogue was produced with the devoted attention of the in-house Publishing team, Polly Atkinson, Hannah Bowen, Tom Love, Kate Owen, Georgina Seage and Elizabeth Silverton. In this task they were ably assisted by designer Paul Sloman, copyeditor and indexer Gerard Hill and proofreader Beverly Zimmern. The remarkable images accompanying this research are the work of Stephen Chapman, Tung Tsin Lam and Eva Zielinksa-Millar, supported by Dominic Brown Photography and Richard Shellabear of Todd-White Art Photography. We are especially grateful to Stephen Chapman for his dedication and skill in photographing the sword blades. The photographic programme was overseen with great care by Karen Lawson, Daniel Partridge and Shruti Patel. We are also grateful for the support of Russell Adams, Alexandra Campbell-Ricketts, Paul Carter, Tamsin Douglas, Beth Jones, Tim Knox, Sir Jonathan Marsden, Kajal Meghani, Rachel Sharples, Chris Stevens, Paul Stonell, Nicola Turner Inman, Oliver Urquhart Irvine and Hannah Walton.

Lastly, we would like to extend our thanks to the representatives of artists' estates who have assisted us with our enquiries and graciously given us permission to reproduce works of art in this book: Hamada Tomoo, J. Anthony and Peter Keith, Makino Akinori, Nakagawa Kaoru and Nakagawa Kuniaki and Urushibara Ichiro.

Unless otherwise stated below, all works reproduced are Royal Collection Trust / © Her Majesty Queen Elizabeth II 2020

All items in the Royal Archives: Royal Archives / © Her Majesty Queen Elizabeth II 2020: illustrations on pages 118, 119, 122, 128, 198; Fig. 5.14

Royal Collection Trust / All Rights Reserved: illustrations on pages 210, 214, 215, 222–3, 241, 248, 249

Royal Collection Trust / All Rights Reserved / J.A. Keith: illustration on pages 224, 225

Royal Collection Trust / All Rights Reserved / Urushibara Ichiro: illustrations on pages ii, 212, 213, 218, 220, 221

Royal Collection Trust / Hamada-gama Pottery Co.: illustration on page 73

Royal Collection Trust / Makino Akinori: illustration on pages 186, 216–17

Royal Collection Trust is grateful for permission to reproduce the items listed below:

Bodleian Libraries, University of Oxford, Oxford: Fig. 1.6

British Museum, London, © The Trustees of the British Museum: Figs 3.2, 5.11, 8.3

British Museum, London, © The Trustees of the British Museum / Private Collection: Fig. 8.6

Clarence House, © Clarence House: Fig. 12.9

Collection Nationaal Museum van Wereldculturen: Fig. 10.1

Illustrated London News, © Illustrated London News Ltd / Mary Evans: Figs 5.2, 5.3, 5.13, 8.1, 12.5

Kanagawa Prefectural Museum of Cultural History: Fig. 5.6

The Khalili Collection of Japanese Art, © The Khalili Family Trust: Fig. 8.11

London Transport Museum, © TfL from the London Transport Museum collection: Fig. 8.5

Meiji Jingū, Tokyo: Fig. 5.5

Metropolitan Museum of Art, New York, Harris Brisbane Dick Fund, 1930: Fig. 2.8

Museum of Fine Arts, Boston, Massachusetts, USA / Gift of L. Aaron Lebowich / Bridgeman Images: Fig. 10.2

Museum of New Zealand Te Papa Tongarewa, purchased 1975 with Special Government Grant: Fig. 5.1

Nagasaki Museum of History and Culture, Nagasaki, Japan: Fig. 2.4

Nara National Research Institute for Cultural Properties: Figs 12.4, 12.7

National Diet Library, Tokyo: Fig. 5.4

National Museum of Japanese History, Sakura: Fig. 12.3

National Trust, © National Trust Images / Paul Highnam: Fig. 1.4

PA Images: Fig. 11.3

Rijksmuseum, Amsterdam: Fig. 4.4

Royal Armouries, Leeds, © Royal Armouries: Fig. 1.5

State Art Collection, Art Gallery of Western Australia, bequest of Mrs Caroline Chevalier, 1919: Fig. 5.9

The Tokugawa Art Museum Image Archives / DNP Art Communications Co., Ltd: Fig. 1.1

Victoria and Albert Museum, London, © V&A Images: Figs 1.3, 6.2

William H. Coaldrake, reproduced by courtesy of William H. Coaldrake: Figs 12.6, 12.8

Zōjō-ji Collection, discovered and donated by related temple in 2015; by courtesy of Zōjō-ji: Fig. 12.1

Every effort has been made to contact copyright holders; any omissions are inadvertent and will be corrected in future editions if notification of the amended credit is sent to the publisher in writing.

Uncaptioned illustrations

page xiv: Detail of RCIN 8586 (cat. 108)
page 6: Detail of Fig. 2.5
page 16: Detail of RCIN 2402.2 (cat. 17)
page 36: Detail of RCIN 829.2 (cat. 31)
page 38: Detail of RCIN 27526.1 (cat. 29)
page 39: Detail of RCIN 58821.1 (cat. 7)
page 74: Detail of RCIN 39503 (cat. 156)
page 76: Detail of RCIN 26044 (cat. 57)
page 77: Detail of RCIN 3154.1 (cat. 48)
page 104: Detail of RCIN 1191274 (cat. 66)
page 130: Detail of RCIN 64125 (cat. 73)
page 133 (top): RCIN 62631.a (cat. 88)
page 133 (bottom): RCIN 72786.a (cat. 92)
page 166: Detail of RCIN 7798.1 (cat. 99)
page 168: Detail of RCIN 41530 (cat. 109)
page 169 (top right): Detail of RCIN 100753 (cat. 106)
page 169 (bottom left): Detail of RCIN 7797.2 (cat. 101)
page 186: Detail of RCIN 702798 (cat. 125)
page 210: Detail of RCIN 507122 (cat. 131)
page 212: Detail of RCIN 502218 (cat. 127)
page 213: Detail of RCIN 502220 (cat. 129)
page 228: Detail of RCIN 42037 (cat. 137)
page 230: Detail of RCIN 69750.a (cat. 140)
page 231: Detail of RCIN 1145973.a (cat. 134)
page 264: Detail of RCIN 79563 (cat. 136)
page 270: Detail of Fig. 12.2
page 278: Detail of RCIN 829.1 (cat. 31)